THE CHINESE CENTURY

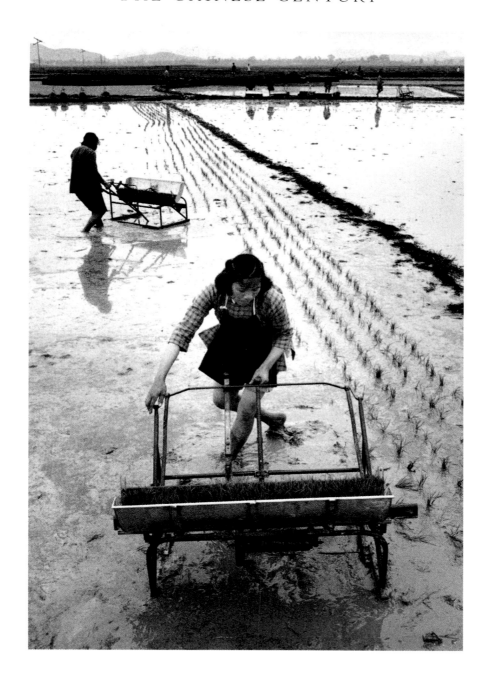

Jonathan Spence & Annping Chin

THE CHINESE CENTURY

A Photographic History

Photographs researched by the authors,
Colin Jacobson and Annabel Merullo

HarperCollins*Publishers*

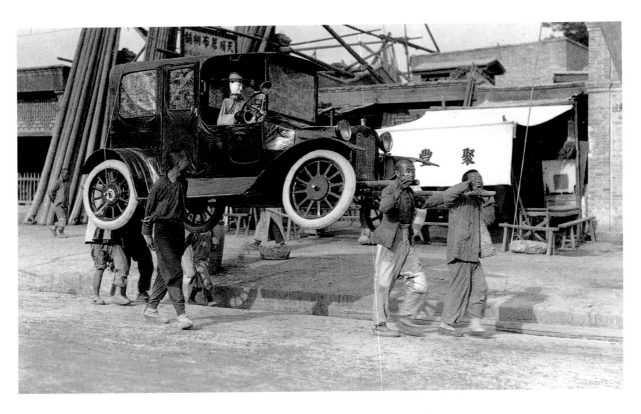

(Above) Peking, 1924: a paper Model A Ford
and chauffeur on their way to be burnt at the graveside, so the deceased
would have transport in the spirit world
[PHOTO: SIDNEY D.GAMBLE]

(Opposite) Children in Beiping, 1937
[PHOTO: GEORGE KRAINUKOV]

(Half title page) Planting rice, South China, 1965
[PHOTO: MARC RIBOUD]

(Title page) Beijing, 1957
[PHOTO: MARC RIBOUD]

Copyright © 1996 Endeavour Group UK
Published in 1996 by
HarperCollins*Publishers*
77-85 Fulham Palace Road,
Hammersmith, London W6 8JB

ISBN 0 00 255801 7

This book was created, designed and produced by the
Endeavour Group UK, 85 Larkhall Rise, London SW4 6HR

Project Manager: Annabel Merullo
Editors: Roger Hudson and Kate Oldfield
Designer: Paul Welti
Typeset by: Peter Howard
Origination by: Zincografica, Bologna, Italy
Printed by: Nuovo Istituto Italiano d'Arti Grafiche SpA, Bergamo, Italy

CONTENTS

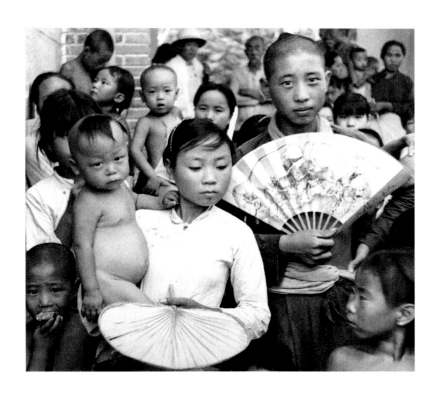

EDITORS' NOTE

The system of romanization used in *The Chinese Century* is Pinyin, which is the official system adopted by the People's Republic of China since the 1950s, and largely replaces the older Wade-Giles system. Pronunciation of Pinyin is mostly as it looks with the exception of: 'c' (as in Dowager Empress Cixi) which is pronounced 'ts'; 'q' (as in Qing) pronounced 'ch'; 'iu' (as in Liu) pronounced 'yo' as in yoke; 'x' (as in Guangxu and Cixi) pronounced 'sh' as in she; and 'zh' (as in Zhou Enlai, Zhu De and Guangzhou) pronounced 'j' as in job. Some names, however, which have been used for a long time in the West, retain their old romanization (such as Chiang Kai-shek, China, Canton, Tibet, Hong Kong and Sun Yat-sen).

Chinese names use the family name first and the given name second.

The photographs reproduced in this book are the result of extensive research in archives, museums and private collections around the world, in China, Europe, America. We are grateful to the archivists, photographers and others who have assisted us and the authors in the task of seeking out this material. The book has enjoyed the support of all our publishing partners around the world, but it would not have been possible without the steadfast help of Harold Evans at Random House in New York. We are also grateful to Hansjoachim Nierentz of Agfa-Gaevert and Bildforum for generously supplying quality photographic paper and chemicals, and for help organising photographic exhibitions.

Photographers' names, when known, are credited in the captions. The sources of the photographs, and of quotations from other books, are listed in the acknowledgements on page 262.

On the Imperial Road leading to the Ming Tombs near Beijing, 1964.
[PHOTO: RENE BURRI]

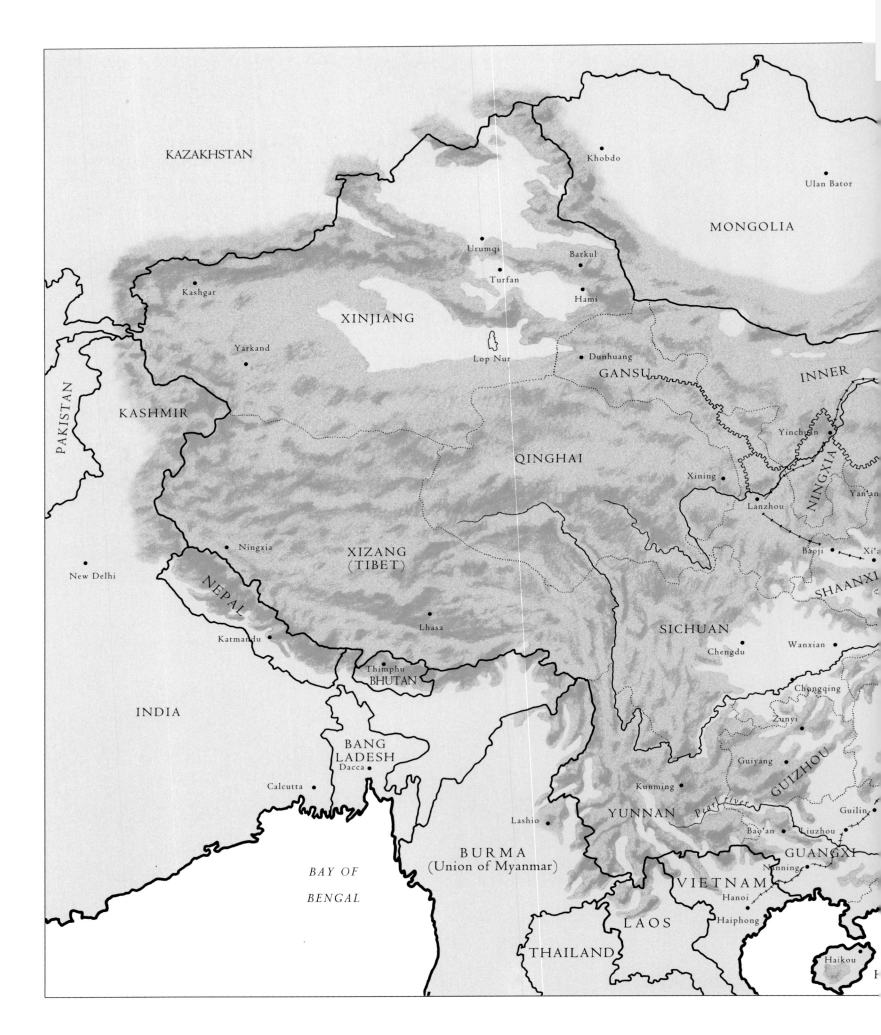

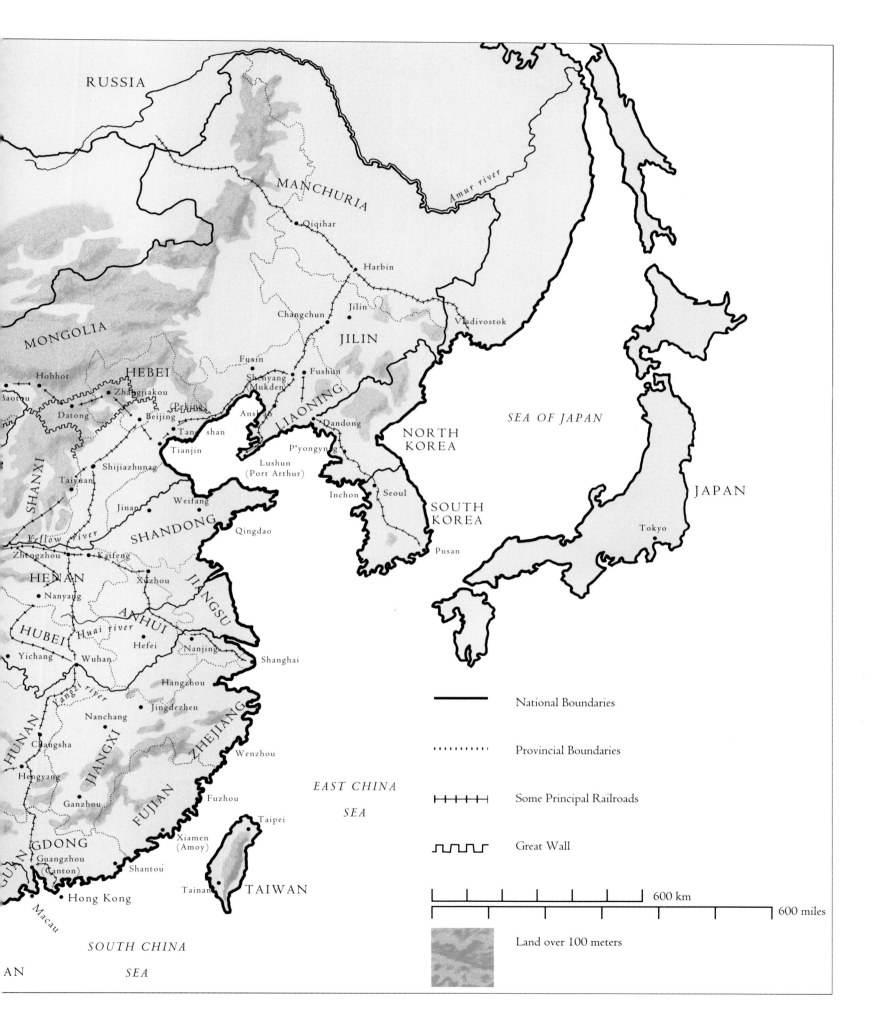

RUSSIA

MANCHURIA

Amur river

• Qiqihar

Harbin

Changchun • Jilin

JILIN

Vladivostok

MONGOLIA

Hohhot •

HEBEI

Fuxin

Baotou

Zhangjiakou

Datong •

(Peking)
Beijing •

Shenyang
Mukden

Fushun

LIAONING

Anshan

Dandong

SEA OF JAPAN

JAPAN

Tan shan

Tianjin

Lushun
(Port Arthur)

P'yongyng

NORTH
KOREA

SHANXI

Shijiazhuang •

Inchon

Seoul

Taiyuan •

Weifang •

Jinan •

SHANDONG

Qingdao

SOUTH
KOREA

Tokyo

Yellow river

Zhengzhou • • Kaifeng

Pusan

HENAN

Xuzhou •

JIANGSU

Nanyang •

ANHUI

HUBEI

Huai river

Hefei •

Nanjing •

Yichang •

Wuhan •

Shanghai

EAST CHINA

Hangzhou •

Yangzi river

HUNAN

Nanchang •

Jingdezhen •

SEA

JIANGXI

ZHEJIANG

Changsha •

Wenzhou •

Hengyang •

Ganzhou •

FUJIAN

Fuzhou •

Taipei •

Xiamen
(Amoy)

GDONG

Tainan

TAIWAN

Guangzhou
(Canton)

Shantou •

• Hong Kong

Macau

SOUTH CHINA

AN SEA

——————— National Boundaries

• • • • • • • • Provincial Boundaries

├─┼─┼─┼─┤ Some Principal Railroads

⅃⊓⅃⊓⅃ Great Wall

600 km

600 miles

Land over 100 meters

9

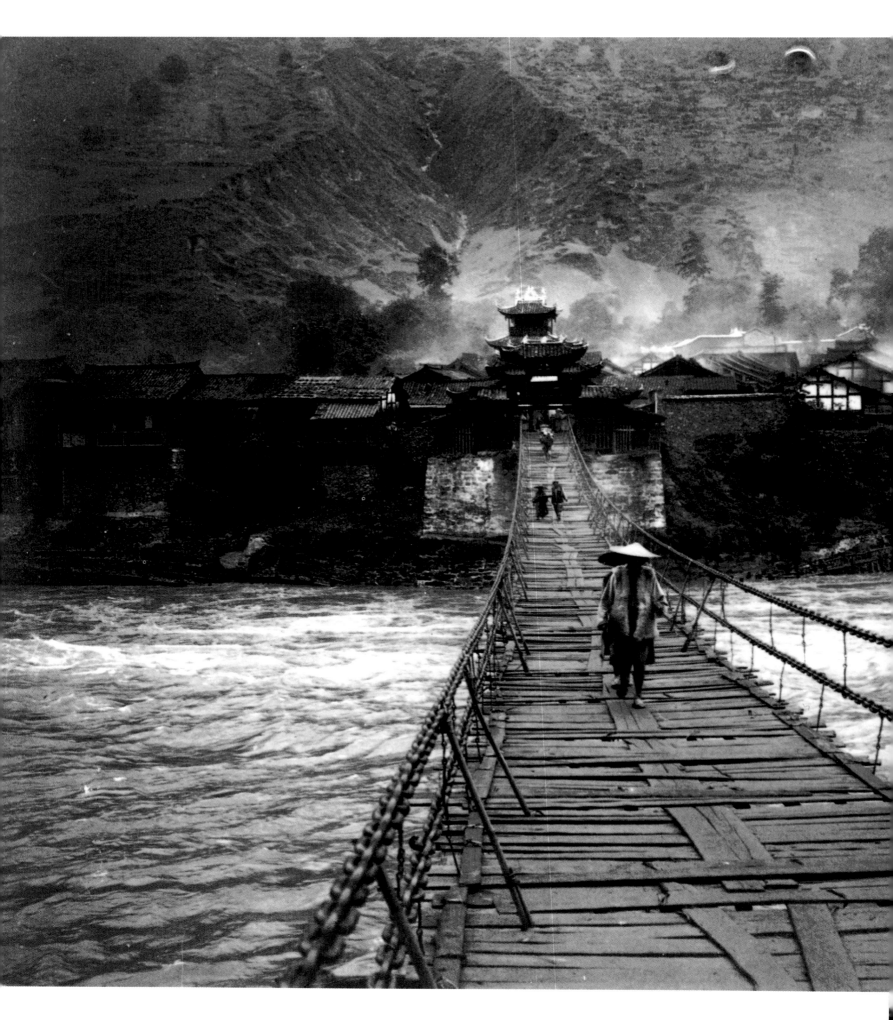

END OF EMPIRE

Into the Middle Kingdom. *Peasants cross the bridge linking China with Tibet in the southwest province of Yunnan. Traditional Chinese belief held that all roads into China led from barbarism into civilization. China, or 'the Middle Kingdom' as it was known, was presented by its rulers and its elite of scholars and officials as the true axis of culture. By comparison, all other countries were intellectually and spiritually impoverished. China preferred isolation. The country's landscape remained unaffected by the outside world for centuries — suspension bridges like this had existed in China for a thousand years before this photo was taken around 1900.* [PHOTO: AUGUSTE FRANÇOIS]

CHINA IN THE LATE NINETEENTH CENTURY retained astonishing continuities with what we know of the country in the third century B.C., when it first became a unified state ruled by an autocratic Emperor. Successive regimes might have standardized the written language, put in place a massive centralized bureaucracy, and built canals and road systems to link the big commercial centers, yet in 1890 Chinese lives remained generally unaffected by these changes. Most people still spoke dialects unintelligible to those from other regions, practiced folk religions in a bewildering array of local temples, raised families and arranged marriages according to local traditions, and dealt with the bureaucracy at any of its levels only when they absolutely had to.

There was, indeed, no way that the traditional state could control every aspect of the society, for late nineteenth-century China was vast, approximately the size of the continental United States, and considerably larger than Europe. The climate and geography of the country ranged from the freezing ice-coated winters and short growing seasons of Heilongjiang on the borders with Russia to the north, to the lush tropical agriculture and fisheries of the southwest on the borders with Vietnam and Burma, and the arid wind-blown deserts that stretched from the edges of Tibet to the outer reaches of Turkestan.

There were wealthy and sophisticated Chinese in certain major cities, as well as pockets of Westerners, with their new industrial technologies and passion for urban planning and public health, along the eastern seaboard. But China remained largely rural and for most of the 450 million inhabitants the world consisted of country market towns surrounded by clusters of small villages. Farm produce was carried between villages and towns on the backs of men and women along narrow tracks, or by small boats on the maze of creeks and inland waterways, because draft animals were rare, too expensive for most farmers to afford. For most dwellers in town or country, life went at walking pace through mud or dust depending on the season. Those with some extra income might choose to be carried in sedan chairs slung between the shoulders of coolies, or conveyed by wheelbarrow.

Though agricultural implements were of the simplest, due to the rarity and cost of iron, China was a country of skilled craft workers, who took care of their communities' needs in millions of tiny workshops. Rarer items like needles, salt, paper goods or children's toys would be sold in towns on scheduled market days, or carried to the countryside by peddlers. Farming households in the north grew their own cotton and wove their own cloth, while in the south families raised silk cocoons on their own mulberry trees and sold the thread in town. Oil for cooking came from

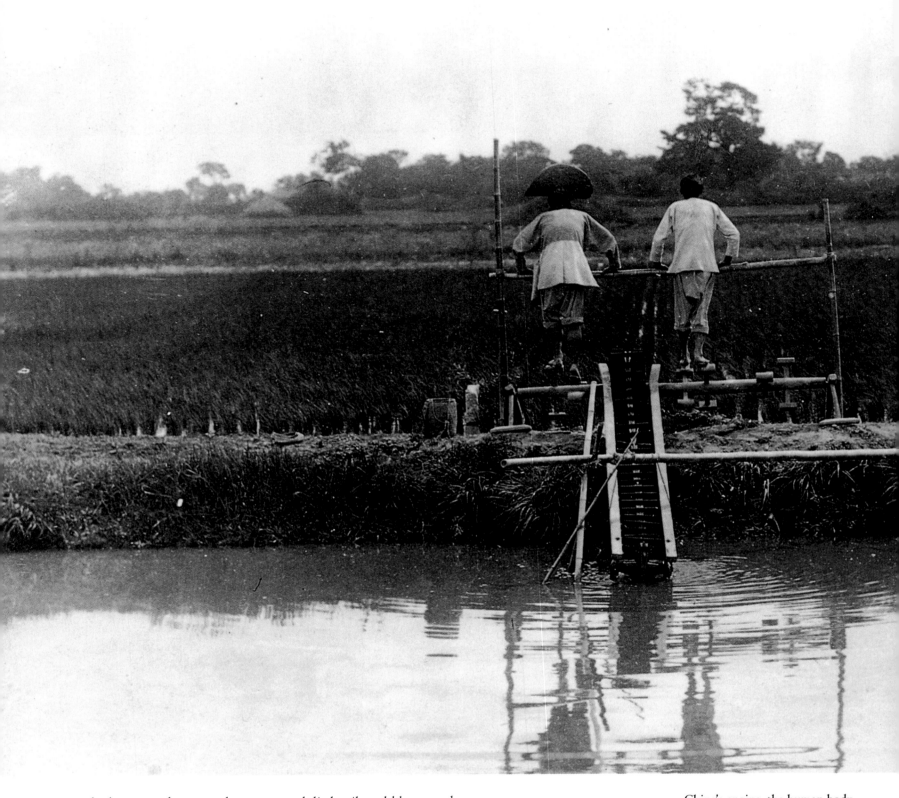

crushed peanuts, hemp seed, or rape seed; little oil could be spared for lighting, except at festivals, and social activities revolved around the rhythms of daylight. Clocks of any kind were a rarity. The hunt for fuel was unremitting, and great swathes of countryside were constantly scoured for twigs, stubble, reeds, or scrub that would briefly boil a crock of water for rice or tea. The water itself had to be carried home by hand, and often laboriously raised from deep wells or low-lying streams by foot treadles or manual pumps. Nothing was wasted, and every scrap of human and animal waste was collected and used as fertilizer.

Unlike the rarely seen splendors of a passing bureaucrat's

China's engine, the human body.
The majority of China's inhabitants led tough rural lives. Mechanization was not even a dream at the beginning of the twentieth century, and even draft animals were beyond the means of most, so the human body remained China's main source of energy. Water

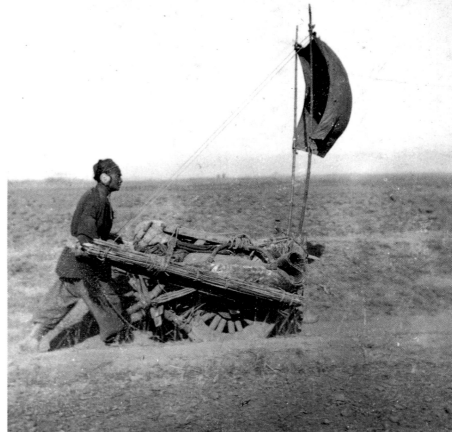

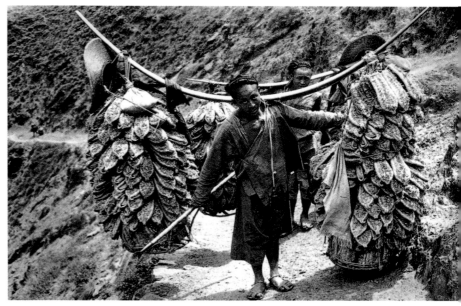

was raised by foot power (above) to fill the rice paddies of the south or to irrigate the millet, sorghum and vegetables in the arid fields of the north. Countless rivers and canals made transport easy in the south, and in the north the harsh wind from Mongolia could be harnessed to ease the burden

(top right). The natural spring of split bamboo carrying-poles (below right) eased the coolies' loads — such as this one of woven straw shoes, the most common footwear in the south because they were more affordable than those made of padded cotton. [PHOTO, BELOW RIGHT: SIDNEY D. GAMBLE]

official costume or the outfits of wealthy families gathered with friends for pleasure or for a religious festival, rural clothes were of sun-bleached blue or gray cotton constantly patched, with faded cloth shoes or straw sandals. Men's hair was shaved in the front and then plaited in a long queue which hung down the back, sometimes reaching below the knees. During working hours, however, it was often curled around the head for comfort, or rolled beneath a simple turban of knotted or twisted cotton. Women, if they ventured out of their household yards and compounds at all, were noticeable for their bound feet. When girls were three or four years old, their toes were bent down against the sole of the foot,

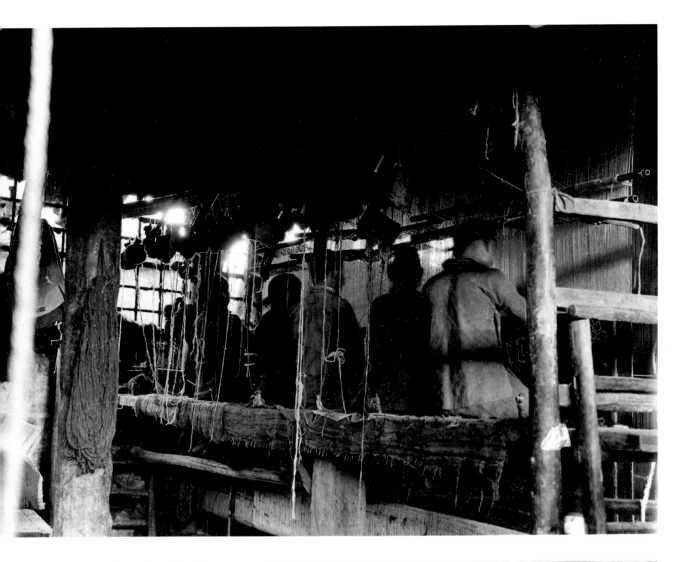

Ingenuity increased productivity *in countless ways. Millions of farming families wove cotton or spun silk thread from carefully nourished cocoons, while others (above) gathered around their looms to weave the rugs which were much coveted around the world. In many families, children as young as four or five (below) were considered old enough to care for their siblings, leaving their mothers free to work.* [PHOTO, ABOVE: SIDNEY D. GAMBLE] [PHOTO, RIGHT: FRANK CANNADAY]

Guarding the family beast. *Few families were wealthy enough to afford a water buffalo to pull a cart and plough the land. Tradition held that while a boy like this protected his creature (above) he could find precious time to advance*

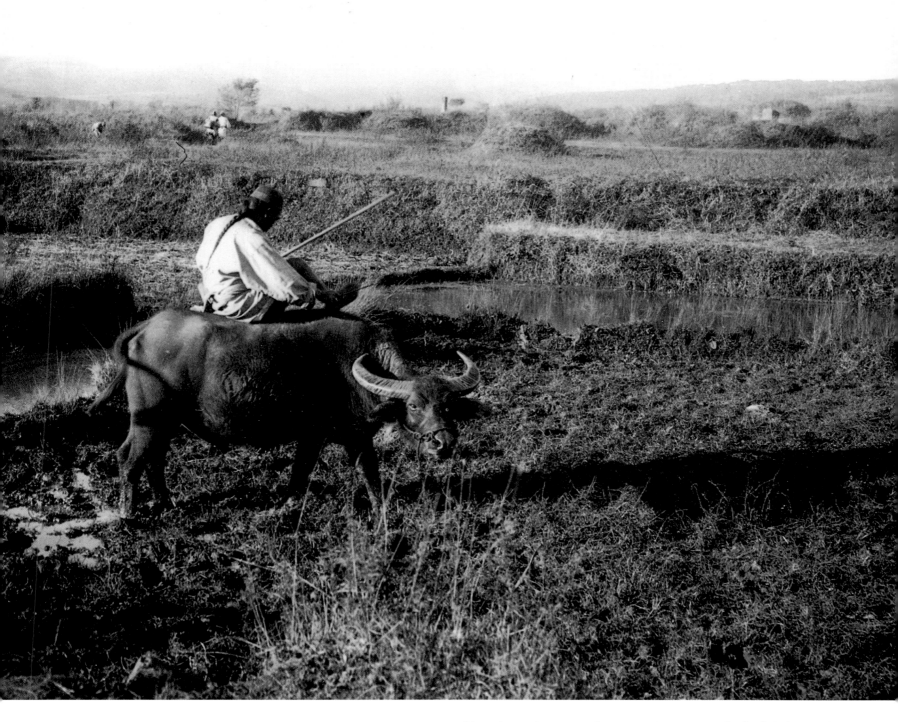

himself by memorizing the classical texts as he rode. An extensive knowledge of the classics was essential to pass the state examinations and enter the ranks of the Qing mandarins. [PHOTO: AUGUSTE FRANÇOIS]

Typical market town *(overleaf). Yunnanfu in the southwest (left) and Hangzhou on the coast (right) of China. Bells hanging from the tilted eves (left)*

would sound in the breeze to ward off evil spirits, while soldiers resting among their standards gave protection against more material threats. Such towns, with

their curfews and ordered rhythms, set the pace for rural life and commerce. [PHOTO, LEFT: AUGUSTE FRANÇOIS] [PHOTO, RIGHT: FATHER LEONE NANI]

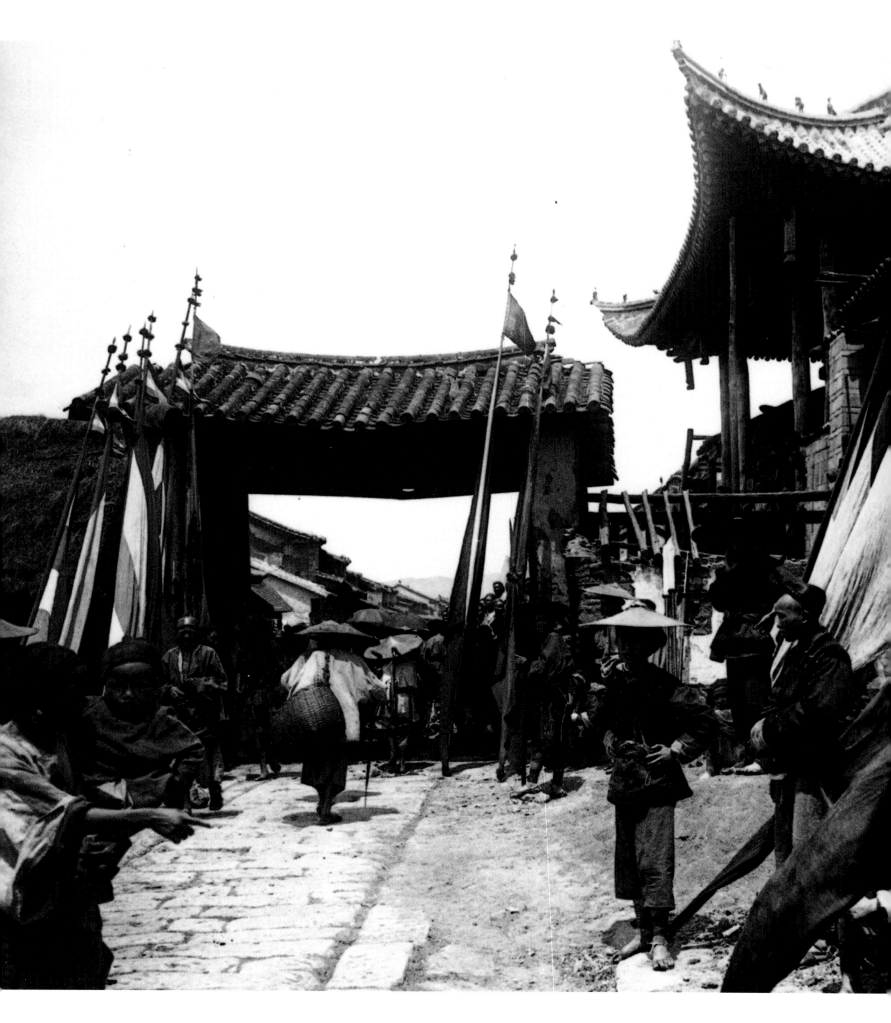

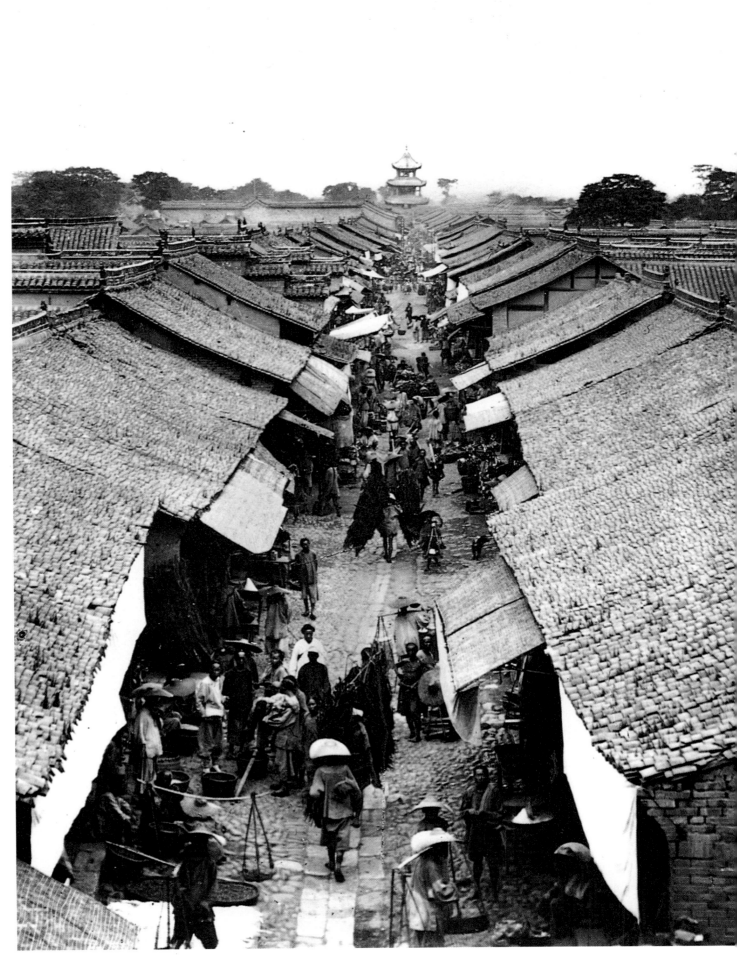

The queue was a pigtail of plaited hair worn behind a shaven forehead. Imposed by the conquering Manchus in the seventeenth century as a badge of submission, the queue was the only significant mark of outside influence on xenophobic, early twentieth-century China. By then, however, it had become a proud possession worn by boys and men alike, and tended by roving barbers or servants.

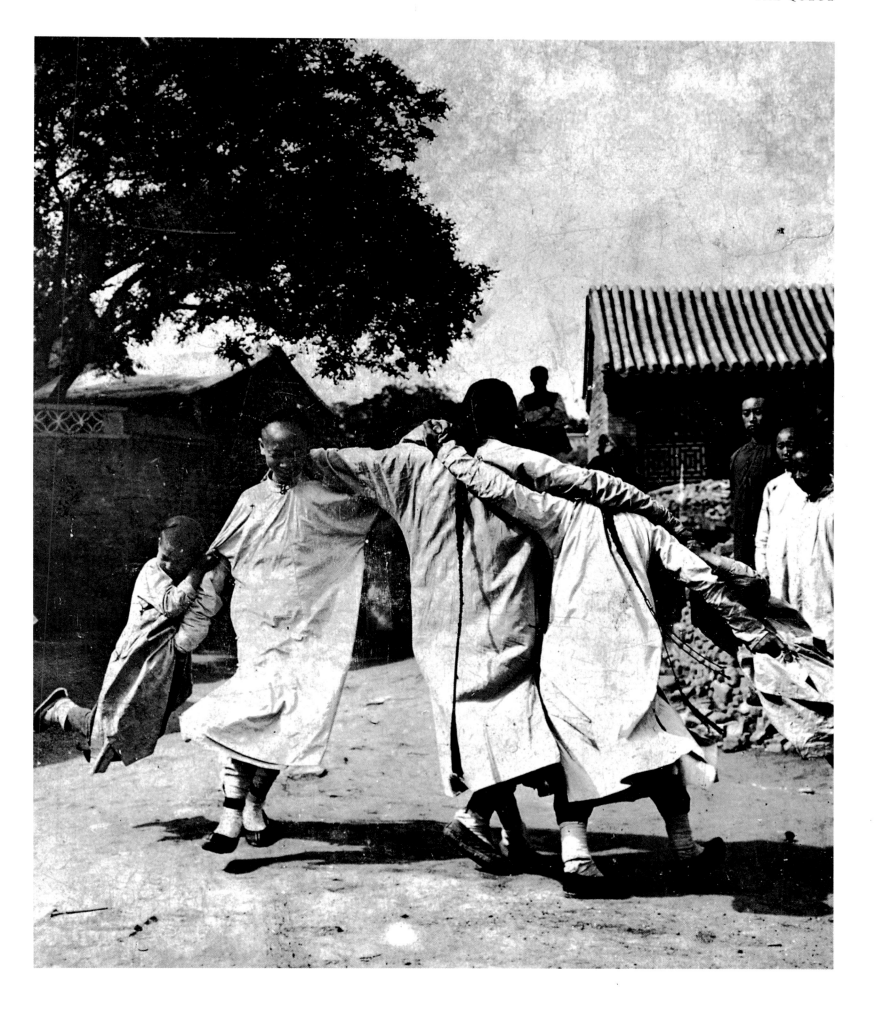

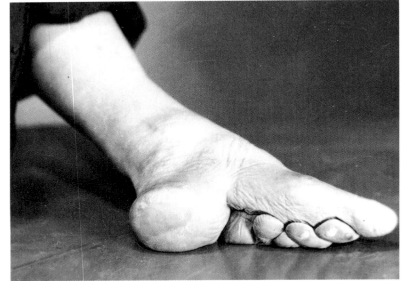

and fastened there by tightly wound bandages that effectively stunted their growth and forced the arch up into a steep curvature. The pain was borne in the cause of obtaining an eligible husband who would demand small feet in the wife chosen for him by the go-between who saw to such arrangements. Normal walking was impossible, so that a woman's progress down the street was slow and painful.

Outside observers often thought these were dominant identifying traits of Chinese life, but in fact each had an origin in the fairly recent past. The shaven forehead and queue of hair was the style of the Manchu tribesmen who had conquered China in 1644 and founded the Qing dynasty. They forced the Chinese to adopt the style as a token of submission, though 200 years later the long shining queue of hair was seen as a symbol of manliness and elegance. Similarly the spread of footbinding among all ranks of female society had been slow, but also steady. The making of tiny embroidered shoes to wear on bound feet became a domestic skill passed down from mother to daughter, and it seems to have led to pride and aesthetic pleasure among both women and men. Growing finger nails to an extraordinary length, and protecting them from breakage in elaborate casings of bamboo or other coverings, was more an indication of superior class. It proved to all that one was not a manual laborer, but lived a life of scholarship or leisure.

At the upper levels of society, where income came from rents drawn from land-holdings and urban real estate, from the salaries of bureaucratic office, and sometimes also from commerce or the management of pawn shops, continuity and solidarity were provided by shared belief in the Confucian value system. The

'Golden Lilies'. *Footbinding was introduced in the eleventh century and spread from the ranks of the wealthy to those of more modest means (such as these two women pictured right) and even to much of the peasantry. Girls as young as three or four would have their feet bound tightly with bandages, folding all the toes except the big one under the sole to make the foot slender and pointed. After a couple of years, the big toe and heel were brought together, bending the arch, causing constant pain and* *hindering free movement. The sight of a woman teetering on her little points, moving her hips from side to side 'like a tender young willow in a breeze' to balance herself was believed to have an erotic effect upon men. The ideal length was three inches. When reformers campaigned to end the custom, few realized that the pain of release would match what had been endured when the growing feet were first bound.*
[PHOTO, RIGHT: FATHER LEONE NANI]

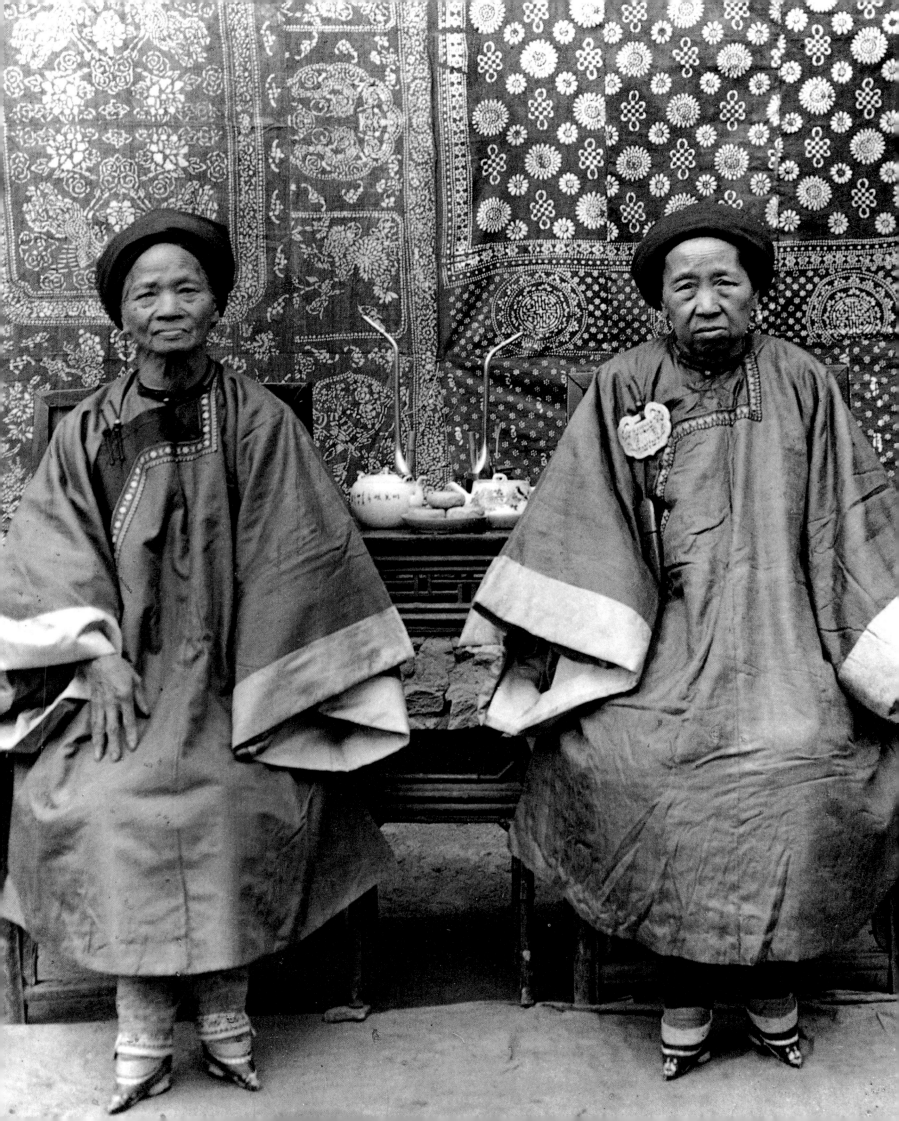

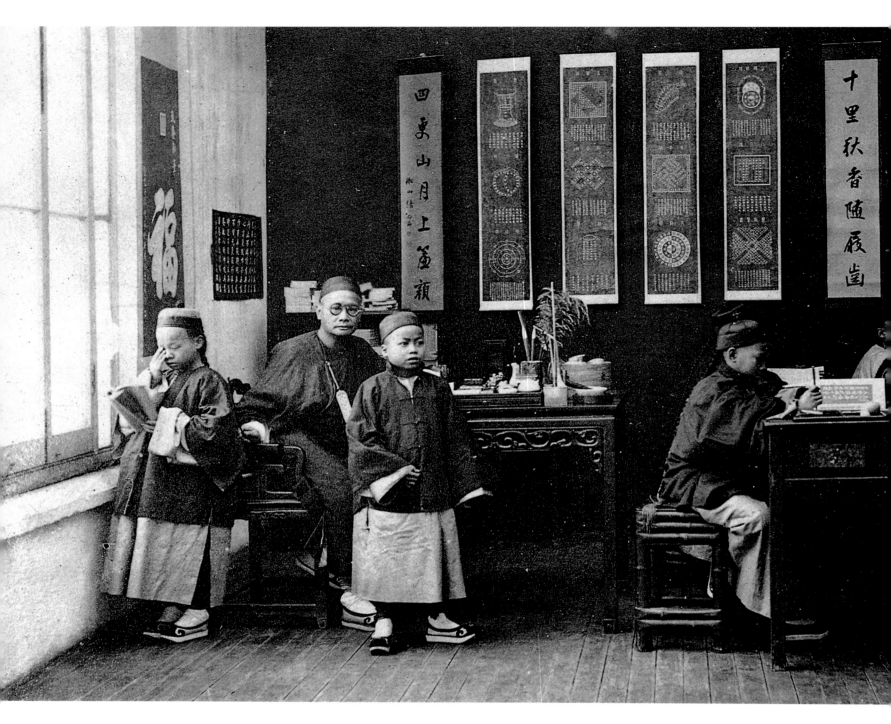

teachings of the fifth-century B.C. sage, Confucius, had stipulated that moral values were best instilled through education and that mutual trust, filial loyalty, and a punctilious observance of rituals in ancestral worship and in everyday life, were central to the good order of the state and the harmony of society as a whole. These values were perpetuated locally through the schooling carried out in specially endowed institutions controlled by the leading clans and lineages. Confucius' teachings, with those of his leading disciples and most important later followers, were institutionalized by the State into a multi-tiered system of competitive examinations. Preparation for these examinations absorbed the childhood and adolescence of millions of young men — women were barred from taking them — and success even at the lowest level, brought great local prestige and was celebrated with

festivities. Success at the highest provincial or national levels of the imperial examinations brought fame and one was automatically regarded as a community leader. It also brought the promise of lucrative government office and a financially advantageous marriage. Critics grumbled that the examinations stifled intellectual creativity, and also noted that there were too many candidates for the limited number of passes, of which each locality had a quota. The frustrations of out-of-work scholars might be dangerous to the good order of the State.

Despite these continuities, by the late nineteenth century some Chinese were aware that their country had been experiencing major upheavals for a century or more. Even if they had not experienced chaos and hardship at first hand, they had heard tales of disaster from travelers, soldiers, peddlers or refugees. The society of China

Budding mandarins. *From the age of six, boys from elite families went to a lineage school, run by the clan to which their families belonged. The pronunciation and calligraphic form of the characters assigned for the day were learnt by writing and chanting them — only later was their meaning explained. On the back wall, a traditional pair of matching scrolls inscribed with rhyming couplets from a classical text flank four horoscope sheets. While the furniture is in a classical Chinese pattern, the influence of the West, in this picture taken about 1900, is already visible in the style of the casement window.*

harsh environment led to farming practices that caused upland erosion, impoverished their lives, and induced massive flooding or silting up of once-fertile lands and rivers below. One rebellion in the mid-century was led by the so-called Hakka peoples who had migrated to southeast China from the northern plains, and were converted to a simple form of fundamentalist protestantism. These rebels drew tens of thousands to their banner of revolt by proclaiming the return of Jesus to earth and the formation of a New Jerusalem on Chinese soil by Jesus' younger brother.

In all these cases, violence circled out across the country, leading to atrocities, famine and innumerable deaths from diseases caused by corpse-filled streams and spread by panic-stricken or desperate refugees. Punishment for all captured or suspected rebels was terrible and swift: interrogation under torture, public beheadings, or confinement suspended by the neck in narrow bamboo cages, until death came from slow strangulation or starvation. Such punishments were accepted under the harsh legal codes that had grown stricter over the centuries, supplementing the control of society by education and moral persuasion, which the followers of Confucius had always held to be the ideal means for the maintenance of social order.

On top of these disturbances and disasters had come wars prompted by the Western powers who, since the late eighteenth century, had been pressing on China's coasts with growing force, seeking to form permanent bases from which to conduct trade and speed the spread of Christianity. British demands and pressures had led to two major wars in 1839 and 1860, in the second of which they had been joined by the French. The French subsequently launched their own punitive war in the 1880s. By the 1890s, Germany and Russia were adding to the pressures, the former seizing a sizable area of Shandong province as a naval and trading base, the latter claiming huge areas of territory along the constantly shifting course of the Amur River on the northern borders of Manchuria.

The Qing emperors and their senior Chinese officials reacted to these numerous crises in two ways: by adapting elements of Western technical skills to build new types of steamships and guns, and by trying to reinforce traditional Chinese values. Many of the Chinese bureaucrats were familiar with the foreign-dominated areas of cities such as Shanghai, Canton, Tianjin and Hankou, where Westerners had drained land, paved and lighted streets, introduced modern systems of sanitation and policing, built wharves, and created a whole new commercial environment of massive offices and warehouses that rose outside the walls of the old Chinese cities. By the end of the century, these fledgling semi-westernized cities were linked together by telegraph, and in some cases by railway lines, designed, built and funded by the foreigners.

The emerging power of Japan was another element in this volatile mixture. For centuries the Chinese had regarded Japan as a small and unimportant neighbor, dependent on Chinese cultural sources for its written script, its philosophy and administrative systems, and owing allegiance to China through a network of

seemed to be developing a new series of fault lines. Some of these were ethnic, as the approximately ninety per cent of the population who considered themselves to be of the early Chinese or 'Han' stock clashed with various groups of less civilized local tribes or recent migrants. Some stemmed from religious tensions or a combination of both factors. Thus, a few insurrections against the State were led by adherents of folk-Buddhist sects, teaching a new kind of millenarianism that promised an end to sufferings on the earth in the coming of a new era or *Kalpa*. Others were sparked by Chinese Muslims, who lived in the country's southwest and far northwest, and often disagreed with local Chinese settlers, or resented government attempts to control and tax them. Similar resentments led to risings of local tribesmen who had been pushed out of their fertile valley farmlands up into the arid hills. This

The Qing penal system *believed that punishment should be carried out in the open as a warning to others. A young thief (above) is tied by his queue and wrists to a post in a market place in western Shaanxi province. Rebels and traitors were exposed in wooden cages (right) which held them by the neck. The planks or bricks on which they stood were then gradually removed over several days until they choked. In Chinese lore it was better to die this way than by beheading, in order to meet one's ancestors in the afterlife as a whole person. There were different punishments for different crimes: the most feared (for treason and crimes against the family) was the 'ten thousand cuts' punishment, carried out while the miscreant was still alive.*
[PHOTO, ABOVE: FATHER LEONE NANI]

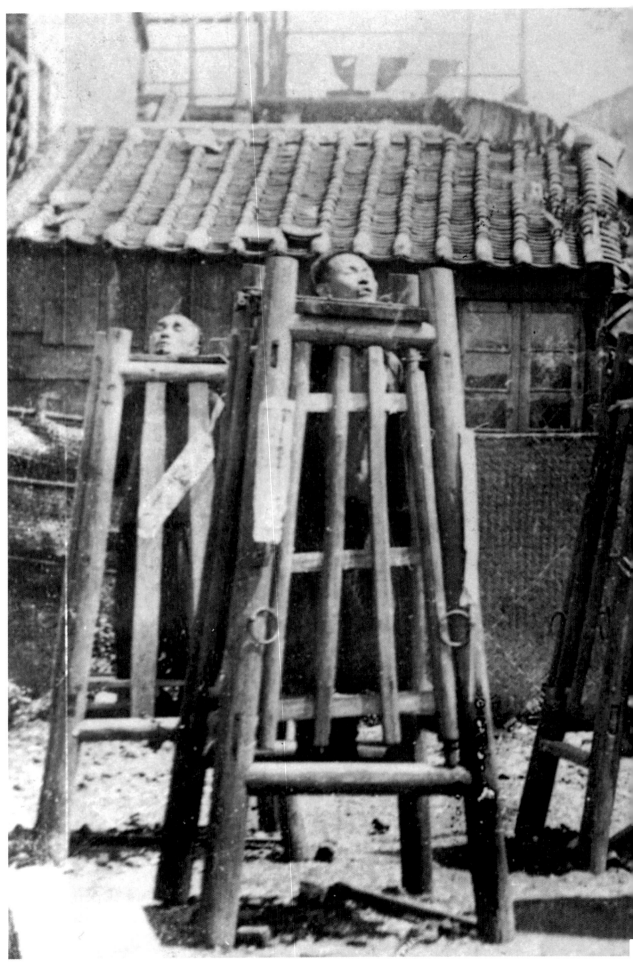

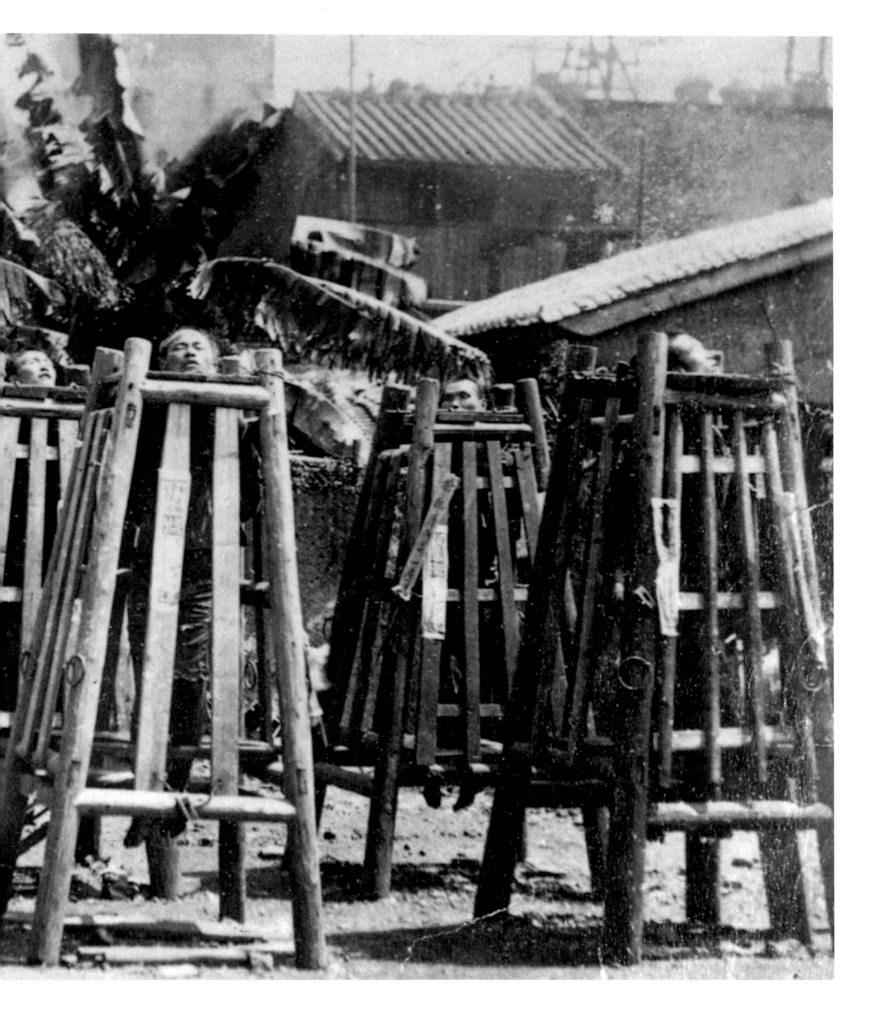

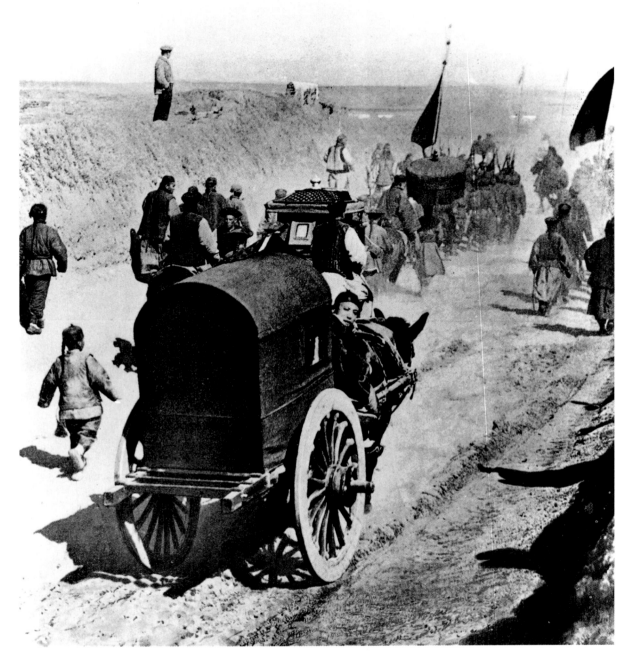

tributary relationships. After the 1600s, when the Tokugawa regime led its Japanese subjects into a state of virtual isolation, contact between China and Japan had been restricted to a few Chinese merchants in the Japanese city of Nagasaki, and Japan was remembered, if at all, as the home of pirates who during the sixteenth century had ravaged China's coastal communities. But the astonishing changes brought to Japanese state and society by the Meiji rulers after the so-called restoration of 1868 forced the Qing to regard them with new eyes. By abolishing the old feudal system and establishing a constitutional monarchy, backed by national military conscription, compulsory and standardized education, an elected national parliament and a carefully constructed group of state-sponsored industrial, shipping and banking corporations, Japan transformed its relationship with the Western powers. The Westerners were forced to abandon the profoundly unequal treaty and tariff systems that they had sought to impose on Japan, as on China, and Japan used the new concepts of international and commercial law to strengthen its own trading position and expand its diplomatic effectiveness round the world.

As Japanese adopted Western dress for civilian life, their armed forces switched to Western uniforms, drill, and organization. By the 1890s, Japan was expanding its power base into Korea, which China had regarded as its semi-vassal state. Japan was also establishing claims to the Ryukyu Islands, was beginning to encroach on Taiwan, to send steamships into the Yangzi River and to eye new commercial and investment opportunities in southern Manchuria. In 1894, China tried to reinforce its own power in Korea at the expense of the Japanese, and the Japanese responded with a startling show of military force. Their armies landed in Korea to protect the rights of their Korean 'allies', their modernized navy of ironclads steamed into the North China sea, and in a short battle completely outshelled and outmaneuvered the

Chinese fleet, which suffered catastrophic casualties. As a coup-de-grâce, Japanese troops landed on the Shandong peninsula, swiftly demolished the defenses around China's main naval base and sank most of the surviving Chinese warships that were riding at anchor in the bay. At the 1895 Treaty of Shimonoseki the Japanese demanded the complete cession of Taiwan to Japan, and the opening of the whole of southern Manchuria as a special zone for Japanese investment and commercial expansion. Though a consortium of Western powers insisted that Japan abandon the latter, they acquiesced in the former and, after a brief military uprising had been suppressed, Taiwan formally became a colony of Japan. At the same time, Japan strengthened its hold over Korea.

There was an outcry by many leading Chinese scholars over the terms of the treaty and demands for thorough-going reforms in government and education. For a few heady months, in 1898, it seemed that the wishes of these Chinese protesters would be realized by the emperor, Guangxu. Born in 1871, Guangxu had taken the imperial title in 1875 when the previous emperor — his uncle — had died young and childless. Until he was eighteen, his actions were controlled entirely by his great-aunt, the formidable Manchu woman known as 'the Empress Dowager', the concubine of an earlier emperor, who had solidified her power through her ruthless and skillful political maneuvering. But when he reached maturity, Guangxu began to study the history and institutions of foreign governments, to learn English, and to examine the political and military causes of Japan's new-found strength. In the summer of 1898, Guangxu chose several new advisers and announced a dramatic program of reform for China, including the improvement of agriculture, modernization of schools, implementation of

Western military drill, introduction of scientific education, a published and precise annual budget, and the abolition of sinecure offices. But these imperially sponsored reforms were announced too swiftly and were too complex and far-ranging for many senior bureaucrats or members of the Manchu ruling elite to accept. The Empress Dowager Cixi, and leading Chinese and Manchu civil and military officials, put the Emperor Guangxu under a form of 'palace arrest', and six of his most talented and radical supporters were executed. The survivors, by a curious irony, fled to Japan where they were given asylum.

Only two years later, in 1900, various groups of Chinese farmers and rural workers rose in revolt in the northern provinces of Shandong and Hebei. They were angered that foreign missionaries used international law and the foreign military presence to protect their interests at the expense of the Chinese. The rebels had been deeply humiliated when Christian converts in the region had exploited their new status, bringing foreign pressure to bear in local property disputes, disrupting religious folk festivals and forcing the Qing bureaucrats to side with the converts against other members of their communities. The missionaries were also seen as high-handed and arrogant. Amalgamating their forces under the name of 'Boxers' — in reference to the type of martial art and religious practices followed by many of them — farmers and workers began to kill missionaries and their converts, and in the summer moved to Peking, where many of them surrounded and besieged the foreign diplomatic and legation quarter.

The rebels were initially given the blessing of the Empress Dowager and were supported by leading Manchu and Chinese

The formidable Empress Dowager Cixi *surrounded by her eunuchs at the newly rebuilt Summer Palace, west of Peking, c. 1903. Cixi, chosen for her beauty, entered the imperial court as a maid in 1852. Within five years she had become the 'honorable consort' of Emperor Xianfeng. When he died in 1861, she became the 'Empress Dowager' and began to consolidate her power – her methods included a coup d'etat and assassinations. Cixi's own son became 'Emperor Tongzhi', and after his death in 1874 she hastily adopted her nephew as 'Emperor Guangxu' in order to remain in power as 'mother' of the emperor. Cixi had Guangxu put under house arrest in 1898.*

In the days after the Boxer uprising, imperial tradition was still observed: Cixi is seen here protected from the elements by a ceremonial parasol, the air she breathes is rarefied by the incense burners carried before her, and the eunuchs wear symbolic robes indicating happiness and prosperity. But Cixi also made concessions to the new order, such as allowing herself to be photographed. Manchu women were forbidden to bind their feet – thus, effectively preventing intermarriage, as Chinese men professed to find unbound feet repulsive – yet they wished to walk with the fashionable teetering gait, hence the curious platform shoes Cixi is wearing.

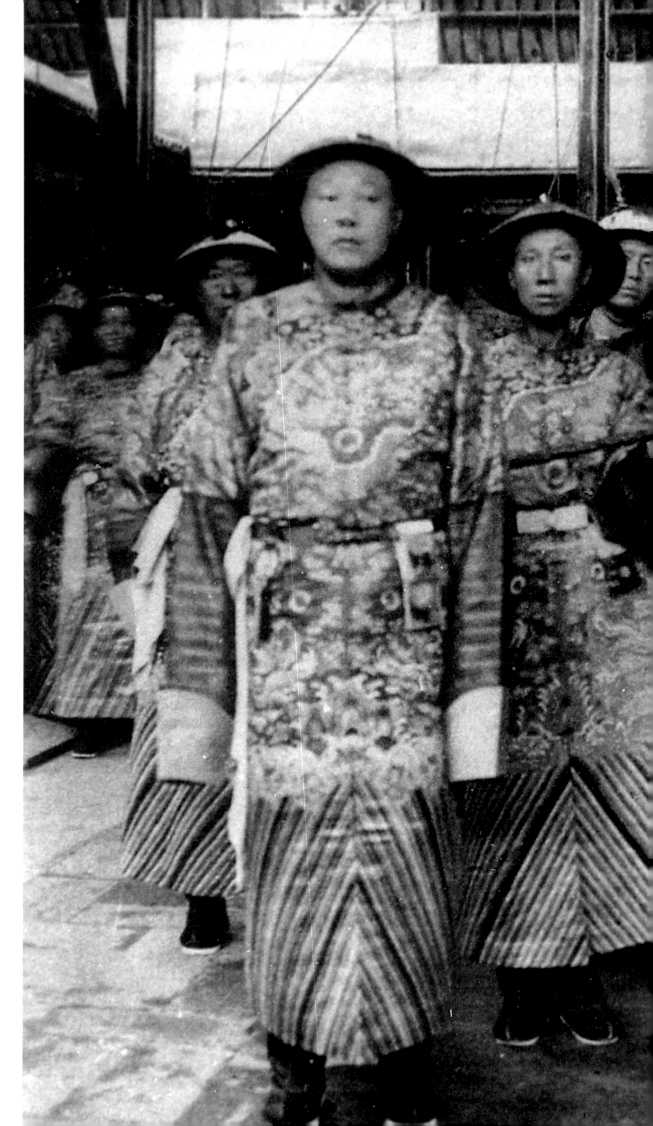

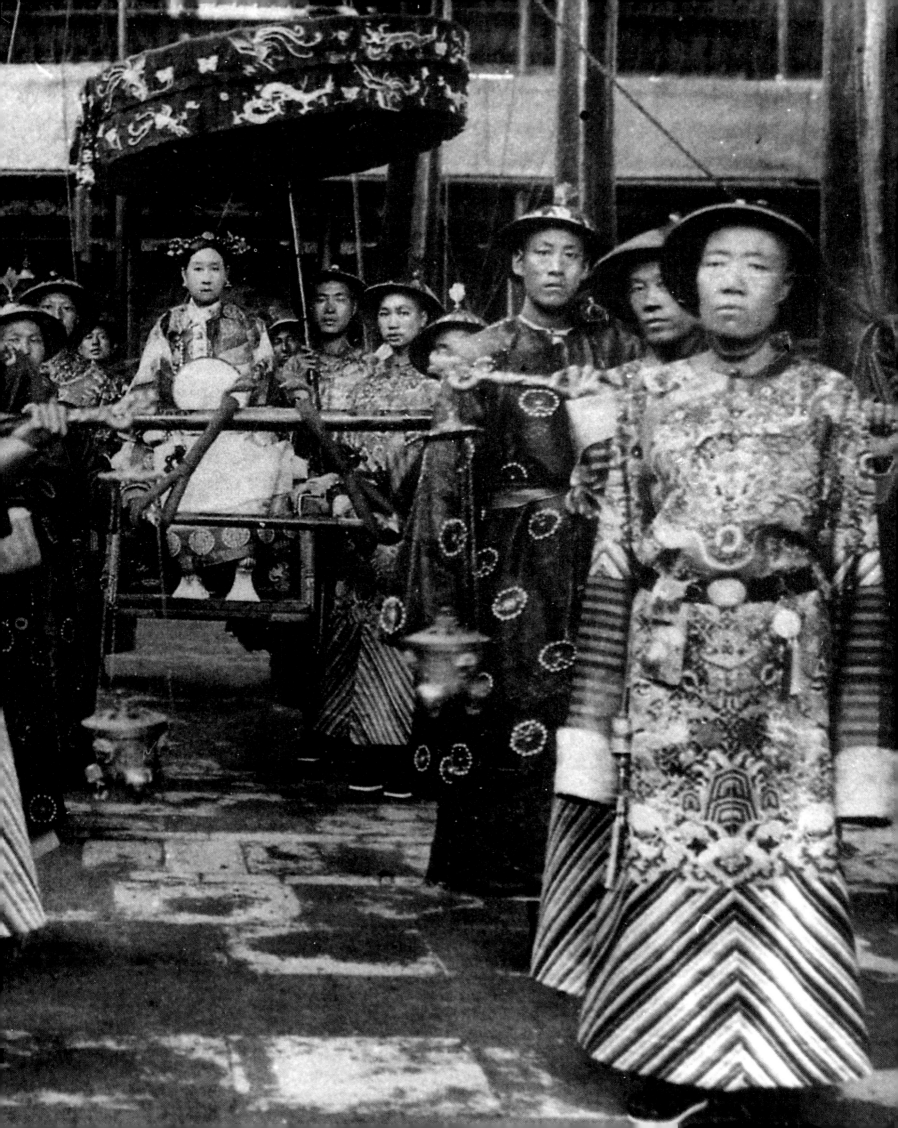

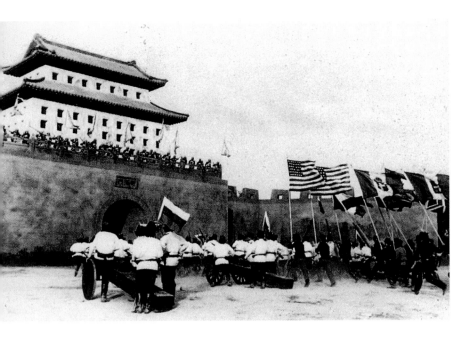

Manchus had come to seem similar to the Han in many important respects, even though Manchu troops and their families still lived in garrison compounds in several major cities, the Manchu language was spoken or written in court circles, and certain religious practices kept their Manchu flavor. But, in seeking reasons for the rapid decay of China's power in the late nineteenth century, especially at the hands of the foreigners, young Chinese ideologues began to exonerate the Chinese people as a whole from failure by placing the blame firmly on the Manchus. The implication was clearly that if the Manchus could be ousted, then the Chinese people could construct their own governmental framework, and reshape their nation on their own terms.

The Boxer Uprising. *The Boxers, so-called because of the martial arts they practised, rebelled against the demands and pretensions of the Christian missionaries and their converts, and besieged the foreign legations in Peking in 1900. Troops from the eight-nation relief force fought their way through the city forcing the Empress Dowager Cixi, Emperor Guangxu and his empress to flee to Xi'an. After the siege was lifted the troops took many photographs to record their triumph. They are seen above re-enacting their arrival at the city walls.*

officials, but this support evaporated after two months when a massive international relief force fought its way through to Peking, and relieved the siege. Hundreds of Boxer attackers and many of the cornered foreigners had by then lost their lives. As the foreign troops occupied the Forbidden City of Peking, the home of Chinese and Manchu emperors for almost 500 years, the Empress Dowager fled west to Shaanxi with her court and the still-sequestered Emperor Guangxu, while British, French, German, Russian, American and Japanese forces launched a series of reprisals against the remaining Boxers and their supporters.

When the Empress Dowager returned to Peking in 1902, it was as a chastened ruler, subject to many penalties: the Qing were forced to pay crippling fines, the equivalent to 450 million ounces of silver, that were to be paid off over the following forty years; Cixi had to endure the humiliation of the execution of some of her leading supporters; and the Confucian examinations were banned in the cities that had supported the Boxers. But in a surprising and effective public relations gesture she now began to receive foreign diplomats and their wives at formal receptions in her newly built Summer Palace on a scenic lake to the northwest of Peking. In 1905, though she still kept her nephew, the Emperor Guangxu, under guard in his palace compound, she instructed a small group of officials to travel to foreign countries – including Japan, the United States, Britain and Germany – to examine their constitutional structures and then to suggest how to change the Qing state in the direction of a constitutional monarchy. Young Chinese nationalists sabotaged this mission by attempting to assassinate its members, but the following year a second expedition departed without incident. In 1905, the Empress Dowager also ordered that the old Confucian examinations be abolished, and that they be replaced by a new system of schools teaching a more practical and Western-oriented curriculum.

These attempted assassinations emphasized a new factor, the growth of virulent forms of anti-Manchu nationalism. During the 250 years that the Qing ruling house had governed China, the

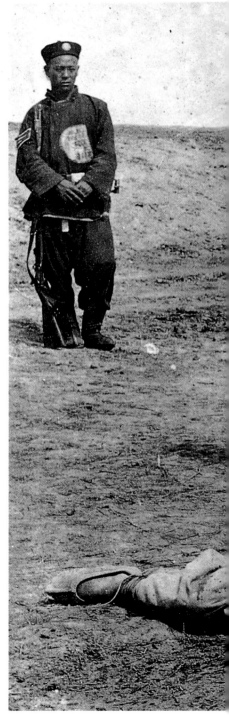

Summary execution. *Foreign troops from the relief force (right) and Qing soldiers stand by the decapitated bodies of executed Boxers. The Japanese officer wipes blood from his sword.*

Such views were spread rapidly in the early twentieth century through newspapers and journals; those published in the foreign-controlled areas of cities like Shanghai could evade the watchful Qing censors. These areas also gave international legal protection to anti-Manchu polemicists who might otherwise have been summarily executed for their views. Documents and accounts detailing the atrocities visited on the Chinese people by the Manchus during their war of conquest in the seventeenth century, and glorifying the deeds and words of those Chinese who had bravely but vainly resisted the conquest, were also appearing. The more the Manchus sought to strengthen the country's army and navy, or to reform its educational and governmental systems, the

more nervous Chinese nationalists became. They were concerned that a Qing state, defended by modern Manchu armies, equipped with the latest firearms and artillery, backed by steamships and linked by a railway system under central control, might indeed prove impossible to overthrow. The prospect was of perpetual servitude to the Manchus, who in their turn appeared to be at the beck and call of Western and Japanese forces.

New opportunities for political organizations and untrammeled expression of anti-government sentiment sprang from the movement of large numbers of Chinese students to Japan, and the growth of big foreign Chinese communities – the so-called 'Chinatowns' – especially in the United States and Canada.

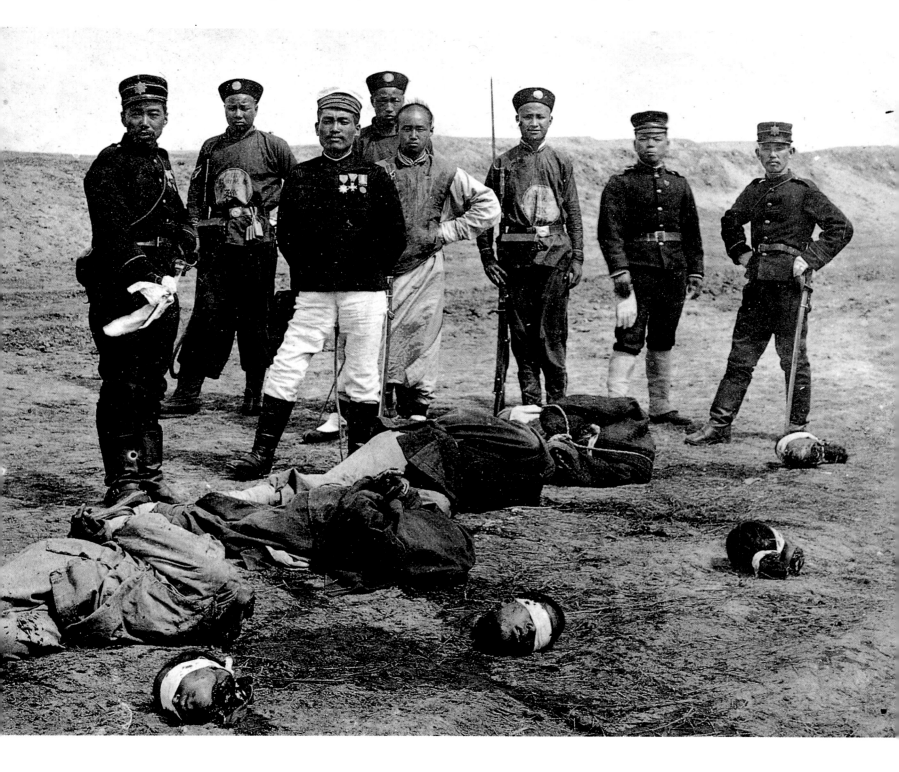

The former was, on the face of it, surprising, given China's recent defeat by Japan, but it was also logical, for Japan was clearly an admirable model to study if one wanted to strengthen a nation. Japanese troops, after months of bitter fighting over control of the southern Manchurian industrial base at Port Arthur, finally defeated the Russians in 1905. This made Chinese admiration even stronger. Now a Western power had been defeated by an emergent Asian state, and the example was intoxicating. That same year, the abolition of the traditional Confucian exams meant that thousands of Chinese students had to seek different career opportunities, and the military academies, medical schools and economics departments of Japan's emerging universities offered exciting prospects. Women as well as men students were able to travel swiftly and cheaply to Japan, and there they formed their own associations, met various political figures exiled after the *debacle* of the 1898 reform movement, and joined new anti-Manchu political organizations, some of which embraced the idea of an electoral form of republican government for China. Back in China, they often infiltrated their local communities with their radical ideas and drew others to the anti-Manchu cause.

Though foreign Chinese communities, especially in the United States, had faced formidable challenges from organized labor, and had been discriminated against in housing, work opportunities, under the law, and in education, they had nevertheless solidified and prospered. The passage of the American 'Exclusion Acts' in 1894 and 1904 prevented those Chinese who were classified as laborers from moving freely into or out of the country, but these restrictions did not apply to merchants or to students and intellectuals. Several men who were emerging as the leaders of the Chinese opposition found a warm welcome among these overseas communities, eager audiences for their speeches, new recruits for their ranks and a rich source of funds with which to expand their subversive organizations, and increase the size and reach of their newspapers and pamphlets.

One emerging leader who benefited especially from these North American Chinese communities was Sun Yat-sen. Sun, born into a poor farming family in southeast China in 1866, followed his elder brother to Hawaii where he received an education at a Christian school before returning to China to study medicine. Frustrated and angry over the weakness of China and his own career failures, he tried to start a number of anti-Manchu uprisings and was threatened with arrest and probable execution in Hong Kong. Fleeing to London in 1896, he almost met his end when the staff of the Manchu legation kidnapped him and made an effort to smuggle him out of England, to trial and certain death in China. But Sun managed to get a message to a friend in London and was released after a public outcry that made him a celebrated figure in Europe and abroad. Moving between Japan and North

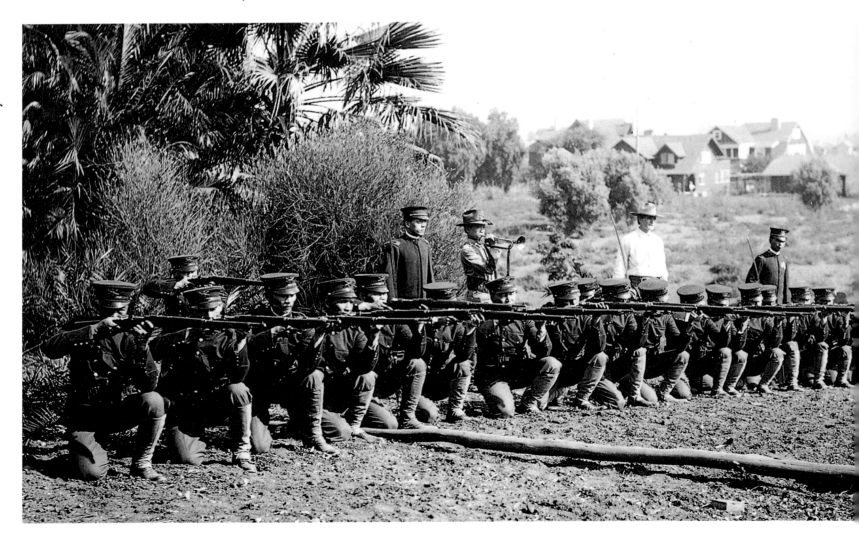

America, Sun used this new-found fame and his own growing political skills to set up a formidable republican revolutionary program.

Sun also laid the foundations for a new form of overseas military organization by enlisting the support of Chinese in California. These groups of Chinese, dressed in military uniforms and armed with rifles at their own expense, drilled in their spare time with American instructors, under the overall supervision of a California eccentric named Homer Lea. Lea — who was not of Chinese ancestry — had met and come to admire Sun Yat-sen on one of the latter's early tours to America, and thereafter dedicated his life to Sun's service. Sun further strengthened his base by enrolling as a member in one of the powerful branches of the Chinese secret societies known as the Triads, or 'Heaven and Earth Societies', which had formed branches in America. Such societies had been powerful in China since the late eighteenth century: binding their members by blood oaths and intimate initiations, they combined elements of mutual economic support, protection against local enemies, and in many cases semi-criminal or overtly criminal practices. Like the students returning home from Japan, such secret society members could infiltrate the political system back in China.

Life in Japan or in Chinatowns highlighted the oddity, or even the absurdity, of many of the customs in China itself. The long plaited queue, for example, began to seem particularly outlandish when worn with a Western suit of clothes, a wing-collar, or a modernized military uniform, and many Chinese men overseas began to cut theirs off. Even if they subsequently fixed fake queues to their own hair or hats on returning to China, this rejection of Manchu custom had a subversive effect. Though it was of course a far more complex matter than cutting hair, by the early twentieth century women were beginning the painful task of unbinding their own feet and slowly trying to draw them back into their natural shape. Chinese parents who prided themselves on their modern education did not bind their infant daughters' feet, and sought to assure them of a marriageable future by forming support societies with other elite families to pledge that their own sons would be induced to marry girls with natural feet. And Chinese nationalists began to emphasize that only Chinese of strong health and modern education would become the free citizens of a rejuvenated Chinese nation.

The ideas of both citizenship and nationhood were new ones for China, and had to be represented by newly coined words that were drawn from linguistic forms freshly developed by the Japanese as they transformed their own society. But the Japanese origins faded into insignificance as the Chinese were led by powerful writers — the foremost being Liang Qichao, one of the fugitives from the crack-down on the 1898 reformers who had

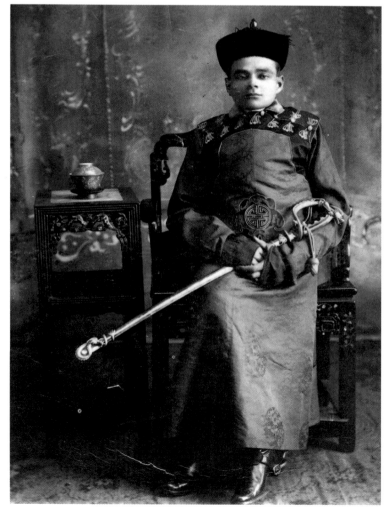

Sun Yat-sen (above), the 'father' of the republican revolution, on an early fundraising trip in America. His call for a strong Chinese republic found many sympathizers among overseas Chinese. Homer Lea (right in his 'mandarin's' uniform), was an eccentric, crippled American (of non-Chinese descent) who supported Sun in his fight against the Qing. Lea's militia (left), armed with surplus US weapons, were recruited from the Chinese in Los Angeles and trained in the suburbs: they never saw combat.

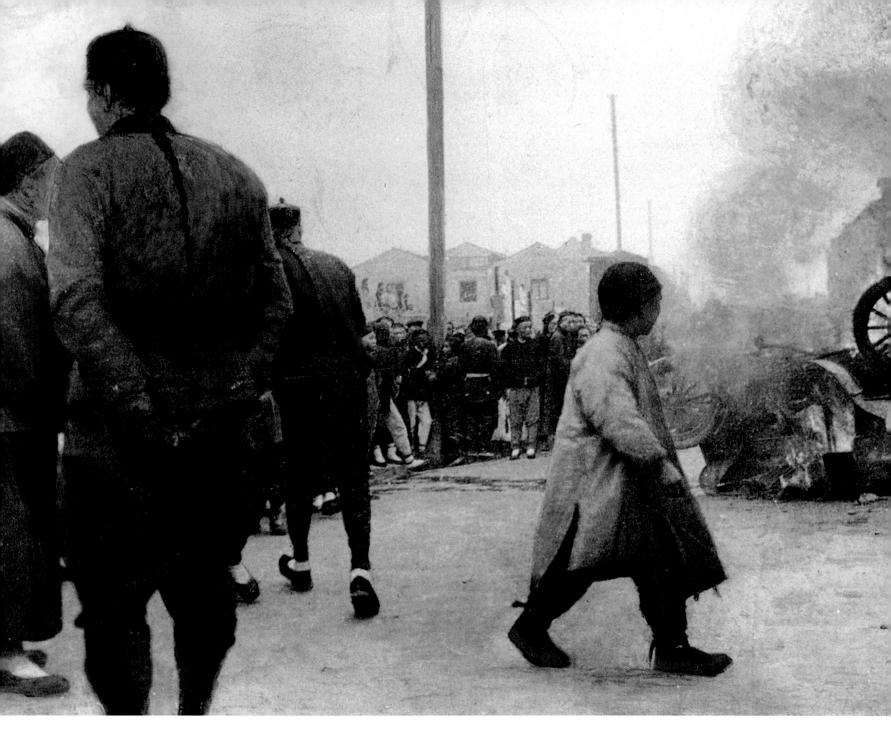

taken refuge in Japan — to contemplate the potential political power of this new idea. Fragmented among their local regions, Liang wrote, the Chinese would be constantly at the mercy of hostile foreign forces, with all that entailed for their country's servitude. But, bonded together as citizens, the 200 million men of China would form an impressive force; and if they were joined in turn by 200 million women, strengthened by education and reform, then the marshaled force of 400 million could surely carry all in their way. Liang Qichao reinforced this message by regular references to Western historical examples. Whether pointing to the example of the unification of Italy in the nineteenth century, or praising the strong women of the French Revolution who had dared to seize their own destinies, Liang Qichao enlarged the dialogue of Chinese political life,

and gave a whole new sense of political possibilities to his readers.

From such impulses and experiences came a new form of action in Chinese history, the politically driven boycott of foreign products in the name of national political solidarity. The trigger for this movement was the United States' decision of 1904 to perpetuate the Exclusion Acts of the previous decades which discriminated specifically against the Chinese residing in, or seeking to enter, the United States. A boycott of American products spread rapidly during 1905, was carried through by many shopkeepers and merchants in urban China and enforced, sometimes violently, by aroused Chinese nationalists. The boycott also cut across the anti-Manchu lines that had been solidifying for a decade, since the Qing government showed that it was sympathetic to the boycotters, echoing the actions of the Qing

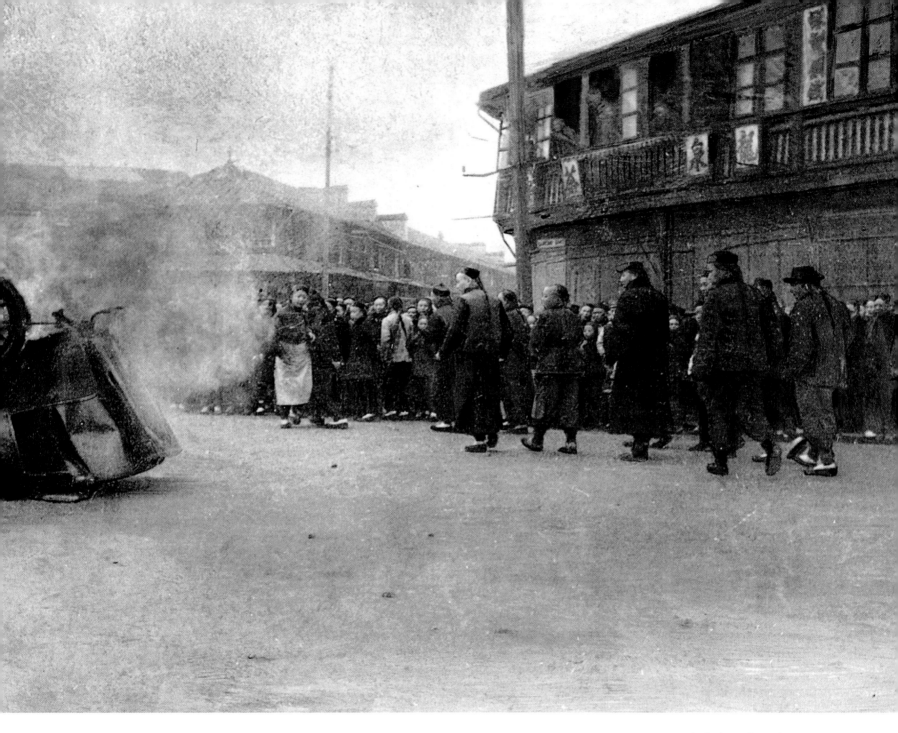

minister to Washington and the Qing ministry of foreign affairs who had sought to bring pressure on the United States to change their stance.

The Qing finally gave in to American pressure, and the Chinese public lost their enthusiasm. But the sense of what could be achieved was exciting and alerted astute Chinese businessmen to the possibilities of using anti-foreignism as a way of strengthening their own economic base at home. The Chinese cigarette industry, restricted largely to sales in southeast Asia because of the overwhelming marketing and production skills of the British-American Tobacco Company, was one of those which seized this opportunity to increase its own domestic market share. Certain segments of Chinese society were moving far and fast, even if the country as a whole continued to look much as it had before.

A British diplomat's car burns in Shanghai. *Nationalist feeling led to rioting and the destruction of foreign property. It was provoked by US legislation around 1906 which discriminated against the Chinese in America. Mostly the protest took the form of a boycott of foreign goods rather than outright attack on them.*

CHAPTER TWO

A FRAGILE CONSTITUTION

BY 1907, IT SEEMED AS THOUGH THE CHINESE government and people had recovered from both the humiliations of the Sino-Japanese war and the disruptions of the Boxer Uprising, and were at last making progress towards a constitutional form of government. The seventy-one-year-old Empress Dowager Cixi seemed an unlikely reformer, but she responded energetically to the challenges now facing China, despite her close ties, both of family and sentiment, with many of the most powerful conservative figures among the Manchu elite. In late 1906 the Manchu-Chinese delegation that she had dispatched overseas after the first aborted mission of 1905, gave their recommendations: that the revision of China's governmental structure should follow the example of the Japanese in the Meiji Restoration. Within a few months, the Empress Dowager and her advisers had formulated a ten-year plan of gradualist reform leading to a national parliament. This would draw its membership from delegates chosen by representative provincial assemblies, that were in turn to be democratically elected – although only men of wealth, property and education could vote.

In a number of major Chinese cities, as well as in the provinces, able and progressive Chinese administrators pressed ahead to form local elective councils, while incorporating the traditional elites into the new system. This was combined with the new forms of organization recommended by students recently returned from Japan. At the same time, the government's administrative structure was replaced by an expanded group of modern ministries geared more closely to the country's military and economic needs. Plans were made to transform the current Peking foreign language college into a national university. A group of talented bureaucrats from the former legal bureaus was appointed to revise China's archaic penal code, and to devise a new system of provisional courts, together with the facility for appeals to a newly formed Supreme Court. Military forces were reorganized on Western principles as the 'New Armies'; those Manchu officers who were sent overseas for training then formed the core of a new General Staff and ran the new military academies. The Qing court also discussed a revamped system of national education, and began to address the vexed question of tax reform.

China's international situation also seemed more promising than a decade before. There was no denying the power of the Westerners and the Japanese in the special 'concession areas' that they had wrung from the Qing by war and by coercive treaties. Furthermore, the foreign powers had a strong grip on China's economy through a system of unfairly low tariffs backed by a pattern of specially negotiated investments and loans. However, there was a respite from the warfare that had ravaged the country

The Last Emperor, *Puyi,*
photographed here aged six, in late
1911, shortly before the abdication of
the Manchu dynasty was arranged by his
regents. Empress Dowager Longyu,
widow of the deceased Emperor
Guangxu, appears partly hidden, on the
left of the photo.

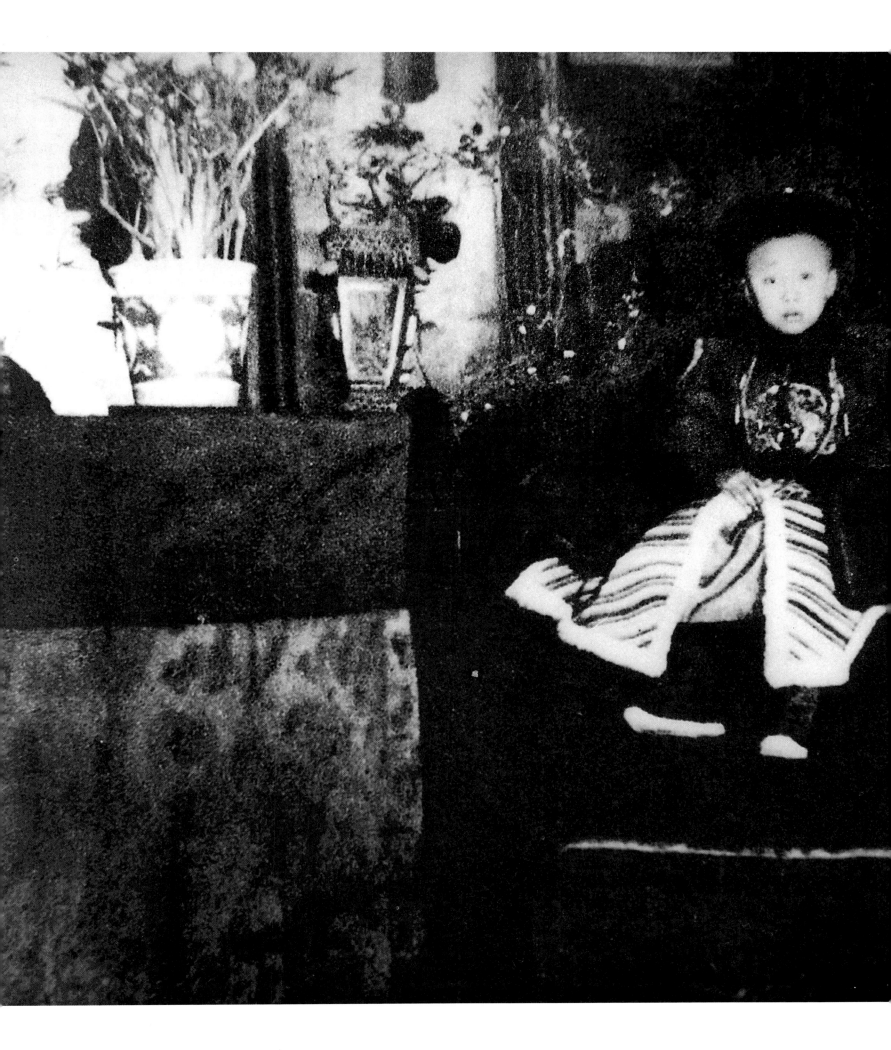

Roman Catholic missionaries *went back to work very shortly after the Boxer Uprising of 1900, in spite of the horrors that were directed against them. An Italian priest (right), Father Leone Nani, performs a multiple baptism at his mission in Shaanxi province. Nani worked in China between 1904 and 1914 and, like other missionaries, tried to record his experiences. Many missionaries 'became Chinese' in order to be more effective in their work, frequently adopting Chinese dress, like Father Nani here, who also has a Manchu pigtail, a long beard and wears a 'jijin', a type of Taoist headgear first adopted by the earliest Jesuit missionaries to China in the seventeenth century. The symbols on it are, however, Christian. The mission buildings themselves were frequently built in Chinese style.* [PHOTO: FATHER LEONE NANI]

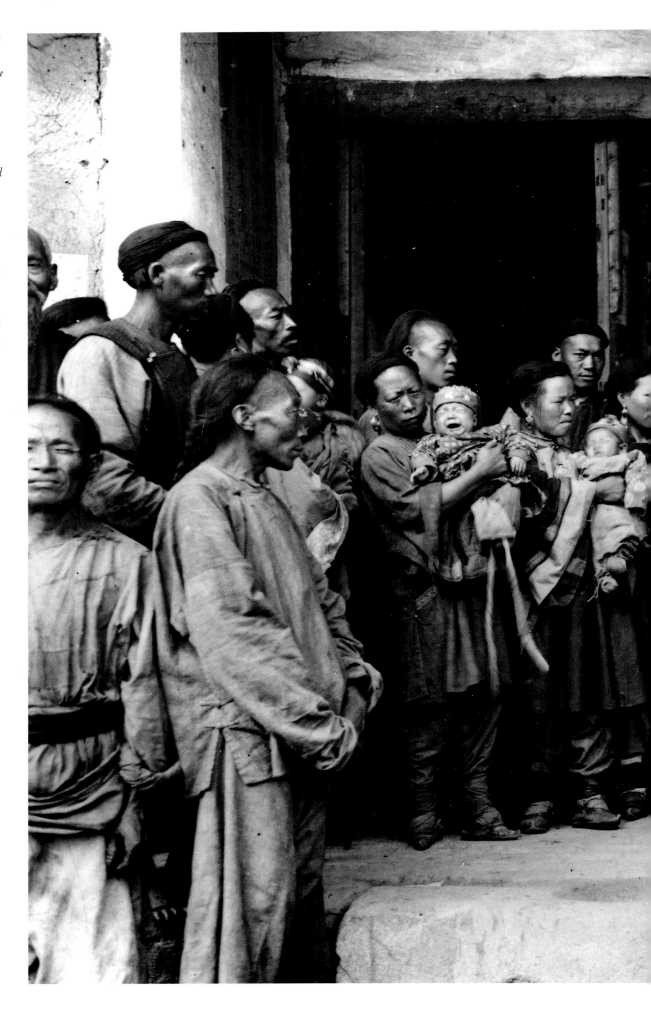

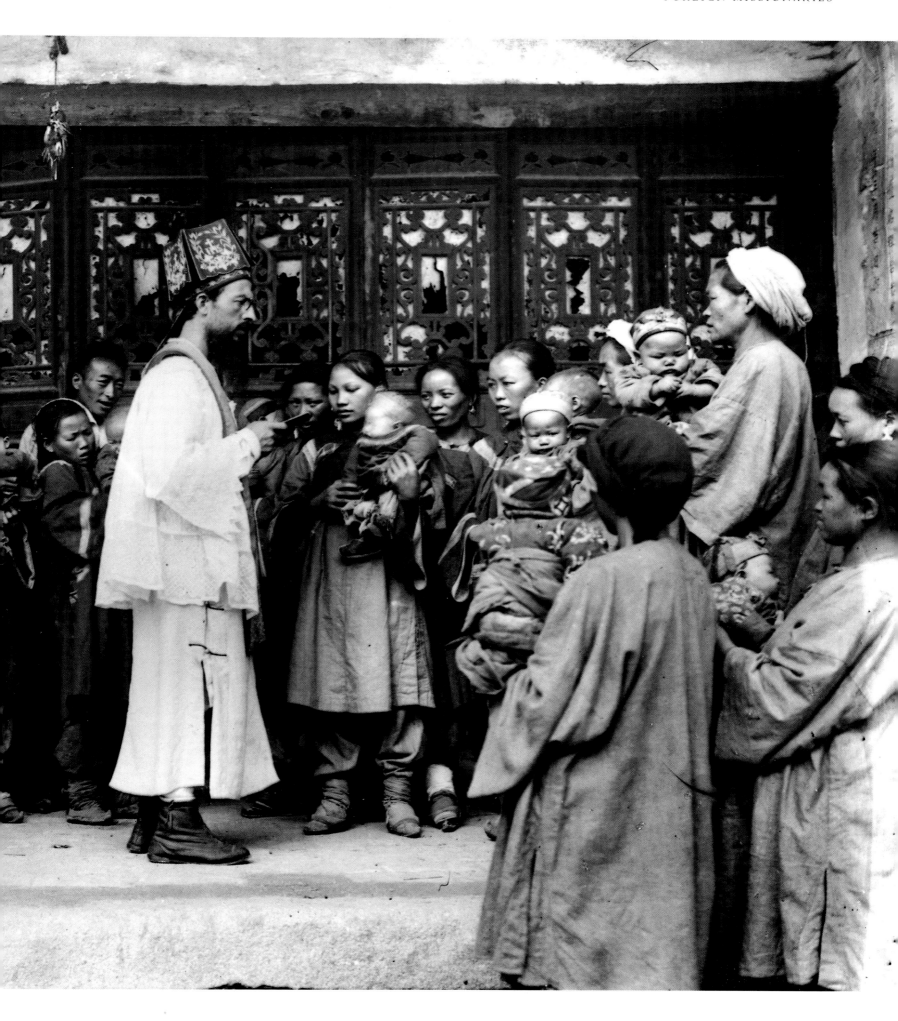

for so many years and Qing diplomats were now established in many of the world's leading capitals, where they were growing more expert at international law and diplomatic negotiation. Most importantly, the colossal indemnity that had been punitively imposed on China after the Boxer Uprising by the foreign powers was now modified or partially revoked by many of them. In 1908, the United States, for example, decided to remit some of the moneys due and arranged that the balance should be used inside China as bursaries for talented Chinese students of foreign languages, and as Boxer Indemnity fellowships to pay for their education and expenses in the United States.

Missionaries, both Catholic and Protestant, who had behaved so aggressively in China in the later nineteenth century, now seemed to focus more closely on China's educational needs — especially the education of girls and women — and on social services such as hospitals, libraries and reading rooms. The Young Men's Christian Association, with its emphasis not only on civic virtues but also on physical fitness and organized sports, also began to exert its influence. The result was a rapid spread of secondary schools, colleges and universities, a flow of new social and intellectual forces sympathetic to democracy and the cities, and new types of Sino-Western collaboration, such as the Yale-in-China venture in Hunan province, a peaceful memorial to a Yale

College graduate killed by the Boxers in 1900. By 1908, Yale-in-China was operating a secondary school and medical dispensary and planning a medical and nursing college with Hunanese elites, to train a new generation of Chinese doctors. Tensions arose over levels of rent, student discipline and the amount of Christian teaching that should be permitted within the curriculum, but such initiatives seemed to be taking firm and constructive root.

There were, however, many reasons why a peaceful transition into a new, more democratic age could not be implemented as the Manchu leaders had planned. The biggest problem was the nationalists' feeling that these reforms only increased the dynastic strength of the Manchus. Anger and frustration over past failures and humiliations were widespread. There were numerous uprisings against the Manchus, many spearheaded by Sun Yat-sen, or those acting in his name. Though these failed and participants were harshly punished, they kept the hostility alive. Those urging restraint and the need for a constitutional monarchy under the existing Manchu ruling house faced opposition from two groups. Some hated the Manchus yet opted for a Chinese form of monarchical government; others, more importantly, rejected the monarchical model altogether and thought China must move swiftly towards a full republic.

The deaths of China's de facto ruler, the elderly and formidable

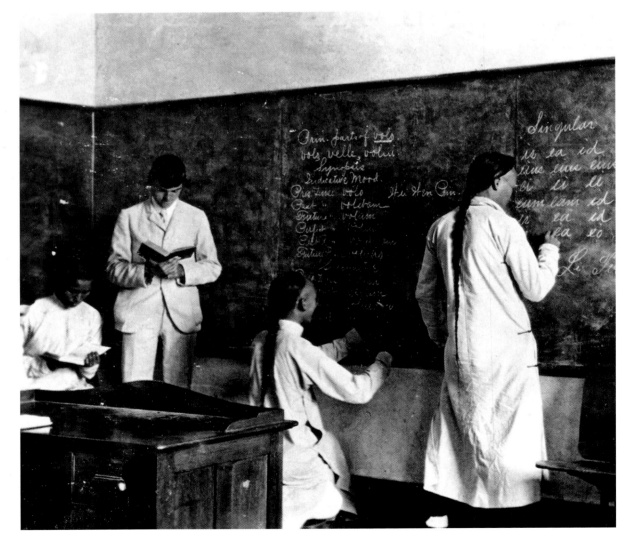

The advance of Western ways. *In a Protestant School (left) boys in Qing scholars' dress learn Latin under the supervision of their suited teacher, while Roman Catholic Sisters of Mercy teach younger children (right) in a Western-style room decorated with Christian iconography.*

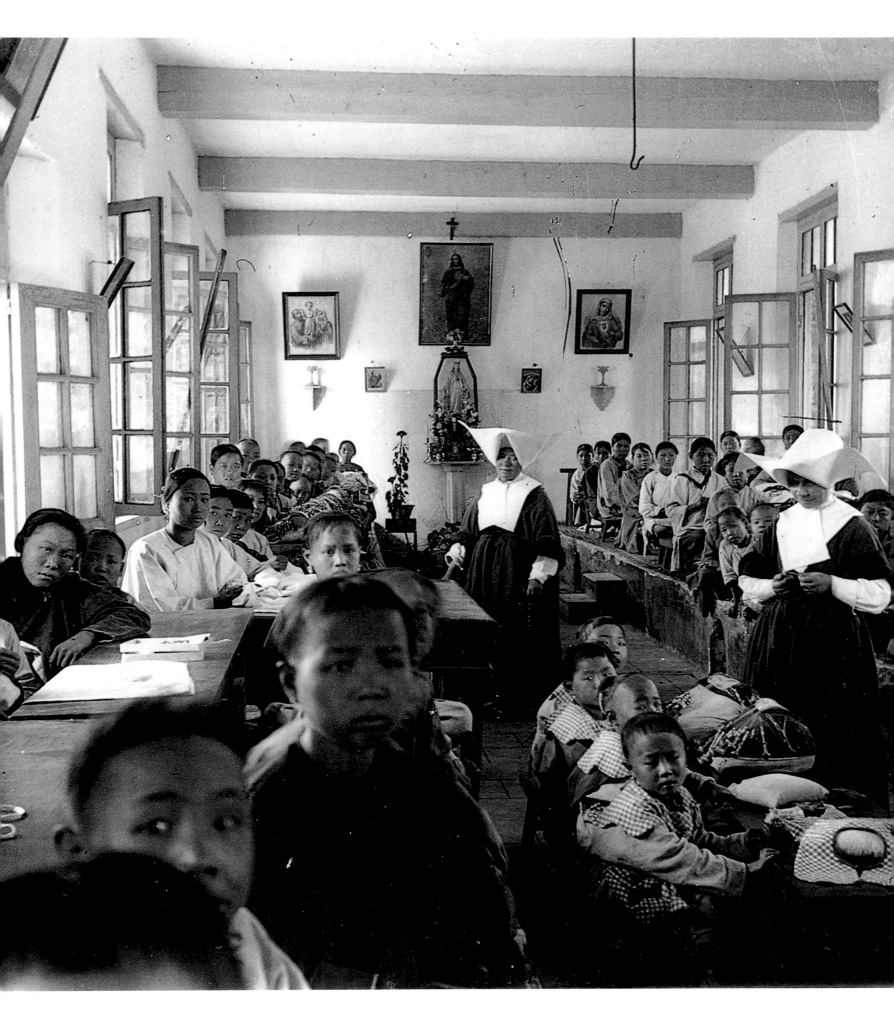

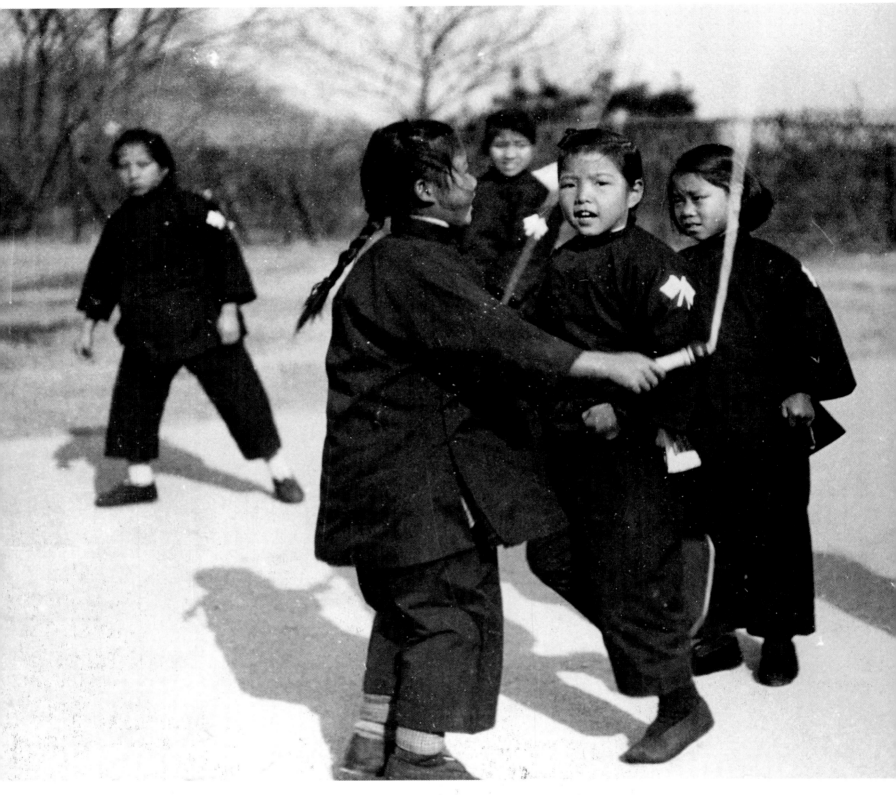

New directions for the young. *The end of footbinding meant that young girls could indulge in physical play, such as skipping (above), for the first time. Physical training like this gymnastic*

class (above right) and uniforms became more common in schools, and Western musical instruments such as trumpets, harmoniums and side-drums were introduced (below right).

The last Imperial funerals *(overleaf). The Empress Dowager Cixi and her nephew, the Emperor Guangxu, died within one day of each other in November 1908. Foreign representatives, including a military attaché from Imperial Germany (above right) were in*

attendance at Cixi's funeral (overleaf, above left). Their embalmed bodies were later carried one hundred miles to the imperial burial ground, north of Peking. The main picture shows Guangxu's catafalque carried on its long journey over the dry northern plains.

Empress Dowager and the still-imprisoned Guangxu emperor within a day of each other in 1908 further complicated the situation. Guangxu had been kept under palace arrest ever since his abortive attempt at reform in 1898, and he had produced no heir; accordingly, the succession now passed to the next-in line, the infant son of a collateral relative of the ruling house, a three-year-old boy named Puyi. The new group of Manchu regents who came to rule in Puyi's name had little knowledge of the problems facing China, and were wary of any change that might undermine their fragile authority. The magnificent funerals of the Empress Dowager and Guangxu, which included the construction of a special road from Peking to the ancestral burial grounds in the north, could not hide the moral and the near fiscal bankruptcy of the new rulers. The regents compounded their own problems by removing from office, on the grounds of 'illness', one of the most powerful Chinese provincial officials and modernizers, Yuan Shikai, even though Yuan was the builder of the most powerful

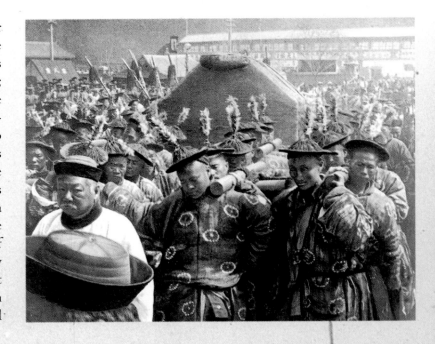

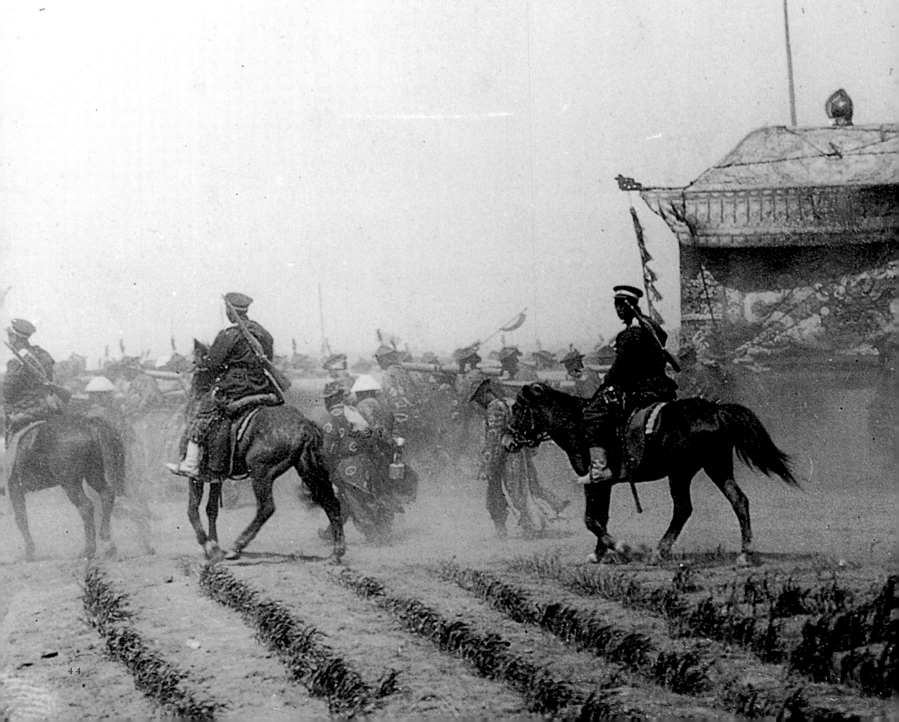

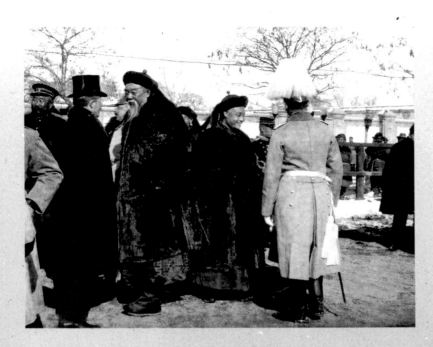

military machine in the reorganized armed forces, and had helped the Manchu conservatives expel the reformers in 1898. Yuan responded to this dismissal by wearing the simple clothes and adopting the rustic lifestyle of the ousted 'recluse' of Chinese tradition, although he shrewdly maintained his web of powerful military and personal connections.

Pressure from the provinces to speed up Cixi's ten-year timetable for the formation of a parliament was such that in 1908 the Qing court announced that the national assembly should convene in nine years, prior to which provincial assemblies should meet and deliberate. However, the edicts were barely circulated before local elites in the provinces, many of the newly affluent merchants, scholars and students returned from study overseas, and the graduates of the new military academies and staff colleges, combined to speed up the plan. By 1909 provincial assemblies, a mixture of elected delegates and others appointed by the provincial governors, were in full session across China.

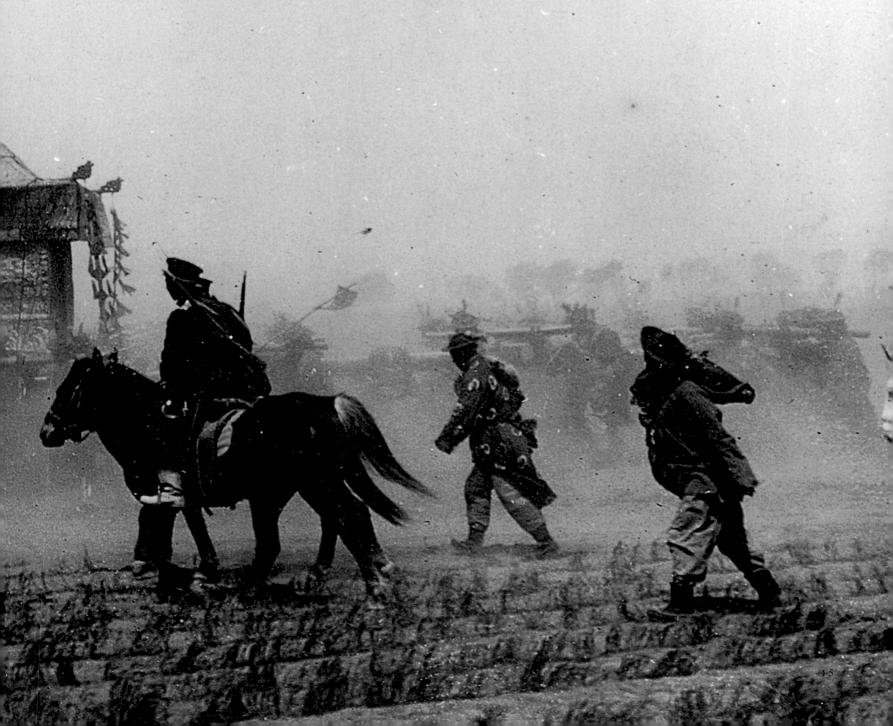

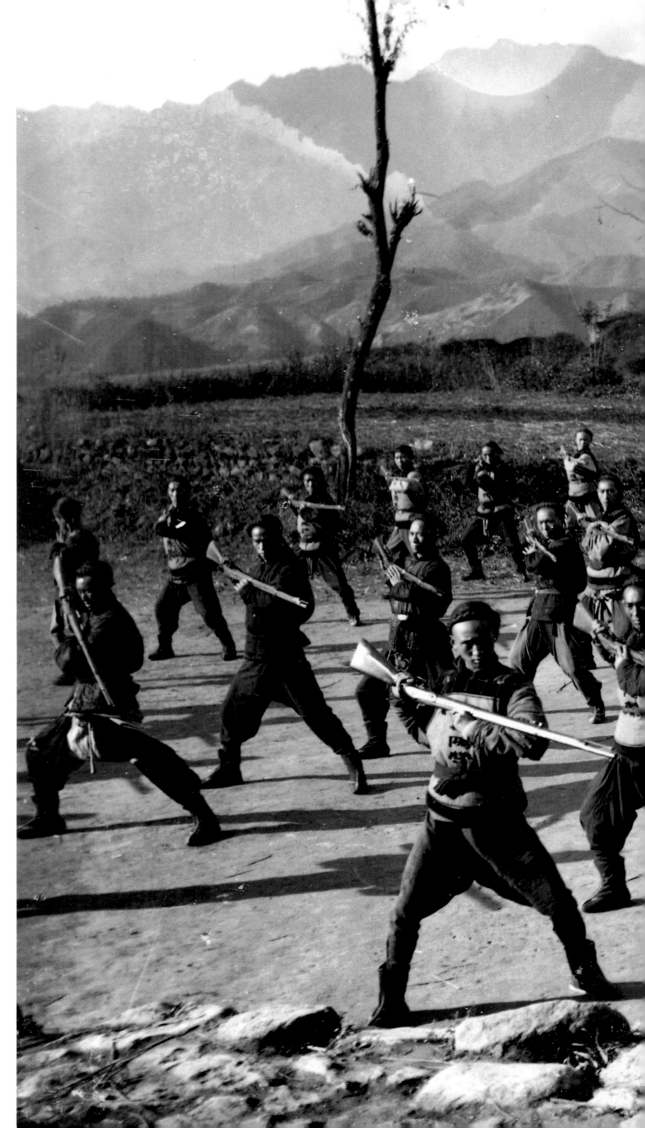

Republican and Imperial soldiers.

A Nationalist soldier (above) poses proudly in his new uniform with the Republicans' white star emblem on his cap. He fastens his collar with a safety pin. Despite the shabby appearance of the Guomindang troops, their organization and spirit enabled them to overthrow the Qing armies. In elegant contrast (right), Qing troops drill in traditional uniform, more suited to the Chinese physique. They wear their Manchu pigtails coiled around their heads. Each imperial soldier would usually have his province of origin and his rank written on his chest. [PHOTOS ABOVE AND RIGHT: FATHER LEONE NANI]

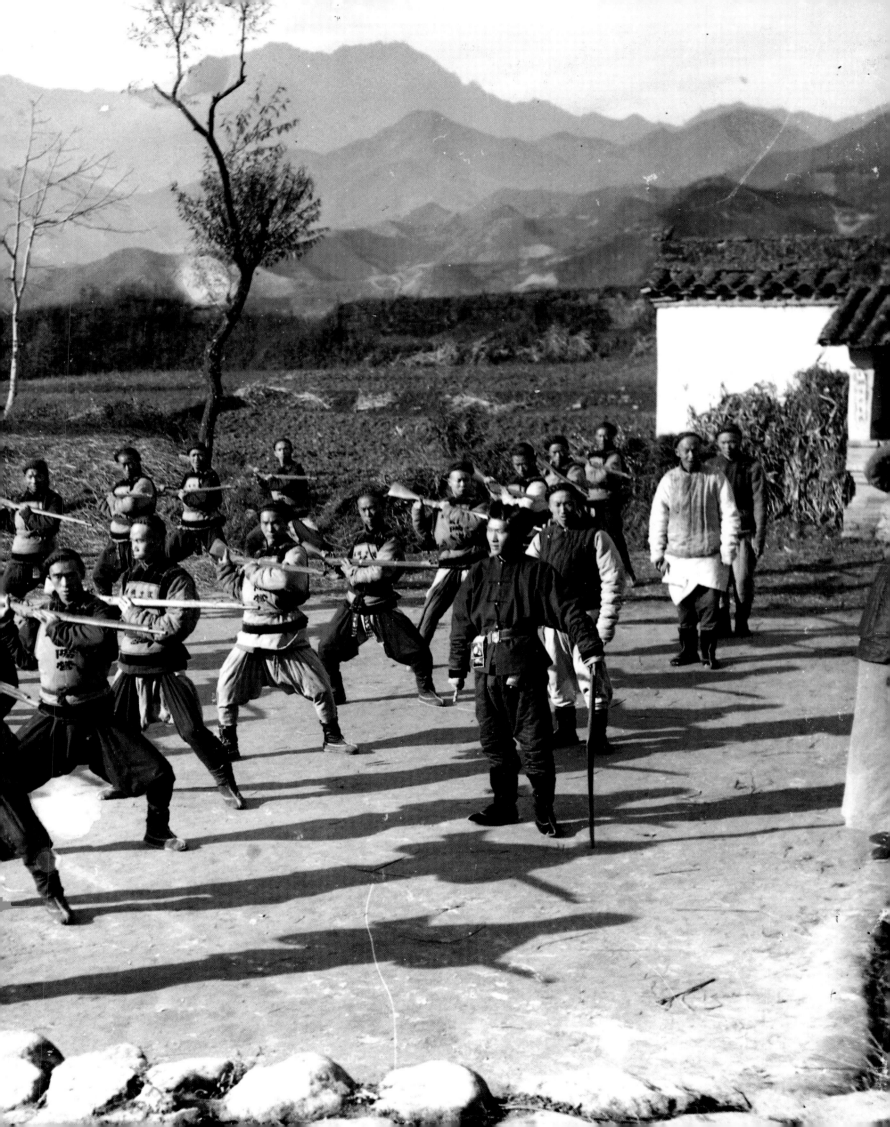

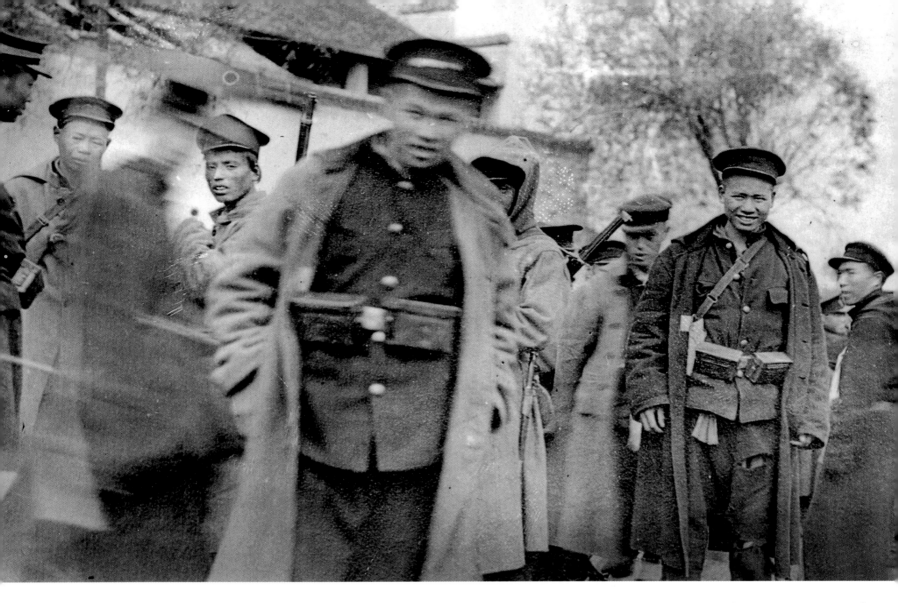

Some of these governors — most of whom were Chinese — were loyal to the imperial court, but, in many cases, their sympathies were with the local assemblies. Soon, members in most of the provincial assemblies abandoned the 'advisory' role stipulated by the court and began to claim control over budgeting and taxation. By 1910 they had begun to nominate the members of the provisional national parliament, and some of these were in Peking that year. Assembly members also demanded a say in military planning and development; in curbing the power of foreigners; in developing their own industries; and in the investment structure and design of the railways that ran — or were planned to run — through their provinces. Railway building, usually with the help of foreign investors, had increased rapidly since the 1880s, and a line now linked Peking to Mukden in the north and to Wuhan in central China. Other lines were in the planning or preliminary construction phrase, such as those from Wuhan to Canton in the south and Chengdu in the West. These new lines were slowly changing the distribution routes for foreign and domestic products and speeding the movements of troops to trouble spots. Provincial leaders, scared and angry at Manchu attempts to centralize and control the rail systems, clamored for the right to reclaim the railways from both foreigners and the government.

It is hard to find any particular pattern in the series of events that erupted in late 1911, forcing the dynasty to an end in

February 1912 and closing the period of over 2,000 years of centralized imperial rule. The catalyst for this was the accidental explosion, on October 9, 1911, of a bomb being made by affiliates of Sun Yat-sen's revolutionary society in the foreign concession area of Hankou, up the Yangzi River, in the tri-city region known as Wuhan.

At the site of the explosion, Qing police came across a full list of the members of the illegal organization which the Hankou leaders had injudiciously kept. Many of these members were soldiers or junior officers in the New Army garrisons billeted in the city. After hurried meetings, they decided to act before the Qing police could arrest them. The mutiny they staged on October 10 was successful. They seized stockpiles of arms and, emboldened by the flight of the local senior officials, they declared their independence from the Qing and their desire to form a constitutional government.

While the Qing court struggled to assemble a loyal military strike force to advance down the newly completed Peking-Wuhan railroad to suppress the mutiny, the news of the uprising spread across China. Numerous provinces followed suit, often led by members of their own assemblies frustrated by the lack of change at the center. Many of the armies were divided in their loyalties, some swinging to constitutionalism, some staying loyal to the Qing and others seizing the chance to expand their own power

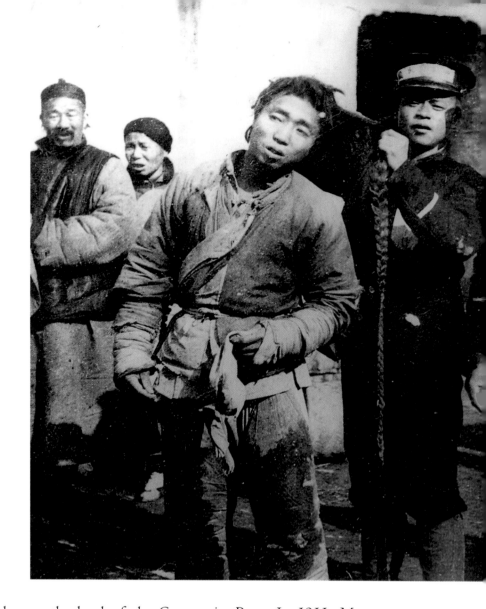

Spearhead of the New Order.
Nationalist soldiers in Wuchang (left), where the 1911 rebellion first broke out. Shortly after the revolution, triumphant Republican troops often forced locals to cut off their queues (right) as a sign that the old Manchu order was finished.

bases. In several cities, fighting was fierce and protracted and casualties were high, even though it was not always easy for individual Chinese to know exactly whom they were fighting for, or why.

Some Chinese with only a vague sense of what the issues were, rushed to claim allegiance to the new Republic and even constructed 'revolutionary' antecedents for themselves as they cut off their own or others' queues and hurriedly learned new slogans. They were satirized for all time by the Chinese writer Lu Xun, (himself a returned student from Japan, then living in Zhejiang) when he created the fictional character Ah Q. While living in Japan, Lu Xun had become depressed and alarmed at China's weakness, and had decided to abandon the study of medicine for writing as a means to reawaken the conscience of China, and to cure the country's 'soul' instead of its 'body'. His Ah Q was a man without principles, at once cowardly and bullying, fawning on the rich and abusive to women and the poor. He claimed to be a 'revolutionary' for the sake of fleeting prestige, but was subsequently executed for the political beliefs he did not even hold. To many Chinese, this depressing fictional creation came to stand for the revolution's fundamental ambiguity. For others, however, the uprising was a formative military experience: a first encounter with violence, ideology and politics. This was the case with the young Mao Zedong, later to assume leadership of China

as the head of the Communist Party. In 1911, Mao was an eighteen-year-old middle school student from a rural family in the Hunan city of Changsha. Here, he was recruited for the Republican cause and fought briefly against the local Qing military commanders. Future leaders and prominent intellectuals would later recall the muddled military conflicts and the uncontrolled violence as local feuds were settled and ancient hatreds of Chinese settlers for local tribespeople, or for more recent local settlers, burst into the open. A fortunate few near the handful of recently built modern hospitals received effective medical help, but hundreds of thousands of peasant and urban soldiers died of their wounds.

As the fighting intensified, some Manchu garrisons were attacked and their Manchu residents – soldiers, civilians, and children – were massacred. The regents for the boy-emperor Puyi appealed for help from the very man they had ousted from office because they had doubted his loyalty: Yuan Shikai. Stalling at first, using the sarcastic excuse that he must still be 'ill', Yuan agreed to leave his retreat when the Qing named him prime minister of the provisional parliament that they had convened in Peking, in competition with the revolutionaries' parliament in Nanjing. Swiftly assembling troops loyal to him, Yuan ordered them to advance on Hankou, which they recaptured in November. But the momentum towards a republic had become unstoppable. On

Victims of the revolution. *Pinioned Republican prisoners await their fate (above left). Wounded soldiers recuperate at the Yale-in-China hospital at Changsha, Hunan province (below left), where Western surgery saved many lives. Elsewhere the vast majority of casualties died because of the almost total absence of military medical services. Qing soldiers (right) execute a rebel in the street at Amoy, whose status as a treaty port explains the presence of the American soldiers in the audience.*

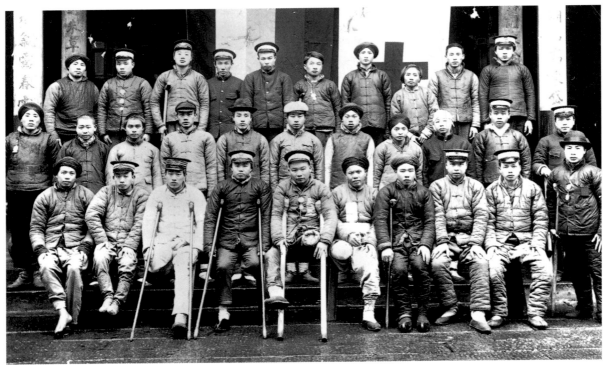

December 29, the Nanjing parliament announced the formation of a Chinese Republic, electing Sun Yat-sen as its 'provisional president'.

Sun, who had been fund-raising in the United States when he learned of the Hankou rising, and had then gone to Europe in an attempt to get a guarantee of foreign neutrality in the current conflict, returned to China and a hero's reception in January 1912. Perhaps he could have ridden the euphoria of the moment to a successful conclusion, and formed a firm base for a new democratic state under his own leadership, had he not been so aware of his own supporters' military weakness and of the fragmented state of the country as a whole. Political disintegration, he feared, could only lead to the strengthening of foreign imperialism in China and the impossibility of any rational plan for national development. He and his advisers therefore negotiated with Yuan Shikai, assuring him in a telegram that the

provisional presidency was actually 'waiting' for him, if he would abandon the Qing and throw his military power and personal prestige behind the new Republic in Nanjing.

Yuan agreed to Sun's suggestions, leaving the Manchu ruling house no choice but to abdicate in February 1912. Always a shrewd political operator, he realized that his influence would be weak in Nanjing, where that of the Republicans and Sun Yat-sen was strongest. He claimed that a succession of military mutinies and disturbances in the north made it essential that he should remain in Peking and that the new capital should be established there. It seems likely that Yuan himself instigated these disturbances, but, whatever the truth, Sun's supporters again felt they had to agree to shift the capital north, from Nanjing, once elections to the new national parliament had taken place.

The various factions in China began to jockey for position in the prospective national elections. Seeking respectability, Sun Yat-

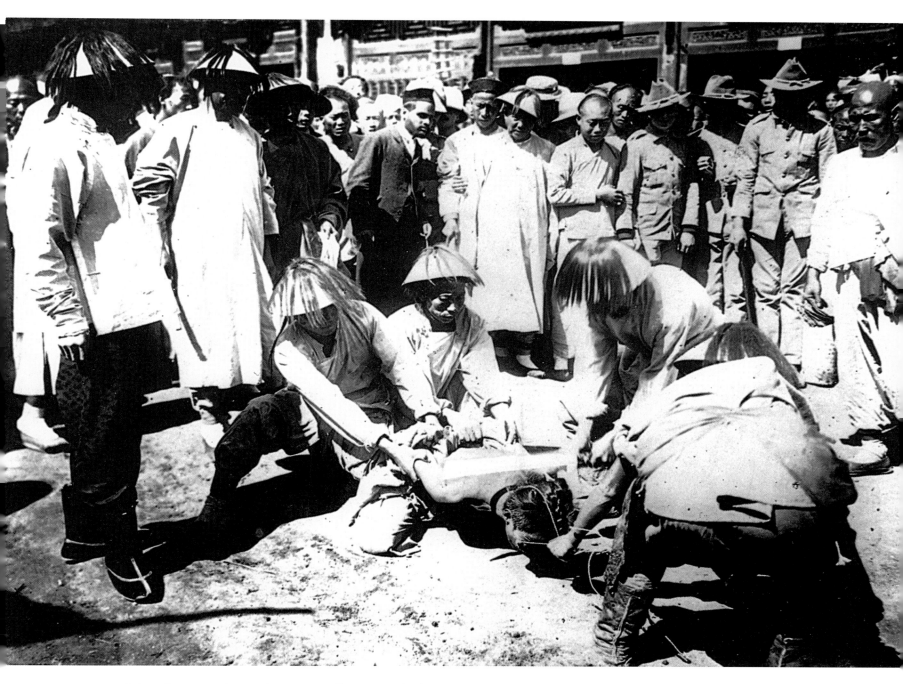

sen reorganized his fragmented Revolutionary Alliance. It had been a broad affiliation of secret society members and civilian and military republican supporters scattered across China and overseas, but he now consolidated it with a number of other political parties into a single coherent organisation that he named the 'National People's Party', or Guomindang, which effectively caught the mood and impulse of the times. Sun busied himself in the national economic arena, having been successfully wooed by Yuan Shikai with the promise that Sun could develop his visionary plans for a vast railway network that would interconnect and unify China, introducing an unparalleled era of trade and prosperity. He left the running of the election campaign largely to one of his lieutenants, Song Jiaoren. The thirty-year-old Song, an anti-Qing revolutionary since he was twenty, had been a founding member of Sun's Revolutionary Alliance in Japan, the director of its most important journal, and leader of the group's central China

operations. Song Jiaoren campaigned vigorously in the fall of 1912, calling for a limit on the president's executive power, giving the crucial policy-formation role to the prime minister, the duly chosen head of whatever majority party emerged from the elections.

In contrast, Liang Qichao, a veteran exile of the failed 1898 reform movement, and long-time resident in Japan, had at first tried to rally his scattered friends and supporters around the idea of a centrist political system which he defined as 'a republican government with a titular monarch'. But, realising the bankruptcy of the imperial system, he had moved to support a fully fledged republican form of government, and became an active member of a party known as the Democratic Party, and a general supporter of a second party, the Republican Party.

The election, which took place in December 1912, was vigorously contested, and though supervision of balloting was

minimal there seems to have been little overt interference by either militarists or foreign forces. The final tally, however, was confused because some candidates had registered with several parties, and not all the smaller parties were correctly registered. Liang Qichao's coalition of various rival parties, now renamed the Progressive Party, had done well in the election, but the clear overall winner was the National People's Party of Sun Yat-sen and Song Jiaoren with 269 seats, though this did not give them an absolute majority of the 596 seats available. Song probably had the potential to be an effective leader of China's new Republic, a popularly elected politician who understood the problems facing his country, and might have skillfully directed it on a new course. But, ebullient and overconfident after his victory, he spoke out more freely than was prudent concerning the ways that the Guomindang might limit Yuan Shikai's presidential powers under the new constitution for China that the parliament would at once proceed to draft. As Song stood on the Shanghai station platform on March 20, 1913, waiting to make the long-hoped-for journey to Peking, he was shot at close range in the chest and died two days later.

The Guomindang were shocked and while they mourned they sought to identify those who had arranged the killing; many signs pointed to Yuan Shikai or his henchmen. The delegates of the new parliament assembled in Peking to draft their blueprint for the new China and to arrange for the first orderly national elections for the new Republic's presidency. In many cases, the provinces they had left were in an unsettled state, with the lines of internal authority unclear. Many provincial assemblies, and the cities in which they were based, were dominated by the military leaders of the New Armies, or by self-appointed military leaders who had

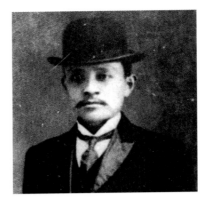

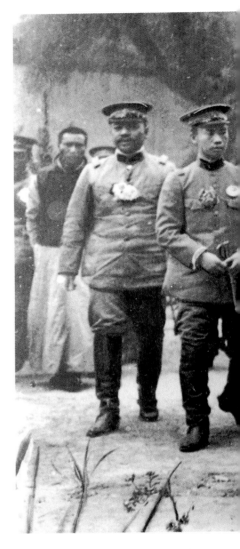

Democracy's best hope. *Song Jiaoren (above), in Western clothing, was Sun Yat-sen's most able lieutenant. Song was assassinated, probably at the orders of Yuan Shikai, three months after he had organized the Guomindang election victory in 1912. He was killed on Shanghai station as he was about to leave for Peking to join parliament where he intended to draft a new constitution to limit President Yuan Shikai's powers.*

Sun Yat-sen *(right), wearing his bowler hat, is flanked by Republican officers and civilian advisers including Zhang Renjie, one of his earliest financial backers, in the embroidered jacket and Homburg hat.*

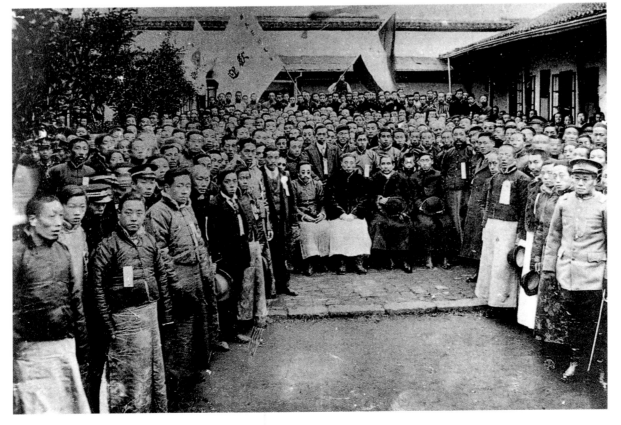

Forging alliances. *Sun Yat-sen, seated in the center in Western clothing (left), attends a gathering of Republican and revolutionary supporters. To his right, in traditional dress, is the leading Zhejiang power broker Chen Qimei. Chen had joined Sun's revolutionary organization in Japan early in the century, and he had inducted the young Chiang Kai-shek into the group. In late 1911, responding to the possibilities created by the rising in Wuhan, Chen led revolutionary troops in the successive captures of Shanghai and Nanjing. These victories made it possible to found the Republic in the Yangzi delta region by the end of the year. Unlike Sun, Chen remained extremely suspicious of Yuan Shikai, and opposed Yuan's elevation to the presidency. Chen was assassinated by secret agents in 1916.*

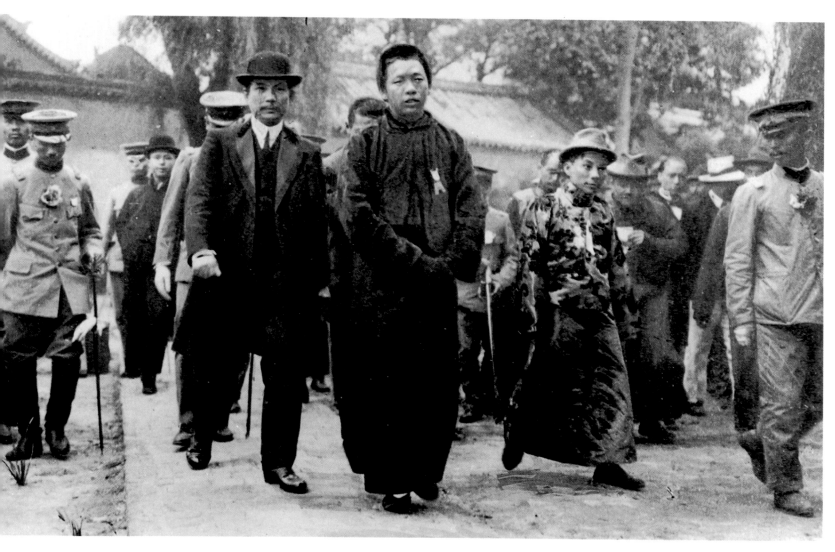

risen to the fore in the months of fighting in 1911 and 1912. Some generals, like the powerful Zhang Xun, who had first come to power when he escorted the Empress Dowager safely back to Peking after the suppression of the Boxer Uprising, continued to support the ousted Manchu regime. Zhang forbade the troops of his formidable and well-armed fighting force to shave their queues, and they thus formed a natural focus of opposition to many of the policies of the fledgling Republic. Much of Manchuria itself had also slid under the control of local militarists, some of whom had been bandits until they assumed their new dignities.

The Guomindang delegates were the most vocal proponents of civilian government and the prompt convening of open and free elections. It seems almost inevitable, though it remains a historical tragedy, that Yuan Shikai, supported by both his military disciples and many civilian politicians suspicious of the Guomindang, decided to quash open political change. In May 1913 police raided the homes and offices of the Guomindang delegates and their sympathizers, and Yuan ordered their removal from parliament and the dismissal of those military governors who supported them. Calling on their forces throughout China, the Guomindang sought to withstand this onslaught and regain their political rights, but they were overwhelmed by Yuan's armies and those of his loyal subordinates. By 1914, Sun Yat-sen was again in

exile in Japan, and many of his supporters were dead or scattered. Only slowly could he create a new political organization that this time would be used to seize power from Yuan rather than the Qing. He called it the 'Revolutionary Party'.

Yuan Shikai had purged the Guomindang in part because he believed that China needed strong and unified leadership and that only he had the power and experience to provide it. Indeed, he did achieve a number of important goals. Working with the remaining non-Guomindang members of the parliament, he formed a cabinet and sought to strengthen the local administration of China, to reorganize the system of military control in the provinces through officially appointed military governors and to centralize tax collection so that he could finance a number of ambitious ventures. Some of his reforms echoed those intended by the late Qing reformers: the broadening of educational opportunities; rationalising the legal code and supreme court system; revitalising the police and instituting model prisons; and strengthening China's international position. Despite his open violation of democratic procedures, he won the recognition of the United States for his regime, at least in part because he expressed a desire that the American people pray for his new government, which touched just the right emotional and religious chords.

Yuan Shikai initially received unexpected support from Liang

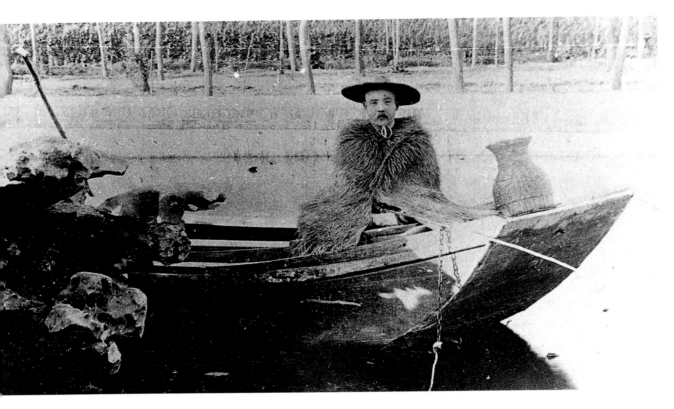

The General as daoist. *Yuan Shikai (left), around 1910. Yuan had been the most powerful general in the Qing army. After he was dismissed in 1908, Yuan assumed the demeanor of the traditional rural recluse as a form of silent protest. A figure clad in straw cloak, meditating as he fished, had long been familiar in Chinese paintings. After the revolution, Sun invited Yuan to become the first President of China only to have Yuan purge the parliament of the Guomindang in 1913 and later even to assume imperial prerogatives.*

A warlord's followers. *Troops loyal to General Zhang Xun and the Qing (right) pause to rest and gamble on the march to try and restore the boy ex-Emperor Puyi in 1917. They still wear their queues as a mark of allegiance to the imperial dynasty.*

Qichao, who had done so well in the 1912 elections that he had been the runner-up to the Guomindang leader Song Jiaoren. After Song's assassination, Liang had forged the coalition of his Progressive Party as an alternate voice to the Guomindang, one that gave more play to the executive power of the presidency in an attempt to curb the centrifugal forces of the provincial governments and militarists. To help strengthen the executive, Liang's party supported Yuan Shikai in his 1913 decision to acquire major loans from foreign banks, which the Guomindang had opposed. After Yuan purged the Guomindang from the parliament, Liang did not resign but accepted a cabinet position as minister of justice. In 1914, Yuan forced the dissolution of the rest of the parliament, formally replacing it with an advisory council of state. Again, instead of refusing to serve further, Liang tried to help stabilize China's shaky currency by serving as head of Yuan's newly constituted 'Monetary Bureau', and also accepted appointment to the advisory council. There he proposed plans for national compulsory education and for a comprehensive plan of military service for China's people.

Despite the backing of some prestigious figures like Liang, however, Yuan's rejection of democracy, denied him a valid mandate and widespread popular support. He responded to opposition in the parliament and in the provinces with openly repressive measures and by reasserting his own prerogatives. Apparently persuaded by the political scientist Frank Goodnow, an American adviser whom he had retained, that he should institutionalize his executive authority, he began to float the idea among his supporters that he might assume the title of emperor, but with a role akin to that of the contemporary Japanese emperor. By 1915 he was placing orders for imperial porcelain and robes and tinkering with reign names for his new rule. His unpopularity deepened after he arranged a series of massive loans with the Japanese, to keep the shaky finances of his government from collapsing altogether. Japanese insistence on taking collateral for these loans in the form of widened trading and investment rights in China and Manchuria, known as the 'Twenty-one demands', further angered the Chinese people. A boycott was started against Japanese goods that mirrored the one a decade before against the Americans. Yuan realised his error in suggesting the revival of the emperorship, and tried to cancel the preparations in 1916, but it was too late. Not only did his supporters, like Liang Qichao, abandon him, but a number of provinces declared their independence from his Peking government and prepared for war. As Yuan sought to rally his military supporters and launched his first strikes against the dissidents, he suddenly died, in June 1916. Yuan, who had believed so firmly in his own abilities to provide the powerful hand on the helm of the Chinese state that was needed for national survival, left his country shaken and beginning to disintegrate under the threat of civil war and competing military leaders.

The mantle of leadership formally passed to Yuan's provisional vice president, a mediocre military leader named Li Yuanhong, who had been thrust to prominence by the mutiny among his troops at Hankou in 1911. Neither popular nor powerful, Li was at best a figurehead. Power at the center thereafter changed hands rapidly and often unpredictably, as presidents, prime ministers and militarists competed for dominant roles. By August 1917, the prime minister was a former protegé of Yuan, Duan Qirui, who as a military leader was the key element in ending another imperial restoration attempt — that of the former boy-emperor Puyi.

Yuan's death had enabled the pro-Manchu General Zhang Xun to pursue his true ambitions. Though consistently loyal to Yuan,

to whom he owed his position as senior military governor under the Republic, Zhang Xun's own deepest loyalties remained to the Qing dynasty. It was for the Qing that Zhang had unsuccessfully sought to hold Nanjing from the revolutionaries in late 1911. It was in honor of the Qing that Zhang had used his position as power-broker in 1912 to assure that Puyi and his family be allowed to keep their residence in the Forbidden City and to enjoy its treasures, served by their enormous household, at State expense. It was in memory of the Qing that he ordered his troops to keep their queues, and in homage to their way of life as imperial guardians of Chinese culture that he had defended Confucius' birthplace from rioting crowds and maintained his official cult.

As the country seemed to be falling apart under the impact of the squabbling between President Li Yuanhong and the corrupt prime minister Duan Qirui, Zhang Xun made a daring bid to place the deposed emperor Puyi upon the throne. Leading 5,000 of his troops into Peking, Zhang assembled an imposing roster of Qing loyalists, visited the eleven-year-old ex-emperor in his palace and persuaded him once more to don his robes of office on July 1, 1917. For eleven days China once again had a Manchu regime, and a flurry of edicts were issued in its name, including several that gave Zhang Xun high noble titles and the offices of chief of both foreign and military affairs in the restored regime. In mid-July, however, troops of opposing militarists attacked Peking, outnumbering Zhang's forces and forced him to seek sanctuary in one of the foreign legations.

This attempted coup by Zhang Xun accelerated the process begun under Yuan Shikai and left China's central government fragmented and weak, with large areas of the country subject to the rule of individual military leaders who were effectively outside the control of any government, central or provincial. China had been in danger of splitting into competing military satrapies since the mid-nineteenth century, when the immense domestic uprisings and the drastic means needed for their suppression led to much power being delegated by the Qing to their field commanders, so creating a partially militarized society. In the later nineteenth century, despite the problems of foreign war and a growing imperialist presence in China, new types of weapon and willing foreign advisers had rapidly developed China's military power, though it remained crucially divided between the Manchu military forces and the New Armies, many of which were led by provincial officials.

Yuan Shikai had controlled the northern segment of these newly modernized forces, known as the 'Beiyang' or 'Northern' Army. Originally developed to defend northern China and the seaboard from domestic rebels and external attack, its defeat by Japan in 1894 gave new urgency to modernizing and streamlining this force. Yuan had been a skillful bureaucratic politician and military strategist, and had used his position as director of military training in the north to advance the careers of key officers and so to foster their loyalty. He had remained in close touch with them even during his years of enforced 'retirement' between 1908 and 1911. One reason for Yuan Shikai's effective suppression of the democratic opposition after 1912 was that scores of these loyal

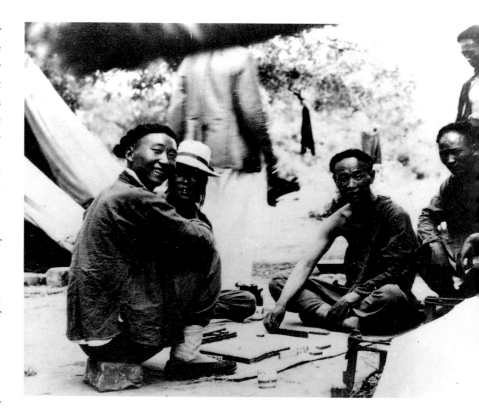

officers had used the disruption of civil government during the revolution to build their own followings in their regions, and to form their own alliances with important figures among the local elites and provincial assemblies. Yuan had named these officers military governors of their provinces, had given them cabinet positions and had incorporated them in the structure of the new Republican military forces.

Duan Qirui, prime minister at the time of Zhang Xun's attempted coup, was just such a protégé of Yuan Shikai, a typical exemplar of the new kind of twentieth-century Chinese politician known as the 'warlords' − manipulative, tough, skillful and ruthlesss. Peking became a political battlefield as individual warlords struggled for the presidency or the premiership, juggled cabinet positions and openly bribed and intimidated the few surviving members of the 1913 Parliament or their successors. After Yuan's death, a number of other major military figures not of his inner circle created their own northern power bases. One such figure was Yan Xishan. Born and raised in Shanxi province, he traveled to Japan for military training. On his return to Shanxi in 1910, Yan slowly developed the economy of his home region and used his troops to tip the balance between battling rival factions among Yuan Shikai's successors. From 1917, Shanxi was known as Yan's turf, and he was not to lose effective control there until after the end of World War II.

Zhang Zuolin was another independent warlord who had led local militia forces in southern Manchuria during the late Qing era. Like Yan Xishan, he shrewdly skirted the traps of the 1911 revolutionary period and the years of Yuan'spresidency, and by1917 was the undisputed master of most of Manchuria, and commander of an enormous army which he used in Peking military and political battles.

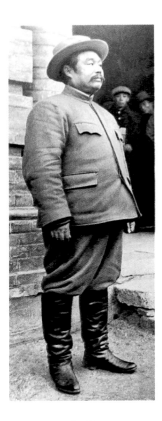 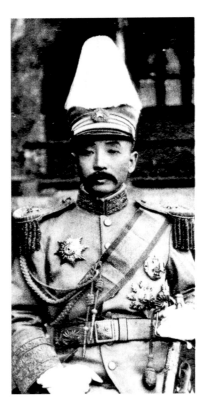 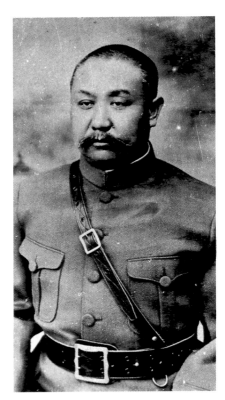 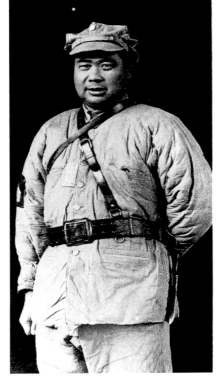

In south China too, warlords had held on to power through the 1911 revolution, or had acquired it just afterwards. Some were highly educated or trained abroad, others were virtual bandits whose de facto military power was rewarded with official titles. The numbers of such men grew steadily after Yuan's death, as social dislocation, unemployment and banditry spread in rural areas. To pay their often enormous armies, certain warlords would demand special taxes and surcharges, while some sold their loyalty for a time to rival warlords and politicians or foreign powers, and others put their entire army on the payroll of a province and used their military strength to enforce payment. Many encouraged the growth of opium poppies in their areas, later extracting enormous profits from the sale of the drug. The warlord who most came to represent the excesses and cruelties of the breed was Zhang Congchang. A powerful man well over six feet tall, Zhang had been born in the 1880s to a father who was an impoverished trumpeter and a mother widely believed to be a witch. After working in north China gambling dens, Zhang became leader of a bandit gang, and then turned that position into a commission with the revolutionary forces in 1911. After a stint of active duty as leader of bandit-suppression brigades — for which his former career well-prepared him, he rose to be divisional commander and superintendent of military education in the Peking government. In the 1920s he became the military governor of Shandong province, where he ruled with brutality and extortion, festooning telegraph

Four of China's most important warlords (above). After the collapse the Qing dynasty, China began to be broken up among the powerful warlords. From the left: Li Yuanhong, reluctant leader of the first revolutionaries who controlled the tri-city area of Wuhan and succeeded Yuan Shikai as President in 1916; Zhang Zuolin, the Manchurian bandit, who became the dominant warlord in northern China in the 1920s; Yan Xishan, eventually a vehement anti-Communist, who modernized and dominated Shanxi province until the 1940s; and Feng Yuxiang, known as the 'Christian General', whose organizational skills attracted the interest and courtship of both Communists and Nationalists.

Against imperial pretensions. Many soldiers opposed Yuan's bid for imperial status. These troops in Shandong province (right), photographed in May 1916, marshaled two divisions to rise against him. Their political leader, Ju Zheng, is third from the right.

poles with the split and severed heads of his victims. He controlled an army of over 100,000 troops, among whom were a unit of Chinese boy soldiers, many only ten years old (armed with rifles with specially shortened stocks) and a unit of White Russian refugees. He also had an entourage of around forty women, many of them Russian or other Western refugees, with whom he used to entertain himself and his guests at his flamboyant dinner parties, which he served off the finest porcelain and washed down with French champagne. He was finally assassinated by the adopted son of a man he had casually murdered.

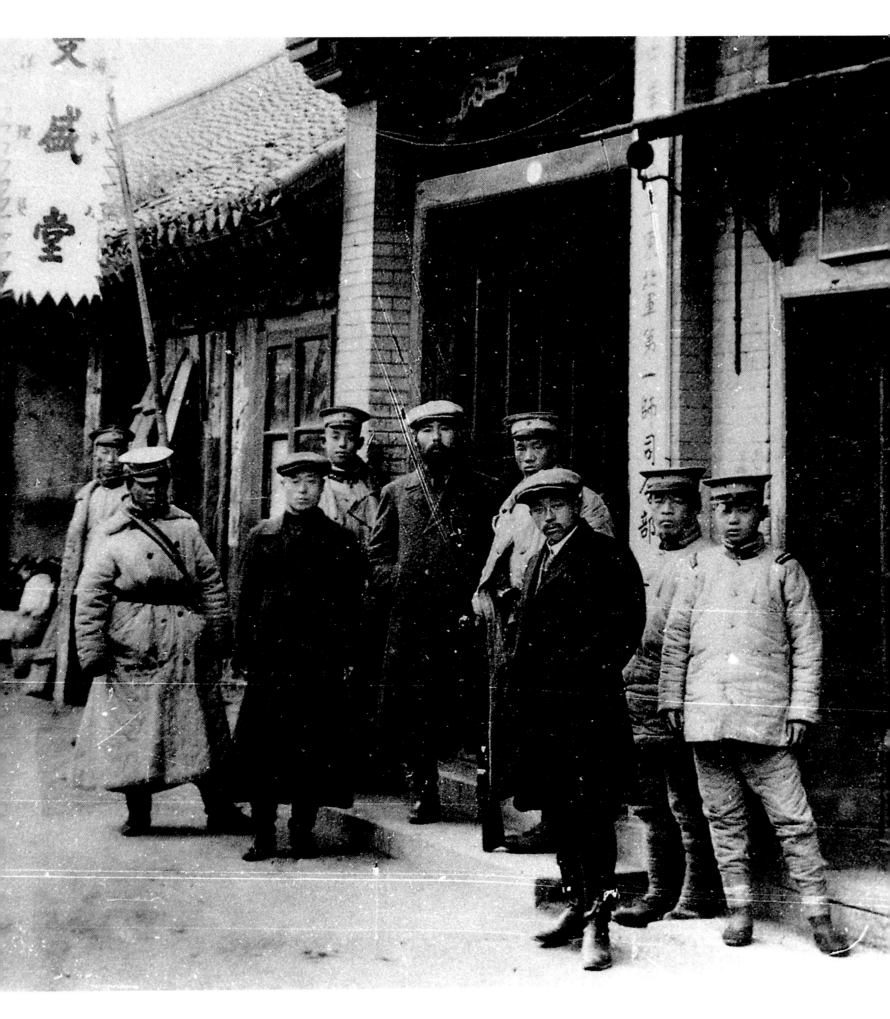

AWAY WITH THE OLD

I N SPITE OF THE POLITICAL TURBULENCE IN THE aftermath of the end of Empire, the country as a whole was comparatively prosperous. Released from Qing bureaucracy, new businesses and commerce flourished. The railway building program of the late Qing had continued and, even if it was with foreign investment, it still gave new opportunities to Chinese entrepreneurs to move massive amounts of goods and raw materials cheaply and swiftly. Chinese businessmen rapidly learned to use Western advertising and pressurized sales techniques from firms such as Standard Oil and the British-American Tobacco Company. Wider sales of imported kerosene and oil, and electric generating plants, developed with foreign investment, were new energy sources which gave the potential to expand plants. Civic organizations such as Chambers of Commerce, which had begun to burgeon under the late Qing, now reached new heights, and in many cases the Chinese leaders of such associations began to run large areas of their cities, and to foster civic improvements and new facilities. Street lighting and the telephone made cities safer and business easier. Although there were still few roads able to carry automobiles, the coming of improved types of rickshaw with inflatable tires increased the pace of movement around cities, and gave employment to tens of thousands of workers — among them many of the dispossessed Manchus.

The Chinese business elite was better educated than before, often in foreign-run schools at home or in colleges and universities overseas. Education in chemistry transformed the salt and related industries and led to breakthroughs in fields as diverse as fabric dyeing and processing, glass manufacture, and steel production. The outbreak of World War I in Europe also had a stimulating effect on Chinese industrial and economic growth, for so many Westerners were recalled to join their armed forces that a whole new generation of skilled Chinese, trained under foreign supervisors, was now able to take over vacant managerial positions. Also, the recall of shipping from eastern waters, and the lack of supplies and spare parts from Europe, stimulated the ingenuity of Chinese engineers and led to import substitution.

A corollary to such growth was the development of a larger industrial workforce in China. While traditional handicrafts still remained largely unaffected by these changes, the new job opportunities combined with hardship in the countryside from the sporadic fighting to bring rural migrants to certain larger cities in search of work. There they co-existed rather uneasily with the members of traditional handicraft guilds, and the local artisans rooted in the area who had a more traditional sense of economic opportunities and priorities. As China grew more firmly enmeshed

Eunuchs evicted from the imperial court *scuffle with police in 1923. Puyi expelled the eunuchs from the Forbidden City (where he and his family had stayed after his abdication) because they were stealing and selling priceless art works from the Imperial Palace. When their transgressions were discovered, the eunuchs set part of the palace on fire, destroying the evidence which would have convicted them. Puyi then feared an assassination attempt. He later remembered, 'I was too scared to sleep. There were eunuchs sleeping ... from the room next to my bedroom all the way to the outbuildings ... it would be only too easy to finish me off'. He had no choice but to evict them, which was 'well-received by public opinion'.*

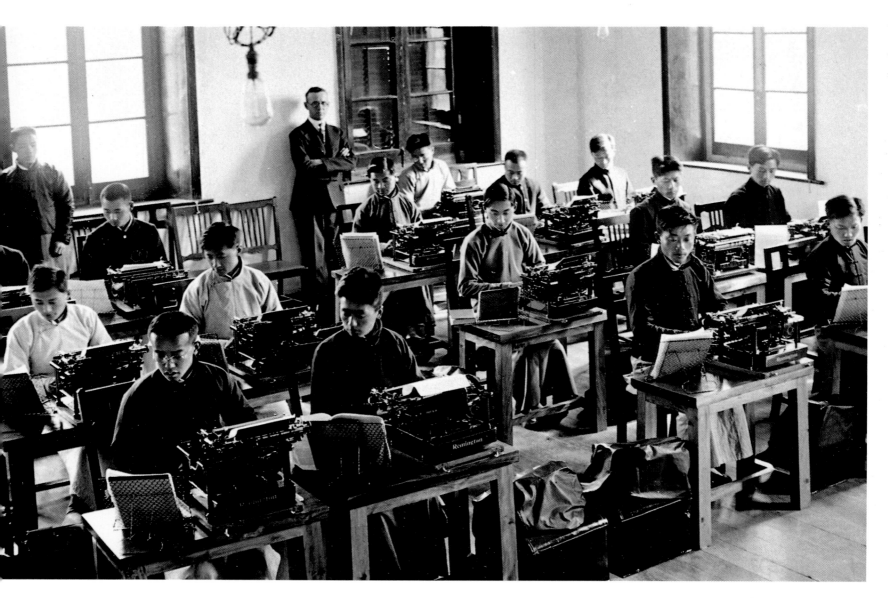

in the international world of commerce and exchange, its agricultural production became subject to the world's unstable economic cycles, which led to unpredictable crises, especially among farmers who moved from subsistence crops into the alluring arena of cash crops such as silk, cotton or tobacco.

Just as the collapse of constitutional government so soon after the fall of the Qing, and the slow slide of vast areas of China into the control of the militarists, did not stop the growth of economic activity, neither did it cramp and suppress intellectual life. On the contrary, the erosion of central control allowed an extraordinary flowering of intellectual energy in China that led some to hail it as a second Renaissance, comparable to that in Europe in the fifteenth century. But this is misleading, for the Chinese were not simply rediscovering elements of their own classical past and grafting them onto their present belief systems in order to create a new synthesis. Instead, they were drawing on the culture of the whole world and confronting a vast range of alien concepts that challenged all their inherited assumptions and beliefs. At the same time they believed that only by creatively adapting foreign ideas to China's needs could they save their nation from disintegration at the hands of the warlords and the foreigners.

One related aspect of these intellectual searches was the problem of language itself. Classical Chinese was extremely difficult to master, and hence elitist. Only those with long periods of leisure for study and reflection could grasp its intricacies, and as democratic and socialist theories got a hold on Chinese minds, students and scholars began to propose the abandonment of the classical language and even the ideographic forms of Chinese writing. Some suggested the adoption of Esperanto, or of a completely romanized form of alphabetic representation, or the use of a Chinese phonetic system for all verbal expression. Eventually it was decided that classical Chinese should be simplified by rendering ideas in a written form which imitated the colloquial or spoken patterns of the language. Thus, complex ideas could be made available to the masses. The adoption of vernacular forms offered new opportunities to writers of fiction, poetry, and political theory, which they were swift to seize, as they experimented with alternate rhythm and metrical structures, and coined new words to fit the new ideas. Some scholars and writers regretted a loss of sophistication, rigor and beauty. But to the young, the changes were symptomatic of a reawakening of their country and an opportunity to enter the culture of the world.

By the late 'teens of the twentieth century, tens of thousands of Chinese men and women had returned home after study overseas to share their new ideas and develop them. The number of schools and colleges with Western curricula continued to increase. Many new literary, scientific and political journals began to spread across the country via scores of new progressive book shops, where they were sought largely by youthful readers. The advertisements in such journals, and in the new vernacular newspapers whose circulation had expanded dramatically, also brought new expectations and information on foreign ways of life. Enormous amounts of fiction — especially French, English and Russian — were translated, as well as complex works of social and political

theory, many of which were first published in the magazine *New Youth*, edited mainly by scholars affiliated with Peking University. Works which explored the social dislocations of the age, or tried to deepen knowledge of the individual psyche were especially popular. Thus, Ibsen's plays presented new concepts of the role of the individual will in society, and the plight of women constrained by the bourgeois family. Sigmund Freud's books introduced ideas concerning the power of the unconscious in human desires, drives, and actions. Socialist ideas were spread through simple introductions to Marx and various forms of guild socialism and anarchism. The importance of Western science was discussed at length, and semi-scientific, or scientistic, ideas such as those of

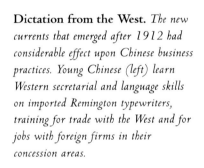

Dictation from the West. *The new currents that emerged after 1912 had considerable effect upon Chinese business practices. Young Chinese (left) learn Western secretarial and language skills on imported Remington typewriters, training for trade with the West and for jobs with foreign firms in their concession areas.*

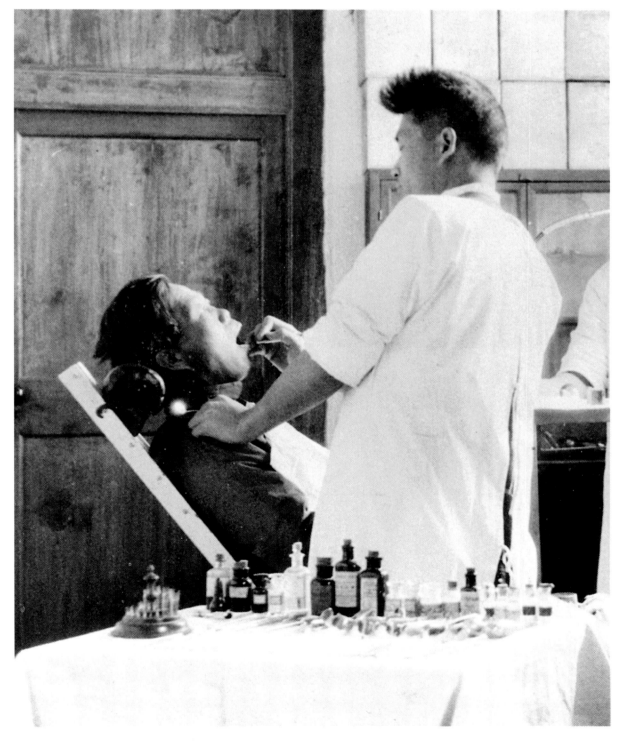

New medicine *(right). By the 1920s, modern dental procedures were being introduced. In 1926, during the Northern Expedition, two Chinese doctors, trained in Western medical practises, relieved Chiang Kai-shek of a painfully impacted wisdom tooth.*

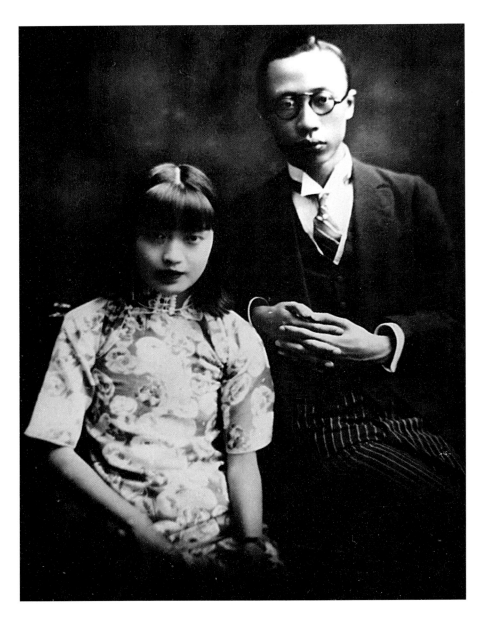

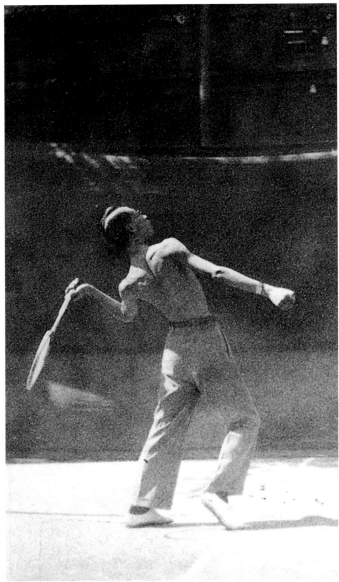

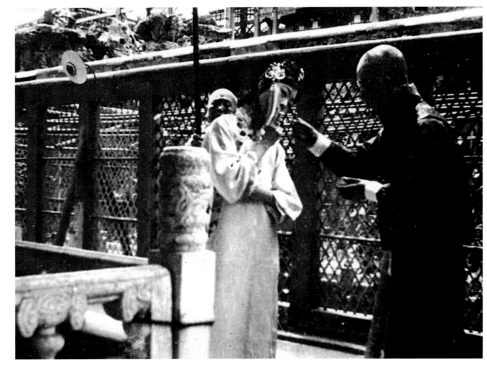

The Emperor modernizes. *In the years immediately after the abdication of the Qing dynasty, the ex-Emperor Puyi lived in traditional Manchu style in the Forbidden City. In 1920, under the influence of his newly appointed British tutor Reginald Johnston, he began to adapt to modern trends: he had his queue cut off by the court barber, he obtained prescription spectacles for his myopia, purchased some Western clothes, learned to ride a bicycle, and even installed a telephone. In 1922, aged seventeen, he was married by arrangement to a young Manchu woman, Wanrong, taking at the same time another Manchu woman as a concubine. According to his autobiography, the marriage was not consummated on their wedding night, and Puyi had no children with either of his consorts. This period, before he and his wife and concubine fled from the palace in the face of hostile troops in 1924, was one of 'intoxication with the European way of life' for Puyi, when he found 'even the smell of mothballs fragrant'. These photographs, which are now in the Imperial Palace Museum in Beijing, are from Puyi's own albums. Three of the photographs show Puyi and his wife, Wanrong, in the Forbidden City, and another catches the Emperor playing tennis. There is even a picture of one of the old personal maids to the former Empress Dowager Cixi taking a turn on the palace swing.*

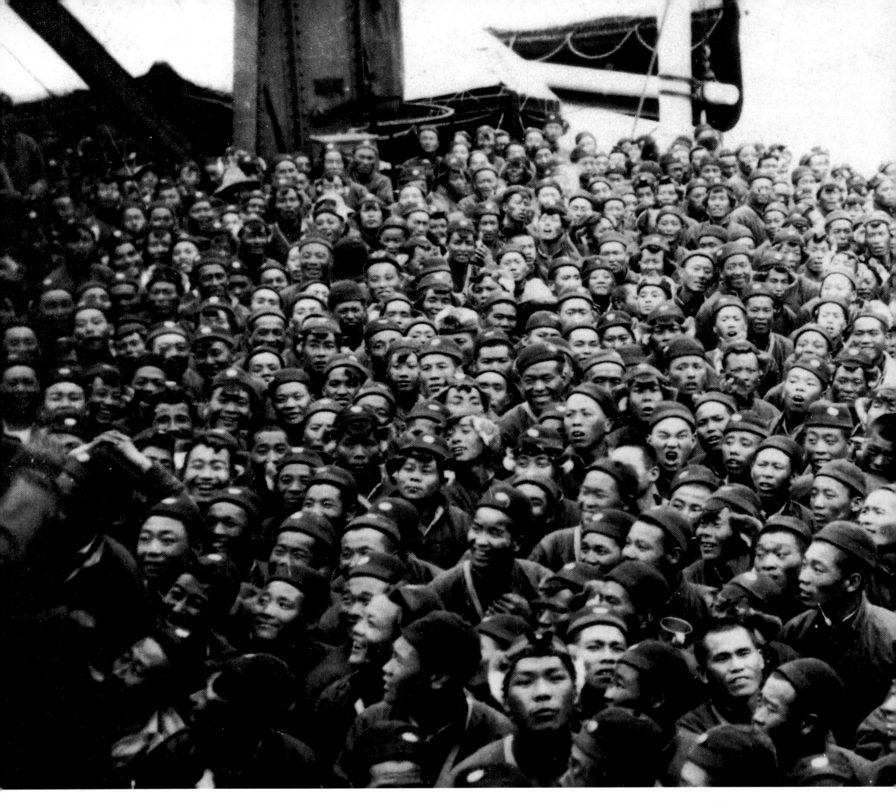

Social-Darwinism — which posited the need for adaptations of social structures to the pressures of the time in order to avoid obsolescence and subsequent extinction — gained a wide currency.

By 1917, building on the popularity of *New Youth* and the prestige of its young, often foreign-educated faculty, Peking University had become the focus of major intellectual debate. Under the alert and generous guidance of its president, Cai Yuanpei, the university showed remarkable courage and initiative in hiring bright young men and women who espoused the new thinking. Cai had experienced Western intellectual ideas through his education in political philosophy in Germany, but he was also a major scholar of traditional learning in the closing years of the Qing dynasty, where he had obtained the highest degree in the

state's Confucian examination system. He used his experience, therefore, to promote the application of new scholarly techniques to the study of China's own culture, and the impressive faculty included experts on classical philology, the inscriptions of the ancient oracle bones, bronze culture and China's literary heritage from the classical histories, through the great poets of the Tang and Son dynasties, down to the seminal novels of the eighteenth century such as *The Scholars* and *The Dream of the Red Chamber*. These complex and intersecting crosscurrents of thought, belief, and social activism came to be bunched together under the general term 'May Fourth Movement', in recognition of the dramatic events that happened on that day in 1919.

In the months leading up to that date, the cultural ferment

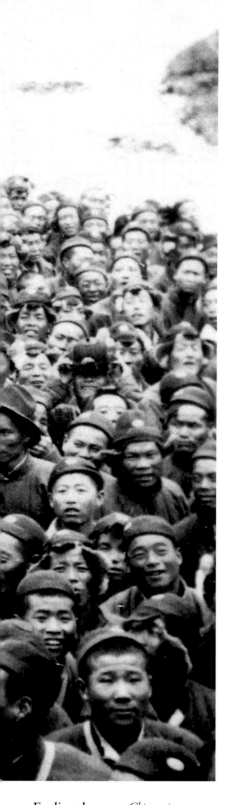

To the Western Front. *Chinese laborers recruited by the British and French (as part of a treaty agreement) leaving China (left). In a completely new development for China, over 100,000 workers traveled to France to help the allied war effort. They were recruited from poverty-stricken Shandong province and promised regular pay and help for their families. They were then stripped, deloused, given I-D tags, and sent off to Europe. The first shipload was sunk by a U-boat in the Mediterranean, killing over 600 aboard, so future shipments were sent across the Pacific, then by rail across Canada and in convoys across the Atlantic.*

emanating from Peking University reacted with international diplomatic manoeuvers and the intricacies and venalities of warlord politics. In August 1917 the Chinese government had officially declared war on Germany. Traditional Chinese diplomacy and foreign policy had rarely reached beyond China's immediate borders and had never tried to intervene in events on the other side of the globe, so this was a major step. By the terms of the declaration, Chinese involvement in the war was to be non-combatant, for Chinese troops were not considered ready for the full horrors of the mechanized battles of the Western Front. But there were other services that the Chinese could render, since by 1917 the British army faced a crisis of manpower.

In taking China into World War I in 1917 on the side of the French, British, and Japanese allies, premier Duan Qirui (himself a former warlord) had a number of hidden agendas. Duan was in a position to ask the Japanese government to make major loans to China ostensibly for the prosecution of the war in Europe. In reality, Duan used the money to strengthen his own northern military base, and advance into southern China with his armies in order to enforce reunification of the country. In return for these loans the Japanese obtained extensive rights to develop railway and telecommunications systems in China, and were granted special concessions in banking, mining, the purveying of military equipment, and unspecified 'rehabilitation projects'. After further loans in 1918, Japan got special rights in the formerly German-dominated areas of Shandong which the Japanese had occupied since 1914, while Duan extended Japan's right to station troops in Manchuria and Inner Mongolia, as well as hiring Japanese military advisers to train his own military forces.

At the Versailles Treaty negotiations in early 1919, Duan's various deals became public, to the intense mortification of the Chinese diplomats there and to the rage of Chinese back home. The upshot was a series of angry and violent anti-government demonstrations in Peking on May 4, 1919, which spread rapidly to other Chinese cities, involving students, teachers, townspeople,

Feeding the guns. *Chinese in France (right), wearing French helmets, unloading artillery charges for propelling large-calibre shells. The Chinese worked as non-combatants in France in 1917-1918. Their jobs included trench digging, burying corpses and wire cutting.*

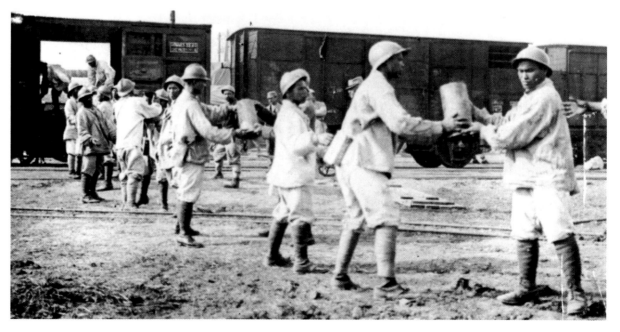

merchants and industrial workers. These demonstrations forced the Chinese delegates not to ratify the Versailles Treaty.

The way the intellectual forces of the May Fourth Movement spread out from the center of Peking to the farther inland provinces is exemplified in the experiences of the young Mao Zedong. Later to be the head of the Communist Party for forty years, Mao was at this time a largely self-taught high school graduate, neophyte writer of radical pamphlets, and manager of a small book shop in the Hunan city of Changsha. Surviving account books from his store show that in a forty-day period in 1920 it sold thirty copies of Bertrand Russell's *Political Ideals*; five copies of John Dewey's lectures, thirty copies of the thought of the anarchist Kropotkin; five copies of *The Coming of Age of Love*; ten of Darwin's *Origin of Species*; dozens of volumes on the Russian Revolution and studies of scientific method; over forty copies of experimental Chinese vernacular verse by Hu Shi, a leading professor at Peking University, and 165 copies of the foremost May Fourth journal, *New Youth*. The total profit from these sales was thirty-five Chinese dollars; the net figure would have been a minus but five of the staff received no wages.

The broad agenda of the May Fourth Movement, as it was now termed in China, was to end warlordism and combine a regenerated form of national politics with a public acceptance of the two central concepts of science and democracy, so as to bring the country in line with Western development. The question was: how to effect this change? Intelligent and worthy men had continued to take part in politics since the assassination of Song Jiaoren and the rout of the Guomindang, but they had found their task virtually impossible. Political change in China at this time was no easy task as the career of the philosopher-activist Liang Qichao once again illustrates. After finally abandoning Yuan Shikai in disgust in 1916, Liang returned to national politics in 1917 when the old national parliament was reconvened following Yuan's death. He accepted the post of Minister of Finance in Duan Qirui's cabinet, ignorant of the secret deals with Japan. He also supported Duan's decision to intervene in the European war. Liang abandoned politics for good only in 1918, devoting the remaining eleven years of his life to study, teaching history and writing.

In these writings, Liang specifically opposed the principles of Marxism, which he found to be narrow, restrictive and stultifying in effect, like late-Qing Confucianism. But though there were others who shared this thought, the tide of the times was running firmly in other directions. For well over a decade before the end of the First World War, young Chinese had been traveling to Paris to study, and socialist and anarchist ideas had become firmly embedded in their thinking. Zhang Renjie, a wealthy Zhejiang businessman, was prominent among these young people. He had served as an attaché to the Chinese minister to Paris in 1902; by 1907 he had become the financial sponsor of a revolutionary magazine and study society in France. Zhang met Sun Yat-sen in 1906, and gave him at least 60,000 Chinese dollars for his revolutionary anti-Qing organizations in 1907. When Zhang returned to China to work with Sun Yat-sen his associates set up a

Corrupt power. *Duan Qirui (right) became premier on Yuan Shikai's death in 1916. He took China into WWI on the side of the allies in 1917. Zang Zongxiang and Cao Rulin (seen above in 1914, standing far left and far right) arranged secret loans for Duan from Japan. In return the Japanese were awarded big territorial concessions.*

May Fourth Movement.
Demonstrators gather in front of the Tiananmen Gate (far right), which was the scene of an uprising on May 4th 1919, after the Versailles Treaty revealed the extent of Duan's corruption and his deals with Japan.
[PHOTO: SIDNEY D. GAMBLE]

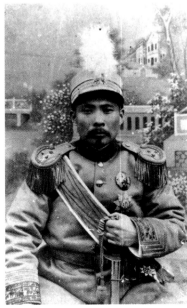

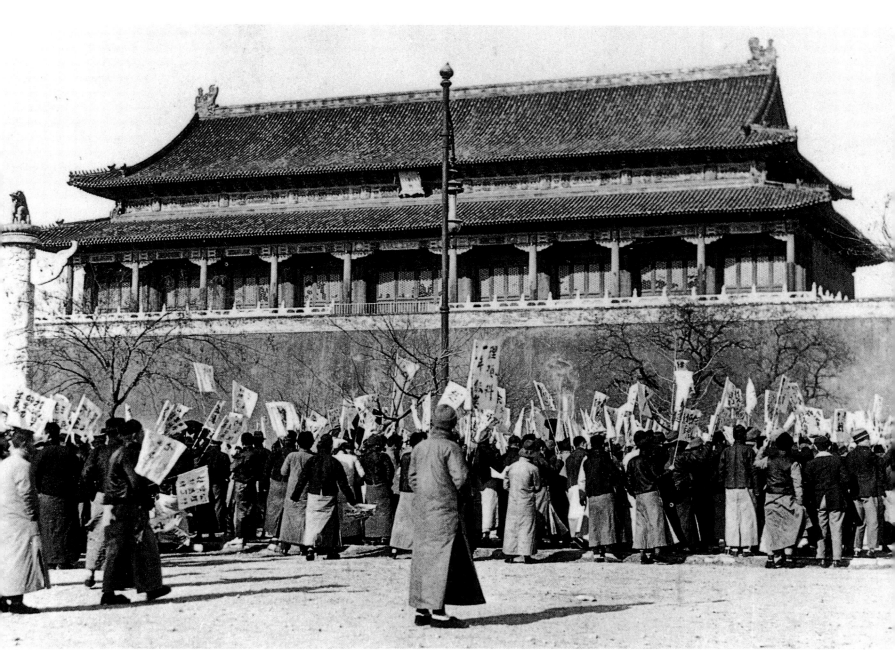

thrift society in 1912 to enable poor Chinese students, after training in French language at a special school in Peking, to study at the college of Montargis, fifty miles south of Paris. When Yuan purged the Guomindang from parliament in 1913, many of Sun Yat-sen's former followers chose to travel to France rather than be with Sun in exile in Japan, and by 1915 they had transformed the society into a work-study program, the Chinese members of which went into French factories to gain labor experience and to help finance their education.

In 1917, the changing economic situation in China had produced a surprising number of volunteers eager to serve in the war against Germany. Over 100,000 Chinese were shipped around the world by boat and train via the Pacific Ocean, the Trans-Canadian Railway and the Atlantic Ocean to help unload Allied vessels in France, to carry supplies to the front, and to help clear the battlefields and trenches of the dead. Two thousand Chinese died there, from German gunfire and bombing, or from disease.

Many others, however, received an education that they would never have had at home. Groups of eager Chinese volunteers — those who had received an education in the United States or Europe — came to work among their fellow countrymen and to teach them reading, writing and industrial skills.

The numbers of Chinese in France at this time — which included several hundred students, and 100,000 or more workers — were augmented by at least 1,000 more Chinese students who had been radicalized by the events of May Fourth and the burgeoning Marxist study groups. Many of this new group, which included newly emancipated female students, met French radicals and were inducted into the Communist Party. When they returned to China in the 1920s, these students became active members in the Chinese Communist Party which had held its first central committee meetings in 1921. Among them were key figures in the Party's later history: Li Lisan, who headed the Party during its most difficult days in the late 1920s; Zhou Enlai and Chen Yi,

In search of the new. *Chinese women (above) departing to study in Japan, their dress a mix of traditional and Western styles. Japan hosted many groups of Chinese students, attracted by its progressive blend of traditional Eastern values and modern Western methods.*

The Ancien Regime. *An aristocratic old woman in silken robes, with bound feet, cigarette in holder and lady's maid to attend her, sits on a copper incense burner watching the presidential review in Peking, to celebrate Armistice Day, on November 13, 1918.* [PHOTO: SYDNEY D. GAMBLE]

death in an attempt to rebuild his shattered political base. He was to be one of their allies in fomenting socialist revolution.

Sun Yat-sen had begun to show interest in socialist ideas in the late 1890s, when he had traveled to Europe during his first exile, and read much of the current socialist literature. His ideas had been sharpened by Japanese socialists during his second exile after 1913, and perhaps they were also refined by his knowledge of the American labor movement, which had developed a sophisticated organization, whatever its antipathy for the rights of Chinese workers in the United States. Socialism's potential for arousing mass levels of support was all the more important to Sun after 1920, when he was trying to establish a regime to rival Peking, either in Shanghai or Canton, so he could renew his bid for national reunification. However, he was desperately short of funds, had too few experienced organizers or administrators to help him and lacked his own effective military machine. Thus, Sun was initially forced into a series of alliances, or humiliating dependencies, with whatever warlords controlled the area in which he happened to be.

The Comintern agents and other Soviet negotiators, when they finally made contact in 1922, cleverly did not offer him some subservient role under Communist leadership. Rather, following the lines laid down by Lenin and his advisers, they suggested a kind of coalition under Sun Yat-sen's own leadership. As head of the Guomindang (which he had now reorganized and reintegrated for the third time in less than a decade) Sun would be free to pursue the dream of his own political system. This he had been rationalizing under the term 'Three People's Principles', his own unique and eclectic formulation, in which he tried to utilize the key values of democracy, socialism, and anti-imperialist nationalism in the interests of national strengthening and union. Since Comintern policy supported indigenous nationalist movements as long as they offered promise of being anti-imperialist and anti-feudal, Sun received major support, in the shape of both funds and arms from the Soviet Union, which were sent by sea to Canton, along with the services of Soviet military experts. The Comintern decided that the members of the small but energetic Chinese Communist Party would work under Sun's banner, along Marxist-Leninist lines, combining their own anti-feudal and anti-capitalist ideology with Sun's, and forming both worker and peasant bureaus. To the triple thrust aimed at industrialists, warlords and wealthy landlords, they would add one more component: an anti-imperialist struggle, which would attempt to reclaim national sovereignty for the Chinese by ending the special privileges for foreigners.

By 1923, under an energetic and effective Comintern agent know by his code-name, Borodin, this new 'United Front' was fully operational, with Canton as its heart. Joint Communist and Guomindang teams were working in the surrounding countryside to form 'peasant associations' and encourage the struggle on the land. Though Canton was not itself a major industrial city, Communist labor activists were deeply involved just down the river in Hong Kong, where they had helped to lead a major seamen's strike. They were working to increase their strength in the key

who became major labor leaders in the 1920s, and loyal associates of Mao Zedong after he obtained power in 1935, until his death in 1976; and Deng Xiaoping, who was only sixteen when he went to France in 1920. Deng was destined to guide China's economic regeneration from the time of Mao's death until the 1990s.

These 'returned' students on their own would probably not have had the power to build up an effective Communist Party and, through organizational inexperience, would almost certainly have been swiftly rounded up by the various warlords and executed. But their time in France overlapped with the crucial decision, made by Lenin in 1919, two years after the Bolshevik revolution, to dispatch a group of Soviet organizers via the international arm of the Party, the Comintern, to China. These Comintern agents traveled first to the Peking region. They included a Russian, a Dutchman and at least one Chinese and recruited their first members from leaders of the Peking University faculty who had sponsored the early Marxist study groups, and had been prominent in the May Fourth Movement. Moving on to heavily industrialized Shanghai, they made contact with the former Dean of Peking University and the current editor of *New Youth*, Chen Duxiu, who was at once attracted to the clarity of the Comintern's revolutionary message, and to the agents' organizational skills. With Chen's help, they began to search among the labor organizations for activists who might provide leadership in a new Chinese Communist Party, which held its first full meetings in 1921. And, equally importantly, they fastened on Sun Yat-sen, who had returned to south China in 1917 after Yuan Shikai's

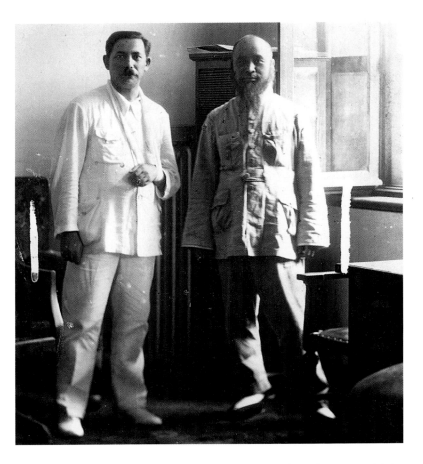

Borodin (left). The Russian Comintern agent known as 'Borodin' (seen standing on the left), helped Sun Yat-sen to organize the Communists and the Guomindang into the first United Front. A contemporary visitor, Milly Bennett, was much taken by this 'great big, handsome and impressive man.' She wrote later, '[when] I worked with him in Hankou, Borodin's dark and glossy hair and walrus mustache showed no threads of silver. His skin was fair. There was nothing of the conspirator in the direct, friendly gaze of his brown eyes…[he] was calm, he was benign…he could be moody, melodramatic, witty…and he had the gift of gab. He had a remarkable memory for names and for faces, and he liked people, especially Americans. He was a man to capture the imagination and the heart as well.' [PHOTO: MILLY BENNETT]

Leaders of the Guomindang (right). In a rare photograph, Sun Yat-sen addresses the cadets of the new Whampoa Military Academy in June 1924, under the white star of the Guomindang. He is attended by key members of his party: his wife, Soong Qingling, is to his left and Chiang Kai-shek to his right. Chiang had just been appointed commandant of the Academy after returning from the Soviet Union. In the white suit, holding the straw hat, is Liao Zhongkai, friend of Sun and Chiang's main rival after Sun's death. Liao was assassinated in 1926. The Academy became Chiang's power base and many of its cadets remained his closest supporters for the next twenty years.

industrial cities of Hankou and Shanghai, for these would be crucial stepping stones on any move towards the north.

Militarily, the Comintern fulfilled its promises. Shiploads of arms and ammunition arrived and an effective military training school – known as the 'Whampoa Academy', from its location on the island of Whampoa in the Pearl River, south of Canton – was established with Soviet help. Here, young recruits were given a rigorous course of military training and political indoctrination. The military training was supervised by the Russian advisers directed by Galen, hero of the Soviet victories over the White Russians in the hard-fought Siberian campaigns, and by a newly emerging power on the Chinese political scene, Chiang Kai-shek.

Chiang, born in 1889, was typical of the new group of restless Chinese nationalists. He came from a Zhejiang commercial family and, like many of his contemporaries, received his military training at an academy in Japan, then joined the revolutionary alliance of Sun Yat-sen in 1906. Commended for his part in the fierce fighting around Shanghai in 1911-1912 in the armies of the revolutionary nationalists, Chiang Kai-shek also became a close associate of Zhang Renjie, who had built up the student societies in France and been such a providential supporter of Sun Yat-sen. Through Zhang's sponsorship, Chiang came to the personal attention of Sun, following him into exile in Japan in 1914, and later joining him in Canton in 1918. Sun dispatched Chiang to Moscow in 1923, to meet Comintern leaders, inspect military training schools and study party political organization. It was after this trip, in 1924, that Sun named Chiang head of the Whampoa Academy. Chiang directed the training of a whole generation of

China's future military leaders, from which were to come some of his most loyal supporters in his later political life.

The Whampoa cadets were not taught only Sun Yat-sen's ideology: there were also several Communists in the Academy, the most important being Zhou Enlai. Active in the earliest Marxist discussion societies in Peking University during the May Fourth year of 1919, Zhou had been jailed for a time by the Tianjin police for anti-Japanese activities and, after traveling with the work study group to France, joined the Communist Party there in 1921. In 1922, he was present, with Li Lisan, at the inauguration of the first branch of the CCP in France. In 1924, in accordance with the new United Front policies, Zhou Enlai was also active in founding the first French branch of the Guomindang, in Paris. Later that year, now aged twenty-six, he returned from France, and was named deputy political commissar at Whampoa under Chiang Kai-shek. Ross Terrill makes the point that,

Zhou was many things that Mao was not: easy going, dashing, gregarious, a conciliator…Raised in a household of books and gentility, Zhou had stepped down the social ladder to join the revolution as an act of moral choice.

Both foreign and Chinese politicians' attention continued to be focused not on Canton but on the shifting battles among warlords for control of the government in Peking. Besides Canton was not the only center of radical activity. Sometimes working with the Guomindang, and sometimes alone, the Communists fomented a number of major strikes in Shanghai, many of which ended in

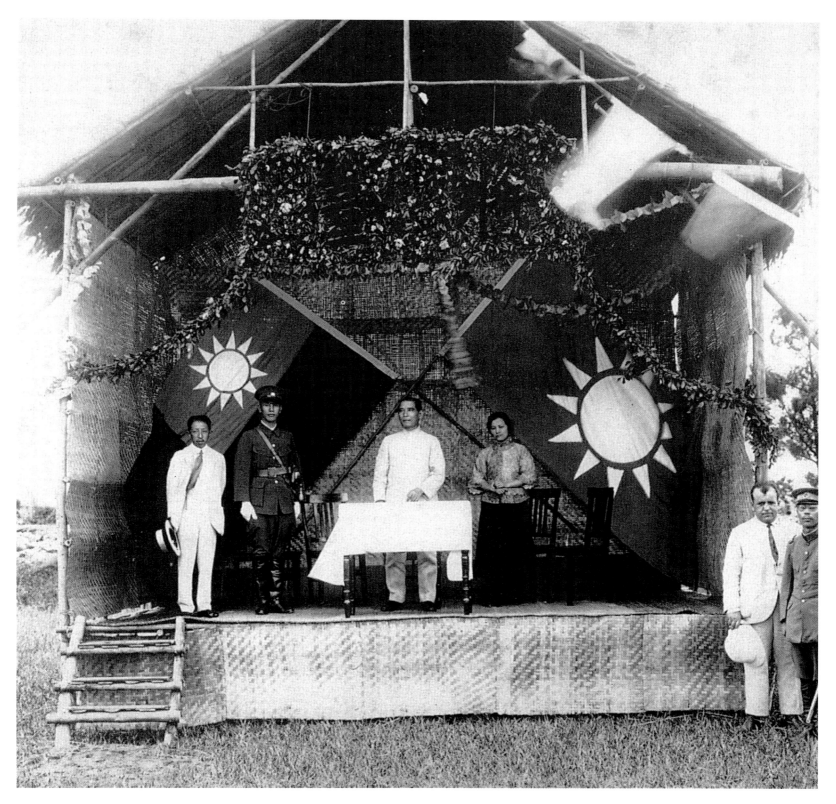

violent repression. In north China, railway workers attempted to close down one of the railways controlled by a powerful local warlord who depended on it to move his troops swiftly in response to the political and military shifts in Peking. He had the union leader beheaded, and his head hung on the station platform. Thirty-five other workers were killed, and many wounded.

In rural China too, reform strategies were not all coordinated and controlled from Canton. The earliest attempt at land reform, indeed, was undertaken up the coast from Canton, by Peng Pai,

the son of a local landlord. In 1923, Peng helped farmers to form associations to foster public health, education, and advanced agricultural skills. He also encouraged them to struggle for rent reduction, and to form local forces to protect their families and homes if the landlords should move against them. The landlords did indeed strike back, and Peng Pai had to abandon his experiment. But the attempt gave useful indications of how the Communists might seek to garner the peasant support which was to become central to the course of China's revolution.

CHAPTER FOUR

ALLIANCE
AND PURGE

BY LATE 1924, SUN YAT-SEN HAD ACQUIRED GREAT prestige as one of China's most tenacious political leaders, and as a man with an overarching vision for the future of his country. Sun relied on his own family to help him maintain power — especially on his son from his first marriage, Sun Fo — and on the family of his second wife, Soong Qingling. Sun Fo, born in 1891, was at the University of California in 1911 when the Chinese revolution erupted, and his father ordered him to finish his studies before embarking on a political career. Only in 1917, after a follow-up MA in Economics at Columbia University in New York, did Sun Fo return to China. He was subsequently named mayor of Canton, which he served with distinction, bringing in new roads and utilities. He also helped his father draft the regulations and the constitution of the newly reorganized Guomindang Party.

Soong Qingling was a beautiful and intelligent woman, twenty-six years younger than Sun Yat-sen, and one year younger than her stepson Sun Fo. She was the daughter of a wealthy merchant and industrialist who had been a backer of the Guomindang since the late Qing. After attending college with her sisters in the United States, Soong Qingling served as Sun's secretary during the early part of his exile in Japan and they married in 1914, returning to China together in 1916. Her own political views tilted to the more radical wing of the party, to what many called the 'Left Guomindang', but Sun clearly cared for her deeply, and trusted her absolutely in political matters. Their closeness was increased during the dangerous days of 1922, when their Canton home was surrounded by the forces of hostile warlords. Qingling helped her husband escape safely to a gunboat on the river, while she herself remained at home to deflect his pursuers. Thereafter she was constantly at Sun's side, and was with him when he died. Perhaps because of this intense relationship, Sun Yat-sen gave similar trust to Qingling's younger brother — known generally as T. V. Soong — an able and polished graduate of Harvard, whom Sun appointed director of the finances of his revolutionary Canton government.

The power of Sun's new army was growing slowly, and the political organization of the Guomindang was being strengthened with the help of his Comintern advisers, but despite these advances, his own base at Canton was weak. He was threatened by three groups, the first being the wealthier citizens and merchants of Canton city, who resented the presence of revolutionary forces in their midst, and the constant taxes and exactions that were levied on them by the Guomindang administration. In 1924, the merchant associations of Canton rose in revolt against the demands of the Guomindang, and occupied much of the city with their own armed militia. After fruitless bargaining, Sun ordered Chiang Kai-

Rounding up the usual suspects. *In the late 1920s and early 1930s leftist sympathisers were regularly arrested by the police, as Chiang Kai-shek and his allies turned against the Communists. In this photo, taken in 1931, traditionalists and those who had embraced Western ways watch the result of one such police swoop from the comfort of their rickshaws in Shanghai. Chiang had modernized the Shanghai municipal police in the late 1920s, giving them better pay and training and a modern communications system. He also made sure they were indoctrinated into the ruling Guomindang's ideology. The left had a considerable force arrayed against them. As well as the municipal police there were Chiang's military and security police units, police and detectives from the International and French concession areas and many foreigners who were happy to collaborate with the Guomindang. Those arrested had little sympathy from Chinese courts or military tribunals, and many were sentenced to summary execution.*

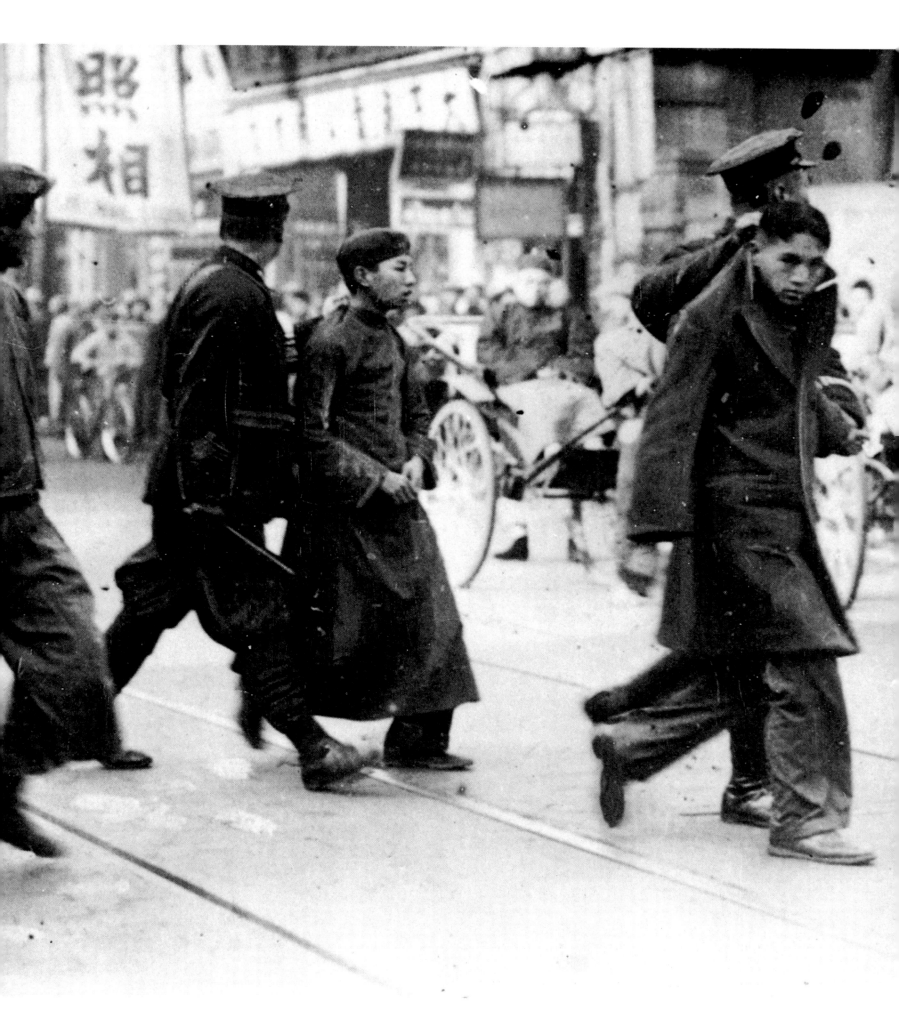

The last journey of Sun Yat-sen.
In March 1925 Sun Yat-sen died of cancer at the age of fifty-nine. His body was embalmed and temporarily laid to rest in a temple in the Western Hills of Peking. Four years later, it was taken south on a funeral train (right), decorated with the flag of the Guomindang Nationalist Party he had founded, to a specially constructed mausoleum in the hills above Nanjing – chosen by Chiang Kai-shek as the new capital of China. All his life Sun had worked to unite China, and was in the middle of peace negotiations to end the civil war when he died. In his last will he urged China and the Soviet Union to 'proceed hand in hand as allies in the great fight for the emancipation of the oppressed'.

Sun's work lives on. *Sun Yat-sen's widow, Soong Qingling (left), was only thirty-three when he died. Throughout their eleven-year marriage she had worked closely with him, and after his death she became leader of the Guomindang's left-wing faction in Hankou. She was reported to be strongly opposed to the marriage of her younger sister, Soong Meiling, to Chiang Kai-shek; Chiang's anti-leftist purges in 1927 forced Qingling to leave China for Moscow, but she returned for Sun's state funeral in 1929. After the Communist victory in 1949 she stayed on in the new People's Republic, while her sister Meiling moved to Taiwan.*

shek to lead the new army and the first class of the Whampoa cadets against the merchant militia. After fierce fighting, Sun's forces succeeded in disarming them but it was certainly ironic, and reminiscent of the darker sides of warlordism, that these cadets' baptism of fire was to shoot at civilians in their own city.

The second threat lay within the Guomindang party itself, not so much from the Communists, who were tied in alliance by the United Front and by their obedience to Comintern orders, but from a factional group that might generally be termed 'the right wing', which included some of Sun Yat-sen's earliest supporters. These men shared Sun's dreams of a strong and united China, free from warlord dominance and the economic pressures of the foreign powers, but they resented his dictatorial control of the party organization, and deeply distrusted the alliance with the Communists. This distrust was partly ideological, but was also based on practical considerations, since many of them were from wealthy landholding or industrial families, who would suffer from any assertion of Communist power. Several of them felt that they were the natural successors to Sun, who was now in his late fifties and appeared frail and ill.

The third opposition group focused around the warlord who controlled Canton, Chen Chiongming. Like many other warlords, Chen had been educated in westernized schools and had been an early revolutionary follower of Sun Yat-sen. He had established

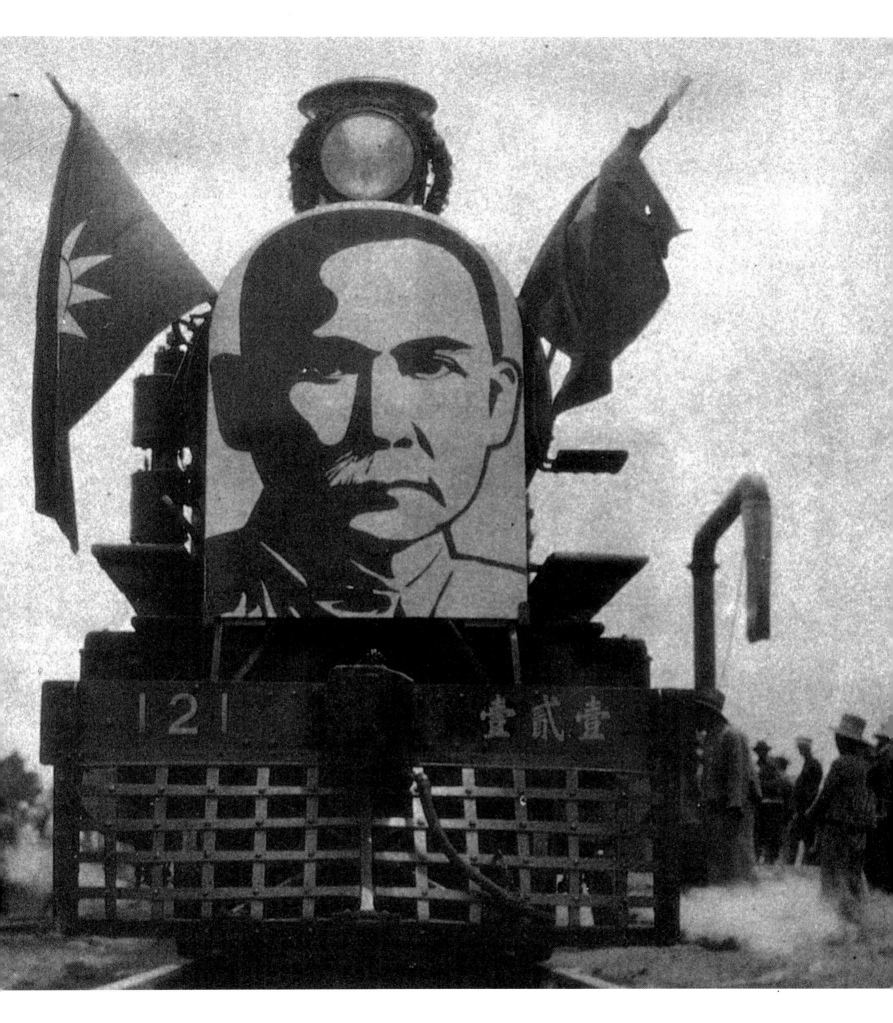

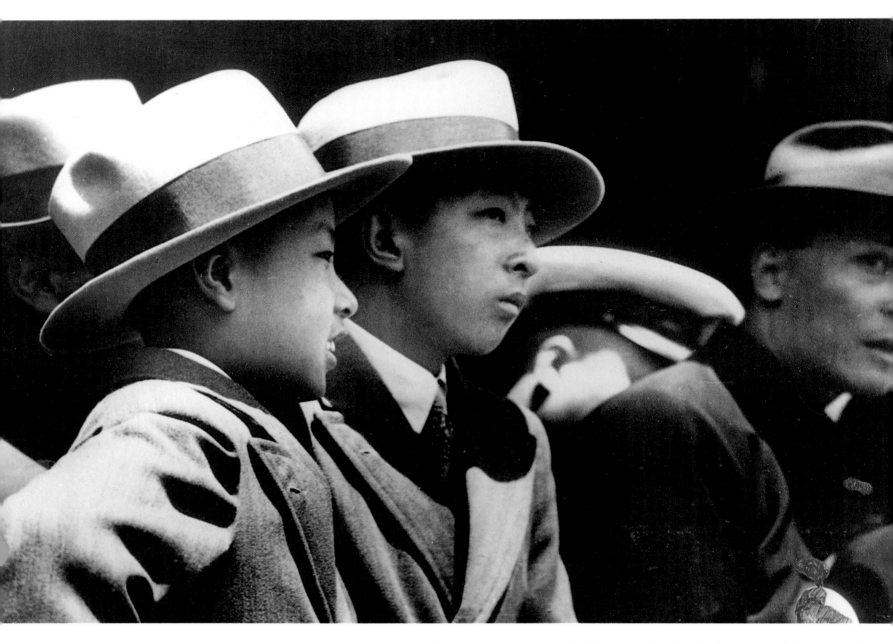

himself as military governor of the Canton region after the outbreak of the 1911 Revolution, a position later confirmed by Yuan Shikai. In 1917, Chen had seemed a sincere backer of Sun but his own ambitions proved too great and, by 1921, Sun forged alliances with certain other warlords in western Guangdong and Guangxi to try to counter this potential military menace. These warlords' troops were also of uncertain loyalty, and might always shift allegiances if not adequately paid.

In late 1924, Sun Yat-sen attempted to avoid a major military campaign by traveling to Peking to meet the political leaders there. This venture was full of risks and uncertainties. Peking in the early 1920s was controlled jointly by the former premier Duan Qirui, who now called himself the 'Provisional Chief Executive of the National Government', and by the Manchurian warlord Zhang Zuolin, whose troops occupied the city. As Sun tried to persuade them to include representatives from worker, peasant and merchant groups in their deliberations, he was stricken by illness. An examination at the new modern hospital attached to the Peking

Union Medical College revealed that he had inoperable cancer of the liver, which had already spread to other organs. Undeterred, Sun insisted on continuing with the unification talks, but his health was not up to the task. He died in Peking on 11 March 1925, at the age of fifty-nine, after dictating a brief will to Wang Jingwei, urging the Guomindang followers to pursue his goals for national reunification.

Less than seven weeks after Sun's death, a series of events occurred that galvanized the left in China, and brought a new upsurge of nationalist feeling. Towards the end of May, a group of Chinese workers who had been locked out of their factory by their Japanese owners during a strike, broke into the plant and smashed some machinery. Japanese guards opened fire and killed one of the workers. On May 30, a huge protest demonstration assembled in Shanghai, but as it advanced down one of Shanghai's busiest streets en route to the Bund they were fired on by Sikh police under British command, and eleven demonstrators were killed. The victims became known as the May 30th Martyrs, and in June of

The privileged few. *These two elegantly dressed boys (left) are the grandsons of the Manchurian warlord Zhang Zuolin. Their father, Zhang Xueliang, was an important commander of the armies of northeast China. For such children there was the prospect of affluence and influence. But the life of a warlord was insecure, and many died violently. Zhang Zuolin was blown up by the Japanese; Zhang Xueliang was addicted to morphine for many years, and his political career ended when Chiang put him under permanent house arrest.*

Disputed succession. *After Sun Yat-sen's death, among the main contenders for leadership of the Guomindang were Hu Hanmin and Liao Zhongkai. Liao was a political activist of the left. His murder (far right) in the late summer of 1925 was believed to have been carried out with Hu Hanmin's knowledge (right). Hu became the chairman of the new Nationalist government in Nanjing, and ordered the arrest of Wang Jingwei and other Communist leaders in Hankou. Wang made peace with Chiang, however, and Hu's ambitions were frustrated. He toured Europe in 1927, returned to China a year later but never obtained absolute power. He died of apoplexy in 1936.*

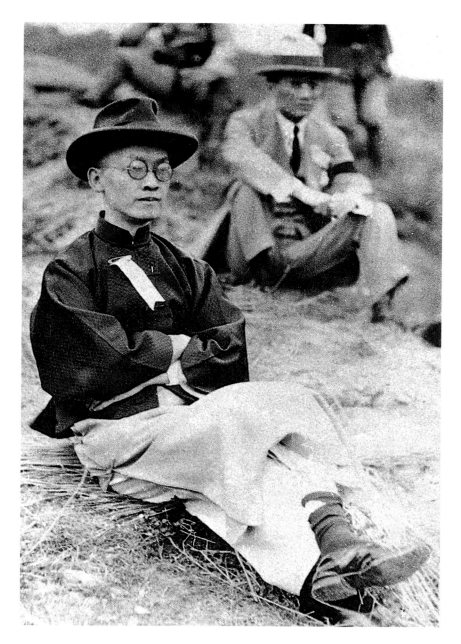
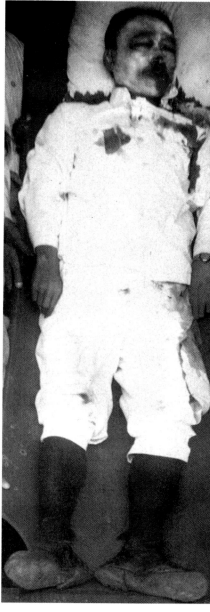

the same year crowds in Canton assembled to protest at their deaths and salute the major strike that had just broken out in Hong Kong. Again, the British police opened fire, this time killing fifty-two Chinese. As news of the three outrages spread across China, the pulse of anti-imperialist anger quickened, and the Communist Party increased its efforts to attract a mass following of the aroused students and industrial workers. The Guomindang faced a quandary: if they waited too long, the Communists might grow too strong to be curbed; if they acted precipitately, the United Front armies might be routed in battle with local warlords, and the Guomindang would be destroyed as an effective political force.

In the wake of these dramatic events, the possible successors to Sun Yat-sen jockeyed for position. The most powerful contender seemed to be one of Sun's earliest lieutenants, the wealthy, San Francisco-born Liao Zhongkai, who had first met Sun in Japan in 1903, in the early days of planning for the revolution. Because of Liao's perfect English, Sun had used him to translate certain key

socialist works that he wanted to study in Chinese. Liao's courage and ingenuity in traveling secretly to north China during 1906 and persuading the French military attaché there to furnish confidential information on the Manchu military forces, had further won Sun's respect. This bond was reinforced by Liao's Hong Kong-born wife, He Xiangning, a talented painter who became the first female member of Sun Yat-sen's Revolutionary Party, and later director of the Guomindang's Women's Department. Liao himself became the main architect of the Guomindang-Communist alliance, the supervisor of finances and the governor of Guangdong province, and a director of the Whampoa Academy. Liao was also a formidable labor organizer, and an expert in the Leninist style of party organization introduced by the Comintern. But, in August 1925, as he stepped out of his car to attend a central executive committee of the Guomindang in Canton, Liao was assassinated. Though it was not proved, there was a general suspicion that another key lieutenant, the much more conservative Hu Hanmin, had been behind the act.

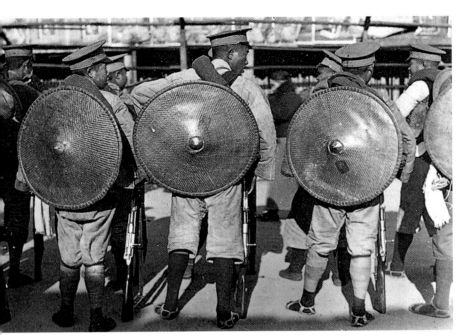

Hankou in 1927. *Left-wing Chinese Nationalists of the Northern Expedition established their base there aided by troops from the south who still retained their traditional broad-brimmed straw hats.* *Foreigners mistook these for shields, contemptuously believing they were evidence of the primitive state of China's forces. That summer, Chinese crowds attacked the foreign concession area of Hankou (right).*

Under pressure, Hu resigned his party positions and left Canton. Wang Jingwei who was firmly aligned with the left-wing factions of the Guomindang, appeared to be left in undisputed control. But, in March 1926, Chiang Kai-shek declared that an armed attempt by leftist forces was being directed against the Guomindang, and troops loyal to him arrested many of the leading Communists in Canton, along with their Comintern advisers. The alliance was resumed, and the arrested people released, only when the Communists agreed to register their members with the Guomindang, abandon many of their committee positions and curb the power of the Comintern advisers. Finding this situation untenable, Wang Jingwei left for France on an extended furlough.

Chiang now had unchecked control of the Guomindang armed forces, and he decided to use them to achieve what Sun Yat-sen had failed to gain by peaceful means. There was much opposition to his military campaign to reunify the country, known as the 'Northern Expedition'. Many members of the left wing of the Guomindang, and the Communists, thought the expedition premature, but in July 1926 the plans were completed, and the armies were grouped under the supreme command of Chiang Kai-shek. Though the later stages of the campaign were left unclear, the first phase called for a rapid drive through Hunan province to attack the northern warlords across the Yangzi River in Hubei.

The Guomindang success was astonishing, and surprised even the optimists amongst them. In early August the troops captured the key Hunan city of Changsha, overcoming a number of regional military forces. In September, the Northern Expedition armies

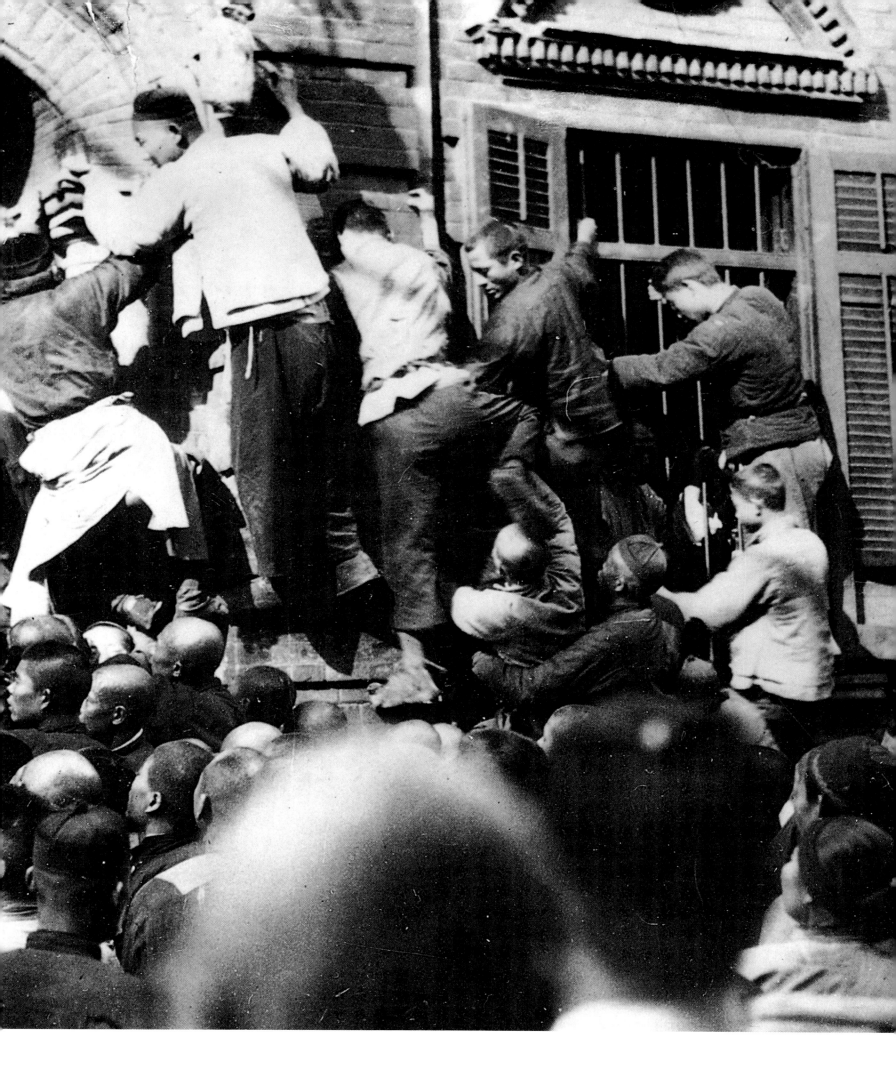

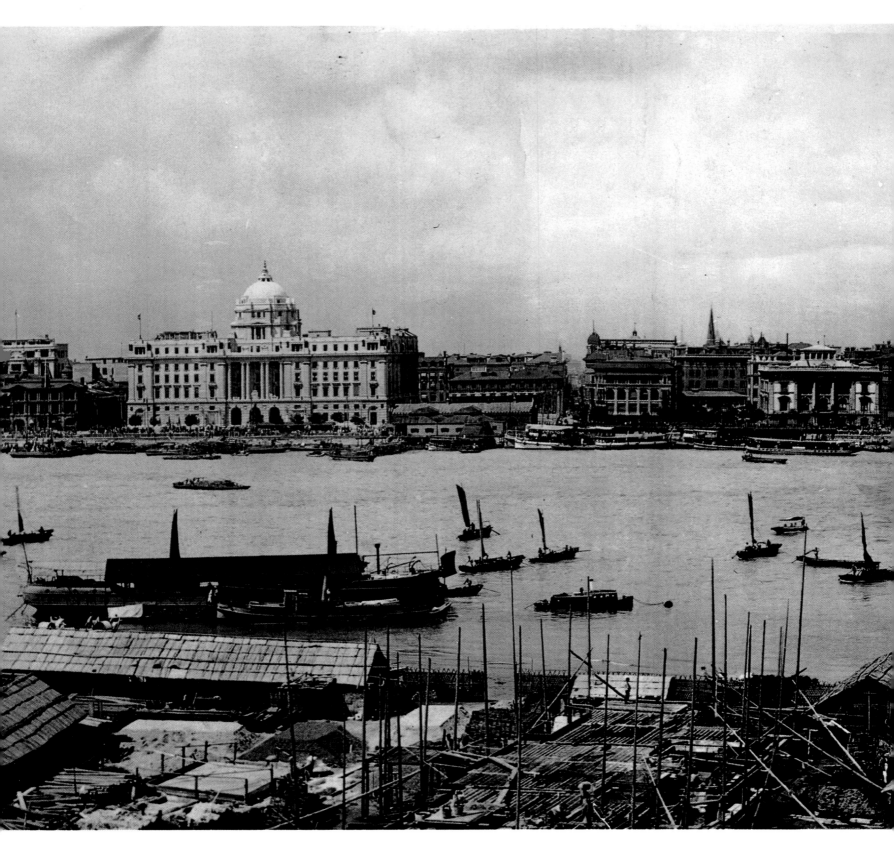

captured the industrial city of Hankou, and on October 10 seized Wuchang, fifteen years to the day since the 1911 revolution erupted in the same city. In November, Chiang's troops captured Nanchang, in central Jiangxi, and there he paused with his main armies, to assess the situation. If Peking was the eventual goal, Chiang had now to consider three options: to continue the drive northward from Hankou, building on the political support of the

industrial workers there; to make a temporary base in Nanjing, site of the republicans' brief moment of victory in late 1911 and early 1912; or to advance on Shanghai. There were strong arguments for each course of action, but he decided to take Shanghai. Shanghai, by 1927, was known around the world as China's largest, most cosmopolitan, most industrialized and most crime-ravaged city. Chiang Kai-shek was undoubtedly mainly attracted to

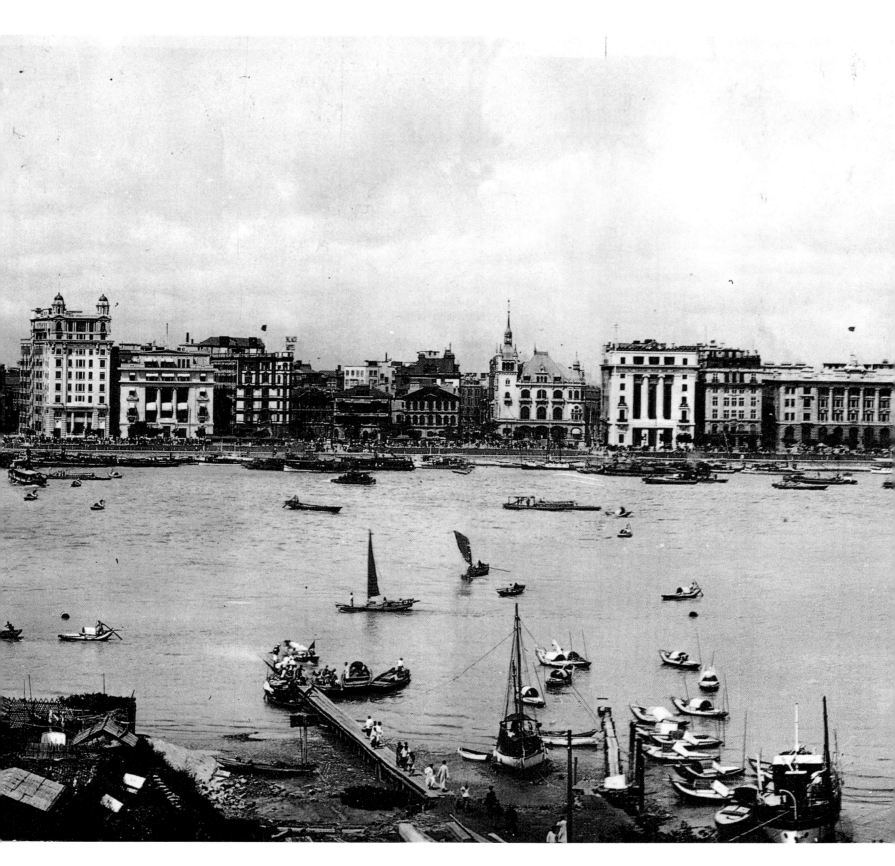

the city because it promised to be a major source of funds for his large armies if he could exploit its great resources skillfully. But the extraction of wealth from Shanghai, whether by taxes, confiscation, or other means, was bound to be full of difficulties. Not only had much of the city been controlled for years by tough and independent warlords with no particular sympathy for the Guomindang, but the two largest sections of Shanghai not under

their thumb were controlled by the foreign powers; one was known as the French Concession, and the other as the International Settlement. These two areas, formed by Chinese treaty agreements with the foreign powers dating back to the 1860s, and expanded several times since then, were administered by governing committees of foreign residents, and subject to the laws of various foreign nations. They operated their own tax systems and

Symbol of Western power (*previous pages*). *The Shanghai Bund was built on undeveloped farmland, obtained by treaty in the 1840s. It hosted a proud and rich mixture of banks, clubs, shopping centers and hotels, all protected under British law. Behind it lay the tree-lined streets where the Westerners lived.*

Western ways. *More than any other Chinese city, Shanghai bore witness to the inroads made by Western culture. For the rich, lines of chauffeur-driven limousines (above left) and taxis replaced the man-powered rickshaws. Magazines began to extol the charms of a new generation of 'dance-hall queens', such as the girl pictured bottom left with modish hairstyle, book in western-style binding, and cigarette. The girl with the sunshade is a star from the Shanghai film studios.*

Painting out the old. *Art students returned from France. bringing with them new techniques, new ideas and a new morality. Under the Qing dynasty, to paint from live female models was not only illegal, it was unthinkable. But by the late 1920s, it was possible for art students from the western painting department of the Shanghai Institute (right) to pose for the camera with their nude female model in their midst.*

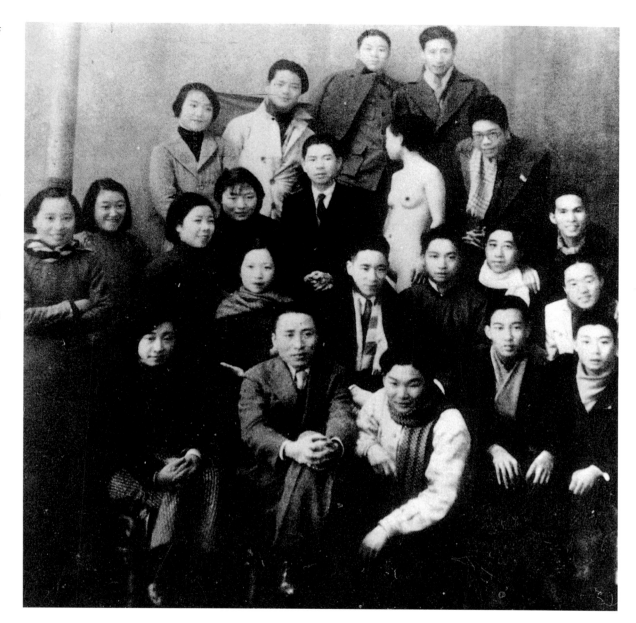

maintained their own military, naval and police forces. They supervized city planning in their areas, and monitored real estate development. They ran power plants, provided parks, sanitation and street lighting, and directed a huge range of social services, from schools and libraries to hospitals. They controlled the elegant track for horse racing, which was one of the social centers of city life, and greyhound racing tracks, the scenes of heavy gambling. They also licensed and patrolled hotels, casinos, dance halls and brothels. Their vast business offices lined the stretch of Shanghai riverfront known as the 'Bund', and their beautiful homes and landscaped gardens stretched over hundreds of acres, while their web of roads reached ever deeper into the surrounding countryside.

Over the first quarter of the twentieth century, ever-growing numbers of Chinese had moved to these concession areas, seeking to benefit from their amenities and their legal systems which offered protection from arbitrary arrest or exactions. By the 1920s, around a third of a million people lived in the French Concession, of whom 12,000 were foreigners; the International Settlement held around three-quarters of a million, of whom over 30,000 were foreigners. These were surrounded by the huge, sprawling Chinese-administered city and industrial suburbs of Shanghai, with about one and a half million inhabitants, almost all of whom were Chinese.

At night, the wealthier sections of Shanghai were ablaze with neon lights. Above the constant din of cars and electric trams, one could hear the warning cries of the city's thousands of rickshaw pullers, as they tried to weave their way through the crowded streets and alley-ways. Since the early 1920s, developers had built up immense entertainment centers, where restaurants offering every regional cuisine, and shops jammed with merchandise, drew thousands of diners, shoppers, and idle strollers every day, making the centers' owners among the new breed of millionaires. Nightclubs were lively and garish, their floors crammed with foreigners and the new-rich Chinese entrepreneurs, who danced to Western bands playing swing or jazz. Cinemas were showing the latest Western films, along with the products of China's own nascent film industry, most of the studios for which were also in

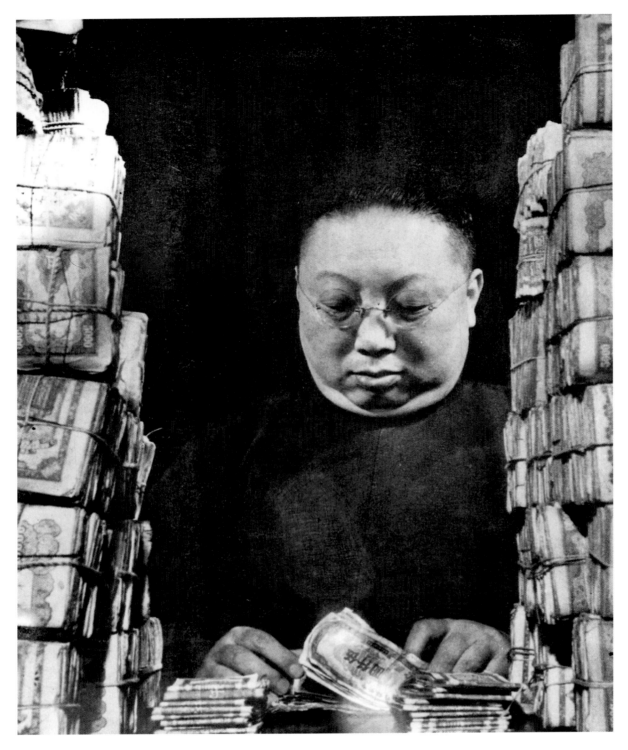

New wealth, old poverty. *Virtually every visitor to Shanghai was appalled by the vast contrasts between the lives of the rich and the poor. The modern banking system established by Sun Yat-sen's and Chiang Kai-shek's brother-in-law, T. V. Soong, and the Nanjing government of the Guomindang, had brought a measure of financial order. The industrious and the criminal could now safely salt away their hard-earned or ill-gotten gains. But, for the desperate refugees from the famine stricken countryside, death on the streets from hunger or cold was the most likely future.*

Shanghai. Estimates of the numbers of prostitutes in the various areas of the city ran as high as 100,000, ranging from the luxurious few who rode to their clients' homes in their own limousines, down to the desperate country women who offered their services in temporary sheds to working men or migrants for a few coppers.

Contrasts between extreme wealth and poverty were omnipresent. Sprawling hovels and mat sheds sheltered the unemployed and the refugees from famine or warlord battles. They lived in misery and died unnoticed. An estimated 20-30,000 dead bodies were collected from the streets each year by the municipal sanitation teams, and in the depths of winter they might find as

many as 400 corpses in a single day. Many of the dead were children.

The problems of the city were compounded by the power of the criminal organizations. They controlled much of Shanghai's gambling and prostitution, ran protection rackets, and monopolized the distribution and sale of narcotics, especially opium. The biggest was the Green Gang, which was first formed in the Qing dynasty by coolie laborers and boat-pullers who worked on the canals and waterways. By the 1920s, it was a large and tightly controlled organization with tens of thousands of members. Its powers were vastly enhanced by the infiltration of members into the police and detective divisions of all the areas of

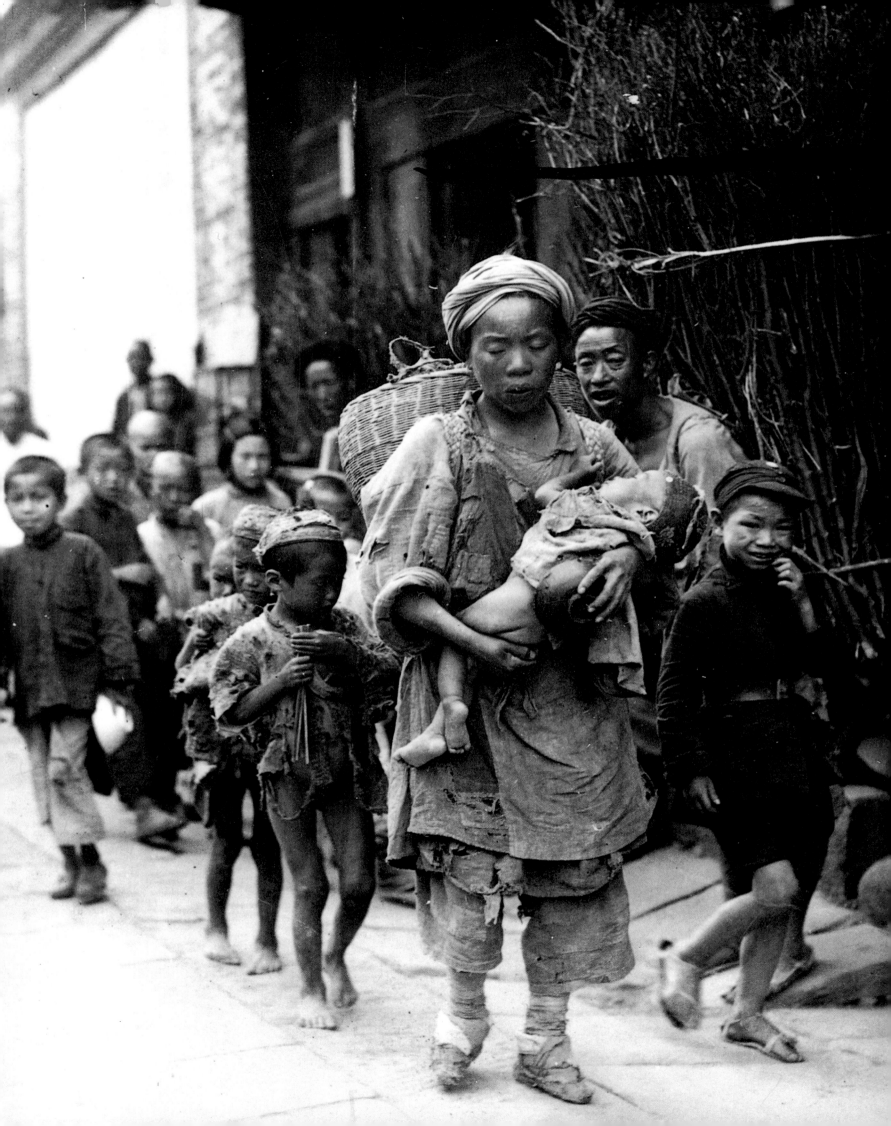

the city. A Green Gang member was the chief of detectives in the French Concession, who thus had access to crucial sources of personal and financial information. The stakes in this shadowy world were colossal: besides the money to be made by those who controlled the brothels and the casual prostitutes, which cannot be ascertained, gambling profits were estimated at 1,000,000 Chinese dollars a week; the profits on narcotics sales at $6,000,000 a month.

Some Green Gang leaders had achieved social prominence in the city, despite the fact that their criminal links were well-known: among the best-known was Du Yuesheng, the uneducated child of a poverty-stricken city shopkeeper, who had clawed his way out of the docks by way of gambling and drug dealing, and by 1925 had risen to control the opium trade in Shanghai. Du maintained his power not only through his underworld connections but also by forging alliances with French administrators and the military commanders of the warlords controlling the Chinese city. He had a mansion on the Rue Wagner inside the French Concession, where he entertained lavishly both his cronies and the leaders of the Western community. Grateful for favors received, the French authorities in Shanghai promoted Du to the prestigious position of municipal councilman.

Chiang Kai-shek, as a young man in the early years of the republican revolution, had been affiliated with underground society organizations in Shanghai, and had also been active in the financial world of the city. He was easily able to make contact with Green Gang and other leaders as his armies approached Shanghai in early 1927, and to plot with them how to oust the local warlords, and curb the growing power of the Communists inside the city. In the greater Shanghai area there were hundreds of thousands of industrial workers. Since 1921, the Communist Party had been trying to identify potential leaders among them, and to develop labor unions. Many of the workers were scattered in small handicraft workshops, but the number of those in larger plants — in the silk and cotton industries, shipbuilding, steel, cigarette and match making — who might be considered as fully fledged members of the 'urban proletariat', was considerable in 1923. And their numbers were swelled by tens of thousands of others working in the docks, in transportation, and in the public utilities.

Organizing labor was both difficult and dangerous. Many of the laborers had only recently come to Shanghai from the countryside, and worked to seasonal rhythms; many were women workers and children, easily intimidated by their employers; many

Sons of the wealthy. *Gambling was big business in Shanghai. The foreign concessions offered safe venues where cards could be played for high stakes (left). For the unprincipled, there were fortunes to be made through organised gambling, the numbers racket, prostitution, greyhound and horse racing and the sale of narcotics.*

Lords of the underworld *(right). In the 1920s, the Green Gang controlled Shanghai vice. Three powerful racketeers known as the 'three lords' ran the distribution of almost all narcotics in the city. Both the Chinese police and the police in the foreign concessions were in their pay, and they 'taxed' every opium den at a rate of thirty cents for each pipe smoked on the premises. Two of the leaders of the Green Gang were Du Yuesheng (right) and Zhang Xiaolin (center). Their Three Prosperities Company grossed an estimated forty million Chinese dollars a year. The Gang used their armed supporters to attack left-wing trade unionists, killing many and handing others over to General Yang Hu, one of Chiang Kai-shek's trusted followers and himself a Green Gang member.*

lived in special dormitories or company housing where the Communists found it hard to meet them. Unemployment was high, and most workers were reluctant to be seen as troublemakers. Some factory owners used threats or violence against union members, while others maintained paternalist control through carefully calibrated gifts or special favors. Nevertheless the Communists made impressive gains. Using the outrage at the May Thirtieth incident, they amalgamated the workers into a central Shanghai General Union, which was able to call 160,000 workers out on strike by mid-June of 1925. Their success was in part due to the anti-foreign nature of the strikes, directed mainly at Japanese and British-owned plants, which insured support from the Chinese bourgeoisie of Shanghai. Strike funds were also dispatched from both the Canton government and from the northern warlords in Peking. The political agitation in 1926 and 1927 encouraged the General Union membership figures to swell dramatically: 43,000 in June 1926, 76,000 by January 1927, and 821,000 by March 1927.

As Chiang Kai-shek held his expeditionary forces outside the city, these Communist-led workers came out in a massive strike on March 21, 1927, that almost paralyzed the city, and seemed to prove the reality of the workers' power. They effectively controlled

the city until the arrival of one of Chiang's generals with his troops. The workers' show of force had alarmed many Guomindang leaders and the Shanghai business and foreign communities so, in the first week of April, Chiang Kai-shek arranged a series of deals. In one of these, the British and other foreigners promised the neutrality of the some 20,000 foreign troops in the area. In another, the Chinese business community promised major gifts to Chiang's war chest. And in a third, Du Yuesheng and the Green Gang members — many of whom had already infiltrated the union and Communist ranks — formed paramilitary units ready for action. Green Gang members of the foreign concession police continued to filter information on Communist plans to Chiang's headquarters, while Du and his men were allowed free passage through the foreign concession areas.

Comintern policy, and Stalin's own preconceptions of how the revolution should unfold in China, demanded that the Communists should maintain the United Front with the Guomindang, so no attempt was made to arm more workers' pickets, or to warn the existing pickets of their imminent danger. At dawn on April 12, 1927, with the acquiescence of Chiang's military forces and the foreigners, the Green Gang forces launched a devastating series of carefully orchestrated attacks against the

main union headquarters and known Communist locations, followed by assaults on the ranks of the demonstrating workers. The coup completely shattered the power of the Communist Party and the General Labor Union in Shanghai, and left thousands of workers and Communist organizers dead.

The Communist Party as a whole was not completely destroyed because there had been divisions of opinion within the Party itself, and within the Guomindang, about the route the Northern Expedition should take, and the exact role that the Communists should play. While Chiang Kai-shek had placed his sights on Shanghai, the so-called 'left wing' of the Guomindang concentrated its operations up the Yangzi River at the large industrial tri-city area of Wuhan near Hankou. It included such figures as Sun Yat-sen's young widow Soong Qingling, his son Sun Fo, and one of his closest friends and earliest supporters Wang Jingwei, who had returned from his self-imposed exile in France one month before. They assembled their forces between April and June of 1927 and, in a pattern reminiscent of the March events in Shanghai, concentrated on cementing labor union organizations, arming pickets, winning over students' and citizens' groups and organizing alliances with local warlords. They also developed peasant associations in the area, pledged to a much more radical program of land reform and confiscation than anything that had been officially attempted before. This, however, so alarmed the Comintern advisers that they ordered the rural associations to pursue less radical tactics, and to dampen their revolutionary ardor. Local groups of farmers would, perhaps, otherwise have formed 'peasant soviets' along the model attempted in the Russian Revolution, with untold effects on the course of China's ongoing revolution.

Mao Zedong, who by this time was thirty-four years old, had been active in Party work in the countryside around Canton and in his native Hunan province, and was an eager champion of this rural radicalism. In a pamphlet circulated to Communist Party leaders in February 1927, Mao recorded his excitement at seeing the farmers daring at last to raise their hands against their tyrannical landlords, and wrote of how the peasants of China would provide an unstoppable force that would sweep all before it. But, such sentiments and actions did not suit Party policy, and Mao had to mute his actions in the countryside lest local landlords turn against the Left Guomindang and its allies. On the other hand, the Communist Party urged the adoption of an extreme anti-capitalist line in the industrial cities, and under the fiery direction of Party leaders like Li Lisan (who had joined the Communist Party in France, and been a key factor in forming the Shanghai General Labor Union) the most active area of leftist operations became known as 'Red Hankou'.

Once again, the Communists overvalued both their own strength and the reliability of their apparent allies. Wang Jingwei, the senior Guomindang figure in Wuhan, was not convinced that the Communists intended to dampen their radical activism in the countryside, a suspicion that was reinforced in July 1927 when a Comintern agent in Hankou — apparently intending to overawe Wang — showed him a confidential message from Stalin to the Communist Party leaders urging them to deepen the revolution. After a series of secret negotiations with the leading local warlords and with Chiang Kai-shek, Wang Jingwei evicted the Communists from the Guomindang, and ordered the Comintern advisers to return to the Soviet Union. Most left the city safely, and retreated back to Canton or to other coastal cities, but many of those they had wooed with their revolutionary promises suffered a terrible fate. The farmers in the remaining peasant associations were rounded up by warlord armies working with the local landlords, disarmed, and in many cases then tortured or shot. Students and other radicals were also attacked, and particularly revolting revenge was taken against any young women who were believed to be loyal to the Communist cause. Those so identified — often by no other evidence than that they had bobbed their hair in the prevailing revolutionary mode — were subject to sexual degradation and mutilation, and often killed with extraordinary cruelty. Many of the Communist organizers like Mao Zedong — who had hitherto been loyal to the Central Committee and to the Comintern — could see no hope of survival in those areas where local warlords, in alliance with the Guomindang, held sway. They still believed in the potential of a socialist revolution, but they retreated, with whatever loyal military following they could muster, into the mountainous hinterland of China, where they hoped to rekindle the fires of rural revolution safe from Guomindang counterattack.

But a little before this, Mao's career nearly ended when he was captured by landlord forces. They marched him towards an enclosure where he was to be shot. He tried, unsuccessfully, to bribe his captors with borrowed money, then made a run for it, reaching some long grass unscathed. The soldiers searched for him, passing within touching distance, but by nightfall he was still free, and they abandoned the hunt. He walked through the night

barefoot and next day spent his last seven dollars on food, shoes and an umbrella, before he returned to his troops.

Desperate to make up for these catastrophes and to rebuild the shattered morale of their followers, the Chinese Communists still obedient to the Comintern ousted the general-secretary of the Party, Chen Duxiu, the former dean of Peking University and editor of *New Youth* magazine who had been first wooed to the Communist ranks by Comintern agents in 1920. He was replaced by an untried younger Party member, Qu Qiubai, who had lived for a time in the Soviet Union. In an attempt to answer Stalin's recent call to 'deepen the revolutionary tide', these Party leaders tried to foster military mutinies, lead armed assaults on Guomindang-held cities, and rekindle the almost-dead fires of peasant revolutionary consciousness. All failed. At the end of 1927 they tried one final gamble: a rising within Canton, to be coordinated by two new Comintern agents sent from the Soviet Union. This planned uprising would, its leaders hoped, bring about the formation of a 'Canton Commune' composed of peasants' and workers' soviets, establish a people's government, evict both the Guomindang and their warlord allies and connect

up with the radical forces of the rural leader Peng Pai, who had managed to resurrect the small rural soviet he had first formed in 1923.

The results were catastrophic. Though Communist-backed workers' forces did launch a general strike in December 1927, they could only gain control of part of Canton city and never formed their wished-for commune. Reprisal was swift and savage. Guomindang and local warlord troops arrested and shot hundreds of civilians who had participated in the rising or were believed to have Communist sympathies. Long stretches of road outside the city were lined with bodies of those who had been shot. Many were beheaded, left to die of starvation in cages, or tied together and thrown into the Pearl River. This savagery pointed to the depths of hatred and fear that now possessed China.

The second half of 1927 saw a lull in the activities of the Northern Expedition. Chiang Kai-shek, troubled by the tensions within the Guomindang, resigned from his military positions, leaving the running of the Party to the two senior heirs to Sun Yat-sen — Wang Jingwei and Hu Hanmin, who like Wang, had returned from his exile abroad. Chiang himself, after returning

A voice for the left. *In 1927 an American reporter named Milly Bennett photographed Communist leader Li Lisan addressing a mass rally in 'Red Hankou' (opposite). 'Li Lisan looks like an Egyptian mummy,' she wrote, 'that is, an Egyptian mummy in the garments of a monk. His yellow skin is tight over his sharp cheekbones; his black, shoddy Chinese gown hangs over his spare frame like a gunny-sack. When he speaks in that curious shrilly rasping voice, it is never a speech. It is an exhortation.'*

The Northern Expedition on the move. *As the brutal purges almost wiped out the Communists in Hankou and Shanghai, Chiang Kai-shek's southern soldiers fought their way steadily north. They still carried their straw hats against the sun, and their bedding quilts knotted round their shoulders. The advance halted briefly in the winter of 1927–1928 when Chiang temporarily resigned from power to arrange his marriage to Soong Meiling and to ease tensions within the Nationalist Party. In June 1928, however, the troops entered Peking, and Chiang and his generals met in front of Sun Yat-sen's tomb in the Western Hills to celebrate their victory.*

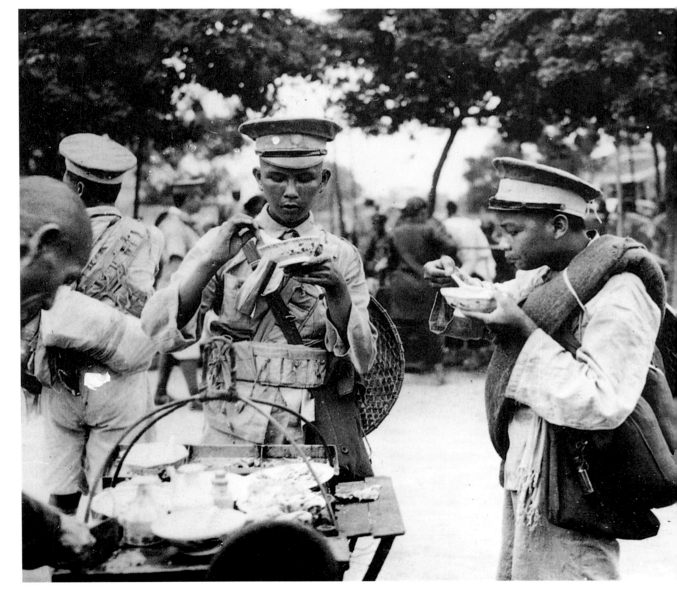

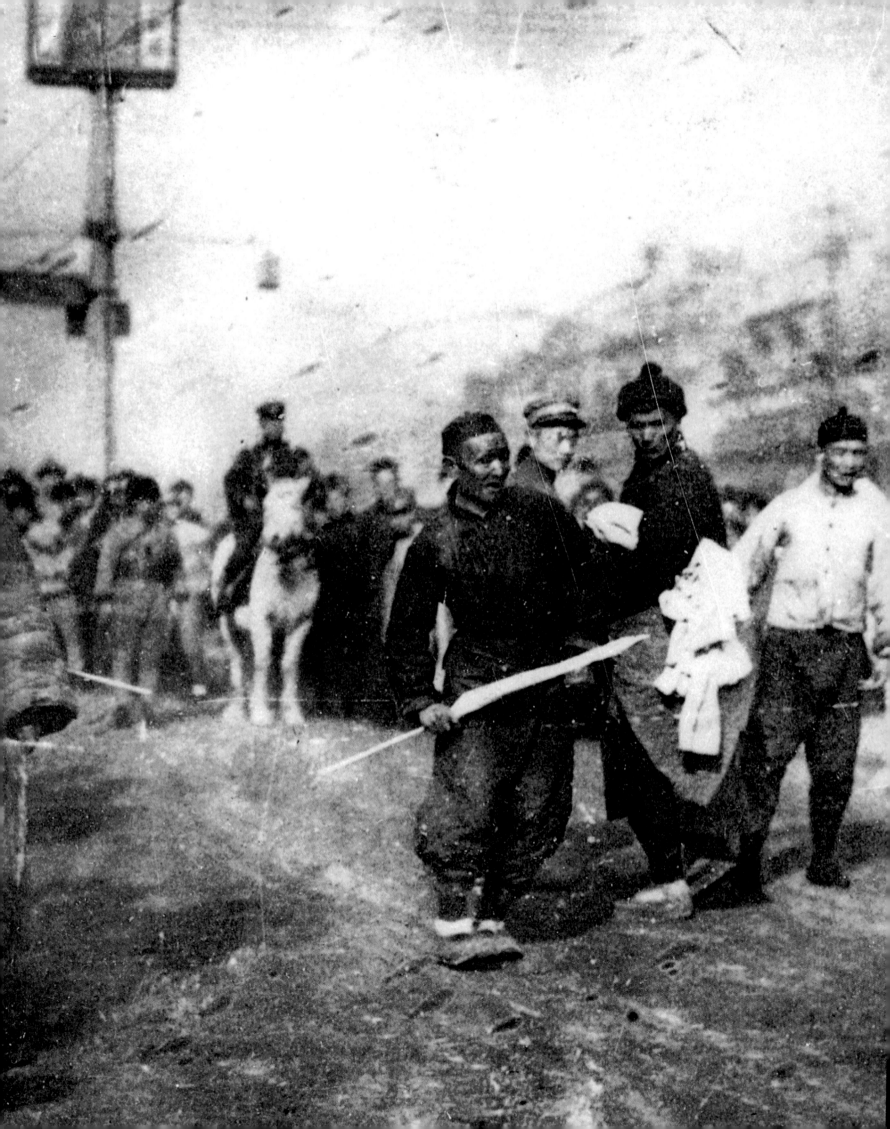

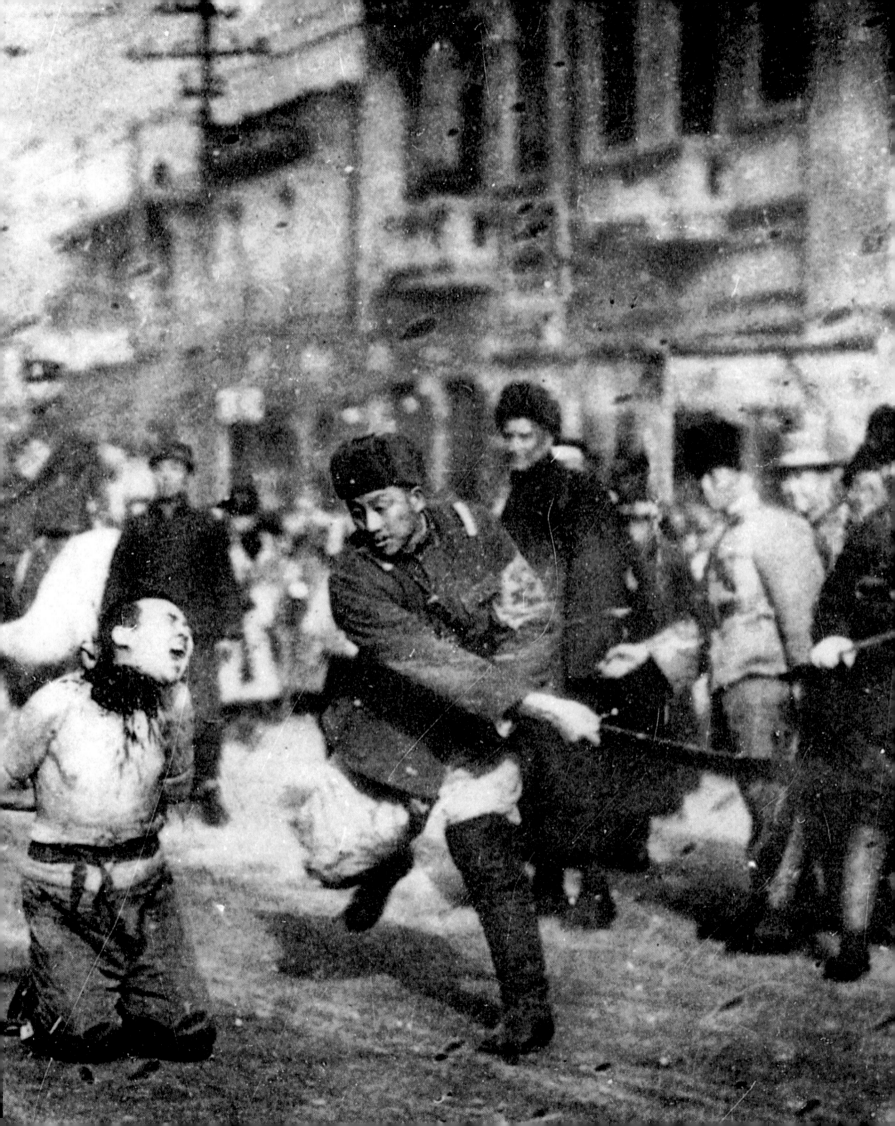

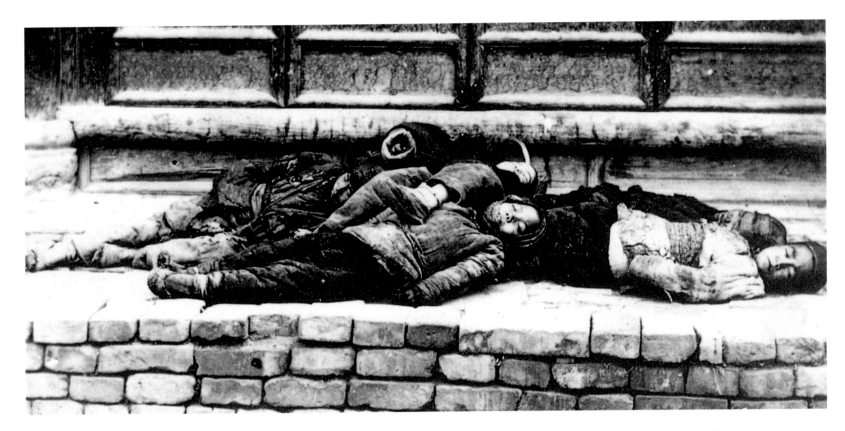

briefly to his hometown in Zhejiang, went to Japan, to seek the support of the Soong family matriarch in his bid to marry her third daughter, Soong Meiling, sister of Sun Yat-sen's widow and of T.V. Soong. Though many of the family opposed the move, not least because Chiang was already married and was not a Christian, Soong's mother eventually agreed, and the couple returned to Shanghai in late 1927 for a double marriage ceremony, one Chinese and one Christian.

Thereafter, Chiang Kai-shek resumed an active role in the Party and forged a series of new military alliances with regional warlords that allowed him to resume the Northern Expedition. Chiang benefited greatly from the financial skills and ruthlessness of his new brother-in-law, T.V. Soong, who was able to raise the colossal amount of money Chiang needed by a combined strategy of taxation, bank loans and strong-arm tactics that even included the kidnapping of prominent Chinese businessmen or their children who were only released after they paid up whatever sums of money the Guomindang had demanded for them.

In early 1928, a new and unanticipated element entered the complicated story. As they advanced across north China, Chiang's troops were blocked for a time by a brigade of Japanese troops.

These were soldiers ordered by the Japanese authorities to garrison key cities in Shandong, allegedly to protect the Japanese civilian residents there, but in reality to defend the immense Japanese investments in Manchuria. After some fierce skirmishing, Chiang decided to bypass the Japanese positions instead of seeking a full-scale confrontation. Anxious for the maintenance of their financial interests in the whole north China region, the Japanese warned the dominant warlord of Manchuria, Zhang Zuolin, whose troops had been in control of Peking for the preceding two years, that he should withdraw in peaceful fashion to Manchuria and not allow the fighting to spread further. Zhang did obediently leave Peking in his specially guarded private train in early June, but some Japanese officers clearly doubted his long-term reliability. As Zhang's train approached Mukden, it was torn apart by a colossal explosion, and he was fatally injured. His assassination gave disquieting proof of the growing power and boldness of the Japanese in north China. The Chinese Northern Expeditionary troops entered Peking shortly thereafter and formally brought an end to the reunification drive. But this had only been possible with Japan's consent. Any sense of triumph that Chiang Kai-shek felt was modified by uncertainties over Japan's plans for China's future.

Swift and bitter reprisals *(previous page). December 1927 witnessed the final nightmare act of what had been a catastrophic year for the Communists. Stalin, angry and embarrassed by the movement's collapse in China, instructed two young Comintern agents to establish a workers' commune in Canton. Too few workers rallied to the call, and reprisals by local military commanders were instantaneous and terrible. Executions were commonplace. The American Consul in Canton, Jay Calvin Huston, witnessed the massacres and sent photos of them back to the State Department in Washington. The photos gave a violent, disturbed and distressing picture of the situation in China and included one of the bodies of children who had been shot and piled by the roadside (left).*

Beaten but not bowed. *The events of 1927 had pulverized the Communist Party, but not destroyed it. Guerrilla troops, among them those led by Mao Zedong in the mountains between Hunan and Jiangxi, continued to fight on, with the support of local bandits and the peasantry. Even in the cities, underground Communist cells worked on, struggling for revolutionary change as the Guomindang government tightened its grip on the country. It was desperately dangerous work. Capture meant certain death. In 1930, an American journalist obtained this photo (right) of a young woman moments before her execution. She has been humiliated, partially stripped, forced to kneel on the ground as her hands are fastened behind her back. The soldier on the left is strapping a leather helmet round her jaw, to make speech impossible, and deny her the chance of any last-minute cry of defiance.*

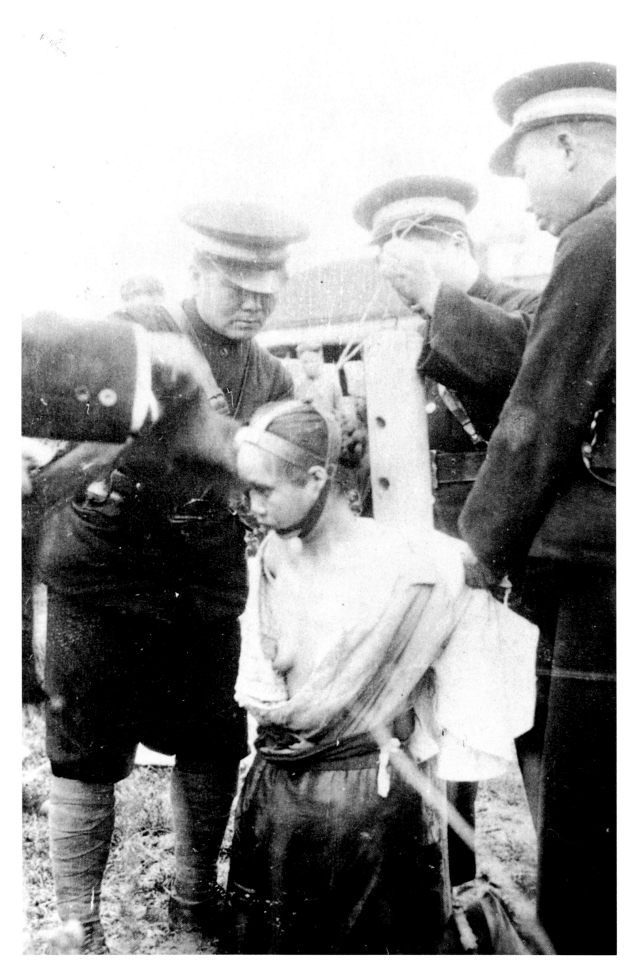

RULE OF THE GUOMINDANG

Trappings of the West. *Driver and plainclothes detective wait confidently for the leader of the new Pan Asian Assembly in 1931 to return to his car while a news photographer stands ready. Guomindang politics were always a mixture of progress and repression and by the 1930s, the automobile, like Western clothes, had become a symbol of new status. But this also made it easier to identify the wealthy and powerful and so there was a dramatic rise in the number of kidnappings and assassinations of car passengers.*

BY 1928, THE NATIONALIST GUOMINDANG FLAG, WITH its white star, was flying from Manchuria to Canton, from Shanghai to Chengdu, and though there were immense areas of the country that the Guomindang still did not control effectively, there was at least a semblance of national unity. The immediate threat of a major Communist uprising was past and the leaders of the Guomindang were free to develop their own vision of China's future. This called for national regeneration through economic growth, and strong social control based on the new priority given to education, and rigorous self-discipline. A powerful army, personally loyal to Chiang, indoctrinated with Sun Yat-sen's three principles and equipped with the latest weapons, would support the Guomindang party, ensure central domination over regional warlords, and eventually diminish the special privileges of the foreign nations who now controlled so much of China's economy. The peasantry were expected to behave like loyal and docile subjects, not making unreasonable economic and political demands. To symbolize these changes, the capital of China was officially moved from Peking to Nanjing in 1928, and the name of the former city was changed from Peking (or Beijing), which means 'Northern Capital', to Beiping, 'Northern Peace'. Elaborate plans were drawn up to transform provincial Nanjing into an imposing national capital, with broad avenues leading to the colossal headquarters of the government and to the Guomindang party headquarters. This transfer ended the period of warlord presidents and the corrupt democratic structure that lingered on in Peking, a change that was symbolized by hanging Sun Yat-sen's portrait over the entrance to the Forbidden City of Peking — five years after the 'Last Emperor', Puyi, had been ejected from the Palace and its transformation into a complex of parks and historical museums.

A vast mausoleum was built in the hills above Nanjing to enshrine Sun Yat-sen's embalmed remains, held for the time being in a temple in the Peking suburbs. The solemn transportation of Sun's coffin to the Nanjing shrine by road, train and boat became a major national event. It was no mistake that the only other major tomb complex in the area was that of the founding emperor of the Ming dynasty (1368-1644), who had made Nanjing the Ming capital. A usurper had transferred the capital to Peking in 1410, and the conquering Manchus kept it there, as did Yuan Shikai. By re-establishing the power of Nanjing the Guomindang demonstrated that they had history on their side.

The government in Nanjing now consisted of five major bureaus or *yuan*. The executive yuan directed the day-to-day running of the government while a legislative yuan discussed policy formation and advised the executive yuan. This latter

constituted what was left of a democratic structure for informed political discussion. The other three lesser yuan were in charge of the judiciary, the state examination systems that routed people into government service, and a 'control' yuan to supervise the behavior and integrity of the bureaucracy. The presidency of the executive yuan was held most frequently by Sun Yat-sen's surviving lieutenants, Wang Jingwei and Hu Hanmin, who followed each other in and out of office depending on their fluctuating political fortunes. Several major warlords, who had played important roles in the fighting of the Northern Expedition as Guomindang allies, were also given official titles in the executive or the other yuan. But the real power lay in the Guomindang party organization.

The Guomindang headquarters were even larger than the buildings that housed the executive and legislative yuans. Most of the key military power, the control of the branch offices of the party across the country, and the national security apparatus was concentrated here. This was the center of Chiang Kai-shek's power; he was not initially involved in the regular business of the five yuan, although he had the title of Chairman of the National Government. Only in 1935 did he assume the formal rank of

president of the executive yuan. Crucial to Chiang's authority was the support of the 'four elders', the senior political figures with long years of proven loyalty to Sun Yat-sen and a record of devoted service to the cause of the nationalist revolution: the four included Cai Yuanpei, the former president of Peking University during the heady May Fourth years and now the national minister of education, and Zhang Renjie, the financial backer of the early student anarchists in France. Zhang was weakened by a slowly spreading paralysis which also attacked his eyesight, but his mansion in the French Concession at Shanghai had been home to many Guomindang power-brokers over the years. He was especially close to Chiang Kai-shek, who addressed him reverentially as 'my true teacher'.

Chiang also received important political support from his in-laws in the Soong family, especially T. V. Soong, who continued to serve as the Guomindang's main financial adviser, and H. H. Kung (husband of Soong Meiling's eldest sister, Soong Ailing) who served as Minister of Finance. All the Soong family were educated in the United States, and had useful contacts with American financiers, educators and politicians. Two nephews of Chiang Kai-

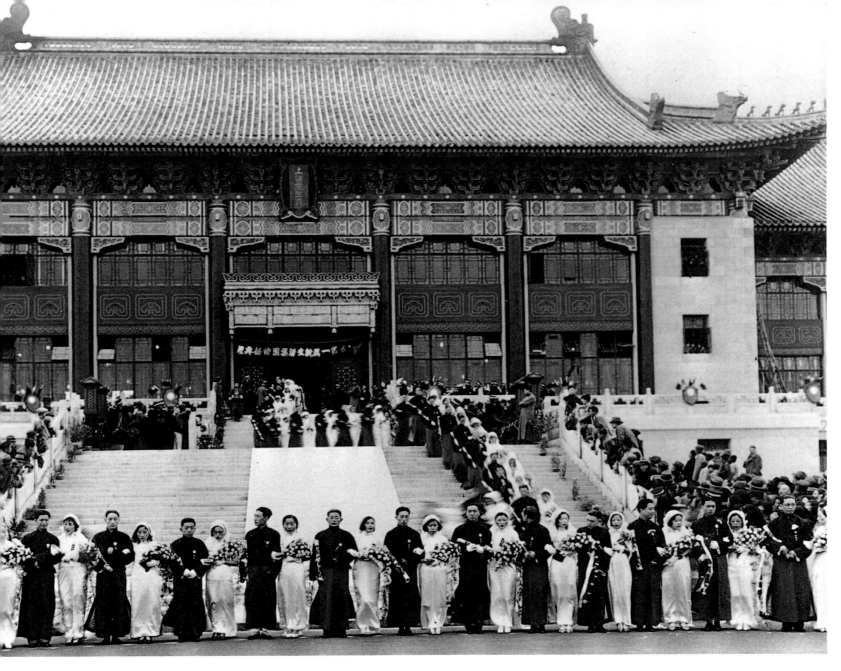

shek's first political patron in Shanghai during the days of the 1911 revolution, known collectively as the 'Chen brothers', served as ideological guides to Chiang, and helped foster a sense of patriotism to which they brought a deeply conservative cast of thought, linked to a residual kind of 'law and order' Confucianism. This found expression in the national purification movement conducted by the Guomindang, called the 'New Life Movement', designed to imbue the people with a sense of moral purpose, and to impose a basic set of puritan and spartan values that would end the extravagance, drug addiction, sexual licence and laziness which Guomindang ideologues claimed were weakening the nation. When the English writers W. H. Auden and Christopher Isherwood met Madame Chiang in 1938, they quizzed her on the new Life Movement because, from what they had heard, it seemed to give rise to much 'priggery and hypocrisy'. Madame Chiang replied that 'the old imperial order had possessed a definite moral code...But this died with them, and a period of chaos ensued, which was a fertile breeding ground for Communist propaganda...The New Life Movement was, therefore, a direct attempt to compete with the Communist platform of economic

and social reform, substituting a retreat to Confucius for an advance to Marx.'

Just as Auden and Isherwood were leaving, Chiang came up the stairs. The writers were surprised by his appearance, as they later recalled:

> We should hardly have recognized in this bald, mild-looking, brown-eyed man, the cloaked, poker-stiff figure of the news-reels. In public and on official occasions, Chiang is an almost sinister presence; he has the impassivity of a spectre. Here in private he seemed to pose, arm-in-arm, for yet another photograph. Under the camera's eye he stiffened visibly, like a schoolboy who is warned to hold himself upright.

Chiang gained particular support from the Whampoa cadets whose careers he had fostered. By the 1930s many held senior positions. The Guomindang military academy (purged now of its Communist advisers and most Communist sympathizers) was moved to Nanjing, and Chiang often lived inside the academy compound. Many of Chiang's loyal young officers formed

attempts to build up the nation. One of their main priorities was to whittle away at the power and privileges of the foreign enclaves in China. Hundreds of foreigners had fled to Shanghai when hostile nationalist troops occupied Nanjing in March 1927. Tens of thousands of foreign troops and sailors in and around Shanghai ensured that the concessions could not be reclaimed for China, but since most foreign traders valued their profits over their privileges, the Guomindang forced foreign importers to pay far higher tariffs on their goods, altered the structure of the law courts in the concessions so that there was more Chinese control, seriously cut back the amount of organized gambling in the concessions and instituted 'opium suppression bureaus'. The goal was to bring all opium distribution under state control, and to issue the narcotics only to registered addicts who would slowly be weaned from the drug by a supervised system of detoxification. This idealistic plan soon collapsed, for the Guomindang made considerable profits from the controlled sale of opium, and took no real steps to prevent syndicates like the Green Gang from taking over the bureaus. Gang leaders like Du Yuesheng became more powerful than ever, especially since Chiang was in their debt for their crucial help against the workers in 1927. Responding to Guomindang pressures, the French in particular removed some of their most corrupt officials from the concession administration; and after 1928, both the British and the French cooperated in swiftly 'extraditing' suspected Communists hiding in the concession areas.

'patriotic' associations, in order to purify the Guomindang ranks of any taint of corruption, to destroy any suspected Communist subversion before it could spread and to protect Chiang Kai-shek from all harm. An offshoot of these groups, known informally as the 'Blue Shirts', became particularly powerful in the later 1930s, and took on many of the trappings – and some of the ideology – of the Fascist parties in Germany and Italy.

One of the Blue Shirts, Dai Li, helped Chiang to develop what was essentially his own private and immensely successful counter-espionage system – euphemistically known as the 'Investigation and Statistical Bureau'. Son of a poor trading family, Dai entered the Whampoa military academy and graduated with the fourth class in 1926, subsequently showing such a flair for intelligence work in Shanghai that he received rapid promotion. By 1935, Dai Li's security apparatus had come to total more than 1,700 operatives. Under Dai Li's direction, political enemies of the Guomindang could be arrested without warrants, interrogated and tortured in secret, and held incommunicado for years in prison compounds or executed without trial. Dai Li also directed the assassinations of several well-known liberal figures who had criticized the Guomindang or its operatives, such as editors of progressive newspapers that criticized Chiang, or leaders of associations to protect human rights. The bureau continued its relentless search for Communist Party 'moles', for despite its 1927 rout, the Party had since managed with some success to infiltrate the Guomindang, and even its security apparatus.

Between 1928 and 1936 the nationalists made significant

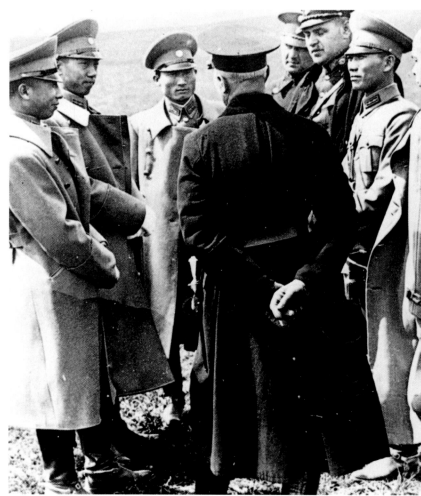

The face of China also began to change, as modern styles of architecture spread from Shanghai to Nanjing and other provincial towns. Thousands of miles of paved roads were constructed, new railway lines were laid, with modern stations and signal systems, cars became a common sight, and buses and trams began to force many of the rickshaw pullers out of business. Fashions changed with creative adaptations of traditional Chinese dress; the cinema also became an influential social force, and Chinese studios grew rapidly to compete for the large audiences created by imported Western films. (The Guomindang tried, with some energy, to censor political criticisms that might be subtly inserted by radical directors and script writers.) The cult of the Chinese film star grew apace, both in the West, where the actress Anna-May Wong suggested a new world of cosmopolitan glamor in the films she made for Hollywood and English studios, and in China itself. When the film star Ruan Lingyu took her own life because of vicious gossip about her in the press, millions of her countrymen felt the blow.

Chinese banking was transformed in this period, as a new breed of pragmatic foreign-trained economists like Zhang Jiaao took over. Zhang had become famous for his courage in resisting Yuan Shikai's attempts to interfere in the Bank of China's management, and rose under the Guomindang, becoming head of the entire bank in 1929. Zhang was a pioneer in raising capital from Chinese rather than foreign sources, and he transformed the bank's

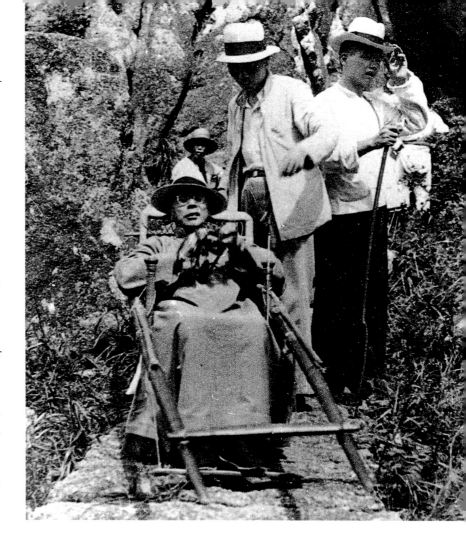

Leaders, old and new *(far left above). Key figures of the 1911 revolution and the May Fourth Movement of 1919 meet in the 1930s in this rare photograph. From left to right: Wang Jingwei, Sun Yat-sen's closest confidant and Premier of China 1932-1935; Li Shizeng, formerly leader of the work-study movement in France and Director of the newly formed Palace Museum; Zhang Renjie, wealthy businessman and Guomindang patron (seated); Chu Minyi, leader of the health and physical fitness movement and martial arts specialist; and*

(far right) Cai Yuanpei, famous President of Peking University and later Minister of Education and director of the Academia Sinica research institute. By the mid 1930s, the party elders were slipping from power. Cai Yuanpei had broken with Chiang Kai-shek over flagrant human rights abuses. Zang Renjie (top right) weakened with paralysis, was often carried on a litter, and mockingly called himself the 'the Reclining Cicada'. By 1940, both Wang and Chu had abandoned Chiang Kai-shek for the collaborationist regime in Nanjing.

Fascist influences. *Senior Chinese police officers, (left) on a visit to Austria in May 1935. The uniforms of the Chinese reveal the German influence on military and police training within the Guomindang, whose ideology blended fascism with Confucianism.*

accounting procedures and its foreign exchange system, winning it international recognition and trust. As the Shanghai stock exchange expanded rapidly, a national plan for economic development was drawn up by Guomindang planners. A new government body known as the National Resources Commission, with an able and professional staff, arrived at a series of huge and complex barter-trade deals with Germany, by which Chinese tungsten needed in the production of armored steel was to be mined and exchanged for German military high technology. Commercial airlines began operations inside China, and the first airfields were built. As foreign airlines began to investigate and exploit the Chinese market, Italian companies were wooed to China to begin airplane production inside the country.

Though there was much that was promising in the China of the 1930s, the country was still subject to serious threats, the most challenging of which were undoubtedly those posed by the Japanese and by the surviving Chinese Communists. Confronted by one or the other, the Guomindang might have worked out a way through to its goal of strengthened reunification, but the combination ultimately overwhelmed Guomindang ambitions and abilities.

Japan's spread into Chinese territory had begun in Taiwan, which the Japanese claimed as the spoil of victory from their war with China in 1895. In this colony, the Japanese determined to create a model for the new Asia of which they were beginning to dream. Japanese administration was grafted firmly onto the island. Two major risings, by the island's own aboriginal inhabitants in

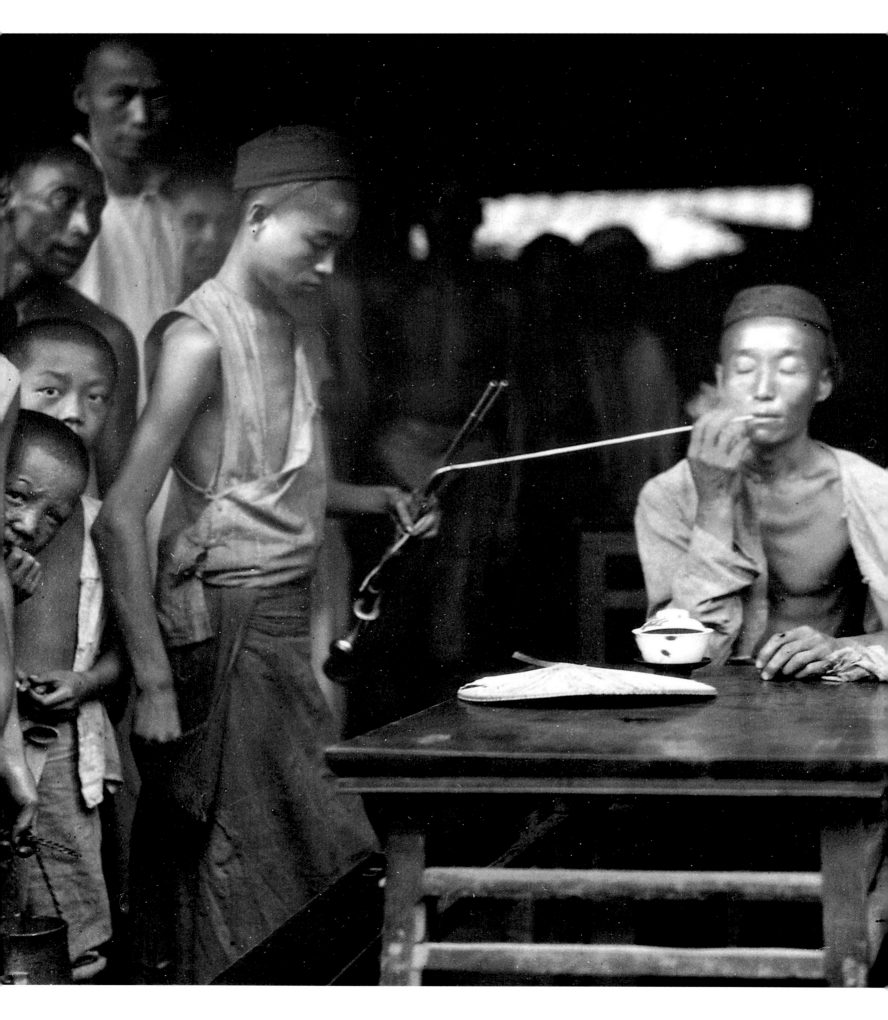

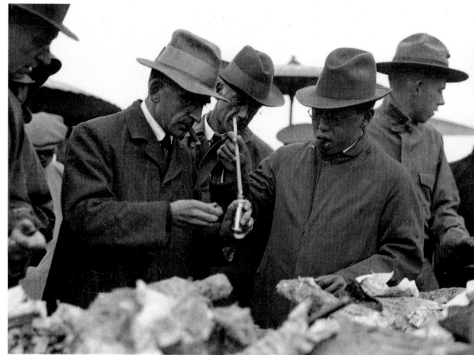

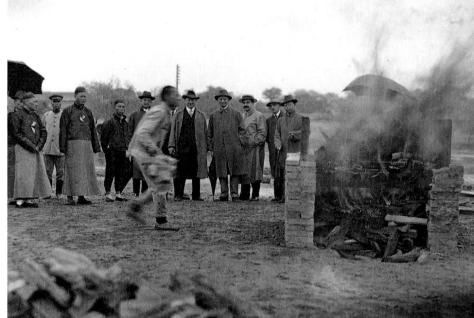

'Renting Smoke'. *During the chaos of the warlord period, opium smoking (left) rapidly increased in China. Military leaders often forced farmers to grow opium poppies as a source of revenue. The Guomindang at first attempted to eradicate opium addiction in 1928 but the income from drug sales was too huge to be abandoned and they switched to a policy of monopolizing the lucrative trade through* the misleadingly named 'Opium Suppression Bureaus'. *Government inspectors seized the stocks of unauthorized dealers (above) which were burned in public ceremonies (below). Unauthorized dealers were suppressed, and known addicts were ordered to register at detoxification centers. In effect, the Guomindang worked with criminal elements to corner the market.* [PHOTOS: SIDNEY D GAMBLE]

'Frosted Yellow Willow'. *Anna May Wong (right) was the first Chinese actress to gain international stardom. She was born in Los Angeles in 1907, where her parents ran a laundry, and made her film debut as a child extra at the age of fourteen. Eleven films later she appeared with Douglas Fairbanks in* The Thief of Baghdad *and found immediate fame. She acted in a stage play,* The Circle of Chalk *with Laurence Olivier in London in 1930, and the following year gave her most famous film performance as Hue Fei in Von Sternberg's* Shanghai Express. *For this role and her parts in other films, including* The Daughter of Fu Manchu *and* Limehouse Blues, *she was labelled 'the foremost Oriental villainess'. She played Zahret in* Chu Chin Chow *on Broadway in 1934, and appeared in cabaret in London. In 1936, she was dismayed to to be attacked by Chinese officials for negative portrayals of Chinese characters, to which she retorted that these parts were all that were open to her, since major Asian roles were reserved for western actresses.* Daughter of Shanghai, *a film she made in 1937, was much more sympathetic in its depiction of China, reflecting America's changing attitude brought about by Japan's aggressive behavior in the East. She was 'as fragilely lovely as a silkscreen figure', but by the time she was in her mid-thirties, her career in Hollywood was almost over. She is seen (left, above) with Frank Dorn, the United States military attaché in Peking, and on a visit to Royal Ascot races (left, below) in June 1934.*

AN INTELLECTUAL'S FAMILY ALBUM

The patterns of life developed by the son and daughter-in-law of the late-Qing reformer, Liang Qichao, can serve as a good indicator of how the changes in China affected an individual family and their circle of friends. Liang Qichao, who had represented the intelligence and dynamism of many Qing intellectuals confronting the revolution, ended up disillusioned by politics and dejected by his experiences with Yuan Shikai and Duan Qirui. But he continued to write on history and politics and to teach traditional Chinese texts and values. His own sons and daughters were given intensive classical educations, but also introduced to the full range of modern subjects. He encouraged them to study overseas, and though he arranged the marriage of his son Liang Sicheng to Lin Huiyin, the daughter of one of his oldest friends, he insisted that the couple go off together to study architecture at the University of Pennsylvania before they returned to China to marry and start their new careers. This novel plan put considerable emotional strain on the young couple. American gender biases prevented Lin Huiyin from taking her chosen course of study and forced her to study fine arts instead, but both of them completed their courses satisfactorily.

Back in Peking, they married and formed a salon of talented young Chinese at their home. At the same time the young couple began to lay plans to preserve China's great architectural heritage. In a series of bold journeys to the interior of China they put their research into practice, and located, photographed and made exact architectural drawings of scores of spectacular buildings and temples. An innovative modern poet called Xu Zhimo, who for years had unsuccessfully wooed Lin Huiyin himself, was a member of their salon, until he died tragically in a plane crash. Xu's own first wife — whom he had divorced — had two brothers, one of whom was China's leading banker Zhang Jiaao, and the other one of China's most distinguished young philosophers. Thus the involved circles of intellectual affinity and influence spread and flourished amidst the chaos of warlord politics, parliamentary corruption, anti-Communist purges and Guomindang censorship.

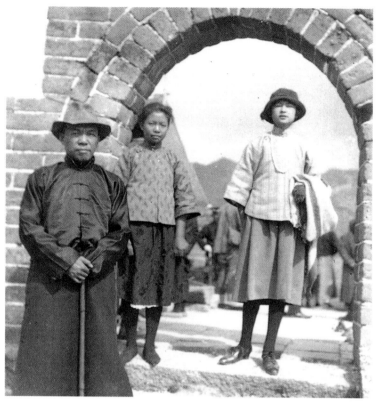

Lin Huyin in London (far left) with her diplomat-father, Lin Changmin; (above left) serving as interpreter for the Nobel prize-winning Indian poet Rabindranath Tagore on his visit to China in 1924 (with co-interpreter and Lin's former suitor, the poet Xu Zhimo); (left) in the dramatic gown and head-dress of her own design at *her marriage in 1925 to Liang Sicheng. (Right-hand page) Lin Huyin on an outing with husband and friends; at the Great Wall with her father-in-law, Liang Qichao, and sister-in-law; on one of many trips with her husband in the 1930s to study and record China's earliest architectural treasures.*

*u Shih
ith sincerest regards
Lucile Swan*

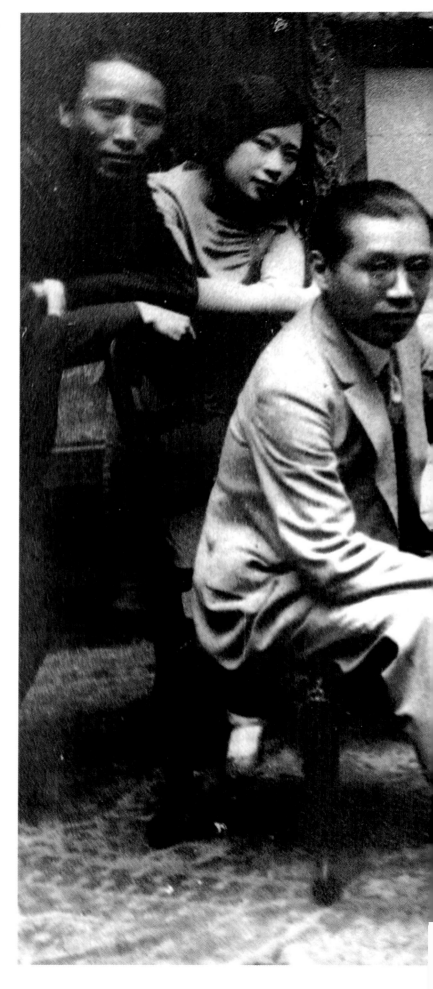

Working with a new model. *By the 1930s many of China's most distinguished intellectuals had become much influenced by Western culture. Hu Shi (above) was a leader of the May Fourth Movement who became both champion of the twin values of 'Science and Democracy' for China, and a protagonist of the movement to spread the vernacular form of writing throughout the country. He adopted a* *pragmatic approach to China's problems and became famous for a speech in which he urged 'Study More Problems, Talk Less of Isms'. Here he poses in Peking for the German sculptress, Lucile Swan. A group of Chinese artists (right) meet in the studio of the French painter, Albert Bernard. Western painting techniques were widely spread by such students showing their own work in many popular exhibitions around China.*

IMPERIAL STUDIO

The drama transformed. *As part of the build-up to their campaign in China, Japanese forces began to place new pressures on Taiwan, which had been a Japanese colony since 1895. To prevent covert support for the embattled Chinese armies, Japanese authorities closed down the traditional Taiwan opera form known as 'Gezai,' the 'airing of complaints' or 'expression of sorrow', shown here (left) in Taipei in 1935. Instead, they ordered Taiwan Chinese actors to wear only western-style dress or military uniforms, and to perform new scripts that glorified the emergent Japanese Empire. In a performance in Yangmei, near Taipei, (right) Gezai actors mime bombing raids on China against a backdrop of Mount Fuji and under paper models of Japanese war planes. They wear western clothes, flying helmets and goggles.*

[PHOTO, LEFT: TENG NAN-KUANG]

[PHOTO, RIGHT: WU CHIN-MIAO]

1914 and 1931, were suppressed using a combination of modern fire-power and terror. The education system was reorganized, and the teaching of Japanese history and language were introduced. The most able students were sent to Japan for their higher education and expected to return imbued with ideas of discipline and social order which, Japanese scholars had preached, were now all too absent among the Chinese. The essence of true Confucianism, the heart that gave strength to Asian belief systems, had now passed to the Japanese, according to these theorists.

The Japanese brought levels of representative government to Taiwan (at least at the rural level and in urban wards) that neither the Qing, nor Yuan Shikai, nor the Guomindang had ever instituted in China itself. Using modern technology, seed strains and irrigation techniques, they increased agricultural production and geared it toward the needs of the Japanese home islands. They developed domestic industries in Taiwan, especially light engineering and chemicals, that would integrate with their own military production. The architecture of Taiwan was transformed along modern Japanese lines, and immense new buildings in Taipei manifested the power of the Japanese governor-general and his

bureaucracy. Social and police control were strict, and the watch for Communist infiltration unremitting. Steadily, Taiwanese were introduced to the idea that they were now privileged to be citizens of Japan and subjects of the Japanese emperor. Through youth groups and paramilitary training, they were prepared for a possible role within the Japanese army. Some Taiwanese who had fully absorbed the lessons of their Japanese teachers were encouraged to settle on the east coast of China, especially if they had relatives there, so that they could begin to spread the new hybrid doctrine in ways that would bolster Japan's economic and cultural prestige.

Since the late nineteenth century, Japanese entrepreneurs and politicians had also been intrigued by the huge food and mineral resources of Manchuria. Frustrated in an attempt to seize the southern part of the region in 1895, the Japanese began to invest in the area instead, particularly the region between Port Arthur and Mukden, and along the Korean border, which they linked by modern high-speed railways. Skillfully exploiting the treaty rights to police the South Manchuria Railway line, which they had won from the Qing and the Russians after their victory in 1904-1905, the Japanese developed wide swathes of country on either side of the track, initially claiming this was an essential measure of protection against bandits. They built up major commercial centers at each of the designated stations, developed railway marshalling yards, mining operations, and local depots, and fostered tourism with chains of comfortable hotels. In the north of Manchuria on the other hand, especially around Harbin, Russian influence was strong. Large communities of White

Russian fugitives from the Soviet Union had settled, and there was also the threat of Soviet intervention in response to perceived Japanese economic or political provocation.

The railway police were steadily expanded to include units of the regular army from Japan, and these units grew rapidly in their turn, until by the late 1920s there were well over 20,000 highly trained and well armed Japanese troops in the area. After 1928, these army units began to show ever greater independence from the civilian control of the government in Tokyo, and ambitious officers began to seek postings to Manchuria.

Manchuria's huge natural resources of coal, forest products, wheat, fish, and iron ore drew large numbers of Japanese investors; Japanese banks soon opened branches to finance these interests, and support services, schools and hospitals followed in their wake. For a time, the Japanese were content to work alongside Zhang Xueliang, the oldest son of the assassinated warlord Zhang Zuolin, apparently believing that, as a known opium addict with a considerable reputation as a playboy, he would pose no threat to Japanese interests. But Zhang Xueliang reformed his lifestyle, recognized the validity of the Guomindang call for Chinese reunification, and began to fly the Guomindang flag in Manchuria. The Japanese tried to get to Zhang through two of his father's close confidants, but when he asked them to dine with him and then had them shot while he left the room to take his daily injection of morphine, Japanese opposition hardened. In September, 1931, Zhang was distracted by a whirling Beiping social life that included a notorious flirtation with Mussolini's

Social life in Peking. *In 1928, Peking lost its status as capital to Nanjing and was renamed Beiping, City of Northern Peace, though it remained a center for social life and political intrigue. One of its prominent figures was the Manchurian warlord Zhang Xueliang, seen here at play in 1931 as his homeland was being conquered by the Japanese (third from right). His wife was Yu Fengzhi (far right). Standing behind her is W. H. Donald, Zhang's Australian confidant and adviser. At this time Zhang was notorious for his addiction to opium and morphine and for his affair with the Countess Ciano, Mussolini's daughter and wife of the Italian Minister to China. (Below) Two skaters in carnival dress. The skater on the right wears the white star of the Guomindang while on her sleeves are the messages, ' take it easy' and 'I don't bite'. (Far right) An increasing number of Chinese women adopted western hairstyles, wore western-style high heeled shoes, had their traditional slit-skirted 'qipao' made of modern fabrics and cut in a semi-western fashion.*

The Puppet Emperor's new clothes. *At Japan's invitation, Puyi became Chief Executive in Manchukuo in 1932 and in 1934, Emperor, but he remained completely under Japanese control. He is seen here (left) in 1936 with Muto Noboyushi, Japanese Ambassador to Manchukuo (on the right). In his autobiography Puyi later said Noboyushi was 'the true Emperor of Manchukuo' and 'as powerful as a god'.*

The Japanese in plain clothes. *In 1932, the Japanese seized large areas of the Zhabei district of Shanghai and briefly established their own collaborationist regime. After their withdrawal, the Guomindang tried to compile lists of Chinese collaborators and to infiltrate the Japanese concession areas in Shanghai in order to gauge Japan's war plans. The Japanese Naval commander instructed that all Chinese agents be rounded up and executed immediately. Two members of the Japanese secret police lead a Chinese agent to his execution past Japanese marines.*

daughter (wife of the Italian minister in China), when the Japanese army launched a second power play in Manchuria, the 'Mukden Incident'. Claiming that they had been fired on by Chiang's troops, they moved to occupy the city of Mukden, and from there spread their hold rapidly across Manchuria. Chiang Kai-shek, anxious to avoid an open confrontation with Japan, ordered Zhang Xueliang not to respond with force, but to seek help instead from the League of Nations. When the League proved ineffective, Zhang was left without resources to regain his ancestral land.

In March 1932, the Japanese installed the ex-Emperor Puyi, who had been living under Japanese protection in Tianjin, as 'Chief Executive' of a new Manchurian state to be called Manchukuo – 'land of the Manchus' – hoping that his prestige as China's former ruler would lead the inhabitants of Manchuria to accept him and the Japanese power behind him at the same time. But even before this, the Japanese had made their imperial ambitions obvious by launching a major attack on the Chinese sections of the city of Shanghai, claiming that their nationals had been attacked there. Though much of the civilian population fled in panic, and whole areas of the densely populated industrial area of Zhabei were leveled, the garrison commander of Shanghai, Cai Tingkai, led his troops in a three-month battle against the Japanese. The courage of the Chinese troops won world-wide admiration, and the Japanese finally agreed to a face-saving

settlement. During the fighting the threat to public health in Zhabei from the amount of corpses there, and the need to curb looters, led to the formation of a joint Japanese-Chinese collaborationist regime. This did maintain a level of order and was a forerunner of similar regimes five years later when the Japanese invaded China in full force. Dai Li and Chiang Kai-shek's other intelligence forces took careful note of the collaborators for future vengeance.

In 1933 the Japanese pressed into the region of Rehe north of Beiping, and into Inner Mongolia, forming pro-Japanese puppet regimes there also. In 1934, Puyi was formally installed as emperor of Manchukuo. Within a year, after breaking the morale of the local residents and the garrison forces by an elaborate pattern of psychological intimidation, false information elaborately leaked and leaflet campaigns to spread alarm and confusion, the Japanese forced the Chinese to declare a demilitarized zone in north China around Beiping and Tianjin, which effectively gave them control of the entire area. Each of these moves, from 1928 to 1935, not only inflamed Chinese hostility against Japan, but also aroused intense anger against Chiang Kai-shek, seen by many as an appeaser. The charges seemed confirmed by Chiang's constant attempts to suppress anti-Japanese sentiment and prevent any major anti-Japanese rallies.

Chiang hesitated partly because he did not feel his forces were

ready yet to oppose the Japanese in open warfare, but more importantly because his greatest priority was to wipe out the Communists once and for all. With the Communists suppressed, he believed that he could redeploy and rearm his troops to curb Japanese encroachments. The ability of the Communists to survive even the disastrous blows they had suffered in 1927 was proof in part of their own courage and organizational skills, and also of the very real levels of misery in the Chinese cities and countryside which were not addressed adequately by the economic or social policies of the Guomindang government. Following the collapse of the Canton Commune and of the various other attempts at urban insurrection, many of the Communists had retreated to the countryside and there were a dozen Communist rural bases in the late 20s and 30s, often of considerable size. In these bases, known as 'soviets', the Communist leaders experimented with different types of land reform or expropriation, recruiting guerrilla armies from among the peasant population, and using bandits and secret society members to swell their ranks when necessary. One of these

was led by Mao Zedong in the Jinggangshan region on the borders of Hunan and Jiangxi provinces. Later, because of Mao's role in the revolution, it received much prominence, despite its lack of success, and by 1929 Mao and his military co-commander Zhu De had retreated to a mountainous area on the Jiangxi-Fujian border, where a new rural guerrilla government was in process of formation. This was to become known as the 'Jiangxi Soviet'.

The Jiangxi Soviet, which lasted from 1929 to late 1934, seemed for a time to be a model of what the Communists might be able to achieve. Building on techniques of guerrilla army strategy that recruited troops from among the poorest peasants and landless laborers and armed them with homemade weapons or captured Guomindang equipment, Zhu De and Mao taught a highly mobile form of warfare, in which retreat was always the best tactic against superior forces, and deception and surprise were paramount. Locals, including women and children, were recruited and taught the basic premises of the Communist program. A surviving report by Mao from 1930 shows how carefully he

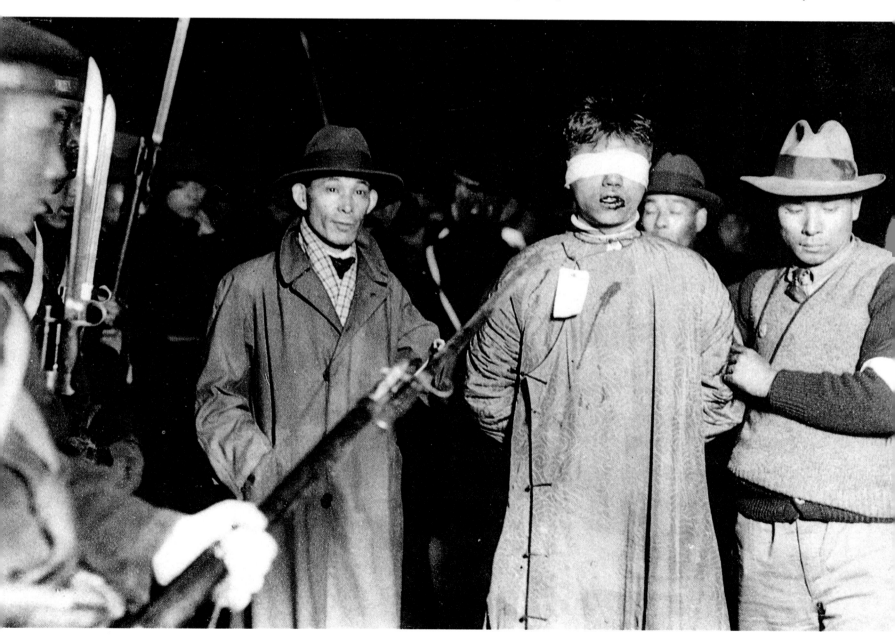

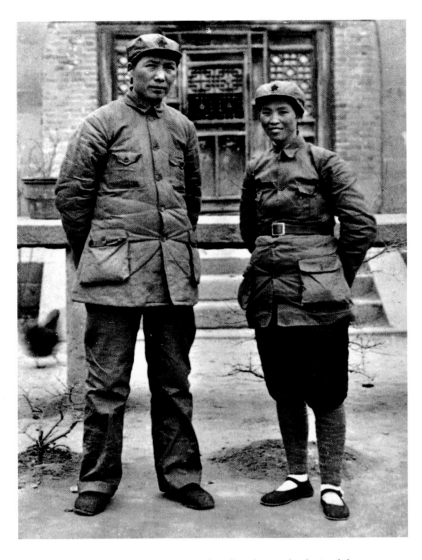

cities or to retreat to the Jiangxi Soviet, where they jockeyed for leadership with those following a radical rural line.

This concentration of leaders and ex-leaders in Jiangxi, the comparative proximity of the Soviet base to Chiang's own military headquarters at Nanchang, and the revived morale of the Guomindang after the suppression of a number of splinter groups within the central leadership ranks, encouraged Chiang Kai-shek to launch a series of major assaults against the region, starting in 1930. Chiang's tactic was to move slowly, as he carefully assembled his military forces around the Soviet, and embargoed the area to travelers who might bring in food supplies or ammunition. He built support roads to supply his own troops, and established a linked system of armed block houses. All of these techniques were suggested to him and implemented by a group of senior German former staff officers, veterans of World War I, whom he used as his advisers. Chiang was able to draw the noose so tightly around the Jiangxi Soviet that the Communists could only fight to the last or attempt a daring escape. They decided on the latter.

Though the Communist leaders left around 40,000 troops behind to distract the Guomindang forces, over half of these were either seriously ill or wounded, and many were speedily rounded up and killed, or relocated by the Guomindang. The bulk of the Communist armies, some 86,000 troops in all, escaped from the Soviet in October 1934, and embarked on the retreat that they later immortalized as the 'Long March'. Despite the exaggerations and embellishments, the Long March was an astonishing saga of danger and survival against terrible odds, which took the retreating Communists almost to the borders of Tibet and then in a huge curve up towards the north, into Shaanxi province which they reached in early 1936, and where they regrouped with a Soviet already formed in the area by another Communist fugitive force. On the way, the Long Marchers had covered twenty miles or more a day, often soaked or freezing, forced to wade bogs so deep that the troops had to be tied together with cords and then had to sleep standing up. The small group of women with them faced the added burdens of pregnancy or miscarriage, and Mao's own second wife – his first wife, whom he had left in Hunan, had been arrested and shot by the Guomindang – actually gave birth to a child on the march who was left with a peasant family. But, however hard-stretched, Mao insisted that those who had suffered under the imperial regime, such as the non-Han peoples, should not now be exploited by the Communists. When passing through the lands of a particularly grasping tribe, called the Lolos, he insisted that the exorbitant price they demanded for supplies be met. One of his officers cemented proceedings

looked for tensions between landlords and their laborers, or between rich peasants and poor, which could be exploited in the name of class so that land could be seized, after a violent struggle, and new supporters be brought to the Communist Party. Married women were promised the right to divorce freely and run their own lives; those not yet married were promised protection from arranged marriages or from being sold into marriage. Child marriage was forbidden. Prostitutes were freed from their demeaning contracts, churches and temples were taken over as shelter for the troops, poor coolies were offered land and a stake in the new society.

Such policies did not sit well with the senior Party leadership. The official leaders of the Chinese Communist Party, first Qu Qiubai and after him Li Lisan, continued to follow the Comintern line about the need for urban insurrections among the workers, but such an approach became increasingly untenable as Chiang's counter-espionage forces in the cities grew more sophisticated. The urban Communists' position grew worse after the British and French began to allow Dai Li's agents into their concession areas to look for radicals. Their confidence was severely shaken after several 'moles' who had infiltrated high levels of the counter-espionage system were exposed and executed. By 1932, the Communists' urban leaders were forced to go completely underground in the

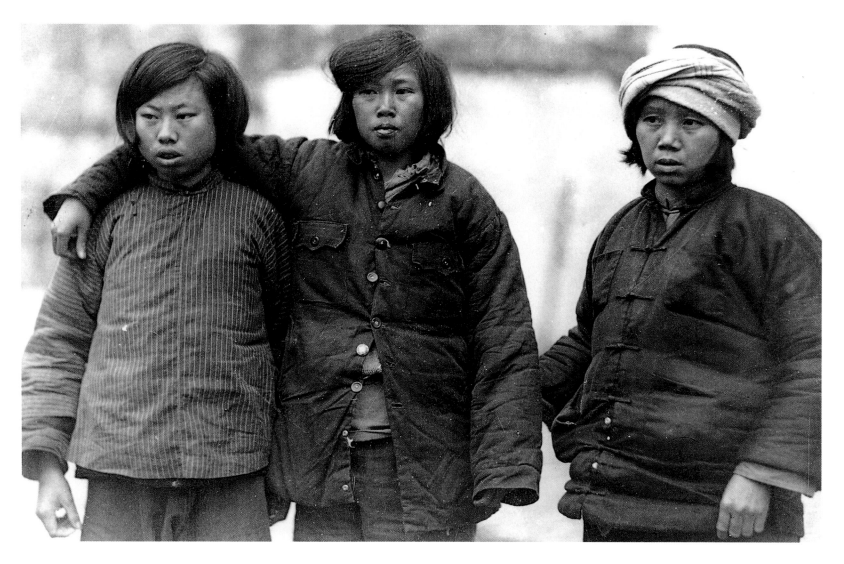

by drinking to eternal friendship with them in chicken's blood.

At least two-thirds of the Communist force had been killed in combat, had died of exposure, starvation and exhaustion, or had deserted by the time they arrived. But the survivors were battle-hardened veterans of a new kind in the Chinese revolution, and deeply loyal to Mao Zedong, who had managed to gain control of the party organization in the course of the march, early in 1935. But this was not the only surviving Communists force. Those who stayed behind in the Jiangxi area, and escaped being rounded up and killed by the nationalists, hid out in isolated pockets in the hills and forests, gaining a new kind of guerrilla experience in isolation from both the Party leadership and the local rural population. Later, regrouping, they were to form the nucleus of a new Communist army, which would play a major part in the coming war. Elsewhere in China, other small Communist groups survived, and even managed to reinfiltrate the cities.

But, as far as Chiang Kai-shek was concerned, the last real Communist threat was represented by the Long March survivors and their allies in Shaanxi. He focused his military attentions on that province in 1936, even as the Japanese were acting ever more aggressively against Chinese sovereignty. To remove the onus from himself, he ordered the final campaign to be coordinated by Zhang Xueliang who had been driven out of his homeland along with his

Manchurian troops by the Japanese in 1931. This move backfired: anti-Japanese sentiment was felt so strongly by both Zhang and his army, that they could no longer countenance the idea of continuing a murderous civil war while the Japanese grew daily more powerful. Chiang flew into Xi'an, Zhang's headquarters, to force the reluctant general to act in December 1936, unaware that Zhang had been meeting secretly with Chinese Communist representatives to arrange for a cessation of hostilities. On the night of December 12, Zhang's troops launched a surprise attack on Chiang Kai-shek's bodyguards, and captured the shivering Guomindang leader, who had fled to a cave in the hills wearing only a nightshirt when he heard the sound of firing. Though some Communist leaders wanted to use this opportunity to kill Chiang, their long-time enemy, they were dissuaded by Stalin, who believed the time was now ripe for a new national united front against the Japanese aggression, and that Chiang was still the most suitable leader for the task. They held Chiang captive until he agreed to drop his war against the CCP and direct the attentions of the nation to a new United Front against the Japanese. Grudgingly, Chiang agreed. Though he refused to put his acceptance in writing, when he was released on Christmas Day 1936 and flew back to his capital in Nanjing, the whole country knew what kind of a deal had been reached.

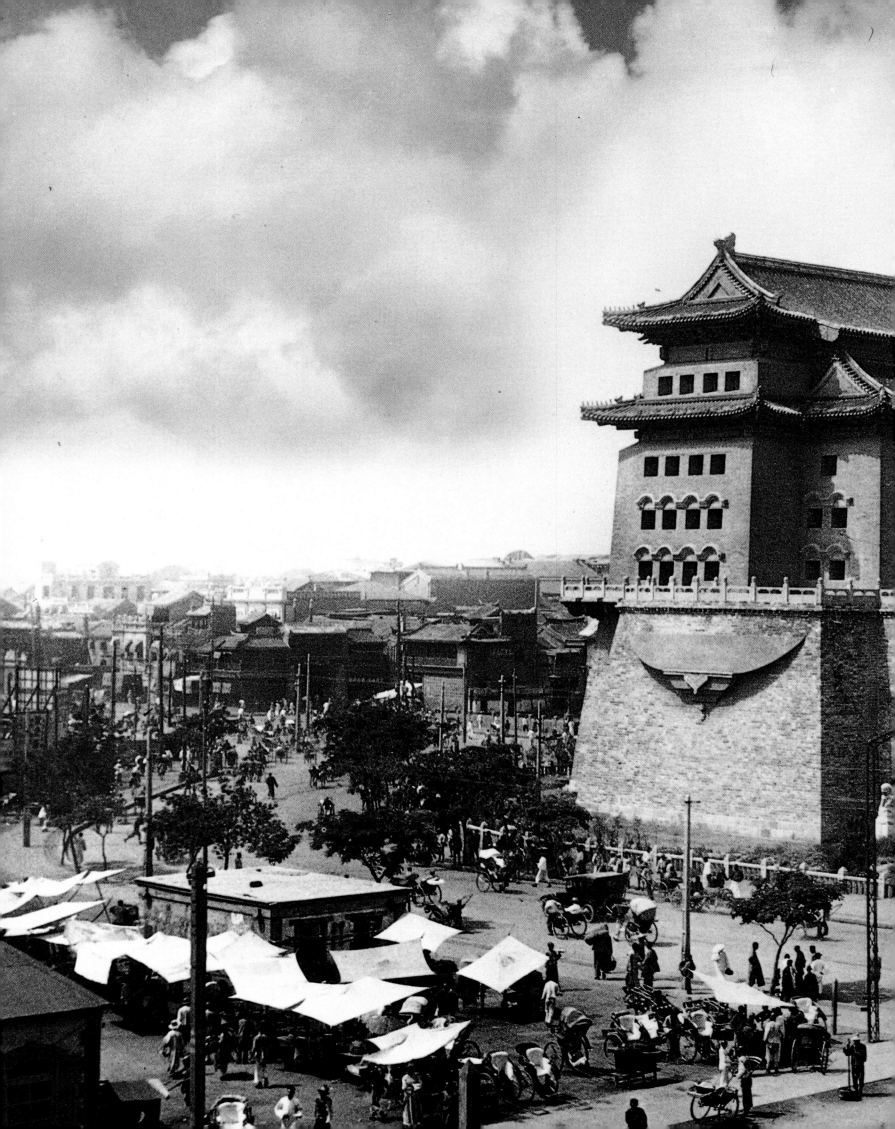

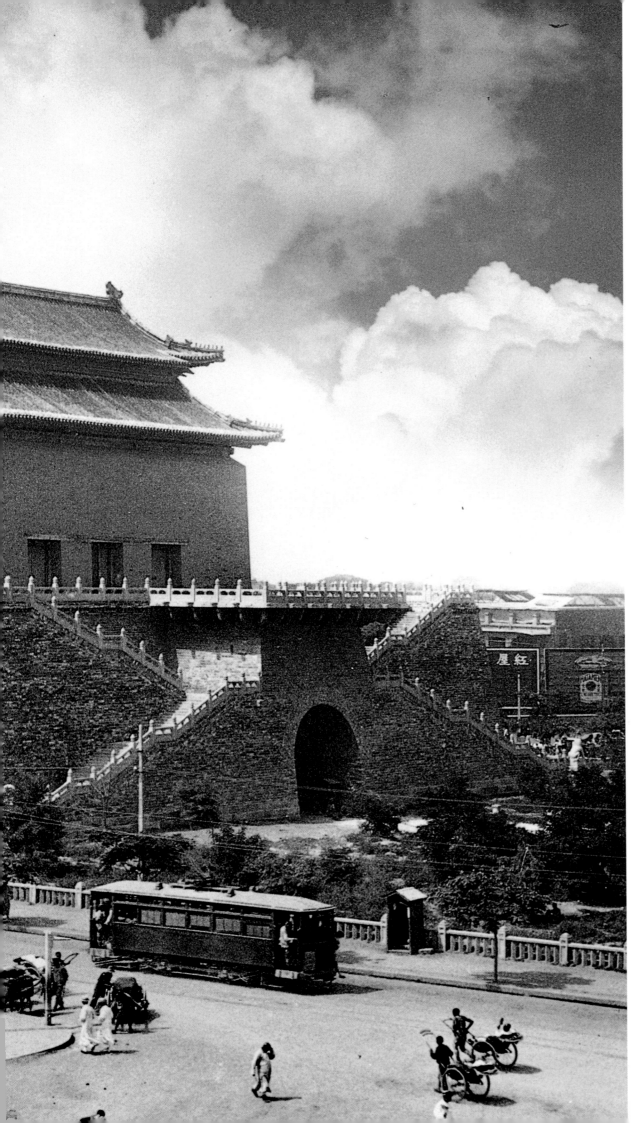

Peking's magnificent walls *and gates, mainly dating from the fifteenth century, were one of the city's glories. As symbols of China's mighty past, however, they stood in the way of progress. Successive municipal governments cleared away sections of the city walls to make room for the increasing number of cars, trams and buses. This tranquil picture conceals another story. New electric trams threatened to drive the traditional rickshaws off the streets and in October 1929 over 25,000 desperate and impoverished rickshaw-pullers rioted, severing the trams' power cables, smashing tram windows and destroying passenger shelters. They were dispersed by troops, the four ringleaders were publicly shot and nine hundred were expelled from the city.* [PHOTO: GEORGE KRAINUKOV]

117

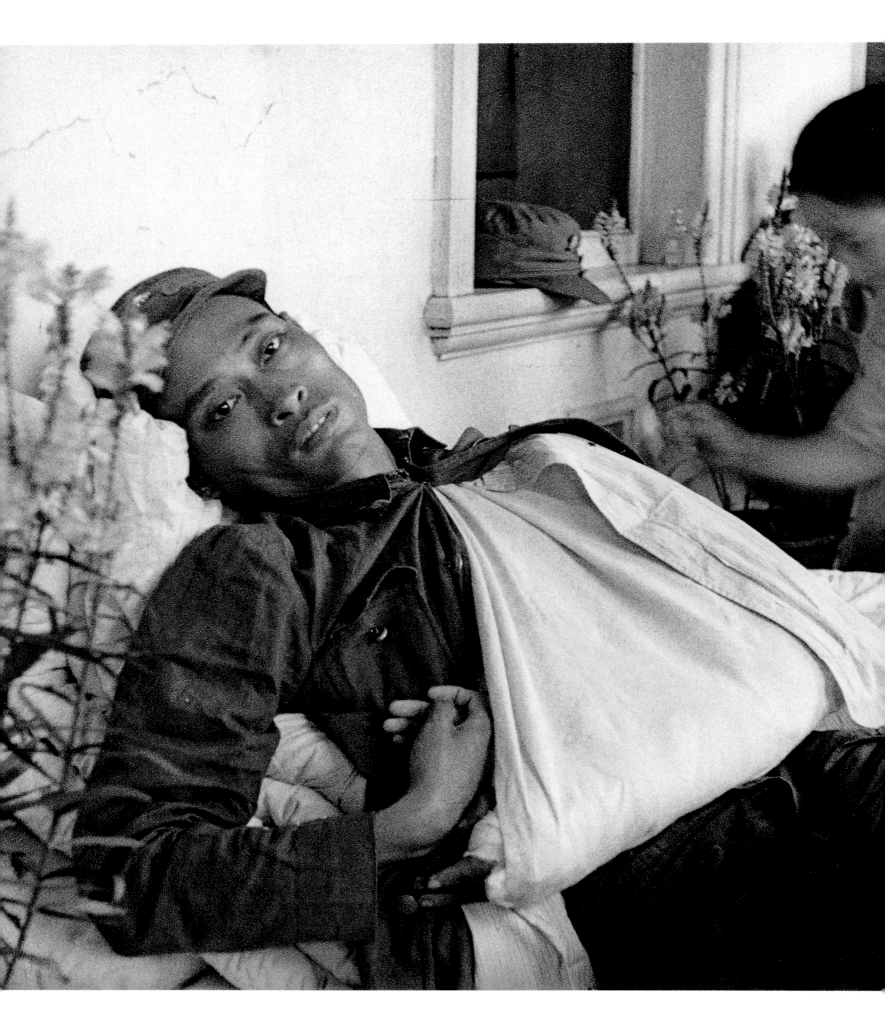

The wounds of China. *By August 1938, when this photograph was taken, Japanese troops had penetrated deep into China. This soldier, wounded during the Hankou campaign, was among the minority of Chinese casualties lucky enough to find a hospital and a nurse. Frank Dorn, United States military attaché, witnessed the chaos and horrors of the Chinese retreat towards Hankou, recording the 'deep dread among the thousands of bloody, filthy, wounded soldiers struggling to keep ahead of the enemy, begging for a bowl of rice, a clean bandage, a ride on a truck, a place to rest — even as their hollowed, feverish eyes showed they knew their pleas would not be heard.'*

This photograph was taken by George Krainukov (1888-1960), a White Russian who lived in Shanghai from 1922 to 1941. He recorded the unfolding drama in his country of exile, in both newsreels and still photography, and a number of his pictures are included in this chapter.

WAR WITH JAPAN

FOR FORTY YEARS, AS BOTH FEARED ENEMY AND admired model, Japan had dealt with either a weak or an uncoordinated China, playing one Chinese leader off against another. Now, with the formation of the United Front, the Guomindang, Communists, warlords, and the refugee Manchurian armies of Zhang Xueliang all agreed that the attempt to halt Japan must be given precedence over any other aspect of national politics. Writers, intellectuals, students and workers' groups all applauded the United Front in public, and suggested that in future the Guomindang, rather than suppressing them, should call on their loyalties.

Although there was an end to the fighting between rival armies inside China this did not help in the struggle against the Japanese. The Communists were poorly armed, and fragmented. Zhang Xueliang's troops, already suffering low morale from their years of exile, had now lost their only leader as well: as proof of his sincerity, Zhang Xueliang had offered to return with Chiang Kai-shek to Nanjing after the Xi'an kidnapping was resolved. Chiang accepted the offer, but as soon as they reached Nanjing he had Zhang tried by a military court on charges of mutiny and disloyalty. Zhang was initially sentenced to death, but Chiang commuted the sentence to life imprisonment; this was in turn commuted to permanent house arrest, which was rigorously enforced, and prevented Zhang ever playing an influential part in either Manchurian or Chinese politics again.

Chiang's own army was a curious mixture of the antiquated and the ultra-modern. During his Nanjing rule, Chiang had continued his alliances with the warlords who had supported him on the Northern Expedition and after. Many of these warlords stayed in their own provinces and had no resources to buy modern arms, ruling, often by intimidation, over hapless rural populations. The peasants protected themselves as well as they could from both warlords and the omnipresent bandits through militia groups and crop-theft prevention teams, armed often with little more than sickles or perhaps an aged musket or two. The ex-Whampoa cadets, who formed a nucleus of senior officers loyal to Chiang, were well-trained in military theory and in Guomindang ideology, but they often had little combat experience. Those who did have experience, like Cai Tingkai who had fought so brilliantly against the Japanese during the 1932 attack on Shanghai, were perceived as threats by Chiang so he transferred them to the country regions, and dispersed their forces.

During the 1930s, Chiang strengthened his armies by using the skills of German military officers in place of the ousted Comintern advisers. Having already helped Chiang drive the main Communist forces out of the Jiangxi Soviet, the Germans now

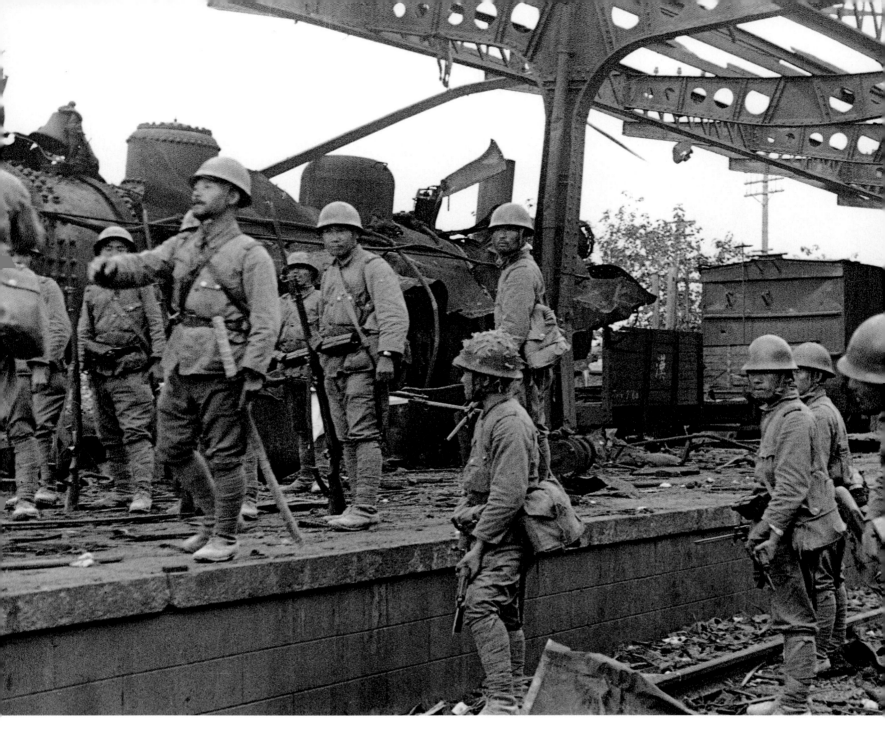

directed the construction of a system of defense works and reinforced block houses around Nanjing, in case the Japanese should try another attack on Shanghai and advance towards the Guomindang capital. They also warned Chiang that he must try and create a mobile strike force of well-trained and well-equipped troops – a division or two, or even less – from his sprawling armed forces and ready to move into action at any time. The Germans had not, however, taught Chiang how to respond to the kind of fast armored columns that the Japanese had been perfecting in their Manchukuo training grounds.

Chiang was always short of the money he needed for his armies, and not even the fiscal ingenuities of his brother-in-law T. V. Soong could keep the Guomindang solvent. Chiang sought to remedy this deficit in part by barter deals with the Germans, by which the latest German military equipment would be made available to China in exchange for China's rich resources of tungsten, otherwise unavailable to Germany, and essential in the

construction of tanks and armor-piercing shells. But these promising deals fell through when Hitler forged a major military alliance with Japan, and ordered an end to all military agreements that might seem to affect Japan adversely. The Americans, British and French, though all apprehensive about the growth of Japanese power, were mainly interested in preserving their special privileges in China, and limited their overt actions to a refusal to recognize the Japanese collaborationist regime of Manchukuo. This had little effect save to induce the Japanese to walk out of the League of Nations when the vote there went against them.

China's full-scale war with Japan grew from an apparently trivial incident in July 1937. Ever since the Japanese had forced the Guomindang to acquiesce in the formation of a demilitarized zone in north China between Beiping, Tianjin and the Great Wall, the Japanese army had been using the area for military maneuvers. Initially presented as training for their police forces, these exercises grew larger in scale and more provocative as 1937 wore on. In July,

The Fall of Hankou. *Japanese troops, led by an officer with samurai sword, survey the bombed wreckage of the Hankou railway station". The Japanese captured Hankou in October 1938. Its fall was a bitter blow to the Chinese, who had attempted to form a new government base and defensive perimeter there after their disastrous losses in east China. Once it was clear that the city would fall, the Chinese authorities tried to enforce a 'scorched earth' policy, planting explosives throughout the city, intending to leave it in ruins. But as soon as the officials had fled, Hankou residents removed the explosives, to prevent further damage to their property. The Japanese commander ordered a calm occupation of the city, looting was forbidden, and groups of 'patriotic prostitutes' were shipped in to service the victorious troops. Nevertheless, in Frank Dorn's words, 'when found, Chinese stragglers and wounded who had been unable or too weak to escape were kicked into the river'.* [PHOTO: GEORGE KRAINUKOV]

two of them fell on busy thoroughfares in the foreign concession areas. On another occasion a bomb landed outside two of Shanghai's largest and busiest department stores. The force of the explosions in the crowded spaces was so colossal that people were hurled into the air and smashed against the face of the buildings. Within a few moments, over a thousand people were killed, and thousands more injured.

The Japanese responded to this botched attack by landing troops and calling in reinforcements. The battle for the city was concentrated in the Chinese-controlled areas and suburbs, carefully avoiding the international concession areas. Such huge crowds of Chinese sought safety in these that the foreign police had to close them off. In the ensuing chaos, the Japanese established firm positions in the Chinese industrial suburbs and began to advance. Chiang Kai-shek sent his elite units into action, with orders that they were to hold the city at all costs, to defend China's national integrity. This order might have galvanized the country and made Chiang appear to be a strong and decisive leader, but it reduced his area commander's military flexibility. It also hardly squared with another order that Chiang and the Guomindang planners gave, to strip down the main industrial plants and move the machinery essential for industrial and military production by boat or road to designated inland staging points, of which the first was in the Wuhan tri-city region. The factory staff and selected skilled workers moved inland too, to complete what was a logistical triumph that paid off richly in the years ahead. In these months, too, universities in both north and central China began to pack up their books and laboratory equipment, and make plans to have their students and faculty move with these precious resources to new locations in the southwest of China, beyond the reach of the Japanese.

While this strategic withdrawal was underway, the Chinese troops fought tenaciously and bravely, and suffered enormous casualties, but they could not withstand the extraordinary firepower of the modern Japanese artillery, or their warplanes. When Japanese reinforcements landed successfully at Hangzhou, on the coast southeast of Shanghai, its defenders were forced to retreat. By December the retreat became a chaotic rout, compounded by hundreds of thousands of civilian refugees.

Meanwhile, the reinforced Japanese army in north China had been registering victory after victory. Having seized Beiping and Tianjin without a fight in late July, they used the railway lines to move their troops and supplies to the south and to the west. The Japanese reliance on the railway should have allowed the Chinese to check them by severing the lines, laying ambush or concentrating superior forces at certain key points. But there was no integrated defensive plan, and the uncoordinated Chinese forces retreated helplessly as city after city fell.

However, Japanese aggression was checked for a time at the strategic Shanxi city of Taiyuan. The area was rich in minerals, and its major road and rail junction controlled access to the Yellow River and to the agricultural and industrial heartland of the Wuhan region on the Yangzi River. Here, Chinese armed

as Japanese troops were digging emplacements near the Marco Polo Bridge, south of Beiping, shots were exchanged between their forces and Chinese troops posted nearby. The Japanese protested, but instead of withdrawing and apologizing — as they had done so often in the past — the Chinese stood their ground, and Chiang ordered reinforcements to their aid. Japanese garrison troops from Manchukuo began to move toward the area, while reinforcements were sent from Japan. By August the two nations were in open combat.

To forestall a repetition of the Japanese attack on Shanghai in 1932, Chiang Kai-shek ordered his newly trained air force to bomb the Japanese warships that were at anchor in the river off the Shanghai Bund. It was a day of violent and unpredictable wind, which made flying and aiming extremely difficult. Flying high to avoid the Japanese anti-aircraft fire, and utterly miscalculating the force and direction of the wind, the inexperienced Chinese pilots released their bombs. All the bombs missed the Japanese ships, but

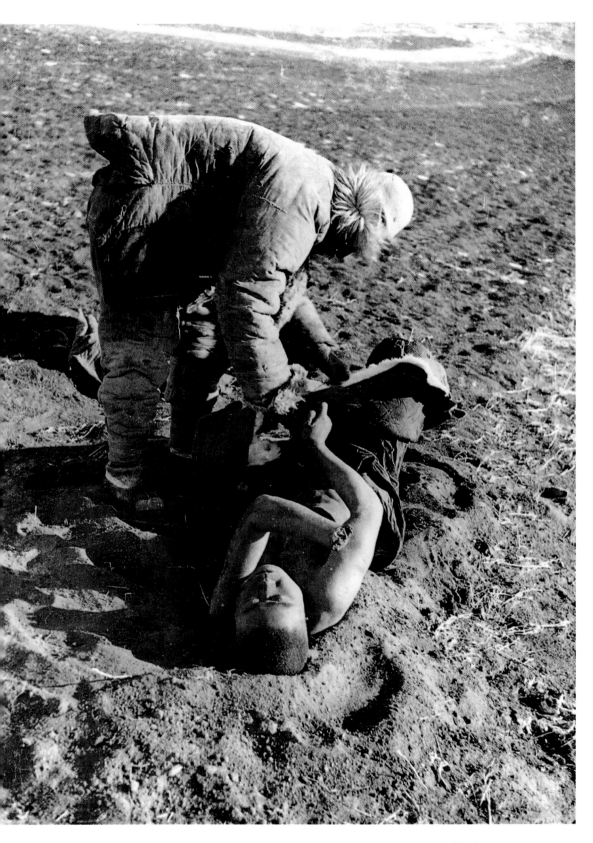

The fruits of war (above). *A dead Chinese soldier is stripped of his clothing by one of his former comrades. The victim was one of many killed in the shadow war between invading Japanese troops and mixed forces of Chinese regulars, local guerrillas and bandits, that took place before the Marco Polo Bridge Incident of July 1937. The photograph was taken by* Fang Dazeng, *a 25-year-old Chinese news photographer. who traveled south and recorded the outbreak of open combat after Marco Polo Bridge. He disappeared in the disastrous rout of the 132nd Division of the Chinese army in late July, presumed killed.* [PHOTO: FANG DAZENG]

Man and beast. *The number plate on the Dodge car* (right) *identifies it as a staff car from the 132nd Division, destroyed on the same battlefield south of Peking where Fang is reckoned to have perished. The Japanese ambush of the Chinese troops was witnessed by Frank Dorn: 'Caught in the cross fire, the Chinese were*

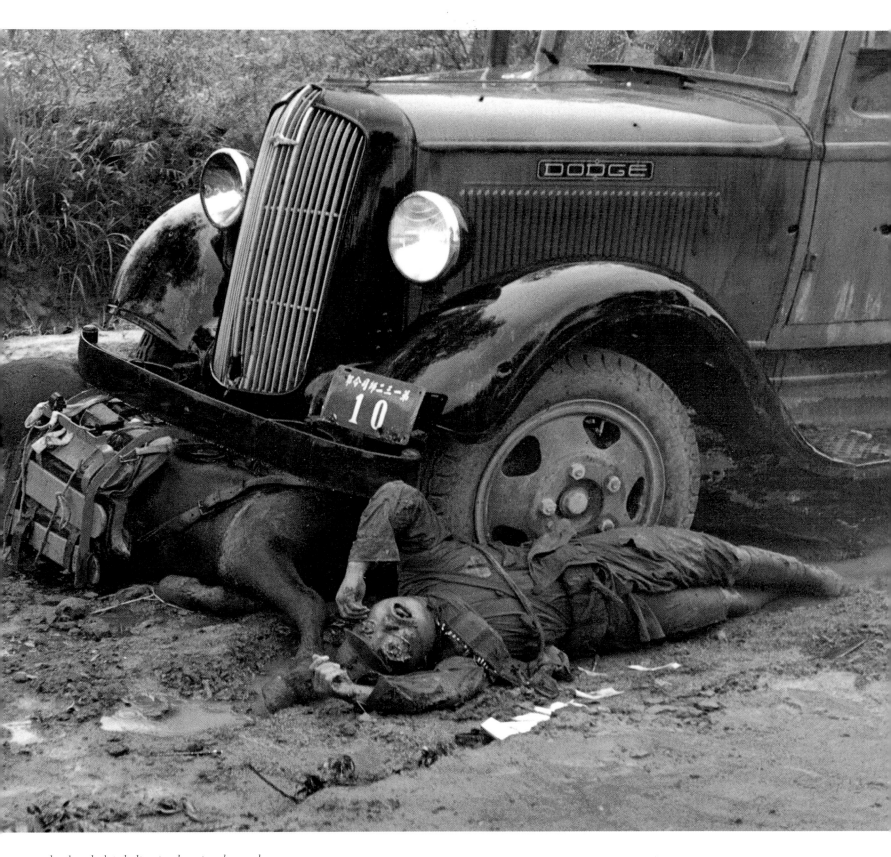

*slaughtered, their bodies ripped to pieces by metal
fragments. When the carnage was over, nearly six
hundred Chinese lay sprawled on the ground or hung
grotesquely from the sides of bullet-riddled trucks.' The
Japanese air force then bombed the wounded.*
[PHOTO: GEORGE KRAINUKOV]

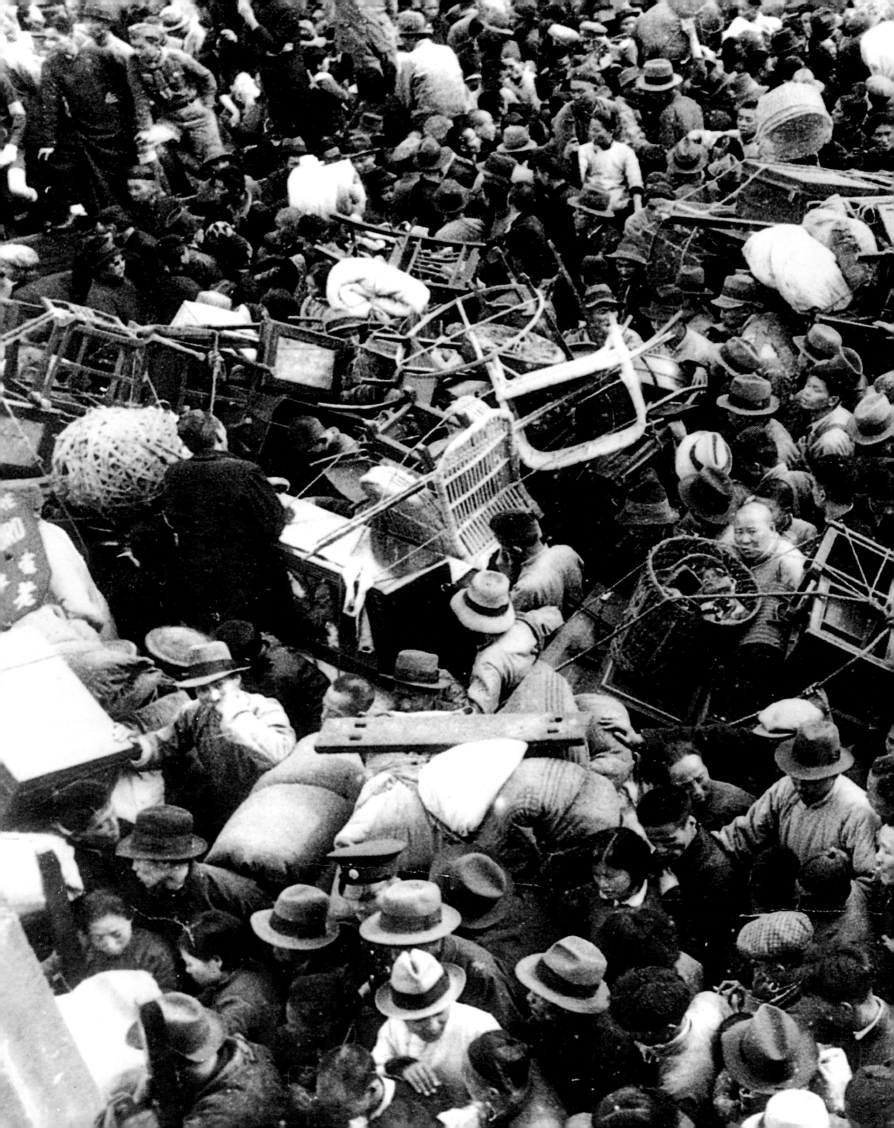

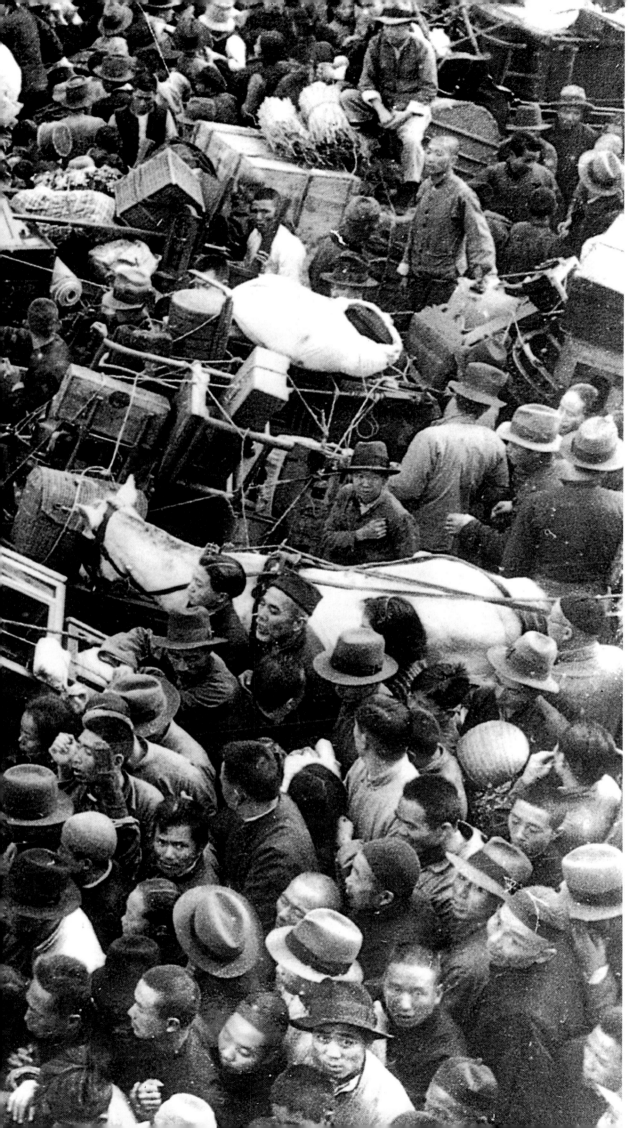

Panic in the streets. *In August 1937 the war spread to Shanghai. Japanese troops occupied the shores and docks along the Huangpu River and began shelling the city. Here Chinese civilians, bearing what possessions they can, push and struggle for safety at the gate of the French Concession.*

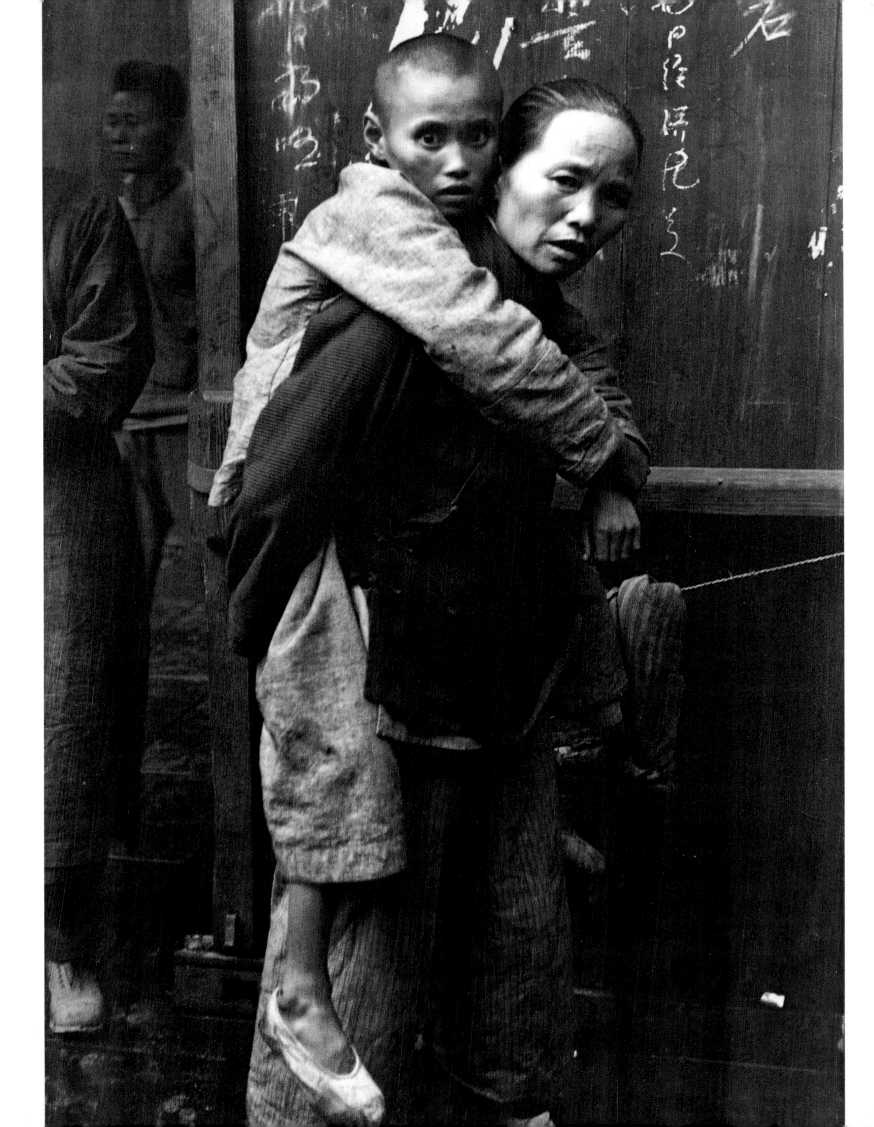

forces, including those of the Guomindang and of the Shanxi warlord Yan Xishan, fought for over a month to hold the city in the face of continued Japanese artillery and aerial bombardment. When the artillery breached the ancient city walls, there were days of bitter hand-to-hand fighting until the defenders broke and fled on November 8, 1937. Chinese civilians and troops struggled with each other on the only bridge that offered escape across the swift Fen River, often hurling each other off as Japanese aircraft strafed and bombed them. Ten thousand or more died, but such terrible casualties were becoming commonplace. The American military attaché, Frank Dorn, reported the Japanese reprisals following the Chinese Nationalist atrocities against Japanese civilians at the railway junction of Dongzhou a month before:

the Kwantung Army descended on the small city in overwhelming force: bombing, strafing, artillery and mortar fire. Japanese troops battered down the gates, poured into the town, and wreaked a terrible vengeance. Every man of the garrison they caught was killed and beheaded. Hundreds of women were raped. The place was sacked and then set afire. A vast column of heavy black smoke rose high in the sky. In a single day, Tungchow [Dongzhou], the former terminus of the Grand Canal, was reduced to blackened ruins, battered walls, death.

These Japanese atrocities were thereafter to be repeated in other captured cities of North China. Often, it appeared, Japanese commanding officers removed all restraints from their subordinate units until the appetite for violence had been sated.

In mid-December, 1937, the Nationalist capital of Nanjing suffered a similar fate. The Chinese troops fleeing Shanghai were in such disorder that they were unable to regroup and hold many of the carefully prepared defensive perimeters around Nanjing. Pouring into the city, they compounded the confusion within it; many deserted and abandoned their uniforms, often killing civilians for their clothes, as their own commanders panicked and fled. Japanese artillery and armored vehicles, supported by planes, and warships on the Yangzi, smashed through the Ming dynasty walls and gates, and massacred any surviving Chinese troops they could find. The Japanese had expected to negotiate their peace terms with the Chinese officers but they had either been killed or had fled the city. In their frustration, as a small number of helpless foreign diplomats and missionaries watched from their 'international security zone', the Japanese turned on the civilian population, and in an orgy of violence, killed and mutilated both

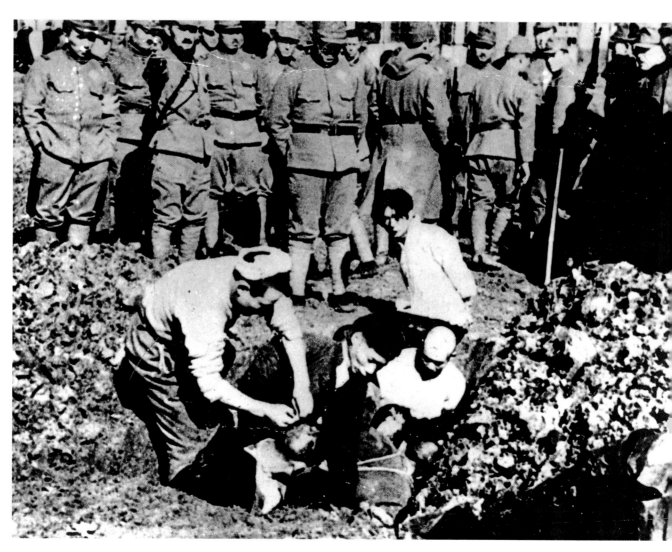

Shanghai refugees, *some wounded, others weak and terrified, like this mother and son, desperately sought safe havens in the Fall of 1937. These two had taken refuge in a safety zone within Nantao, agreed to by both the Chinese and Japanese and organised by several international bodies like the Red Cross.*
[PHOTO: GEORGE KRAINUKOV]

The Nanjing Massacre *of December 1937 will always stand as one of the most terrible events in the history of warfare. Evidence of rape and sadistic killing was often unwittingly provided by the Japanese participants themselves from their own 'souvenir' photographs. Here Japanese troops lounge with their hands in their pockets or look away in boredom, as their comrades prepare to bury Nanjing Chinese captives alive.*

adults and children, leaving a trail of horror that gave to the month of December 1937 the infamous and accurate name of 'Rape of Nanjing'. Frank Dorn reported the bloodbath:

> The Red Cross hospital…was the scene of some of the bloodiest carnage. Bandages were ripped off screaming men, who were then hacked and bayoneted to death. Broken arms and legs were rebroken with clubs. Between sessions of slashing and beating, nurses were repeatedly raped…By the end of December…over 20,000 civilian men of military age had been slaughtered. At least 20,000 young women and girls had been raped and murdered, and then gruesomely mutilated. Over 200,000 civilians, and possibly as many as 300,000, had been senselessly massacred.

China's new capital. *By October 1938, the Japanese had crushed valiant Chinese defences in Wuhan and mid-China and Chiang Kai-shek retreated far inland to Chongqing. Even here the Chinese were not safe from Japanese bombs, as shown (right), though worse damage was prevented by the sorties flown by the American mercenary pilots, known as 'The Flying Tigers' employed by Chiang.*

Nanjing victim. *A young man, awaiting his death, serves as a mute witness to the hundreds of thousands who died in the massacres there.*

Powerless now to check the catastrophic rout in north and east China, Chiang Kai-shek moved his surviving loyal forces to Wuhan, while he prepared to transfer the government of Nationalist China even further inland, beyond the Yangzi gorges, to the Sichuan city of Chongqing. The defense of Wuhan was initially successful, and was given a surprising boost in the form of close to 800 Soviet planes and pilots, made available by Stalin. Stalin believed, at this time, that it was in Soviet interests to resist Japanese aggression, and thus, despite the bitter anti-Communist policies that Chiang Kai-shek had pursued since 1926, he was considered a viable ally. The Wuhan defenders' confidence was also raised by a series of campaigns in east China in the spring of 1938, around the great railway and commercial center of Xuzhou.

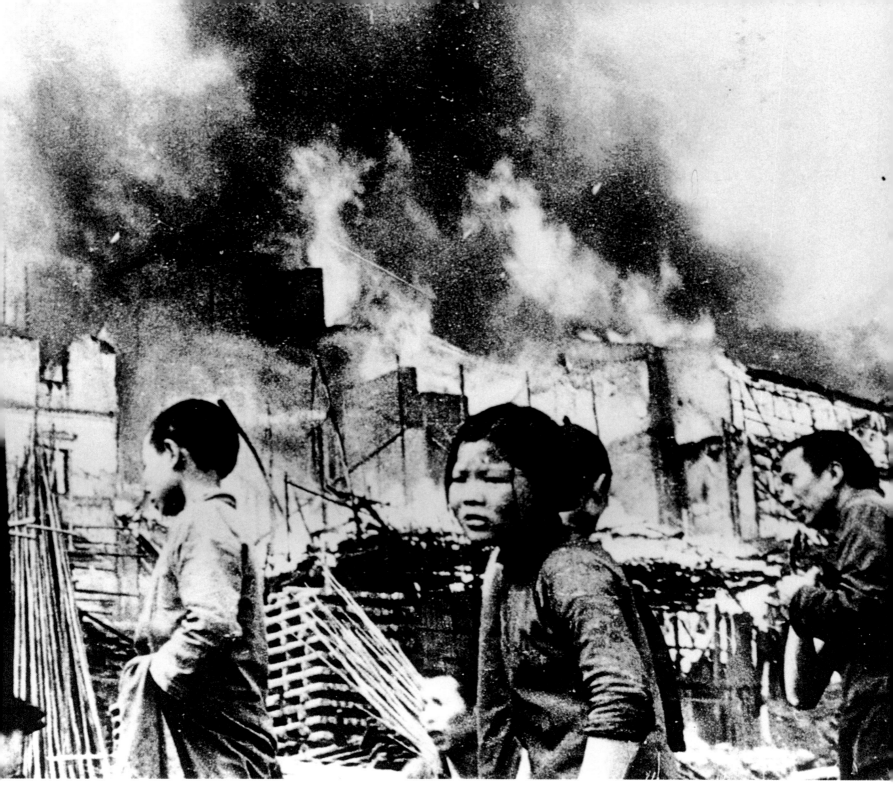

The Chinese fought for over two months with an amazing courage and determination, until at last the city fell on May 19. Often the battles were fought at such close quarters that artillery and planes could not be used, and the bayonet and grenade became the primary weapons.

In June 1938, Chiang Kai-shek gave the orders to blow the dikes on the Yellow River to try and check the Japanese advances, but beyond causing immense destruction to the local farmers and their fields, this dramatic action had little effect. All through that summer and early autumn, Japanese troops, reinforced by planes and armored vessels, pushed their way steadily across country and up the Yangzi River toward Wuhan, often massacring civilians and captured soldiers. Chiang Kai-shek had massed close to 800,000

troops in the Wuhan region, and they held out until late October 1938. But after so many months of strain, morale and battle coordination collapsed simultaneously, and the remaining Chinese troops retreated toward Chongqing as the Japanese occupied Wuhan.

During this terrible year of war, the American officers who had reported on the atrocities against civilians were also close observers of the Nationalist battle plans. Two of the most astute of these observers, Frank Dorn and Joseph Stilwell, were especially struck by the inability of Chinese nursing and medical personnel to do anything for the seriously wounded; the Chinese army, they reported, had almost no backup medical facilities or equipment at all, and an unbelievable number of Chinese wounded died. It could take weeks for wounded soldiers to reach medical aid, and often that was no

War on the move, war in the streets. *Hankou fell to the Japanese in October 1938, after being heavily bombed. George Krainukov, moving ever westwards with the shifting battlefields, caught this moment after a Japanese air raid in the summer of 1938. The injured lie on the street awaiting medical aid, but those passing by seem more interested in the camera than the suffering.*

The fighting flowed across the plains of northern China around Beiping, in the east from Shanghai to Nanjing, and in mid China towards the railway junction at Wuhan. The Japanese war machine seemed unstoppable. Within two years of the outbreak of open war at Marco Polo Bridge, Japanese troops from the north and east had reached and crossed the Yangzi.

[PHOTO: GEORGE KRAINUKOV]

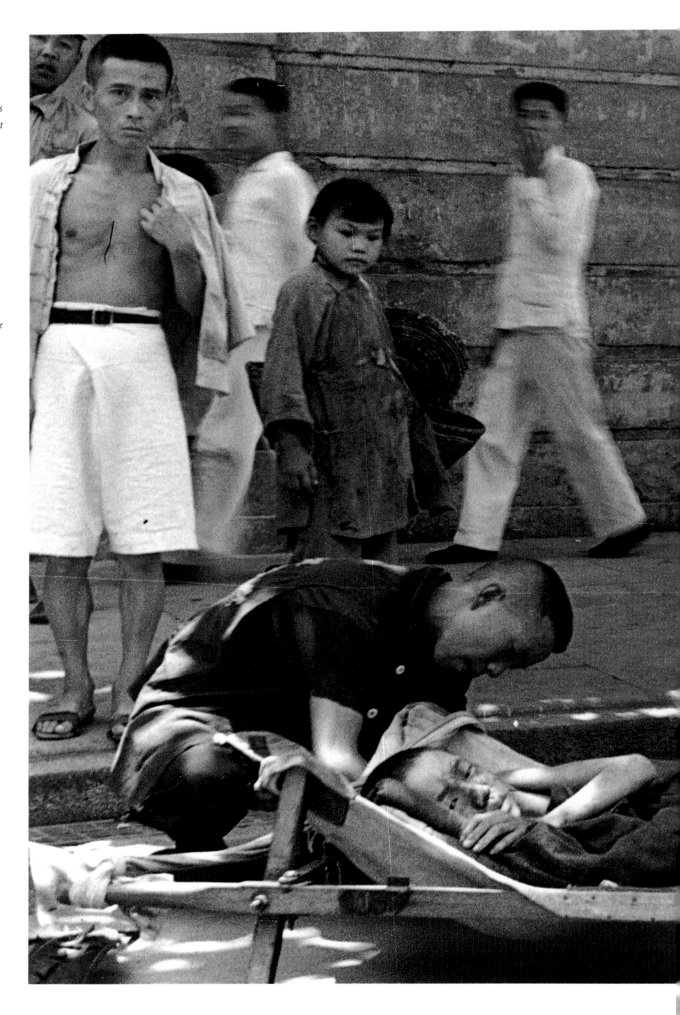

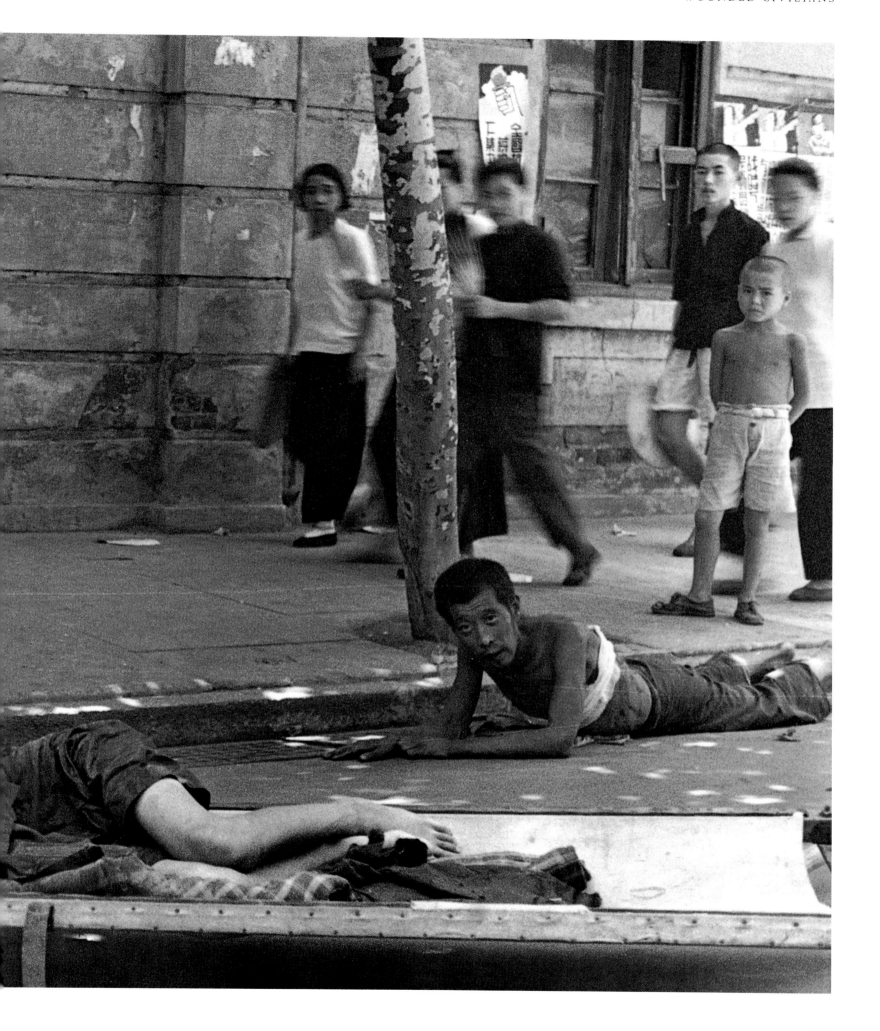

A vision of Cathay. *As well as capturing the specific face of war, George Krainukov compassionately viewed the people of China caught in the uncertainties of the times.*
[PHOTO: GEORGE KRAINUKOV]

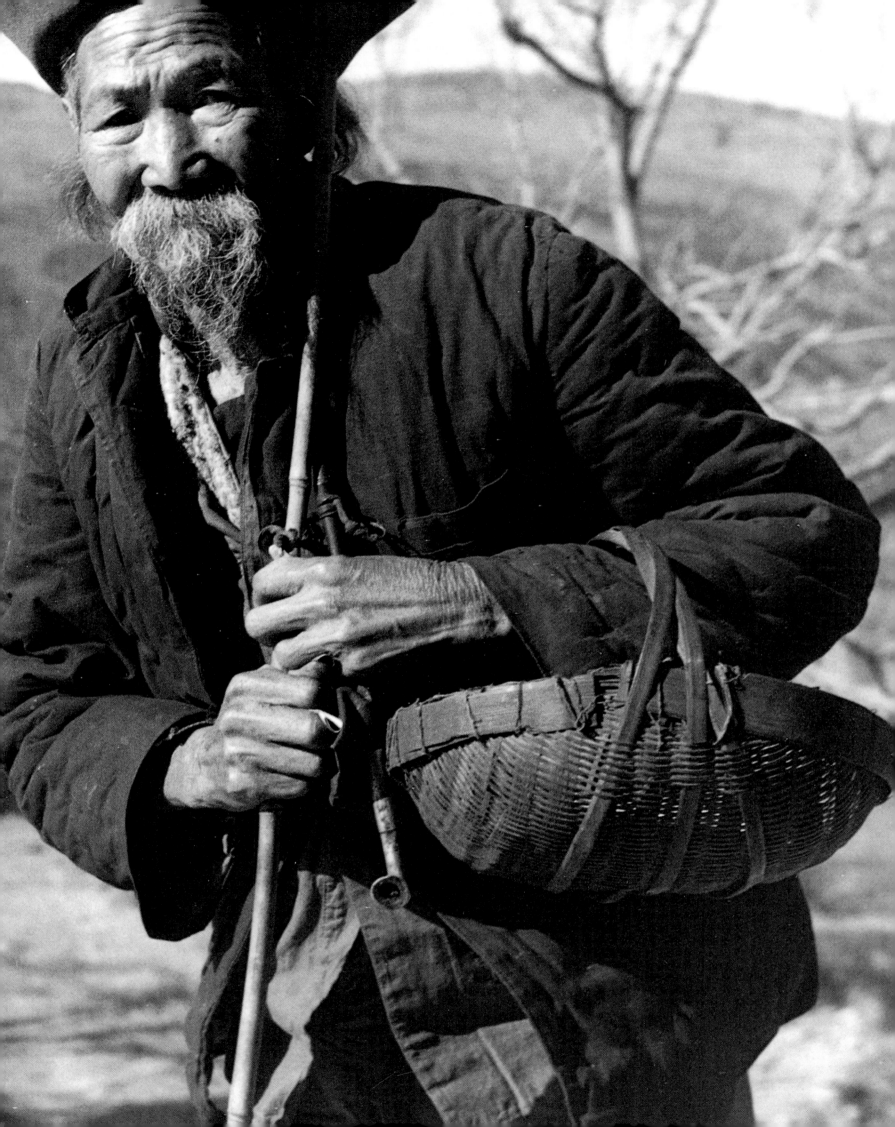

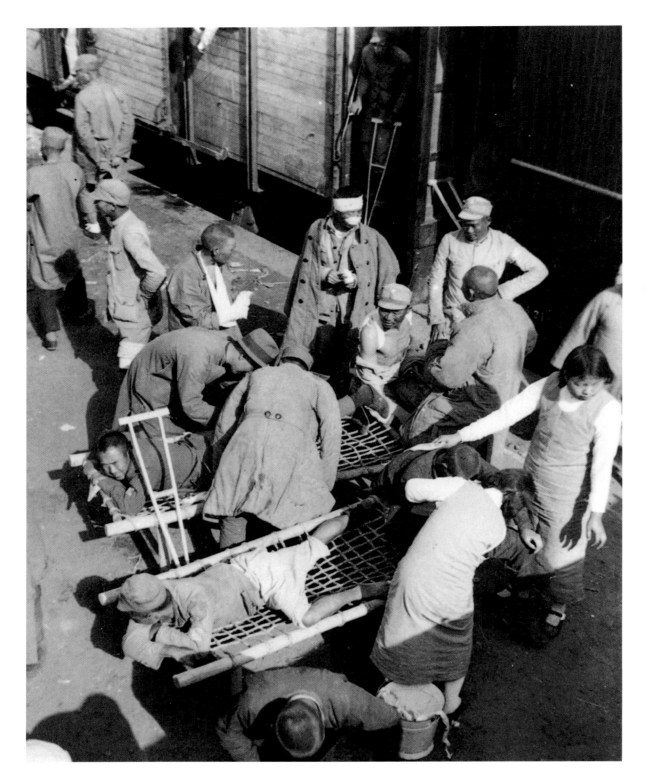

New hope for the wounded. *One reason for the incredibly high number of Chinese fatalities was the lack of provision for the wounded. Chinese troops are unloaded from freight cars (left) to be treated on a station platform. Norman Bethune (right, kneeling) was a Canadian doctor and veteran of the Spanish Civil War. He developed a system of field surgery that allowed doctors to go to the battlefield itself and treat emergency cases as they were brought in from the front lines. He is operating in a makeshift field hospital in a Buddhist temple, among Communist guerrillas in northern China. The equipment was life-saving but simple, and could be packed in ten minutes should Japanese troops break through.*

more than a field-dressing. Walking wounded were given five Chinese dollars and told to make their own way home; those less fortunate died of their wounds, of infection, dysentery and cholera.

Dorn and Stilwell's observations were confirmed by Norman Bethune, a Canadian doctor. Bethune was a committed supporter of the Communist revolution, who had come to Wuhan because he believed that the Chinese struggles against the Japanese mirrored the Republican struggles against the Fascists in the Spanish Civil War, where he had worked as a volunteer doctor. In Spain, Bethune had also noted that many troops died of simple

infections or from loss of blood before they could reach base hospitals; he thus developed a system of mobile blood transfusion units which could operate close to the battle lines. Bethune interpreted the Nationalists' medical incompetence as deliberate callousness, and thus he took his medical skills and ideas to the Communists. By early 1938 he had traveled north through the Nationalist lines, and made his way to the Communist base area in Yanan.

The Communists, almost destroyed during the Long March, had been given a desperately needed respite by Chiang Kai-shek's kidnapping in Xian, and the United Front agreement. Their

guerrilla armies were now technically incorporated into the anti-Japanese defense forces of the Nationalists, but they kept complete command of their own units. They also continued their own social policies in Yanan, but, in deference both to the United Front strategies and to the isolated peasant and landlord society among whom they were sheltering, they muted their calls for radical land reform. They turned their sights instead to partial rent reduction, and to the redistribution amongst rural communities of the land of those landlords who had actually fled the area, not touching the land of those who remained.

The Communist leaders skillfully used the call of anti-Japanese nationalism to increase their own visibility and popularity. The techniques of mass mobilization, which they had developed over the previous decade and a half through their organization of striking workers or peasant resistance in the Jiangxi Soviet, now proved invaluable. Using small groups of Communist cadres, they moved among the village communities, identifying potential village leaders, and teaching basic principles of military organization and guerrilla warfare. Armed only with the simplest, often homemade weapons, Communist-led guerrilla units began to harass Japanese supply lines, catch stragglers, and to surround small isolated detachments or garrisons of Japanese troops so that they could capture their arms and ammunition. When possible, such rural guerrilla units linked up with the small groups of Chinese Communists that had survived in isolated pockets during the 1930s; these groups had often formed networks of local sympathizers that could either be developed into Communist cells or made the basis of a local militia defense force. Larger guerrilla groups were briefly united to cut Japanese-controlled railway lines, or to attack and seize larger Japanese supply trains or company-sized forces.

Moving with such irregular rural and Communist forces, Bethune found the perfect use for his skills. He could set up a small-scale field hospital near the projected area of battle in a temple or abandoned landlord's home, with everything so arranged that it could all be packed and moved out in less than ten minutes. Simple blood transfusions, urgent amputations, the use of antiseptic and saline intravenous solutions allowed Bethune to save many lives. He felt he was reaching the troops who needed him most, and he built up immense respect for the Chinese peasant recruits and the area commanders whom he encountered.

Bethune died in 1939, of infections sustained during a long series of emergency field operations. The sense of admiration that he had developed for rural Chinese resistance to the Japanese, and for the stoic courage and physical endurance of the Chinese, was something that the few other Westerners who managed to get to Yanan or the border region governments – such as Edgar Snow, James Bertram, Anna Louise Strong and Evans Carlson – shared with him. The Communist leaders these Westerners met lived in caves in the arid mountain terrain of north China, ate the coarsest food, and seemed to have a dedicated and single-minded political commitment. The fact that most people in the region lived in caves because there was no other housing, and ate coarse food

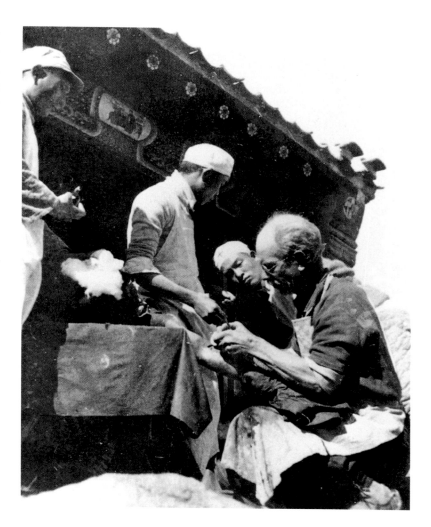

because there were no other supplies, was not of key importance to these visitors. Such deprivation was seen as virtue, and proof of political and moral purity, as is reflected in Edgar Snow's account of the Long March:

> They sang nearly all day on the road, and their supply of songs was endless. Their singing was not done at a command, but was spontaneous, and they sang well...What discipline they had seemed almost entirely self-imposed. When we passed wild apricot trees on the hills there was an abrupt dispersal until everyone had filled his pockets...But when we passed private orchards, nobody touched the fruit in them, and the grain and vegetables we ate in the villages were paid for in full.

Writing with enthusiasm and conviction of their experiences among the Communists of north China, these Westerners gave a welcome ray of hope to those who had begun to be dismayed by the disasters suffered by the main Guomindang forces.

Many Chinese were attracted neither to the leadership of Chiang Kai-shek from his newly chosen base in Chongqing, nor to the Communists and their cave-based guerrilla warfare. Instead, they looked for a way that they could collaborate to some extent with the Japanese in order to maintain some form of viable life in their occupied cities. In these newly created pockets of stability, the collaborationists argued, the organizational skills of the

Party leaders. *Communist leaders in Yanan three weeks before the outbreak of the war with Japan: from the left, Zhou Enlai,* *Mao Zedong and Bo Gu. Mao had overtaken Zhou and Bo Gu to become Party leader on the Long March, in 1935.*

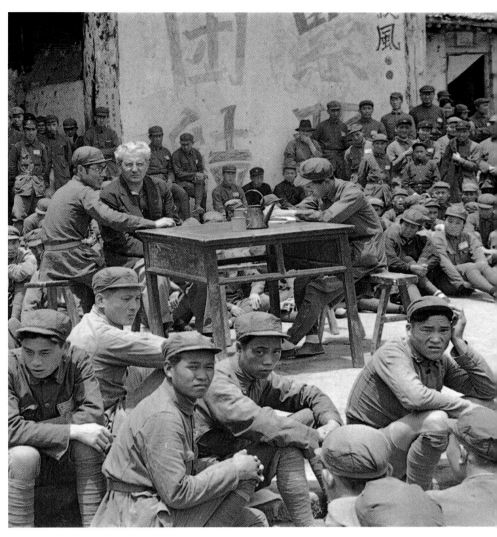

'Fellow Travelers' (*Top right*) *In summer 1937 Communist troops await a briefing from the Soviet diplomat and theoretician, Adolf Joffe. As discussions with Chiang proceeded, the Party saw study groups such as this as essential in maintaining Party orthodoxy. The ebullient American Agnes Smedley (right) was also in Yanan in 1937. She tended to romanticize the Communists and their leaders, such as Zhu De, here. Zhu had been a soldier, a warlord officer and an opium addict before joining the Party in Germany in 1923. He became commander of all the Communist forces, and Smedley wrote a sympathetic bigraphy of him.* [PHOTOS: OWEN LATTIMORE]

The fog of war. *Japanese troops don gas masks in a training session. Chinese field reports from September 1937 listed 400 fatalities from Japanese gas attacks in Hebei province. The Japanese also pumped gas into the tunnel systems that Chinese partisans had built under their villages.*

Japanese, and China's own economic and human resources, could be brought together to engender a new China. These were specious arguments to those who had noted the impotence of Puyi's government in Manchukuo, against the omnipresent power of the Japanese. But Puyi, after all, was a Manchu, and the Japanese had been strengthening their hold over that region ever since the turn of the century.

In Beiping, the Japanese established a new regime after their conquest of the city in 1937. The Chinese business community actively cooperated with their conquerors to form a 'peace preservation committee', and induced Wang Kemin to be their new government's chief executive. Wang was a fine classical scholar, who had obtained one of the senior examination degrees under the late Qing, studied in Japan, and served as a Qing official in several capacities. Moreover, after the 1911 revolution he become an expert economic administrator, and consequently minister of finance in several warlord cabinets, managing director of a Sino-French banking consortium, governor of the Bank of China and financial adviser to both the Manchurian warlord Zhang Zuolin, and his son Zhang Xueliang. Wang's power as head of the Beiping government was reinforced by senior officers of the Japanese Special Service assigned to Beiping, as well as by a so-called 'New

People's Association'. Following the lines of similar associations established earlier in Taiwan and in Manchukuo, members were expected to espouse and propagate Japanese imperial values, foster unity between Chinese and Japanese, and mobilize Chinese manpower to help the Japanese war effort.

Wang Jingwei's route to power under the Japanese was very different. In the late Qing, as an anti-Manchu terrorist he had tried to assassinate the regent acting for the boy emperor, Puyi, in 1910, and was almost executed as a result. An active supporter of Sun during his second exile and his return to Canton, Wang Jingwei was the leading voice of the left-Guomindang at Wuhan during the troubled days of 1927, and thereafter an anti-Communist leader within the new Guomindang government. Although Wang considered himself a fervent Chinese Nationalist,

in the 1930s Chiang Kai-shek regularly told him to negotiate agreements with the Japanese, which made Wang seem a pro-Japanese appeaser.

Wang Jingwei watched the military disasters of 1937 and 1938 with mounting dismay and anguish, and was unable to see how China's current policies and leadership could save the country from collapse. He doubtless knew that in late 1937, just before the Rape of Nanjing, Chiang Kai-shek had been approached by German emissaries bearing an offer from the Japanese of a peaceful settlement to the hostilities. When the Nanjing massacre was followed by a Japanese demand that in any settlement the Chinese Nationalists must also recognize the government of Manchukuo, all possibility of negotiations came to an end. But in early November 1938, just after the fall of Wuhan, the Japanese premier Prince Konoe issued his call for the formation of a 'New Order in Asia'. In this 'new order' under Japanese leadership, the Chinese, the people of Manchukuo and others in the Far East would unite in cooperation against the Communists, and (by implication) against the dominance of the Western powers in the region by the formation of a new concept of international justice. On November 30, 1938, shortly after Konoe's announcement, two of Wang Jingwei's closest associates met with a senior Japanese staff officer in Shanghai to explore these ideas more thoroughly, and to sign some preliminary accords.

Exactly between these two events, on November 12, one of the worst disasters of the China war occurred in Changsha. On that day, one of Chiang Kai-shek's closest military aides and confidants, the governor of Hunan province residing in Changsha, panicked at a rumor that Japanese troops were approaching the city. Without confirming the reports, he ordered the city set on fire. His order was obeyed, and in the terrible conflagration immense casualties were suffered by the 800,000 citizens and refugees who were crowded there, along with incalculable damage to property and cultural treasures. In fact Japanese troops were no-where near the city, and the grotesque misadventure must have further undermined Wang Jingwei's belief in the Guomindang leadership.

Wang Jingwei laid his plans carefully, and after a series of negotiations with Japan and two attempts by Chiang Kai-shek to deflect him — once by bribery, and once by assassination — he traveled to Shanghai, where he met members of Wang Kemin's Beiping regime, the collaborationist leader of Shanghai, and Japanese negotiators. The 'Readjustment of Sino-Japanese Relations', was signed in late 1939. The Guomindang flag now flew once more and the jurisdiction of Wang Jingwei's new 'National Government' in Nanjing, with Sun's 'Three People's Principles' as its official ideology, nominally extended from the Huai River in the north to Hainan Island in the south, eastwards to Shanghai and Zhejiang and westwards to the borders of Sichuan. In imitation of Chiang Kai-shek, Wang established his own Central Military Academy in Nanjing. Drawing on these new officers, on the Guomindang armed forces that had remained in the area, and on various warlord troops, Wang's army reached a strength of around 600,000 men. Foreign acceptance of a selective kind also came, as Wang's regime was 'recognized' by Germany, Italy, Spain, Vichy France, Rumania, Hungary, Japan, Manchukuo and Thailand.

Though Chiang Kai-shek's agents, under the guidance of Chiang's security chief Dai Li, had assassinated numerous Japanese collaborators in the Shanghai region in the late 1930s, once Wang's regime was established the number of assassinations dropped precipitously. There might have been some form of prior deal because both Wang and Chiang Kai-shek, whatever their other profound disagreements, shared a deep hatred and suspicion of Communism. Wang's Nanjing regime joined the anti-Communist pact, led by Japan and Germany, as one of its first diplomatic moves; and despite the United Front, Dai Li's agents never relaxed their anti-Communist vigilance.

After the fall of Wuhan in October 1938, and the Changsha disaster of November, the Japanese launched no more major assaults on the Chongqing regime, which was now free to develop its military and industrial base as the Japanese consolidated their military lines of communication and planned for their longer term military future. It was the Communists who kept the war momentum going in this period. Perhaps believing that their own rural mobilization had given them new strength, they abandoned their previous guerrilla strategies, and in 1940 launched a series of major assaults against the Japanese in north China, which they termed the 'One Hundred Regiment Offensive'. These attacks were soon countered by the Japanese army with extraordinary ferocity, in a campaign that came to have the generic title of 'kill all, burn all, loot all'. While the Communist forces endured shattering losses, the villages in which the fighting occurred suffered even more. The Japanese often killed, maimed, or raped every person they encountered; villagers hiding out in the underground tunnels the Communists had taught them to dig were smoked out, or died in their burrows as the Japanese filled them with poison gas. The result of the One Hundred Regiment Offensive was an immense loss of prestige and popularity for the Communists, which was to take years to rebuild.

While the Communists suffered as many as 100,000 casualties at Japanese hands in this campaign, they were also engaged by the Guomindang armies in central China. Dai Li alerted Chiang to the number of former Communists in the area who were not obeying the Guomindang orders, and Chiang ordered the Communist 'New Fourth Army', operating south of the Yangzi, to retire north of the river or face punitive discipline. When the Communists delayed, Chiang ordered his generals in the region to launch a surprise assault against them. In a few days in January 1941 the Guomindang killed at least 3,000 Communist troops in a series of ambushes, and arrested and executed many more. As the shattered troops regrouped and began to pull north, the Guomindang embargoed any military-related supplies, salt, and other scarce resources, moving across the southern borders of the Yanan regime's areas of control. The war with Japan seemed to be giving way, once again, to a war of Chinese against Chinese.

An American adviser *and his Chinese trainees apply chopsticks to their combat-issue 'K rations' in Yunnan in late 1943 or early 1944. Japan's attack on Pearl Harbor in December 1941 had brought the United States into the war as China's ally. Chinese units, newly trained by the Americans, later fought courageously in the 1944 Burma campaigns, proving the contention of American commanders that, 'if well led, paid, and equipped', the Chinese troops were as good as any in the world.*

WORLD WAR AND CIVIL WAR

BETWEEN 1938 AND 1941 CHIANG KAI-SHEK'S REGIME in Chongqing had been almost totally isolated. Its only open line of communication with the outside world was the Burma Road, carved through the mountainous forests from Kunming to Lashio in northeast Burma by thousands of coolie laborers. Built with almost no modern construction equipment of any kind, the project had cost many lives among its conscripted laborers from accidents, earth slides and disease. The unmetalled road was constantly hit by mudslides and flooding, and was often closed due to bad weather, or to the diplomatic pressures put on the British government in Burma by the Japanese. But its completion was still a triumph of Chinese tenacity in the face of the harsh pressures confronting them.

The Hitler-Stalin pact of 1939 had ended any further chance of Russian help. Chiang appealed to the American Congress for loans, but financial aid was not forthcoming as the US grappled to recover from its own Great Depression. The only significant source of outside help for Chongqing came from a small group of American fighter pilots, known informally as the 'Flying Tigers'. These pilots were hired by Chiang in 1937 to help train a more effective Chinese air force, and later they fought as mercenaries, receiving a bounty of $500 for each Japanese plane they downed. Under their popular leader, Claire Lee Chennault, a veteran pilot from World War I who had been invalided out of the US Army Air Force for hearing disabilities, these flyers in their squadrons of outdated P-40s that the United States government had sold to China, notched up impressive victories over the Japanese. Their prowess checked some of the worst of the Japanese bombing attacks on Chongqing, and gave a much-needed morale boost to the Chinese defenders, but they could hardly change the direction of the war.

With the formal entry of the United States into the war after Pearl Harbor in December 1941, the Chongqing regime became the official ally of the United States. China was also named as one of the 'Big Four' powers of the free world, along with the United States, Great Britain, and the Soviet Union. Under the structure of America's wartime financing, China was eligible for 'lend-lease' war matériel which meant that military equipment, trucks, fuel and planes would be 'loaned' to China but would not have to be paid for if they were used in combat against the Japanese.

The collapse of the British forces in Singapore, after only one day of fighting in February 1942, added urgency to the Chinese military role. President Franklin D. Roosevelt then chose Joseph Stilwell, formerly a United States military attaché in China, who knew the country well and spoke the language, to be coordinator of the lend-lease program, commanding officer of American

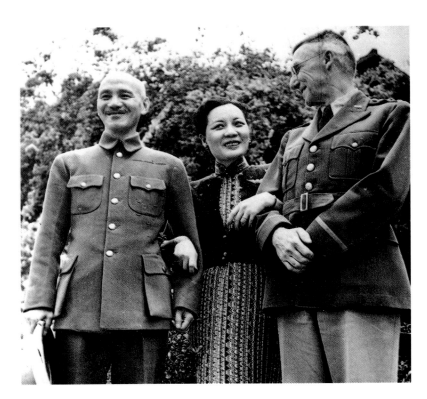

With the loss of Burma and his supply line Chiang Kai-shek had to look to the air. Chennault's Flying Tigers had now been incorporated into the regular wartime US Air Force, while Chennault had been retained in China and promoted to Brigadier General. With reinforcement and replacement planes coming in from the galvanized American wartime factories, a new aerial supply route was opened from India into Kunming, flying light bombers over the Himalayas by the long and dangerous route known as 'The Hump'. To increase effectiveness, American engineers cooperated with the Chongqing government to build new airfields, using tens of thousands of coolie and conscripted laborers to level the land and crush stone for the landing strips. Some of these were well to the east of Chongqing, in the region around Guilin. From these bases, Chennault and the Chinese supporters of airpower hoped to launch bomber attacks on the Japanese in east China, and eventually to raid the Japanese home islands.

Chennault won the support and affection of Chiang Kai-shek and his wife Soong Meiling. He was bowled over by Madame Chiang's youthful looks and command of English, which she spoke with a 'southern drawl'. He later wrote in his diary, 'She will always be a princess to me.' Chennault revered both of them as inspirations for their country and as great leaders. This view was shared by many former China missionaries, and other Americans, who saw Chiang Kai-shek as a symbol of the 'free world' that the allies were fighting to restore. Some reporters, however, were not captivated by Madame Chiang. The English writers W. H. Auden and Christopher Isherwood perceived her formidable qualities when they met her in 1938:

> She is a small, round-faced lady, exquisitely dressed, vivacious rather than pretty, and possessed of an almost terrifying charm and poise. Obviously she knows just how to deal with any conceivable type of visitor... She could be terrible, she could be gracious, she could be businesslike, she could be ruthless; it is said that she sometimes signs death-warrants with her own hand... Strangely enough, I have never heard anybody comment on her perfume. It is the most delicious either of us has ever smelt...

Stilwell was far from convinced. He found Chiang Kai-shek ineffective and vacillating, and his staff and senior officers riddled with corruption.

> [Chiang] writes endless instructions to do this and that, based on fragmentary information and a cockeyed conception of psychology; in fact, he thinks he knows everything, and he wobbles this way and that...it is patently impossible for me to compete with the swarms of parasites and sycophants that surround him.

He also believed that Chennault's claims for the superiority of air power were overblown and unrealistic, that the forward Chinese

Brief harmony. *Chiang Kai-shek, Madame Chiang and General Stilwell are all smiles in April 1942 – Chiang has just put his false teeth in for the photo. Harmony between Stilwell, newly appointed American Commander in China, and Chiang was shattered by the rout of the Chinese and their refusal to heed 'Vinegar Joe' Stilwell's orders. Stilwell said he and Chiang were 'on a raft, with one sandwich between us and the rescue ship is heading away from the scene'.*

First Ladies. *In late 1942, Madame Chiang traveled to Washington, to drum up support for her husband. Congress gave her a standing ovation; Eleanor Roosevelt, the President's wife, entertained her at the White House (right). Stilwell regarded Madame Chiang as a 'clever, brainy woman', and most Americans fell for her charm, though some were shocked by her penchant for silk sheets.*

troops in the newly constituted 'China-Burma-India Theater', and the president's personal representative to Chiang Kai-shek. Arriving in China in March, 1942, Stilwell plunged at once into the campaign against the Japanese in Burma. After several weeks of difficult fighting, the allies collapsed, the Japanese severed the Burma road and overran the whole the country, pushing up to the Indian border. Stilwell characteristically voiced his frustration: 'I can't shoot them, I can't relieve them; and just talking to them does no good. So the upshot of it is that I am the stooge who does the dirty work and takes the rap.' Furious and humiliated, he managed to walk unharmed out of Burma to India with a small group of Chinese and American troops. But for the rest of his life he blamed the defeat on the inept commands of Chiang Kai-shek, the cowardice of several of Chiang's senior officers, and on the arrogance and racism of the British, which Stilwell felt had so alienated the local populations that they welcomed the Japanese in their place.

airfields could not be defended in the face of determined Japanese attacks, and that much of the tonnage flown over the Hump was being wasted or stolen. Stilwell himself believed the key to China's war effort lay in training a small number of elite Chinese divisions, under a carefully selected group of the best Chinese officers, so that they could launch a counter-attack on the Japanese in Burma, reopen the supply lines, and then slowly and carefully move from the area around Chongqing in order to deepen Chinese control. To this end, Stilwell spent much of his time in India supervising the training of the elite divisions, and in Burma as soon as the campaign there reopened in 1943. He also traveled to Washington – as did Chennault – to argue his case.

While these strategic arguments were taking place in Chongqing, Kunming, and Washington, the Communists were slowly recouping from their devastating losses after the One Hundred Regiments Offensive and the New Fourth Army incident. With the United Front now in tatters, the Communists felt free to resume a more active program of land reform, social control, and mass mobilization. Coordinated from the central base area of Yanan, the number of border region governments slowly grew, and the number of Chinese reached by Communist organizational techniques and propaganda expanded proportionately. The need to

capture supplies and munitions remained one of their highest priorities, and they continued to harass Japanese and collaborationist supply lines and garrison units.

The Yanan government was desperately short of funds; it controlled almost no industrial resources, had a shaky currency, and could not afford to alienate its mainly poor supporters by levying taxes. At this most desperate period, during 1942 and 1943, they probably either produced opium themselves for sale in the Japanese-occupied areas, or allowed producers from these areas to ship it through their territories for a fee, but these transactions were hidden behind code-words and ambiguous terms. (By contrast, the Japanese and the warlord allies of the Chongqing regime made no attempt to hide their distribution and sale of narcotics, from which they derived considerable income.) Despite their revenue and supply problems, Communist guerrilla units operated in many areas of north China, even reaching to the countryside around Beiping and into Shandong province, and reasserting a military presence in the central Yangzi River region from which they had been ejected by the Guomindang in 1941.

If anti-Japanese nationalism was the most visible part of the Communists' activity, there were other equally important aspects to their program that were less obvious to outside observers: these

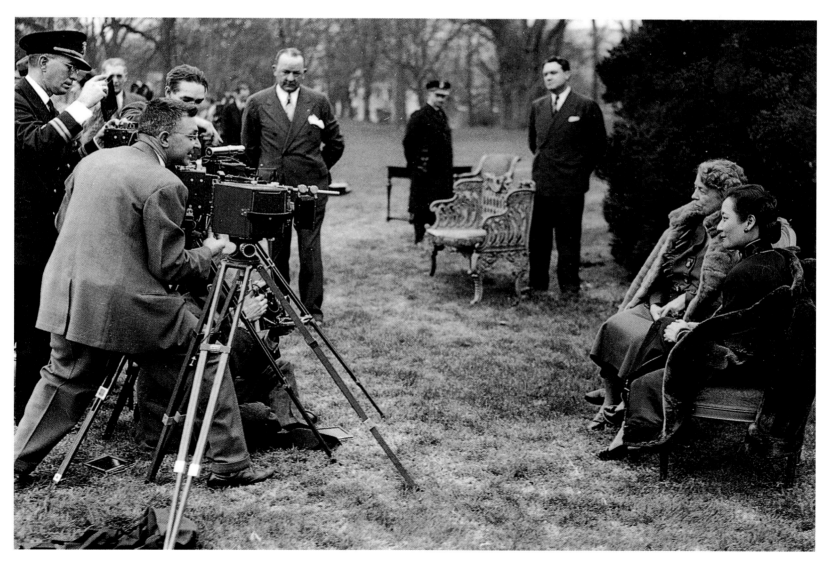

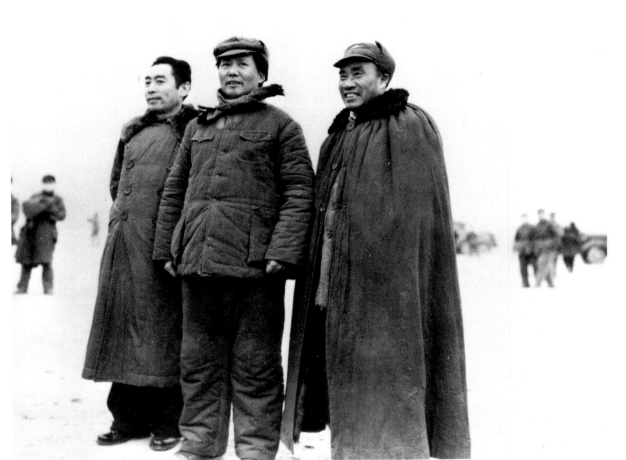

Red triumvirate: *the three major Communist leaders in 1944 – Zhou Enlai (left), Mao Zedong (center) and Zhu De (right). They had expanded from their base in Yanan into huge areas behind the Japanese lines; in response, Nationalist forces had attacked the Communists in central China, and attempted to establish an economic blockade around Yanan. As the Nationalist war effort waned, Americans began to wonder if they should aid the Communists so that they could attack Japan more effectively. Stilwell said the ordinary Chinese were beginning to 'welcome the Reds as being the only visible hope of relief'.*

Japanese recruiting *among the aboriginals living in the central mountains of Taiwan, to replace some of their losses in the mainland China campaigns. They faced a legacy of bitterness because of the ferocity with which they had earlier suppressed aboriginal uprisings here.* [PHOTO: TENG NAN-KUANG]

included the steady growth of Mao Zedong's personal power, the curbing of the independence of the intellectuals, and the deepening of class warfare through identification of class enemies. Mao Zedong had risen to lead the Party in 1935 during the early stages of the Long March. During the Yanan years, he and his main ideological supporters systematically rewrote and reinterpreted the Party's history, to show that Mao had consistently followed a perspicacious and correct 'line' in his thoughts and actions. His various Party opponents were denigrated or their actions and words reinterpreted, to show that they had followed 'erroneous' lines that had brought the Party to the brink of destruction, especially in the case of those Communist rivals who had followed the Comintern line of attacking cities or seeking to curb rural revolution. The most emphasized of Mao's correct lines, was his belief that the poor peasantry of China could be mobilized for revolutionary class struggle by the proletarian vanguard of the Party, and that even without such guidance they were capable of intuitive revolutionary action against their class enemies – the landlords and the rich peasants. Those Party leaders opposed to Mao were said to have variously followed 'putschist' or 'Trotskyist' lines by trying to take cities as bases, or fostering the idea of permanent revolution, or of being overly subservient to Moscow, or ignoring Chinese social realities in the name of a misdiagnosed higher truth. Slowly Mao's deeds were accorded an epic quality: his development of the 'Red Army' was seen as a central part of his wisdom; his experiences in

the Jinggangshan mountains during 1928 and 1929 become central to his heroic vision; the depth of his reading in Marxist philosophy was stressed; and his simple life style in Yanan, with its caves and guerrilla fighting, became a new revolutionary vision.

As Mao's writings were purified and reordered, and the past was simplified, the Chinese in the Communist-controlled areas were first urged and then compelled to study the new texts. The technique used in Yanan was one that became central to the organizational practice and theory of Chinese Communism: following some form of public presentation by Mao or a key lieutenant like Liu Shaoqi, the audience would be subdivided into small groups which would meet in the presence of a Party ideologue carefully chosen by the central leadership. The small group would then carefully 'study' the documents and speeches assigned, until they had grasped the 'correct' interpretation. Those disagreeing or wavering in their loyalty could be isolated by this process, and pressured to 'reform' their thinking. Those showing intransigence would be subjected to harsher pressure through large public denunciation meetings, or in extreme cases could be sent to work with the masses in some form of labor, expelled from the party, or even executed.

In Yanan, the first dramatic use of these techniques was the 'Rectification Movement' of 1942. The thousands of Communist sympathizers who had made their way to Yanan since 1936 – many of whom had indeed been 'bourgeois intellectuals' or at least late-comers to socialism – were taught how to apply correct class analysis

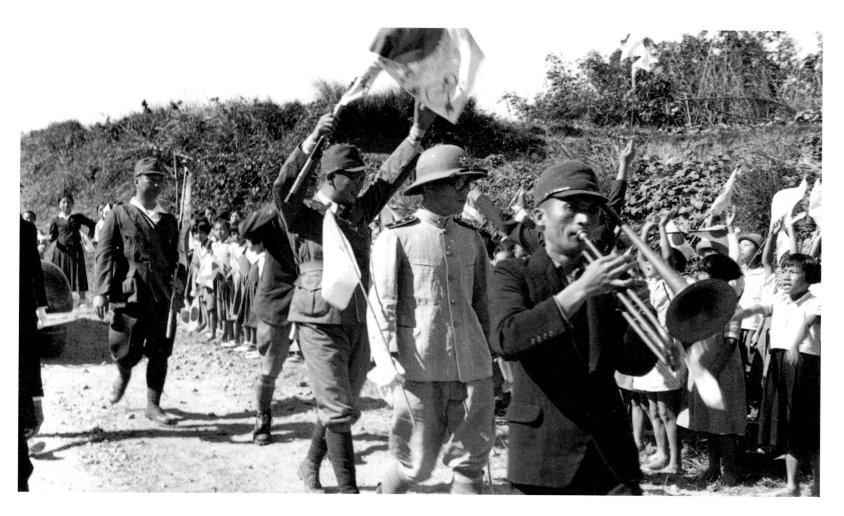

to literature and art, to learn from the masses, and avoid blurring of the revolutionary message by giving a falsely nuanced picture of class relations. Intellectuals were forced to acknowledge that the class nature of the socialist revolution transcended the demands of women's rights or of any other form of self-assertion. The fate of the well-known writer Ding Ling was typical. She had joined the Communist Party in 1931 after the Guomindang executed her husband without trial. She had then managed to escape to Yanan after a long period of house arrest under the Guomindang, only to be expelled from her Party positions and made to undergo labor reform among the masses for suggesting that male cadres in the party often sexually pressured the female rank-and-file.

Mobilizing the peasantry and teaching 'correct' class viewpoints was a complicated and ruthless process, at which the Party grew steadily more skillful during the Yanan period. Successful prosecution of the rural revolution depended on analyzing the villagers by categories (the basic ones being rich peasant, middle peasant and poor peasant), and then applying land reform or land redistribution on a carefully graded scale so that the poor peasants would gain the most, and the rich peasants yield up the most. But within such a structure, endless variations were possible. Not only did the leaders' own priorities shift, depending on how strongly they needed the support of different economic levels, but landless laborers, children or widows, veterans of Red Army service or those wounded or crippled by the Japanese, all might have claims to make on the local resources. The task of

Party leaders, sent to the villages of north and central China, was to identify potential peasant leaders in a given village, especially among the poor peasants or landless laborers, and to encourage them to classify the local inhabitants according to the accepted schema. The harsher the punishments of those accused of landlord or rich peasant status, and the more of their property seized or goods distributed, the greater the incentive for them to lie about their wealth and seek to conceal it, or to exploit private rancors and local village feuds. Mass denunciations and struggle sessions were used as a pressuring device, and the Party's power was strengthened by recruitment of those implicated in the violence. The legacy of bitterness left in the countryside by these practices was deep and enduring.

The Party also recruited for local village militias, guerrilla fighting units, and the steadily growing regular armies of the Yanan government through this process. The army, under the overall command of Mao's veteran comrade Zhu De, was an indoctrinated force of well-trained veterans that, despite its supply shortages, was a match in the field for the northern collaborationist regimes' defense forces, and even for regular Japanese troops.

In the three collaborationist regimes of Manchukuo, Beiping and Nanjing, local Manchu or Chinese troops played a greater part in local defense and peace-keeping as the war wore on, for the Japanese army was now dangerously overextended. There was a growing need in Japan to extract as much as possible from China to help the war effort. Industrial and food production in both

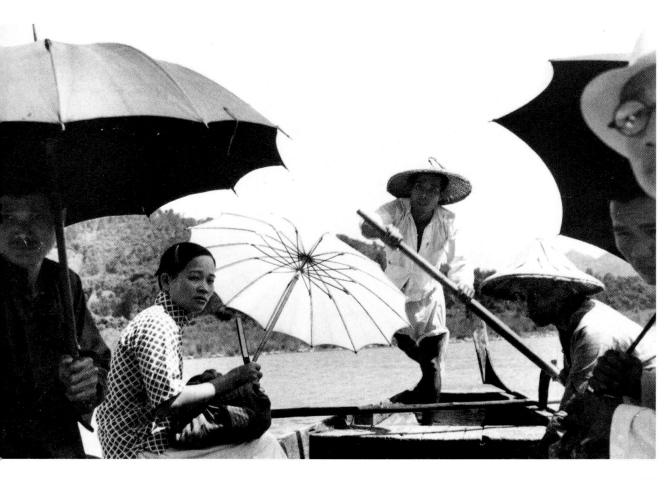

Life in Japanese Taiwan: *passengers on a traditional ferry one summer day in 1940; young women on a beach; and a woman crossing a street in Taipei against a backdrop of Japanese movie posters in 1943. The clothes reveal the increasing mixture of Western and Chinese ways on the island.* [PHOTOS: TENG NAN-KUANG]

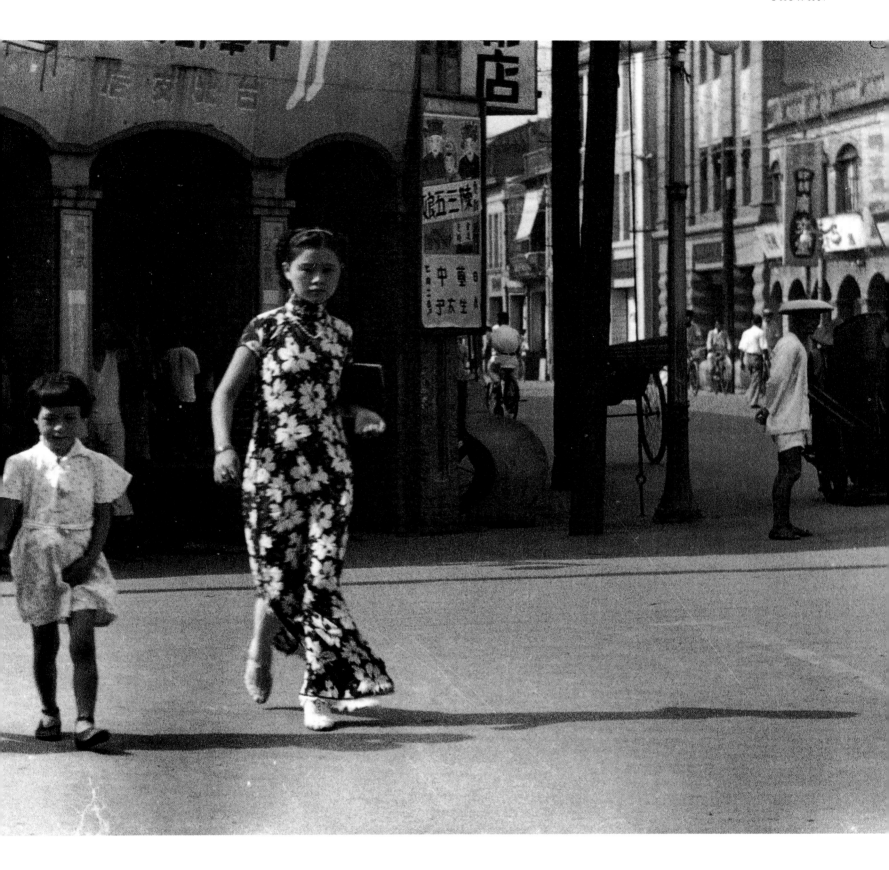

Life in Beiping. *For many Chinese the pattern of daily life was little affected by war or Japanese occupation. One tenacious recorder of these daily rhythms was Hedda Morrison, who lived in Beiping (Peking) from 1933 to 1946. As a German national, and hence a nominal ally of Japan, she could move freely in north China throughout the war. Photographing the ordinary people of the city she loved, became her passion, but there was one rule she always followed: neither the open face of war, nor Japanese or puppet troops would ever be allowed to intrude into her images.*

[PHOTOS: HEDDA MORRISON]

Common soldiers, power brokers.
Japanese soldiers rest during their vicious and protracted campaign in China, protected with passages from the Lotus Sutra asking for Buddha's blessing and safekeeping. Yunnan warlord Long Yun flanked by Airforce General Chennault (right) and General Wedemeyer in late 1944. Stilwell initially had dismissed Long as 'a comical little duck', but came to recognise the powerful position Long and his armies had constructed out of opium growing, control of the Chinese end of the Burma Road, and the hoarding of food. When this picture was taken, Wedemeyer (Stilwell's successor) had already received orders from Washington to ease Chennault out of his airforce command.

Taiwan and Manchukuo increased rapidly; in Manchukuo especially, this was achieved by vicious forms of coerced labor in factories and mines. Emperor Puyi was unable to check these abuses of his nominal subjects. By the early 1940s they included a nightmare pattern of biological experiments on Chinese victims, conducted by Japanese doctors and scientists, into the effects of poison gas, deadly bacteria, live dissections and intense extremes of heat and cold. In 1941 and 1942, such bacteria were deliberately spread among the Chinese populations in the Nanjing regime to gauge their efficacy, and a biological warfare plant was constructed on the outskirts of the city itself. Japanese soldiers in Manchukuo were also trained for combat in China or southeast Asia by bayonet or sword practice on helpless Chinese prisoners. Brutalization had now become a routine aspect of military training and practice. As part of this process of concentration of power, the Japanese also took over the foreign concessions and imprisoned the Westerners in isolated camps. In Shanghai, this system was rendered more complex by the isolation of the Jews into a special ghetto community under Japanese control. Though this was done as a sop to their German allies, the Japanese commandant refused to do as the Germans had requested and have the Jews from China

shipped back to Europe and almost certain extinction.

In the spring of 1944, the three-year lull in China's conflict with the Japanese came to a sudden end when the Japanese launched a major campaign in central and south China. Chinese troops, trained in India under Stilwell's guidance, were now fighting vigorously and successfully against the Japanese in Burma, aided by retrained troops from Yunnan, and the Japanese sought to blunt the force of that campaign. Secondly, Japanese troops in the Pacific islands were fighting a protracted and bitter but ultimately losing battle with the American forces, and a major victory in China would help shore up weakening military morale. Thirdly, United States bombers, based in the Chinese Nationalists' easternmost airfields in Jiangxi province, had managed to reach Taiwan, and bomb Japanese installations there.

Under the code name of 'Ichigo' ('number one'), ten of their finest divisions were sent to cut the last Nationalist-controlled railway lines in central China; to end the Nationalists' hold over Henan and Hunan which supplied most of Chongqing's food and many conscripts for the Chinese armies; and to capture and destroy Chennault's airfields in Jiangxi, Guangxi and Guizhou provinces. Forewarned by French intelligence, Chiang's own intelligence services dismissed the tip as a Japanese plant, and took no action. The result was the worst series of defeats for Chiang Kai-shek since 1938. Japanese divisions moved swiftly across central and south China, routing a number of major Chinese armies, and achieving all their major objectives. Eventually they were badly overextended and, blocked by fresh Chinese troops whom Chiang had been holding in the north to contain the Chinese Communists, they came to a halt in Guizhou province in September 1944. The Chongqing regime not only lost over 500,000 troops in the fighting, but also lost control of three provinces and was completely cut off from north China. It was unable to contain the Communists effectively, and unable to reinforce its more northerly units, which could now be mopped up by the Japanese.

After this debacle Chiang's many critics became far more vocal, and Western and Chinese observers focussed on Chongqing with a new precision. Stilwell's staff, the American foreign service, and resident journalists all documented Chongqing's problems in their detailed reports. People now began to see that what was once believed to be a stronghold of heroic national resistance, was in fact a corrupt center of intrigue and graft, of dubious alliances

with regional warlords, of vicious and degrading conscription, with starving recruits roped together to stop them escaping on the way to the front; according to one contemporary estimate, as many as 1.4 million Chinese conscripts died of disease or maltreatment before they saw action against the Japanese. Chiang's critics were also appalled by the speculation and fraud in currency and black market goods, the rampant inflation that the government could not check, and the extraordinary callousness of the Guomindang authorities to the rural populations enduring famine and other natural disasters. In contrast, the few reports on the isolated Communists presented them in an almost romantic light, as purveyors of simple values of honesty, frugality and peasant courage, a vision reinforced by the reports of the 'Dixie Mission', a United States aid and training group that traveled to Yanan in 1944. General Stilwell, gratified that his warnings about the airfields had proven correct, but deeply dejected by the wider military picture, lobbied Washington successfully to put more pressure on Chiang Kai-shek to reform his armies and modernize his command structure. Stilwell then delivered the new instructions from Washington with such undiplomatic directness that Chiang had no choice – if he was to preserve any dignity at all – but to request Stilwell's recall. The Americans reluctantly agreed

to do this at the end of 1944, out of fear that Chiang might withdraw from the war altogether.

After the traumas of Ichigo and Stilwell's departure, 1945 was a calmer year in the China theater. Chiang Kai-shek had been present, with Churchill and Roosevelt, at Cairo in 1943 to decide on the future direction of the war, but he was not invited to the even more important meeting the same two leaders held with Stalin at Yalta in February 1945. The deals struck there, to encourage Stalin's rapid entry into the war in East Asia, were as disastrous to China's sovereignty as those made by Japan and the allies in 1917. Stalin was given assurance of the return of all the Soviet Union's territories lost to the Japanese, resumption of Russian control over the base at Port Arthur, and renewed control over the former Russian railways in Manchuria. China was not even informed of these commitments.

A succession of US military advisers came to China in Stilwell's wake, and substantially – though with greater tact – they continued his policy of trying to retrain a small number of key divisions and equip them with modern arms so that Chinese forces could play a major part in the final assaults on the Japanese. In spring 1945, General Wedemeyer and the Chinese Nationalists decided on a plan code-named 'Iceman' for a counter-attack

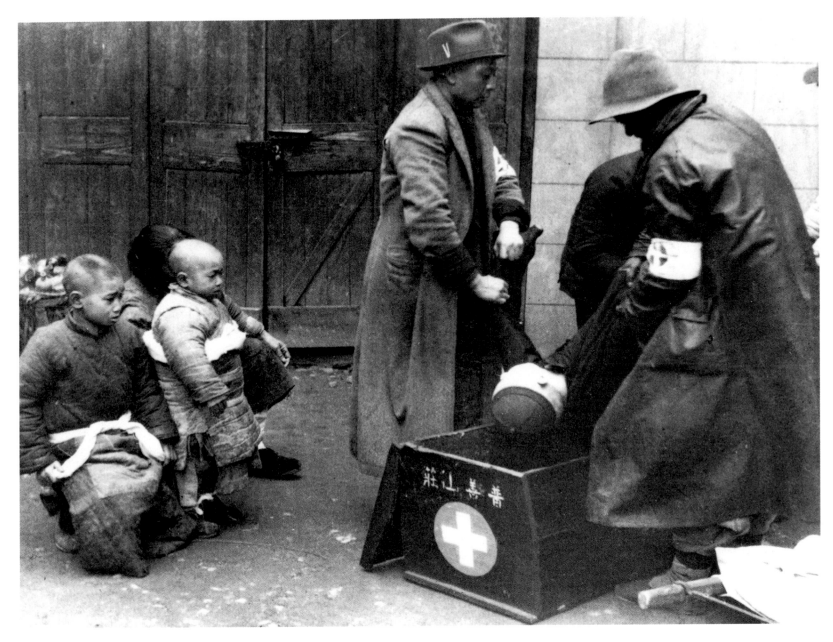

Stop and search. *Other faces of Beiping (Peking) under Japanese occupation. In the harsh winter weather of February 1941 the corpses of city derelicts who have died overnight from hunger or exposure are collected by city health workers, as poor children look on. The simple coffin is marked with the name of a cemetery in the countryside nearby. A group of prostitutes, with modish Western hairstyles, relax for a moment before returning to their clients. Outside a cinema, collaborationist police frisk the traditional robes of a bicyclist for hidden weapons or anti-Japanese propaganda.*

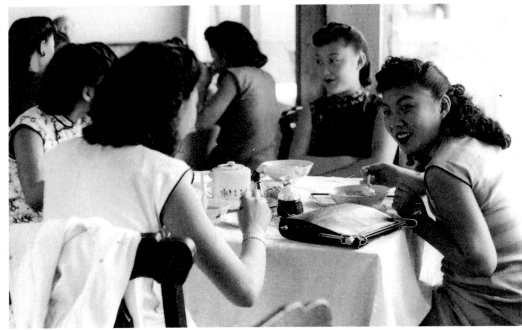

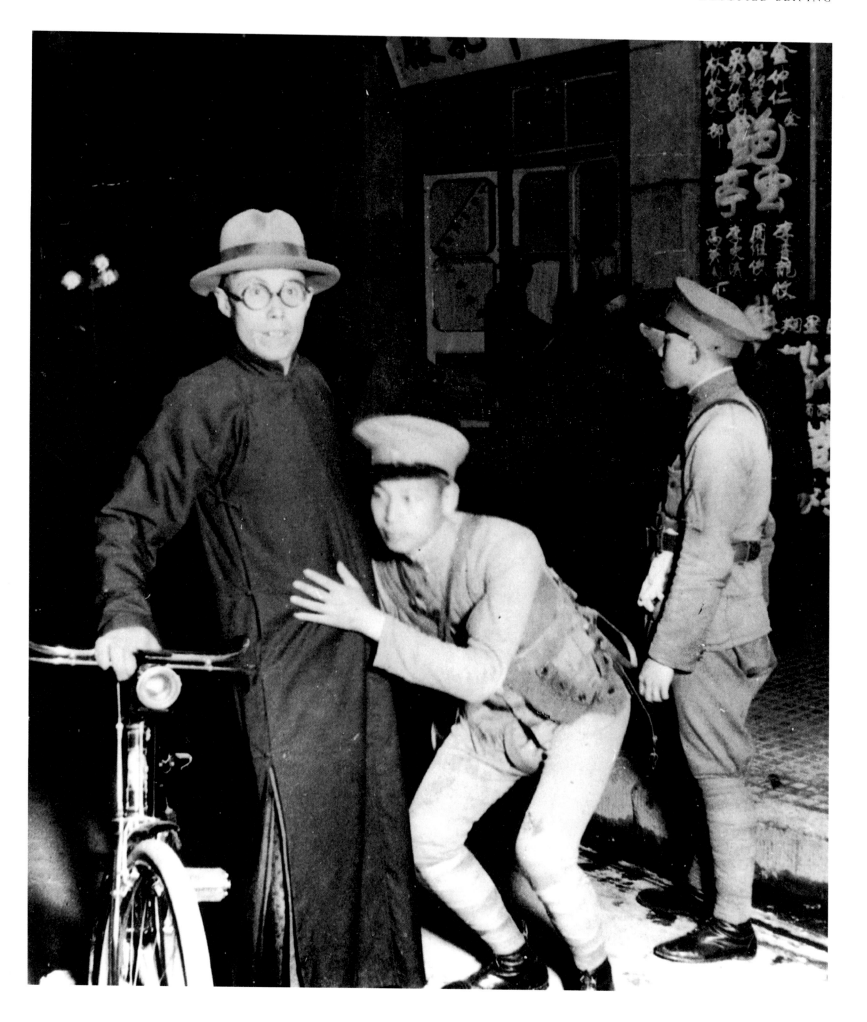

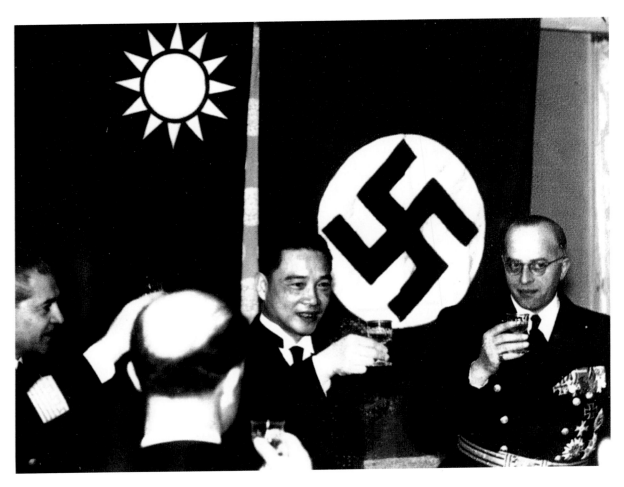

Collaborators and losers. *Wang Jingwei drinks a toast with German diplomats at Nanjing in late 1941. Both an ally and a rival of Chiang, by 1938 Wang had despaired of China's ability to resist Japan and attempted a peaceful settlement. In 1940 the Japanese named him head of the collaborationist Nanjing regime. Claiming to be Sun Yat-sen's true heir, Wang always flew the Guomindang flag (left) in his new state. Chu Minyi (below center in beret, after his trial) was western-educated and a close friend of Wang. He collaborated as governor of Guangzhou (Canton), and was executed by firing squad in August 1946. (Right) Some of the million or so surrendered Japanese troops are given a final health check by the Guomindang before going home at the end of World War II.*

against Japan to be launched in the fall of 1945. However, before 'Iceman' could be implemented, atomic bombs were dropped on Nagasaki and Hiroshima in August 1945, and within days Japan surrendered, though not before Stalin's troops, responding to the Yalta agreements, had poured into Manchukuo, occupied much of the country, and arrested the ruler Puyi. As the war ended with bewildering suddenness, the whole strategic picture changed, though Chiang Kai-shek's main forces were still isolated in the southwest.

What China now desperately needed was a respite in which to reintegrate the country, restructure the government, and rebuild shattered lives. By the end of the eight-year war with Japan, the Chinese had lost 3,000,000 men in combat; at least 18,000,000 civilians had died, and the fighting had created 95,000,000 Chinese refugees. Property losses exceeded US $100,000,000. But China was granted no respite. Aided by the American Air Force, Chiang Kai-shek tried to move forces loyal to him to the key east coast cities, and to accept the surrender of the Japanese units there, but the task was of immense complexity. Communist troops from the northern base in Yanan had at once raced for Manchuria and not only reached it ahead of the Nationalists but linked up with the Soviet forces there, from whom they received large stocks of surrendered Japanese military equipment.

Old local loyalties swiftly reasserted themselves. Chiang Kai-shek's southern warlord allies wished to stay in the south, and would not move north. Those dispossessed of their homes by the war hurried to reclaim their property after long years of Japanese

and collaborationist occupation and rule. The wide geographical extent and long duration of these regimes meant that millions of people were classified as collaborators in different ways, and vengeance was savage. Wang Jingwei had died before the war ended, and was thus spared the humiliation of a treason trial and execution, but Wang Kemin, head of the Beiping regime, was at once arrested and died in jail. Puyi was arrested by Soviet troops and held in prison for five years before being handed over to the Chinese Communists in 1950. Many of the family members of these leaders, and their staffs, were arrested and executed for their wartime activities. Yet, in the frenzied search for loyal political allies to help them reassert control over the newly reoccupied cities, the Guomindang insisted on sparing many major collaborators whose administrative and political skills they now desperately needed. To confuse matters further, thousands of apparent collaborators had in fact been double-agents, recruited by Dai Li and his intelligence apparatus. Dai Li had carried many of their names in his head, and his death in a plane crash denied some of these former double-agents the means to prove their true loyalties. Accordingly a good many of those executed as traitors after brief trials in 1946 might in fact have been loyal supporters of the Guomindang.

The long war had also divided China's intellectuals, and alienated many from the Nationalist government. Those who had stayed on in the occupied areas of Nanjing, Shanghai or Beiping in order to continue with their work, felt unfairly stigmatized as collaborators. Those who had chosen to support the Guomindang

war effort, by working for its many propaganda teams, had often grown disillusioned by the party's stale rhetoric, and by the terrible poverty and suffering that they witnessed. The students and faculty of China's major universities, many of whom had joined the great trek to the southwest in 1937 and 1938, and resettled in the 'United' exile university in Kunming, had lived in a curious hybrid world under the anti-Guomindang warlord Long Yun, yet also receiving a certain amount of American cultural or democratic political influence. They had suffered especially badly from the galloping inflation which had completely eaten up their salaries and, like many other writers and artists, they were resentful of the harsh and unimaginative censorship that the Guomindang attempted to impose. Those who believed in a democratic option under both the Guomindang and the Communists had seen the systematic repression of their aspirations by Guomindang police and agents who infiltrated or broke up their meetings and arrested their leaders. The Guomindang's abuse of political power reached a pinnacle in 1946 in Kunming, when Wen Yiduo, a liberal considered by many to be China's finest living poet, was assassinated by agents believed to be following orders from Chiang Kai-shek. Wen Yiduo's only apparent 'crime' was that he had spoken out angrily at the funeral of an assassinated friend.

One might have thought that the Communist intellectuals would have been similarly disillusioned by their wartime experiences, and that this would have partially redrawn the balance, but such was not the case. Some, no doubt, resented the insistent pressures to which they were subjected, the rhetoric of obedience to the tenets of 'Mao's Thought', and the restricted curriculum of political activism and Marxist-Leninist analysis that was the core of Yanan's own 'Resistance University'. But, most apparently believed sincerely that the Communists offered the best chance for building a strong and united China, or they were unconvinced that democracy could take root in China in the current circumstances, or they had been effectively moulded by

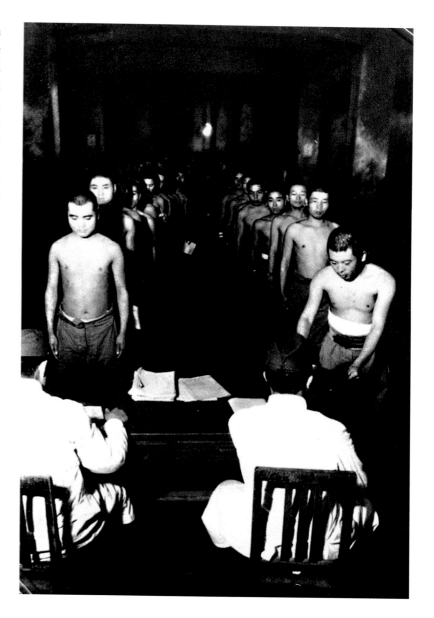

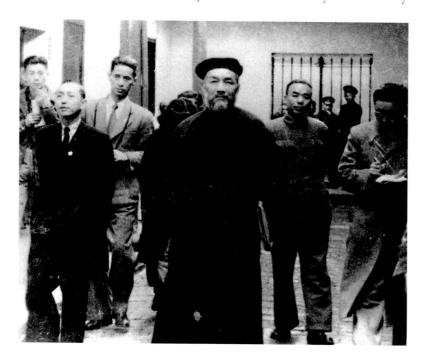

their revolutionary wartime experiences and their small groups and struggle sessions to accept the prevailing Maoist class analysis of their society. The Communists seemed at least to offer the possibility of an honest, albeit tough, regime, one that would endeavor to prevent the reinstallation of foreign imperialism in China, and one that would address some of the worst inequalities that so obviously existed in the poverty-stricken countryside and among the industrial workers.

Chiang Kai-shek compounded his bleak situation by making a number of blunders. He insisted on sending many of his best-trained troops to Manchuria, to contain the Communists there, even though his advisers warned him that this dangerously overextended his armed forces. He condoned the use of extraordinary violence and cruelty by the landlords who returned to reclaim lands that had been seized by their peasants in the land reform movements of the previous decade. He placed enormous weight on a protracted campaign to recapture Yanan, even though it was no longer an important Communist stronghold; the Communists were able to evacuate easily when the Nationalist armies at last took over the area in 1947. He failed, via various

The final throws. *The Americans, trying to prevent further civil war, arranged in August 1945 for Mao Zedong (seated in the front of the Jeep) to meet Chiang Kai-shek in Chongqing. The American Ambassador, Patrick Hurley wears a Homburg hat. The talks were a failure because Chiang thought he had the upper hand. War resumed and Chiang sent his best troops to the north, where they were roundly beaten by the Communists. Defeated Guomindang troops (right) wait for evacuation to the south by rail in 1947. A Communist activist (below), captured in Shanghai in the late Forties, is pinioned before being taken for execution by municipal police, regular army police, and plainclothes military police.*

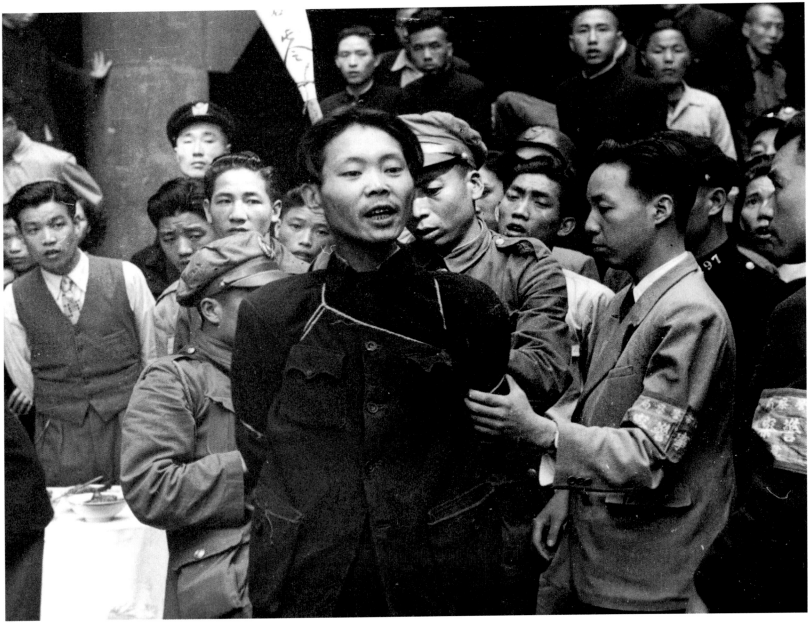

currency reform attempts, to prevent China's rocketing inflation and his lack of success was exacerbated by the blatant speculation of his circle in the newly issued currencies. He allowed unnecessarily ruthless reprisals against the Chinese in Taiwan to be carried out by Nationalist troops, treating the inhabitants as collaborators to be punished and fleeced. The reoccupation of the island did not bring a joyful close to fifty years of Japanese colonial domination, and led instead to a violent uprising of the Taiwanese against the nationalist forces in February 1947. This was savagely suppressed by the Nationalist army and police, leaving 10,000 or more Taiwanese dead, many of them influential citizens or prominent intellectuals, and a legacy of bitterness that was to last for generations.

Finally, Chiang Kai-shek was not able to exploit successfully American goodwill, military support, and potential funding that still lay at his disposal. Admittedly, American policy itself was vacillating, but its central message was clear enough: that China should try and avoid a disastrous civil war so soon after the ending

of the previous conflict, that it should implement some meaningful social reform program, and that Chiang should at least explore the possibilities of establishing some form of democratic process in his government. In pursuit of these goals, the American ambassador in Chongqing arranged for Mao Zedong to visit Chongqing under safe-conduct for preliminary unification talks with Chiang Kai-shek. President Truman also dispatched General George Marshall – later famed for establishing the 'European Marshall Plan' – to mediate between the opposing forces in China. Marshall managed to arrange a brief cease-fire, and made plans for a democratic consultative conference; but Chiang then balked at these plans, the conference fell into abeyance, and the fighting resumed. Despite these disappointments, the Americans sent now unneeded war matériel to the Nationalists, and used their marines to hold key harbor and transport facilities for the Nationalist armed forces, even as they grouped to renew hostilities with the Communists. Senior American officers with experience of China, like General Wedemeyer, also returned to help the Guomindang.

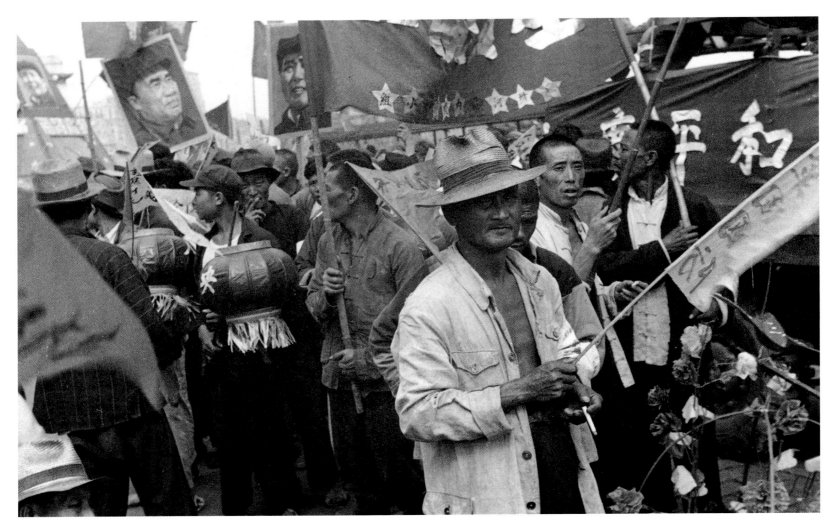

But it proved impossible for Chiang Kai-shek to hold his tottering regime together without the stimulus of Japanese occupation as a focus for Chinese national unity. The Communist forces, led by one of their most able generals – and a former Whampoa graduate – Lin Biao, held onto northern Manchuria despite the onslaughts of Chiang's armies, while Communist guerrillas spread across the region and behind Guomindang lines. By 1947, following Mao Zedong's instructions, the Communist armies abandoned guerrilla strategies and moved over to concerted frontal assaults. Poorly commanded, suffering from low morale and unsure of the ultimate purpose of the renewed fighting, the Nationalist forces, despite their modern equipment and legacy of US technical assistance, were unable to hold their key positions in north China. By late 1948, the Communists had forced the main Nationalist armies in the north to retreat, and others began to desert. In January 1949, Beiping fell to the Communists without a fight. A westerner, Derk Bodde, recorded the scene in his *Peking Diary*:

> At their head moved a sound truck from which blared the continuous refrain, 'Welcome to the Liberation Army on its arrival in Beiping! Welcome to the People's Army on its arrival in Beiping! Congratulations to the people of Beiping on their liberation... !' Beside and behind it, six abreast, marched some two or three hundred Communist soldiers in full battle equipment. They moved briskly and seemed hot, as if they had

Red Star over China. *His banner announcing that he will 'exert his energies for the national defense', a straw-hatted resident of Shanghai on the fringe of a Communist victory parade in the summer of 1949. Behind, drummers march under photos of Red Army commander Zhu De and Mao. Later the same summer, Shanghai children clamber among the fluted portico columns of one of the giant foreign buildings on the Bund, to catch a closer look at their new masters.* [PHOTOS: SAM TATA]

been marching a long distance. All had a red-cheeked, healthy look and seemed in high spirits. As they marched up the streets, the crowds lining the sidewalks...burst into applause.

As Chiang and his leading officers began to retreat to carefully prepared bases in Taiwan – whither they had already dispatched many of the finest paintings from the Imperial Palace Museum, the historical archives, and the remaining gold reserves – the Communists advanced swiftly to the Yangzi. Chiang's capital of Nanjing fell, also without a fight, in April, and Shanghai at the end of May. On October 1, 1949, as Communist troops approached Chongqing and Canton, Mao, standing on the top of the Gate of Heavenly Peace in the old imperial city (now renamed Beijing), announced the formation of the People's Republic of China.

CHAPTER EIGHT

A COMMUNIST STATE

THE NEW COMMUNIST GOVERNMENT WAS FACED AT once with a formidable array of challenges, perhaps the most important of which was to achieve national reunification, and end almost forty years of civil war. Within a few months, one wing of the Communist army had pushed down to occupy Canton, while another, far to the west, had driven into the Xinjiang region. This vast area, with its largely Muslim population, had been at the mercy of the Soviet Union and various warlord regimes ever since the 1920s. The possibility that it might declare its independence or become a puppet of the Soviets was a real threat to China's security on the western border. But, within less than a year, the Communists had extended their hold across the region from Urumqi to Kashgar, and the Soviet Union remained content to have Mongolia as a satellite People's Republic in the Soviet sphere, leaving Xinjiang to the Chinese Communists.

In a third reunification campaign, a strong force moved south through Qinghai province and advanced on Lhasa in Tibet. Tibet had been independent during the years of the warlords and World War II, and indeed China's hold over the region had never been more than partial, constantly disputed by the Tibetans themselves and by other foreign powers. Now, claiming that the Tibetan people were struggling against feudal superstition and exploitation, the Chinese armies entered the country in the name of 'liberation', even though some Tibetans protested 'liberation from what?' The Communist troops rolled over the opposition of the small Tibetan army, capturing the whole of Kham in October 1950. Having shown the power of their military forces, they waited patiently for the Tibetans to capitulate, which they did in the spring of 1951 after the United Nations failed to respond to pleas that it intervene and support the claims of the fifteen-year-old Dalai Lama to rule.

Although Tibet was promised a measure of religious independence, Communist military power was clearly established over the country, which was renamed the Xizang Autonomous Region. Now only Hong Kong and Taiwan seemed to elude the Communist forces. Choosing not to risk a confrontation with Great Britain, which was still a formidable presence in the Far East, the Chinese made no attempt to invade Hong Kong, even though the colony was virtually indefensible by land or sea. On the other hand, Taiwan's recapture would make a grand termination to the 'War of Liberation', and finally expunge the shame of the Japanese victory over China in 1894. Major units of the People's Liberation Army were transferred to the east-coast province of Fujian opposite Taiwan, and the islands of Quemoy and Matsu where the Nationalists still maintained bases.

In December 1949, Mao Zedong left China for the first time

Spring waters. *Mao in the late 1950s relaxing with the families of Party leaders in the resort area of Lushan in Jiangxi province. Mao enjoyed swimming and it also served to demonstrate his vigor. But it worried his bodyguards, and still more his doctors, since sometimes he had to share the water with dead animals and human waste. Throughout his rule images of water were often employed, only near the end being replaced by ones derived from the sun.*

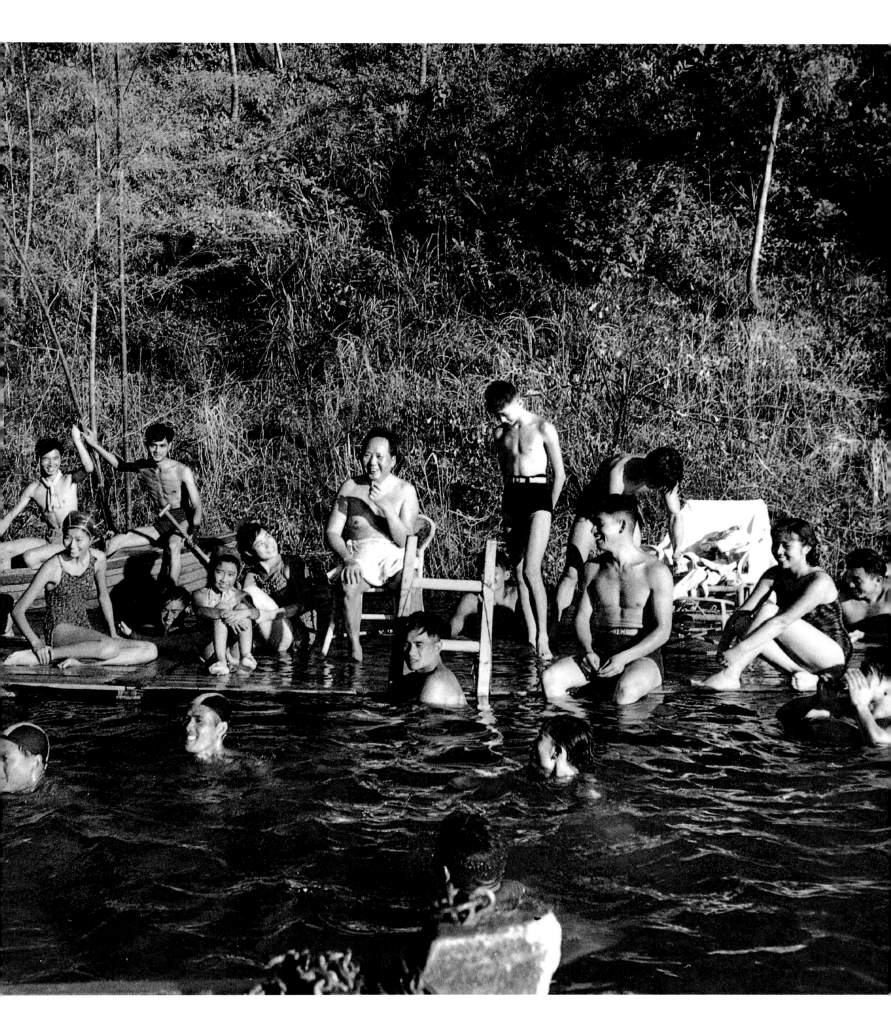

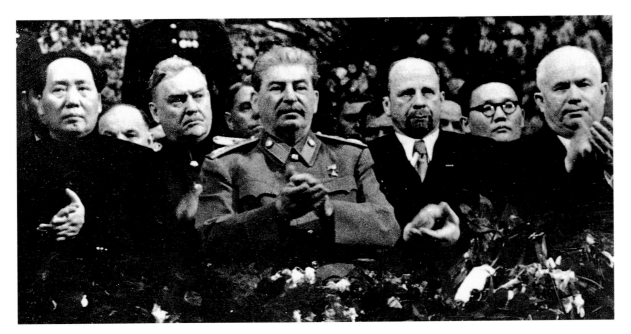

A cold alliance. *Mao visits Stalin in 1949 (left). Stalin drove a hard bargain over what little assistance he gave, but Mao reacted angrily when Khrushchev, on the right, attacked Stalin's memory in 1956.*

Party activists allot land. *Land reform was an extraordinarily complicated business, since it aimed to punish 'exploiters' and reward 'victims' with allocations made on the basis of Party loyalty, and claims of wartime suffering. The value of land had to be calculated, allowing for soil types, irrigation and erosion.* [PHOTO: SHI PANQI]

and traveled to Moscow to meet Stalin. Compared to Stalin, Mao was an upstart, and though he had presided over a major Communist victory in the world's most populous country, tension between China and the Soviet Union, dating back to the earliest days of Comintern involvement in 1920, remained strong. Mao was not accorded a dramatic welcome in Moscow, and had to wait several days before even meeting Stalin. Bargaining over treaty provisions was difficult and protracted, and, in January 1950, Mao summoned Zhou Enlai, the recently named premier of China, to join him in Moscow. Zhou had proved his diplomatic skills in the Communist base area of Yanan and in the delicate negotiations with the Americans and Nationalists in Chongqing in the closing years of the war, and his presence got things moving. When a treaty was at last signed in February 1950, the two countries agreed to aid each other immediately in case of attack by Japan or one of 'Japan's allies' – a thinly veiled reference to the United States, which had played a major role in Japan's post-war rehabilitation – and the Soviet Union offered China US$300 million in credits. As a quid pro quo, China had to acknowledge the 'independence' of Mongolia, and accept Soviet involvement in the trans-Manchurian railway, as well as continued Soviet occupation of Port Arthur and Dairen. Other agreements led to the formation of joint companies in Xinjiang through which the Soviets would help develop (and be the natural recipients of) oil fields and natural gas, as well as non-ferrous metals. A Sino-Soviet civil aviation agreement opened regular air transport between Peking and Irkutsk and other cities in the eastern Soviet Union.

The Soviets also provided technical advisers to China, especially in the fields of engineering and construction, and China's urban reconstruction program brought the distinctive Stalinist-style of heavy-handed architecture to China, especially to government offices, hotels and railway stations. Under Soviet influence, the Chinese cleared a huge area in front of the Tiananmen Gate of the former Forbidden City, to make a parade ground for vast political rallies, on the model of Red Square in

Moscow. The Square was flanked by a grandiose hall of the people and a people's revolutionary museum, and plans were laid to erect a revolutionary martyrs' memorial in the center. Chinese architects and architectural historians who appealed for a style of architecture more in consonance with China's past were overruled. Amongst these was Liang Sicheng, the son of the radical Qing philosopher Liang Qichao. His bid to make a people's park incorporating the city walls of Beijing – world-famous for their beauty, but seen as a menace and a traffic problem by city planners – was rejected as impractical and feudal. The destruction of the walls and their great gateways proceeded steadily, leaving a series of huge new boulevards around the city in the spaces where the walls once stood.

The decision of Liang Sicheng to stay on in China under the Communists, though he was intimately tied to hopes for a republican China through family and friends, was one taken by tens of thousands of other intellectuals and artists. The Communist Party actively appealed to their sense of patriotism and duty to build the 'New China' and they were promised decent salaries and responsible positions if they stayed on. Similar moves were made to woo back prominent Chinese studying in the United States and Europe. Many responded, even though they had little sympathy with or knowledge of the Communist Party's ideology. Those from wealthy or intellectual backgrounds were reassured by the Communists' show of maintaining various democratic structures, such as the People's Consultative Conference, which were meant to allow non-Communists a say. At the head of these organizations were many former warlords, Republican politicians, and senior Guomindang defectors, as well as heads of universities and research institutes, and leaders of labor union organizations, including those who had been intimately linked during the Nationalist period to the Green Gang and other bitterly anti-Communist secret societies.

Later, many of these figures were bitterly to regret their decision to return, for they were incarcerated and forced to meet in

small groups where — under intense pressure from Communist loyalists — they 'confessed' to a variety of allegedly bourgeois sins and shortcomings. But at this time, the writers, painters, and scientists — ranging from the great novelist Lao She to some of the world's leading rocketry experts — gave a cosmopolitan gloss to the Communist image, as did the recognition extended first by Communist bloc countries, then by Burma, India, Pakistan and Ceylon within three months, and by Norway, Denmark, Finland and Sweden soon afterwards. China's diplomatic goal was also to isolate Taiwan, though the exiled Guomindang government there continued to hold the Chinese seat in the United Nations and in the National Security Council. Thus, when Great Britain offered recognition to the new Chinese state, China refused to accept on the grounds that Britain continued to have diplomatic ties with Taiwan.

To deepen their hold over China, the Communists divided the country into six areas, each of which was placed under a quadrumvirate of veteran Party leaders, who represented respectively the Communist Party, the civilian government, and the political and the military sectors of the People's Liberation Army. In some cases, one man held three or even four of these regional positions, giving him enormous power. Potential saboteurs were identified and rounded up, the population was disarmed, inflation was curbed through stringent price controls, prostitutes were registered and forced to undergo 'reeducation', opium sales were forbidden, and city and rural governments were filled with Party loyalists.

The Communist Party moved with zeal to deepen and extend land reform. Though the confiscation of land was limited to a small percentage of Chinese who could be identified as landlords or rich peasants, this still involved millions of people. To implement the reform, the Party inducted hundreds of thousands of student activists via crash courses of revolutionary training, before dispatching them out into the countryside to work

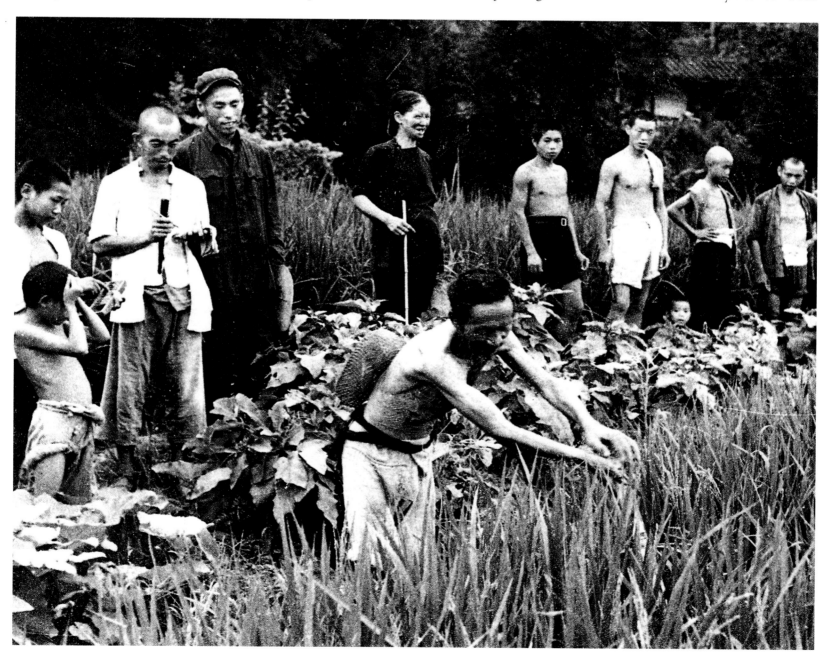

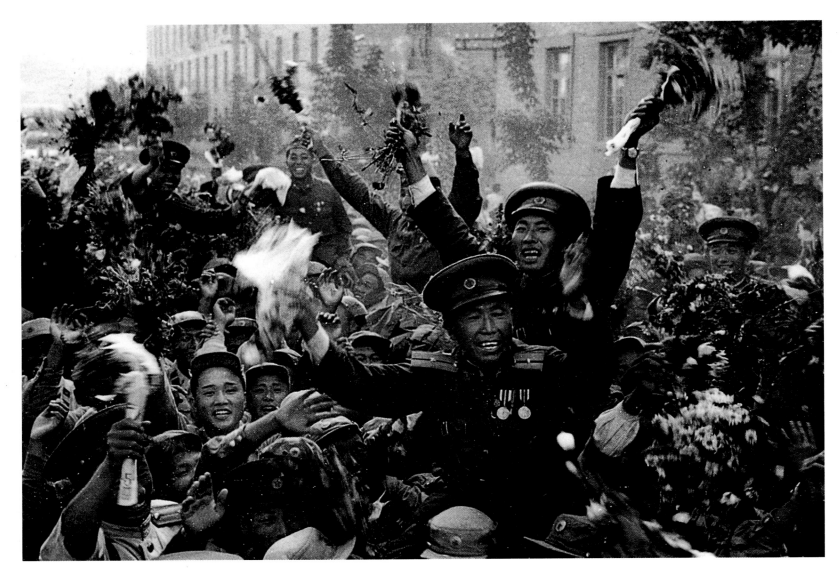

alongside veteran Party cadres. Techniques used in the Jiangxi Soviet, in Yanan, and in the civil-war period of land reform were now honed and streamlined. Identification of the alleged exploiters, struggle sessions involving the masses, public trials of those found to be guilty, followed often by their public humiliation, beating or death, were widespread. While these proceedings brought a new group of potential revolutionary leaders to the fore, they gave a taste of revolutionary activism to hundreds of millions of peasants, and firmly committed the poor and the landless laborers — who received a small allocation of confiscated land — to the Party. Those peasants in the middle- or lower-rich ranges were allowed to keep their own land and livestock but were encouraged to share their draft animals and pool their land and their labor in mutual aid teams, drawing rewards from the heightened agricultural productivity in direct proportion to the amount of their investment.

The first year of the People's Republic was harsh and unpredictable but it also brought hope to China, as the laborious reconstruction of the shattered country seemed to take hold. Intrusive though the state was becoming in many aspects of social life, China might have avoided the extraordinary levels of violence and coercive pressure that ensued had it not been for the outbreak

of the Korean War in the summer of 1950. Evidence suggests that the Chinese, unlike the Russians who dominated the North Korean regime, did not have advance warning of this conflict as their military interests were directed towards Tibet and the Fujian coast opposite Taiwan. But the swift dispatch of United Nations forces to Korea, commanded by General Douglas MacArthur, the dramatic change in North Korea's military momentum after MacArthur's daring, outflanking landing of amphibious forces at Inchon, and the rapid movement of UN troops toward the Chinese border all put extraordinary pressures on the Chinese leadership. By October 1950, tens of thousands of Chinese troops were being moved north from Fujian and other regions, many of them clandestinely crossing the North Korean border.

The Chinese maintained the fiction that these troops were 'people's volunteers', and there were many raw recruits among them, but this was a large-scale and formal military operation, coordinated by General Peng Dehuai under Mao's overall direction. A veteran of the Jiangxi Soviet and the Long March, Peng was most famous for his leadership of the One Hundred Regiments Offensive against the Japanese in north China during 1940. Those campaigns had led to terrible Japanese reprisals, and ultimately checked the Communist military build-up for two years

The Korean War. *Chinese war heroes being feted in North Korea (left). This fits better with the Communists' picture of the industrialised capitalist West halted by revolutionary 'volunteer' armies, than the photo (right) of wounded Chinese POWs being repatriated after the 1953 ceasefire. The 900,000 Chinese casualties included Mao's eldest son, who was buried in Korea. The courage shown by the Chinese troops in the suicidal head-on charges against the United Nations forces gave rise to a new mystique of Chinese heroism and endurance.*

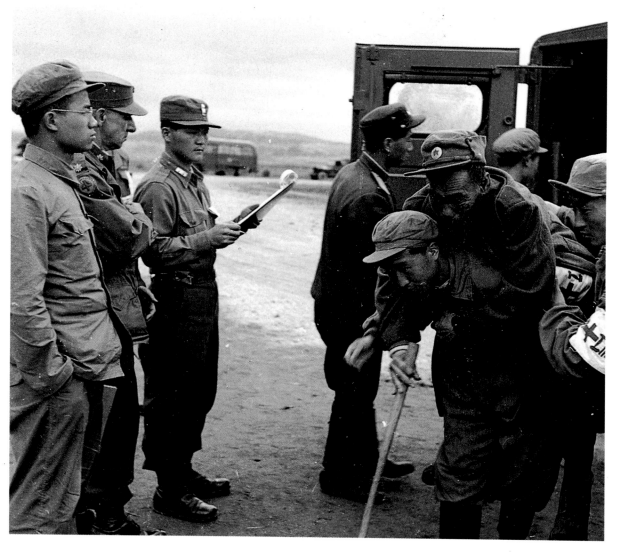

or more. However, the One Hundred Regiments Offensive had marshaled over 400,000 Communist troops to confront a tough, regular army with superior weaponry, to destroy their lines of communication and halt their momentum. This was just the sort of operation that China now had to conduct in Korea, as poorly armed and equipped Chinese troops faced the overwhelming artillery and air power of the United Nations' forces spearheaded by the Americans. Though without warm winter clothing, adequate ammunition, or signals and engineering technology, the Chinese forces stormed the United Nations' positions in 'human wave' attacks of immense courage that led to enormous casualties on both sides. By the summer of 1951, amid Western threats of nuclear retaliation and Chinese charges that the West was using chemical weapons, the war fell into a protracted stalemate. Bitter fighting had claimed hundreds of thousands of Chinese lives, but Peng was still in command of over 700,000 Chinese troops. The final treaty settlement left the border between North and South Korea roughly where it had been before the conflict began, but there was no doubt that the Chinese had checked the UN advance and altered the entire course of the war.

In the long run, the effect of the Korean War on China was not so much military or strategic as emotional and organizational. The nature of the war and the tensions that it generated led to an abiding fear and distrust of the US and a deep paranoia about the loyalties of China's own population. Despite the sympathy of many World War II American observers for the Yanan base area, China's leaders felt that, in general, the US had not helped the Communists. However, they had given great assistance to the Guomindang with airlifts, troop movements, matériel and advice in the civil-war period, and continued to support the Nationalist claim to represent China in the UN in early 1950. Once the Korean War erupted, President Truman ordered the American Seventh Fleet to patrol the Taiwan Straits, thus ending any chance that the Chinese might have to capture the island. The immense casualties that the UN inflicted on the Chinese in Korea — estimates range as high as 900,000 — were perceived by the Chinese as being all caused by the Americans. The Americans were also blamed when over 14,000 Communist prisoners of war sought to be repatriated to Taiwan rather than to China. Support for the Chinese war effort domestically now went under the slogan 'Aid Korea, Resist America'.

Communist campaigns to raise funds, enlist recruits, and encourage people to accept hardship as scarce food and resources were diverted toward the front, spilled over into anger with all

'Feudal superstitions'. *One consequence of the Korean War, in China itself, was the intensification of campaigns against these and 'capitalist elements'. Christian churches were closed and other religions suppressed, with their clergy 're-educated' to prepare them for life in the new society, like the Taoist priest (above) and the Buddhist nun (right). Tibetan Buddhist lamas (far right) lost secular power but were otherwise undisturbed, until the uprising there in 1959.* [PHOTO NEAR RIGHT: HEDDA MORRISON]

Westerners. Though most Western business personnel and missionaries had been forced out of China already, there was a hunt for scapegoats and victims, for secret friends and acquaintances of foreigners, for those with foreign education and job experience, or those who had been converted to Christianity or had known missionaries. Attacks on churches and foreign business escalated and exacerbated tensions already high due to the take-over of foreign assets and the nationalisation of foreign businesses. The idea of the mass struggle and criticism campaign, hitherto mainly aimed at obdurate intellectuals or landlords, now spread to the Chinese business communities, to the bureaucracy, and to all who could be held guilty of profiteering or corruption. Almost thirty thousand people were executed in the single province of Guangdong according to contemporary reports, usually after only the most perfunctory of trials. The act of 'labeling', by which a person was designated according to class or former family background, now became harsher and more widespread. As the terror of being so labeled spread, compliance with government doctrines grew, until many Chinese began to acquiesce in the most extreme government policies. It also became harder for ordinary Chinese to stay outside the political arena, for non-participation in such huge campaigns as the 'Three Anti' campaign of 1951 – against corruption, waste and bureaucratic obstructionism – was seen as tantamount to a confession of guilt. The 'Five Anti' campaign that followed in 1952 was even more protracted and harsh. Directed against all those in the 'bourgeoisie' who allegedly had practised bribery, tax evasion, or cheating on contracts, this campaign shattered individuals and their families, and led many to commit suicide or attempt flight after repeated public humiliations.

The Korean War was finally settled by a truce in 1953, after the death of Stalin and the election of Eisenhower in place of Truman as US President, and the Chinese were free once again to concentrate on the steady economic restoration of the country, based on the First Five-Year Plan, designed to cover the years 1952-1956. This was a Soviet-style master plan focusing on specially designated state-run industrial enterprises, particularly mining, iron and steel, heavy machinery, railways, trucks, and power plants; it successfully stabilized urban wages, restrained inflation, and restored confidence in the government. A good example of such an achievement was the design and construction of the road and rail bridge across the Yangzi River at Nanjing, which opened fast, unbroken communication between Peking and Shanghai – previously all passengers and goods had to be unloaded at Pukou on the north shore and ferried across to the south bank. The general political pressures continued however. They were given new focus by Mao Zedong's sudden announcement that Gao Gang and Rao Shushi, the immensely powerful Party bosses of China's two most important industrial and economic areas in southern Manchuria and Shanghai, were both guilty of defying Party priorities and unity by building their own personal 'fiefdoms'. Gao Gang committed suicide when the charges were made, compounding his guilt in

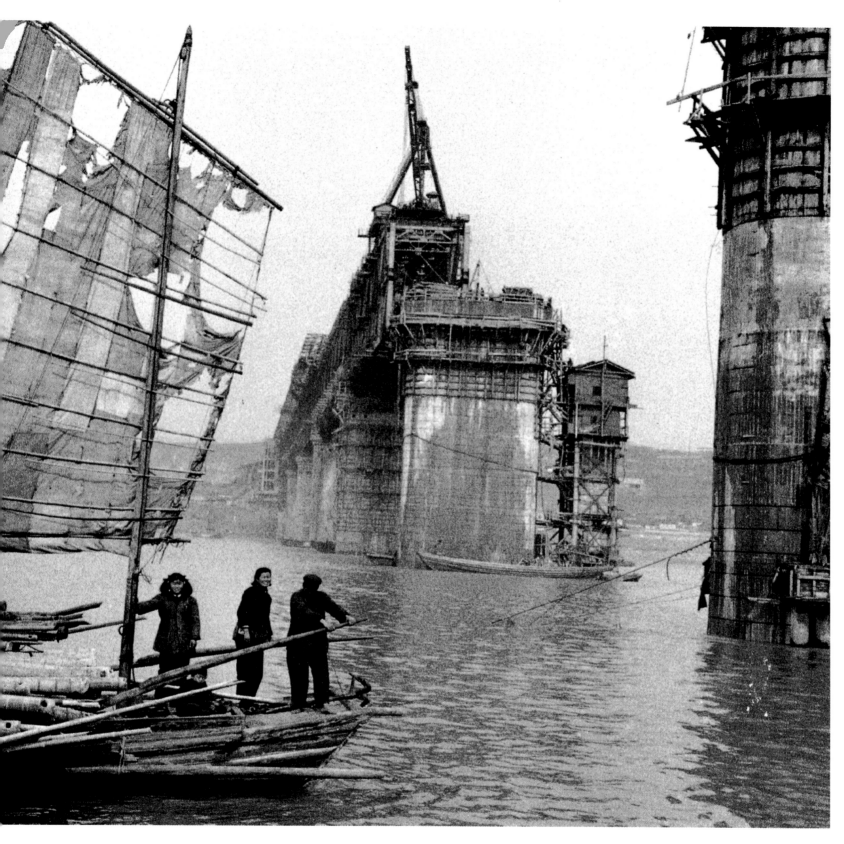

Taming the Yangzi. *For millenia the river had been a symbol to the Chinese of the immense and largely unmanageable forces of nature. It had never been bridged, neither Qing nor* *Guomindang engineers having the resources for the task. Railway lines and roads from Peking ended on the north bank, and passengers had to be ferried across to the south. To bridge the* *Yangzi was an early Communist priority, made possible by the technical assistance of engineers from the Soviet Union. This 1957 photo shows the massive piers of the bridge to Nanjing* *nearing completion. The fragile river craft carries bamboo to be used as scaffolding on the bridge.* [PHOTO: MARC RIBOUD]

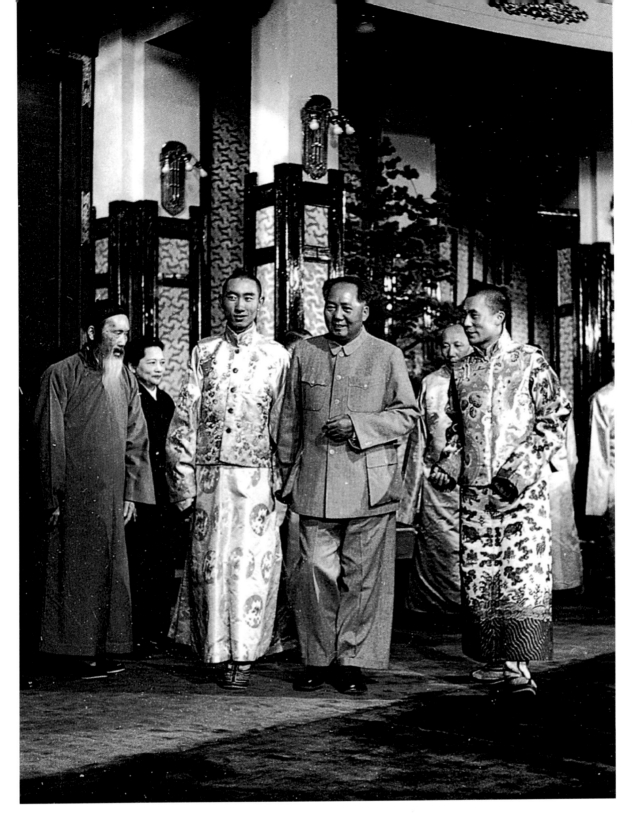

The Leader and the Lamas. *Mao with the two leading Tibetan Buddhist figures, in Beijing in 1954: the Dalai Lama (right) and the Panchen Lama (left). Their temporal power had been ended by the forcible integration of Tibet into the People's Republic in 1950, but Mao still felt the need to cultivate them at this stage. The Dalai Lama took sanctuary in India after the failed Tibetan uprising in 1959. Only after another five years did The Panchen Lama speak out against Chinese policy in his homeland.*

Zhou Enlai in Geneva *in 1954 to look after China's interests at the negotiations to end France's war in Vietnam. Dulles, the American Secretary of State, publicly refused to shake his hand at the conference but Zhou's diplomatic skills won him wide praise, and helped establish a new image of China as a constructive member of the international community.*

the eyes of the Party, for suicide was seen as the ultimate treason.

The impeccable revolutionary credentials of both men made the charges the more startling. Rao Shushi was an early Communist labor organizer in Wuhan who rose to be leader of the New Fourth Army in the Yangzi Valley during World War II. Mao had trusted Rao so much that he had named him head of the department which supervised the promotion and discipline of Party personnel — perhaps the key post in the Communist patronage system — and a member of the select group chosen to draft China's new constitution. Gao Gang had been a founder of the Shaanxi region guerrilla base to which Mao led the retreating Long March in 1935; later Gao had coordinated all of the troop

and supply movements through his region during the Korean War. In 1952, Mao named him head of the State Planning Commission which supervised the entire shape of China's First Five-Year Plan. The fall of two such major leaders on vague charges of political disloyalty and personal ambition — no precise evidence was ever furnished to prove their guilt — pointed to serious weaknesses and divisions at the center of the Party, and perhaps to an emerging paranoia on the part of Mao Zedong.

One of the reasons for Gao's fall (and those of at least six other leaders of the Manchurian region of the Communist Party who fell with him in 1954 and 1955) may have been that he in particular was on record as expressing skepticism over the idea of

collective management of enterprises. At this exact time, the Maoist leadership of the Party was beginning to suggest radical changes in the patterns of land-holding and of rural work, claiming that there was a reemergence of a type of rural capitalism. To careful observers, there seemed little doubt that, though peasants were now producing more on the land they owned because of the partial pooling of resources, there was also less available for the growth of the economy as a whole, since the successful peasant entrepreneurs were simply eating more and having more children, while those less able were being forced to sell off their land and to return to a pattern of landless labor. In 1955 therefore, the Party began to order the formation of larger 'cooperatives' of peasants. Within these cooperatives people might still keep their titles to their land, but the amount they received proportional to their investment would decrease and the amount the State extracted in the form of mandatory grain purchases at artificially low prices would increase, as would State supervision over what kinds of crops were to be grown. In theory, the extracted surplus would be pumped into the industrial sector to enlarge the scale of collective enterprises, guarantee existing job structures and pay for more workers, and still maintain low grain prices for the population as a whole in the cities.

One obvious result of the fall of Gao Gang and Rao Shushi was an increase in Mao's own power and perquisites. When in Beijing, Mao resided in the closely guarded wooded lake-side compound to the western side of the Forbidden City, known as Zhongnanhai. There he lived by his own time scale, reading by his private swimming pool, and summoning his officials and acolytes to visit him when it suited him, day or night. Regular weekly dances allowed the senior Party leaders to mingle informally to the tune of waltzes and foxtrots with their junior staff. In this sheltered setting, secretaries and attendants gradually became a source of sexual companionship to Mao. He had lived through much emotional turmoil in his personal life: he had left his first wife while in the Jiangxi Soviet, and she was subsequently arrested and shot by the Nationalists. He abandoned his second wife in Yanan, sending her off to the Soviet Union for 'medical treatment', and took as his third wife, Jiang Qing, a former Shanghai actress. She in turn was rejected, for she irritated him with her hypochondria and was often absent for medical treatment. Mao nevertheless kept up some semblance of family life, and spent time with his two daughters, from his second and third marriages. Of Mao's two sons, both by his first wife, one had been killed in the Korean War, and the other was

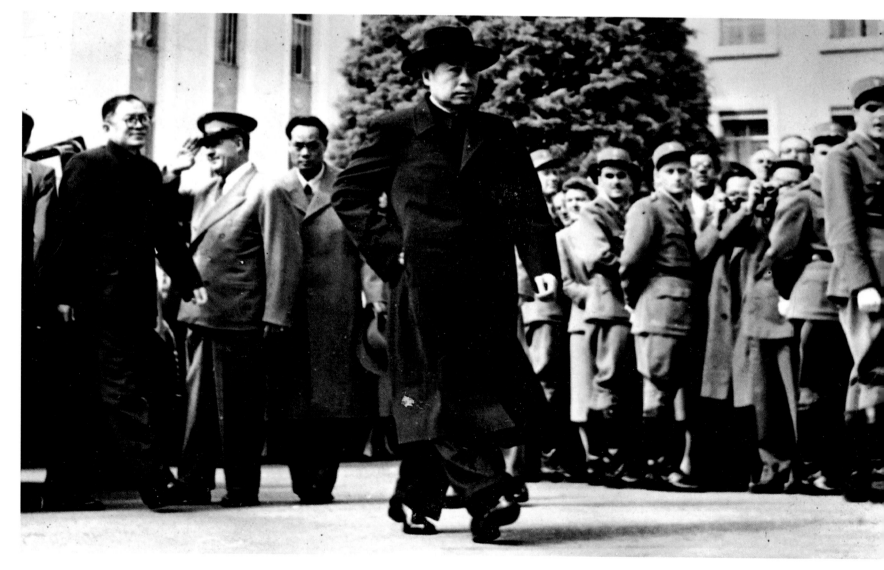

Time with his family. *Though Mao's family life was marked by tragedy — both his brothers and his first wife were executed in the civil war, one son from his first marriage was killed in the Korean War and the second often spent time in mental hospitals — once in his comfortable compound in Zhongnanhai in Beijing he drew together a semblance of family life. Mao (top) reads with his daughter Li Na, whose mother was Jiang Qing, his third wife and leader of the Gang of Four. Mao (below) and his elder daughter Li Min, born on the Long March to his second wife, look at Li Na in 1951. The little boy is Mao Yuanxin, son of Mao's dead younger brother. Dr Li, Mao's personal physician, said Li Na was 'caustic, mean... downright rude', while Li Min was 'honest, simple... polite, but not very bright'. Mao (right), his feet, legs and dressing gown muddy after a swim in the Xiang river, with children from his Hunan home town.*

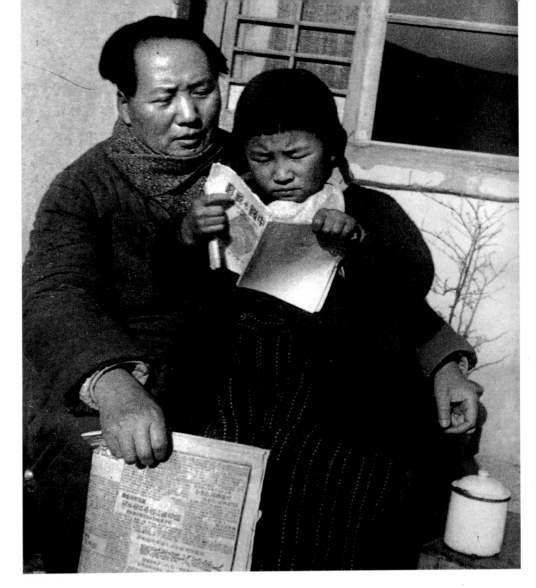

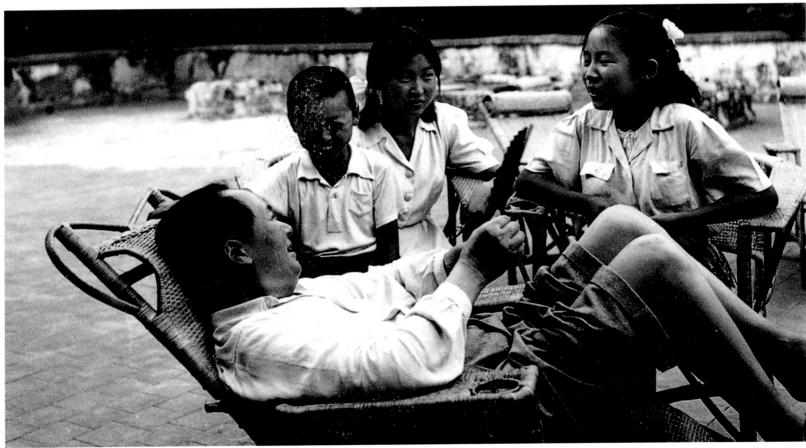

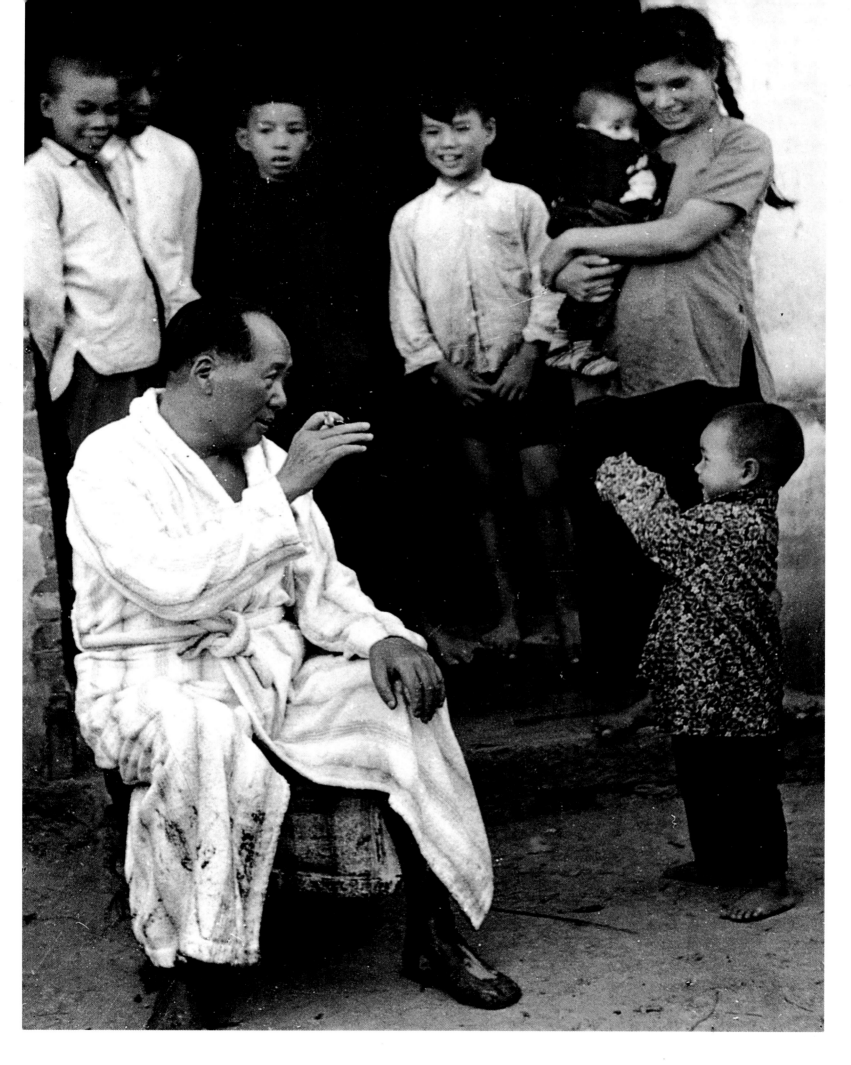

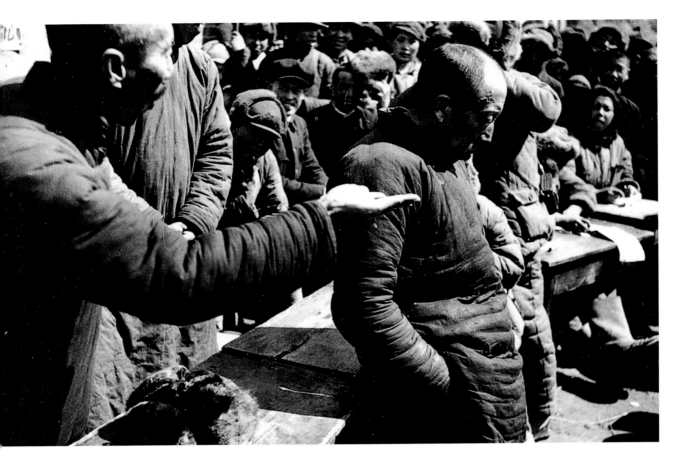

Public humiliations. *The landlords had been the target in the first land reforms in 1950-51. In the mid-1950s the levelling-down process continued and it was the turn of the wealthier peasants to be picked on, like this one in the northern province of Jilin. Zhang Bojun, (right) the Minister of Communications, is attacked at a rally in July 1957 of 3000 staff from the ministry. A few months before Mao had encouraged criticism from the intellectuals via the Hundred Flowers Movement, but the Party's Anti-Rightist campaign swiftly followed, stage managing scenes like this.*

mentally handicapped and needed special medical treatment.

In his constant travels around China, Mao showed his restless and eccentric side. When he attended important regional Party meetings, or stayed at one of the villas he had arrogated to himself in selected cities, he went by his own private train, complete with his own sitting room and bedroom parlor cars, surrounded by his own bodyguards. Here again he entertained young female companions, either from his own staff or those who caught his attention elsewhere. Discovering that his special railway cars had been bugged by his security chief later caused Mao intense anger, and led to the removal of the officials concerned. On these trips Mao would make carefully orchestrated public appearances, and pose for photographs with appropriately awed workers, students and peasants. He would also indulge his delight in swimming by taking his entourage into the local rivers in carefully calibrated proofs of his own informality and physical fitness – Mao had turned sixty in 1953. As well as allowing him to indulge his appetites, such journeys enabled Mao to meet large numbers of Party officials in the provinces, to gauge their responses to his suggestions, and personally to assess their characters and their loyalty. But, given Mao's immense prestige as father of the revolution, and his official positions as Chairman of the Standing Committee of the Central Committee of the Communist Party, head of state, and chairman of the military commission that had ultimate control of the People's Liberation Army, it is hard to know how often people dared to share their thoughts with him honestly.

What Mao heard, saw and read in the mid-1950s, seems to

have convinced him that the Party was moving on a correct track, and was basically loyal to him, and that it was time to recruit the intellectuals more actively into the ranks of his supporters by relaxing some of the controls over their thoughts and writings that had been imposed ever since the 'Rectification Movement' of 1942 in Yanan. This decision coincided with, and may have been actively fostered by, developments in the Soviet Union and Eastern Europe. In early 1956, Nikita Khrushchev, who had succeeded Stalin as the leader of the Soviet Communist Party, delivered a speech to Soviet Party personnel denouncing the excesses of Stalin. Such a speech could easily be read as a coded criticism of Chairman Mao as well, since his cult of personality was deepening, and his writings were required reading for the whole country. Khrushchev also called for a lessening in the levels of tension that had typified the period of Cold War confrontation between the Soviets and the Americans, and underlined the messages by visiting President Eisenhower at Camp David. Such actions contradicted Mao's repeated statements that a clash between the Soviet and capitalist blocs was inevitable, and that the East Wind now prevailed over the West. By stalling on various Chinese requests that they be given more Soviet technical help with their development of a nuclear arsenal, even though he had allowed Chinese physics students to study at the advanced nuclear research institute at Dubna, Khrushchev seemed to underline his decision to keep China subservient. In late 1956, because his new stance failed to be reflected in the actual Soviet imposition of power in Eastern Europe, major risings erupted in both Czechoslovakia and Hungary, and were repressed by the Soviets

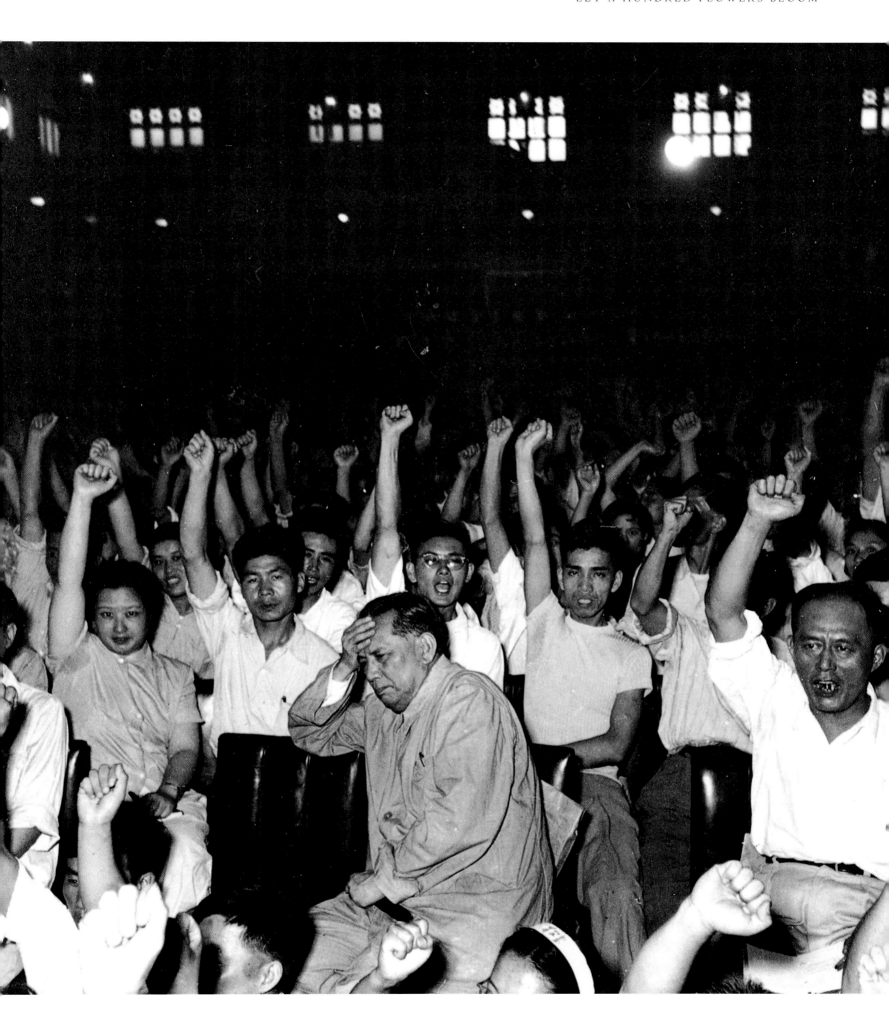

with massive military force. In the midst of these important shifts, Mao called on the Party and the intellectuals to 'let a hundred flowers bloom' in the fields of culture and science, and 'a hundred schools of thought contend'.

The refusal of any influential figures or groups to respond to this call during the remainder of 1956 convinced Mao that the message had not been correctly heard. So, in February 1957, he followed it up with a general address to senior cadres and intellectuals on the subject of 'Contradictions' within society. Pointing out that most so-called contradictions were not in fact antagonistic ones, and only certain overt political crimes or acts of class war should be so considered, Mao appealed for a fresher look at Chinese society and its current problems, especially as those might be reflected in official Party politics and behavior. It was a frank and positive speech, in which Mao discussed the number of those who had been killed in the revolution, reflected on the problems of land reform in different socialist societies, laughingly suggested the need for wider birth control programs to consolidate China's economic gains, and suggested a partial easing of censorship. Mao gave examples of those he considered intellectual heroes, because they had insisted on the correctness of their own ideas even when opposed by the power of the State or the forces of ridicule – this eclectic list included Confucius and Jesus as well as Galileo and Copernicus and the dancer Isadora Duncan. He admitted the unsettling nature of what was happening

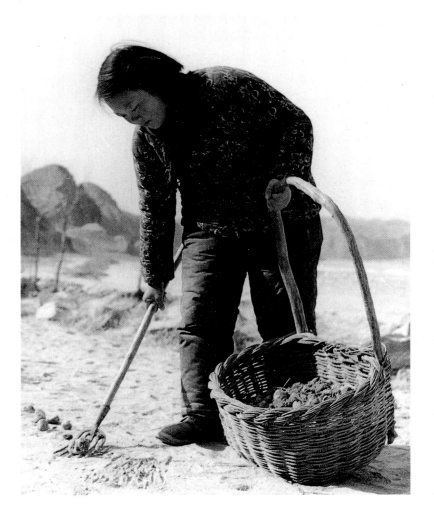

in Eastern Europe, and noted that many people found elements of Marxism deeply distasteful. It seems probable that he hoped thus to defuse potentially dangerous grievances among the intellectuals, and to convince them that the Party leadership was on their side.

Though this rambling but vigorous speech was not carried in any of the official Communist newspapers or theoretical journals – as Mao's remarks so often were – its general message circulated widely in intellectual and bureaucratic circles, and in the late spring of 1957 the Chinese at last began to respond. At first tentatively, but then with emerging vigor, they began to vent a vast range of grievances. These included all sorts of examples of Party vulgarity and incompetence, the nature of censorship and repression, the absurd inhibitions on freely representing society as it really was, the cumbersome educational system, and how Party supervision stifled everyday life. The criticisms came from all over China, from people in many walks of life, and at first were carried in several national and local Party newspapers. An Assistant Professor at Lanchow University criticized leaders who thought it 'only natural' that 'the Party's orders are above the law'. A learned journal accused Party officials of 'sitting in sedan chairs and keeping themselves from the masses'. And many observers prophesied the bleak future that the intellectuals would face in such a political atmosphere: the editor of the Antiquarian Publishing House claimed, 'scholars of classical literature will find themselves without successors.'

As the response began to criticize the nature of Marxist-Leninism itself, however, and its irrelevance to the needs and aspirations of the Chinese people, the official avenues for publication dried up. By June 1957, the Party had begun to institute a crack-down against the more outspoken critics, and in July Mao's speech on Contradictions was finally published in a Party journal. But now it had been almost entirely rewritten, either by Mao or by rival leaders in the Party, and its sense changed beyond recognition. The definition of what constituted 'antagonistic contradictions' was now reworked in a far more inclusive way. The class problems within society, and the need for constant vigilance against class enemies, were reemphasized. References to tensions within the Communist Party and to worries over the outmoded nature of Marxism were dropped. Allusions to peasant suffering and poverty vanished, as did those suggesting birth control to limit China's population. The references to most of the foreign modes of independent thought were expunged, along with those to Confucius. And the constructive role of the Party in guiding and guarding the life of the State received new prominence.

By the late summer of 1957, this counter-attack was transformed into a full-scale purge of the intellectuals, under the name of an 'Anti-Rightist campaign'. It was claimed now that the purpose of the whole movement had been to reveal the masses of 'poisonous weeds' that lurked among the flowers. Students and their teachers, creative writers, artists, editors, Party officials and scientists in many areas, along with economists, statisticians and journalists, were summoned by Party cadres for group struggle

Anti-Rightist victims. *Hundreds of thousands of the government's 'critics' were sent from their urban jobs to the countryside to 'learn from the peasants' in 1957. A botany graduate (left) deepens her view of rural life by collecting dung; her offence is that she comes from a 'capitalist family'. In 1958 four well-know artists(above) show contrition for 'bourgeois' behavior by decorating buildings in Nanxian villages in Hebei with socialist art.* [PHOTO, ABOVE: SHI PANQI]

sessions. Forced to write out confessions of the thoughts, motives and hidden attitudes that lay behind the criticisms such people had voiced, they had to lay bare every detail of their lives and those of their parents. The Party claimed that five percent of the intelligentsia were known to be of doubtful loyalty, so to conceal any fact concerning foreign books read, feudal teachers admired, or aspects of capitalist society secretly yearned for, could lead to personal disaster.

In the general miasma of self-criticism that followed, many people sought to protect themselves by criticizing their contemporaries; the cadres doing the investigating thus built up a formidable body of evidence and charges that could be entered and cross-checked in the dossiers that were becoming a standard item of each citizen's life. Though only a few people were executed, and

usually only if they had advocated some form of violence, those sentenced to some form of coercive reform through labor in their localities, or sent to areas far from home to work in isolated rural villages, numbered hundreds of thousands. Marriages were sundered in this process, and mothers were separated from their children. An incalculable number of promising academic careers were ruined, and the creative arts in all areas were crucially damaged. Government economic bureaus relinquished their finest specialists, and those with advanced statistical training; and even the State-run businesses lost many of their most knowledgeable staff, those who had gained experience through long exposure to Western or Guomindang business practices. The greatest tragedy was probably the legacy of timidity spread among the Chinese intellectuals as a whole. Though it cannot be proved that the critics were deliberately 'set up' in any way — and the evidence seems to suggest that Mao, who had hoped for a reassertion of loyalties, was initially surprised by what happened — most intellectuals lost their trust in the Party and it became impossible for those within it to offer frank criticism of their superiors, let alone analyze the distant leadership in the provincial capitals or in Beijing. With remarkable suddenness the promise of the Party to reform society was outweighed by all the suspicions and doubts to which no one dared any longer give voice.

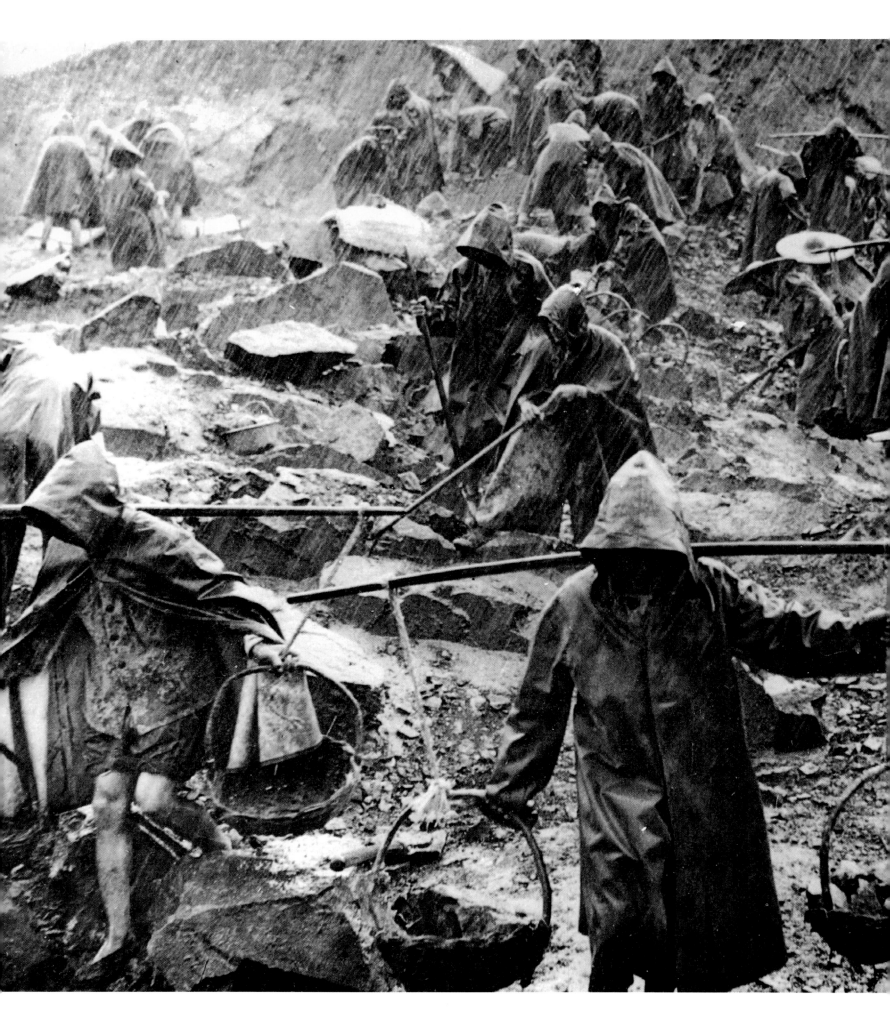

GREAT LEAP, GREAT FAMINE

The Ming Tombs Reservoir, *built between May and August 1958, was one of the first mass-labor projects that ushered in the Great Leap Forward. In May, Mao himself visited the site thirty miles north of Beijing, in a six-bus entourage, and dug the soil there for half an hour. He soon started sweating, so stopped for tea, and then did not return. His doctor commented, 'It was the only time in the twenty-two years I worked for him that Mao engaged in hard labor.' Yet Mao told senior Party leaders, in reference to this very project, 'Officials, no matter who, big or small, including us here, should all participate in manual labor as long as they are able.' The people of Beijing and the surrounding countryside certainly had to work in blistering heat and pouring rain to finish the reservoir, digging out huge rocks and great quantities of sand with nothing more than shovels, shoulder poles and baskets.*

INSTEAD OF DISCOURAGING THE COMMUNIST LEADERSHIP, the critical storm aroused by the Hundred Flowers Movement pushed it in a more radical direction. Mao had consistently believed that the human will was an unstoppable force, one that could 'overcome all obstacles'. His own survival, and that of the Party, seemed to prove this insight correct. In Mao's mind, it was human willpower and mass mobilization together that had led the Chinese Communist Party and peasantry to overthrow Japanese power and the Guomindang. It was the same combination that had stopped the apparently overwhelming forces of the United States in their tracks in Korea, and compelled them at last to sue for peace. China's potential for growth was thus as limitless as the population; if the Soviet Union was balking at further aid, if the United States was locked in hostility to China, if the intellectuals themselves could not be relied upon, then it was to the peasantry and the urban workers that the Party leaders must now turn. Mao's own view was that the peasantry constituted 'blank sheets of paper' and accordingly that it was on them that 'the most beautiful poems could be written'. Such thoughts echoed Mao's earlier personal experiences in the countryside rather than any classical Marxist theory of class background and potential for revolution.

The grouping of Chinese rural laborers into cooperatives, which took place during 1956 and 1957, was to Mao an excellent start, but the innate conservatism and acquisitiveness of certain wealthier peasants and more cautious rural cadres still rankled. What was needed, Mao felt, was an amalgamation of the existing 740,000 cooperative units that had emerged after land reform into much larger aggregates that could release the creative energies of the entire peasant population. An essential part of this process would be the abolition of private plots and of all personal rights to land, and the payment of all according to need. In the spring of 1958, the first experimental communes were being formed by amalgamating twenty-five cooperatives into single commune units of between 9,000 and 10,000 households, or some 50,000 people. By the end of 1958 the Party claimed that the spontaneous power of these examples had led to the formation of 26,000 communes in rural China, incorporating 99 percent of the entire peasant population.

The intersection of human will and social organisation that Mao and his more radical followers seem to have believed would transform China's productive capacity was to come from ending all the old divisions of labor, age and gender. By transferring the child-raising to day-care centers, and the cooking to central kitchens, and making care of the elderly the commune's responsibility, millions of women would be released for work in the fields. By centralizing militia forces under commune

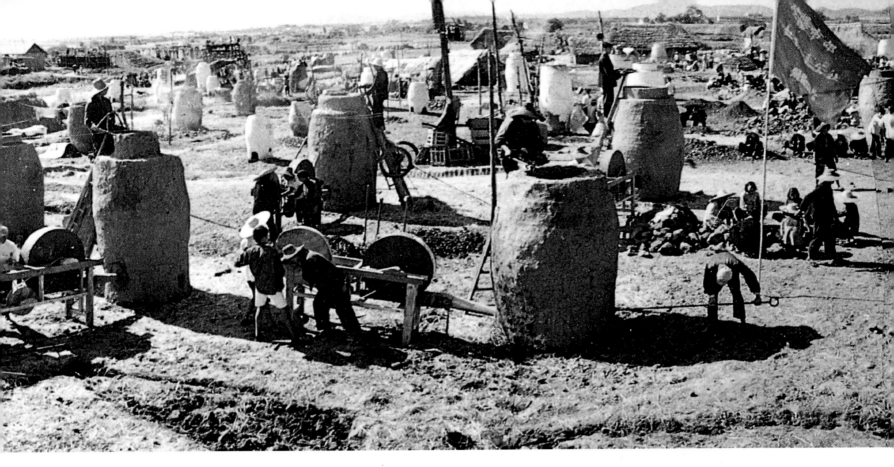

leadership, China would become a great people's armed camp, capable of repelling all outside aggressors. By establishing teams of medical personnel in the communes and having them train and assign paramedics – popularly known as 'bare-foot doctors' – to each production brigade, health care would be made available to all. Education, too, would be centered in commune schools, and linked to deeper ideological training, leading to a spontaneous increase in intellectual creativity, as each peasant would now be free to be a poet, novelist or painter. Industry would be brought out to the suburbs and countryside, as rural households collected their own fuel, made their own small backyard furnaces, and smelted their household metal objects and unneeded tools into steel to form the heart of a new industrial surge. All of these endeavors would be given coherence and efficacy by the guiding thought of Chairman Mao.

The production figures that the commune leaders sent into the provincial Party leadership, and that were forwarded in turn to Beijing, seemed to justify all the Maoist hopes for this transformation of China. The 1958 harvest was apparently by far the largest in China's history. Dense interplanting, deep plowing, opening of new previously barren lands to agriculture, and the use of every available pair of hands, were bringing in ten times the normal yield in many areas, and in their euphoria local Party leaders promised to double or treble that in the coming year. The government could thus feel free to extract ever larger amounts of grain from the countryside in the form of taxes, confident that would still leave the commune workers more than they had ever had before. In some areas, the circulated production figures were so huge that peasants were told to leave land fallow; in other areas, crops already growing were rooted up and fed to livestock so that different crops could be planted to diversify the diet.

Backyard steel furnaces *like these in Henan Province, were central to Mao's vision of how to attain swift modernization, yet the steel produced from them turned out to be useless for engineering purposes. Mao's Doctor Li recalled how they had 'transformed the rural landscape. They were everywhere, and we could see peasant men in a constant frenzy of activity, transporting fuel and raw materials, keeping the fires stoked. At night the furnaces dotted the landscape as far as the eye could see, their fires lighting the skies.'*

Only gradually did it become clear that something had gone disastrously wrong. The figures bore no relation to reality, rather they were the result of a spiral of euphoria. Pressured to make ever more inflated claims, local commune leaders had compounded lies with lies as the figures passed up the chain of command, until they reached central government bureaus where either no one had the skills to check them – many statisticians, accountants and economists had been purged in the Anti-Rightist Campaign of 1957 – or the courage to query them.

In some areas, even at the end of 1958, a few local Party leaders began to search for better organizational forms, to calm the hysteria, and to move to smaller units that would be more manageable. A few senior leaders in Beijing also went on trips of inspection to try and assess what was really happening. But it was not until July 1959, at a meeting of the senior Communist leadership at the Jiangxi mountain summer resort of Lushan, that any leader had the courage to tell Mao Zedong directly that something had gone wrong. The lone critic was Peng Dehuai, the former leader of the Chinese forces in Korea who, after being named Minister of Defense in 1954, had been professionalizing and modernizing the People's Liberation Army, his reforms prompted by the high Chinese casualties in Korea. Peng was too experienced in Party politics to criticize Mao directly or publicly,

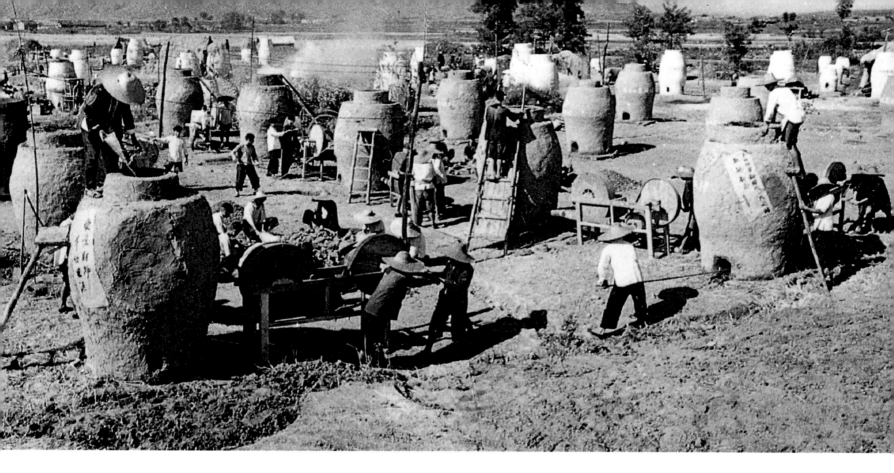

but instead handed him a letter in which he discussed what he had heard about problems with the Great Leap, and also commented on the fact that some rural areas with spectacular production figures had in fact been receiving aid from the State at the same time, which made their figures correspondingly high. Mao circulated these remarks to the other Party leaders at Lushan and attacked Peng for 'factional activity', one of the most serious charges possible in the Communist leadership. Mao removed Peng from his post and also purged several of his close supporters. Peng never held senior office in the Party, army or government again.

But purging Peng Dehuai could do nothing to halt the grim slide, first towards extreme food shortages and then, in late 1959 and 1960, to famine. Grain extracted from the countryside cushioned the urban workers (including of course the government officials and their families in Beijing). Though no news of the famine was carried in the Chinese press, and its extent was unknown at the time to foreigners, countless oral and written records later showed how entire villages and communes were decimated as the people dug for grubs or ate bark and acorns. The catastrophe was compounded by the erratic cropping patterns that had been imposed in many areas, by the planting of crops too late in the season for them to reach maturity, by the withering of crops in improperly opened-up wasteland, by exhaustion of the soil through deep plowing, and by the desperate local populations being driven to eat seed grain. There was a heightened risk of disease to the malnourished infants, and a sharp drop in fertility among the adult population. The result was one of the worst famines in human history. Later, demographic statistics showed that as many as 20 million people died famine-related deaths during the three years that followed the Great Leap.

Among the victims were many of the intellectuals and other critics of the Party who had been relocated to the countryside for their outspokenness in 1957. Utterly unskilled at rural labor, they could contribute little and often died unless they could somehow gain the peasants' sympathies. Thousands in forced labor camps also died, as their already small food allowances were cut back to one or two small dumplings filled with chaff each day. The scholar Ningkun Wu had answered the call to return home from the University of Chicago to serve Communist China as a professor of English, only to be denounced as an 'ultrarightist' for teaching *The Great Gatsby*. He and other intellectuals were sent in thin cotton clothing to build a labor camp in the Great Northern Wilderness bordering Siberia. In 1960 he was sent to a special prison for political rightists where he suffered extreme starvation. One day he was handed a pathetic note written in beautiful calligraphy begging for some of his food. Wu hesitated to share his life-saving provisions until another note arrived in the same classical hand: 'He who saves a man's life does a deed better than building the Buddha a seven-story pagoda.' Wu despaired at the sight of 'such elegant calligraphy reduced to such abject circumstances.' Some days later, he was ordered to bury the author of the petition who had died of hunger.

One added reason for the Party in China to conceal the extent of the disaster was that leaders in the Soviet Union – despite their own record of disastrous rural experimentation – were vociferous critics of the Leap, which they derided as a parody of Marxism. During the late 1950s, Soviet-Chinese relations continued to decline, despite a visit that Mao made to Moscow in 1957 in celebration of the fortieth anniversary of the Bolshevik Revolution, and a swift visit by Khrushchev to Peking in 1959 to report on his Camp David talks with President Eisenhower. In 1960, the Soviets withdrew their technical advisers from China, leaving many

Back-breaking work. *A mother and daughter pull their craft upstream on the Li River in the south-west, evidence that well into the 1950s muscles continued to power much of the country. The Great Leap pooled the strength of hundreds of thousands of laborers in a series of giant projects, trusting that cumulative force would compensate for lack of mechanisation.* [PHOTO: EMIL SCHULTHESS]

Human chains. *(overleaf) The first signs of the Great Leap mass mobilization of labor were in rural canal and irrigation projects, such as this one in Jiangxi Province, in which local peasants moved five million cubic feet of soil . A year after this project began in December 1957, Mao was becoming alarmed at the human cost of such schemes. In a speech to Party leaders he said, 'Half of China's population unquestionably will die; and if it's not half, it'll be a third or ten percent...If you don't lose your jobs, I at least should lose mine.' He suggested a figure of 70 billion cubic meters of soil and rock to be moved, as compared with the first projection of 190 billion cubic meters, and the previous year's total of 50 billion cubic meters.*

183

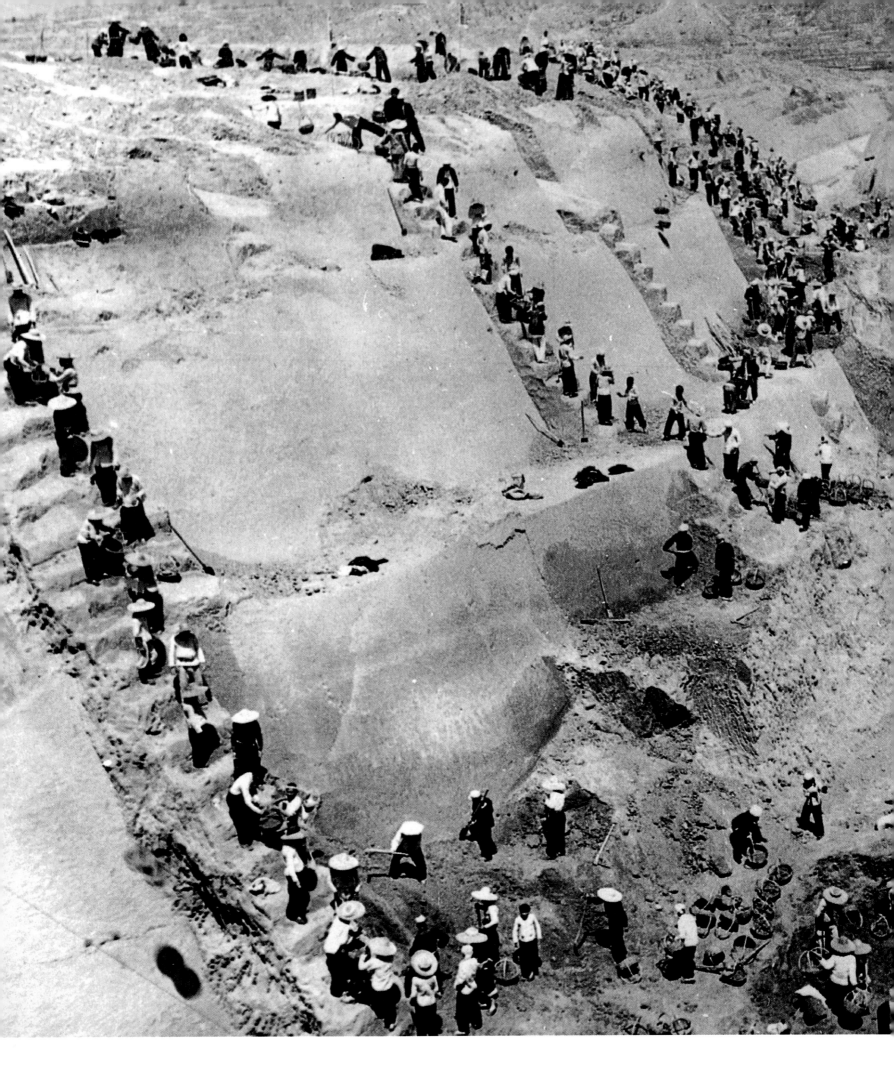

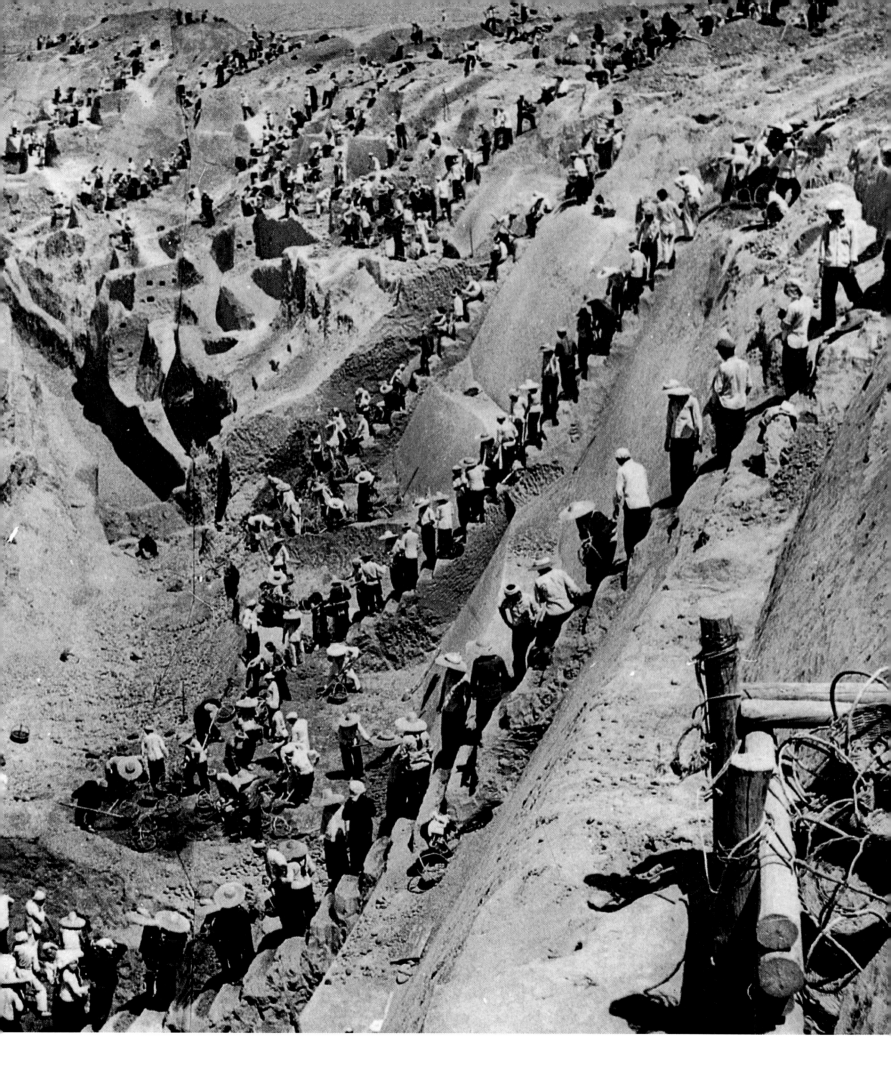

HISTORY REVISED

Mao digging at the Ming Tombs Reservoir *in May 1958 (see caption p.179), with veteran revolutionary Peng Zhen beside him (top). This photo was widely circulated as proof of Mao's devotion in sharing the hardship of the masses. At the time Peng was Party Secretary of Beijing, but after he was purged in 1966, the photo became an embarrassment and was creatively adjusted (below).*

important industrial and engineering projects still unfinished. The Chinese in turn withdrew their students and military officers who were studying at technical institutes and military academies in the Soviet Union.

Though the Soviets refused to help China build its own atomic bomb after 1958, many of China's best nuclear physicists were assembled thereafter to go it alone, under the overall coordination of Nie Rongzhen, one of the most successful revolutionary commanders in the Yanan period and a major leader in the civil war against the nationalists. Utilizing thousands of amateur 'peasant-geologists' to hunt for uranium, which was found and collected in large quantities in Hunan and Fujian provinces, Nie and his teams worked at secret bases in the desert areas of Qinghai, Ningxia and Lop Nor. The bases themselves were specially created research cities, built in part by the local communities and by the scientists themselves, who also grew their own food during the famine years. The successful detonation of China's first atomic bomb in October 1964 was presented as a triumph for Mao Zedong's thought and the people of China — though in fact many of the scientists responsible for the success had been trained in nuclear physics in Moscow and and elsewhere overseas, and had also consulted thousands of Western technical journals. But these details were not emphasized.

In a similar way, the development of China's first major oil fields at Daqing in Manchuria was credited to the local peasants and workers. Mao declared Daqing as a national model for self-reliance, and promoted many of its staff to important national positions, even though they (and presumably he as well) knew that much of the work was done by experts working with drilling equipment obtained from overseas.

Despite the resounding rhetoric of these and many similar claims, for several years after 1959 Mao was in partial political eclipse. China was plagued by many problems besides those that followed the chaos of the Great Leap. In 1959 a major uprising in Tibet led to a renewed invasion, the destruction of many monasteries, and the flight of the Dalai Lama to India. Border tensions with India flared into open warfare, and the government and people of Indonesia turned on the Chinese in their country, massacring thousands and causing colossal damage to Chinese property there. Mao stepped down as head of state — he was someone who had always disliked formal protocols, so this decision may well have been voluntary — and declared he would devote more time to broad theoretical issues confronting the nation.

Much of the actual running of the country between 1959 and 1966 was in fact in the hands of a man very different from Mao, Liu Shaoqi. Five years younger than Mao, Liu was born in 1898 in Mao's home province of Hunan. After working as a labor organizer in 1920, he traveled under Comintern sponsorship to study in Moscow before returning to China to work in the Shanghai union organization and the Jiangxi mines. Thereafter he played a prominent role in the Party labor movement in Shanghai and in north China, and worked with the New Fourth Army and organized underground anti-Japanese resistance. His major Party

speeches and writings in Yanan and at the time of the founding of the People's Republic made him second in prestige only to Mao, and he had especial responsibility for maintaining Party discipline as the ranks of the Party grew dramatically. In April 1959, after he was named Chairman of the People's Republic in place of Mao, one of his first acts was to publicly praise the achievements of the Great Leap. Shortly afterwards, however, he called for more rigorous ideological training for the 17 million members of the Communist Party, pointing out that 70 percent of them had joined since 1953. To strengthen Party discipline Liu's most celebrated work, *How to be a Good Communist*, first written in Yanan, was revised and reissued in a special number of the Beijing Party paper, *People's Daily*, with instructions that it be read by all Party cadres.

In an attempt to tighten Party discipline farther, Liu and other senior Party figures went on inspection tours in the early 1960s. Liu's wife had prepared the way for these tours by conducting rural investigations on her own, concealing her real identity and encouraging the local peasants to speak out about the true situation on the land that they were farming, and about the corruption of the local Communist cadres. These Party investigators discovered numerous gross abuses in the way the Party members wielded power, and they used a Maoist technique against some by encouraging public struggle sessions in which criticisms could be aired, and they could then be forced to make public confessions. The investigative campaigns of this period were seen by many –

including Mao – to be improperly directed at some of the veteran and less well-educated rural cadres, whose lives and careers seemed to typify the kinds of new rural Party activism that Mao had long espoused. When Chen Yonggui, the head of China's most famous 'self-reliant commune' of Dazhai in Shanxi province, was found guilty of abuses and of fixing the books to make his production figures look more impressive, Mao fought back to protect this symbol of his ideology. Mao appointed Chen to the presidium of the People's Congress, and had his own photo published along with Chen's in *People's Daily*.

Clearly the issue now was not only the pace but also the kind of revolutionary development that China should follow. Liu Shaoqi and countless other Party members wanted planned development, along Soviet lines, in which collective industry and collective agriculture could be carefully coordinated by the professional Party bureaucracy. As a corollary to this vision, they sought a lessening of control over every aspect of daily lives. The Chinese people should be encouraged to consume, as long as the growth of heavy industry went unharmed. In the countryside, once basic quotas were met on the collectivized land, farmers should be allowed to work in their spare time on small, private plots, to grow extra food for their own consumption or for local sale. In contrast to the drab, utilitarian blue and gray 'Mao suits' that had been mandatory during the leap period, the Chinese were to be allowed once again a certain cheerfulness and idiosyncrasy in dress, along with a certain openness in art. Even some foreign influence should not be

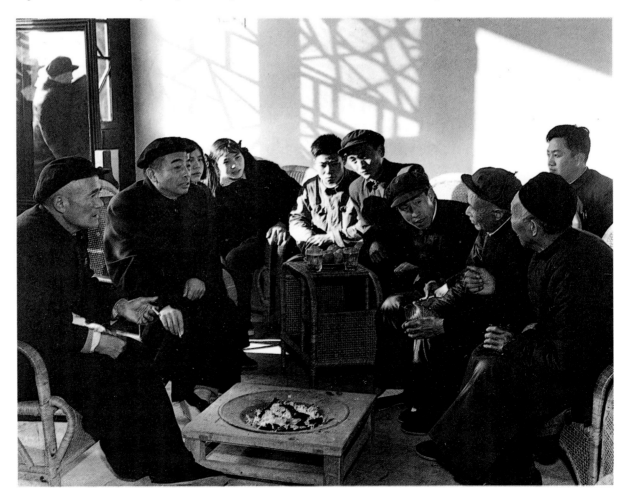

A lone voice. *Veteran Red Army commander and Minister of Defense Peng Dehuai was the only leader to speak out against the Great Leap. Here (second from left) he talks with former Red Army comrades and their families in Jiangxi Province, assembling evidence of the grossly exaggerated Great Leap claims that lay behind the famine. He courageously voiced his fears to Mao in a private letter in August 1959. Mao replied with a strident attack on Peng's lack of loyalty and had him purged from office.*

considered taboo. The result was a partial renewal of the cultural vitality that had existed before the Anti-Rightist Campaign and the repetitive communitarian rhetoric of the Great Leap.

No less a figure than the Premier, Zhou Enlai, defended the independence of creative and intellectual works if they were not 'anti-Party' or 'anti-socialist', and Liu Shaoqi suggested that college graduates, specialists in the relevant fields, should replace their Party section chiefs if those men were uneducated recruits from the guerrilla years who lacked all technical knowledge. The mass-oriented type of research projects so favored in the Great Leap were abandoned, and a number of academic forums renewed their work on Western scientists from Copernicus to Einstein, or on economists from Adam Smith to Maynard Keynes. The Philosophy Department at Beijing University introduced classes on Kant, John Dewey, and the Existentialists. Some of those who had been sent to the countryside during the Anti-Rightist purges were allowed to return home and in some cases given back their jobs. Though they did not write about their famine experiences, one can assume they talked about them with family and close friends. The head of the Beijing Party Committee convened a group to study the Central Committee documents during the Great Leap, urging them to 'trace the responsibility for the hunger' that people had suffered during those years. Whether it was precisely true or not, the blame for much of the abuse of authority that accompanied the Anti-Rightist Campaign of 1957 was laid at Mao's door and, in the moderately safe form of innuendo and historical allegory, Mao himself was depicted as being merely the latest in a long line of tyrants.

Perhaps the writing of Wu Han, one of China's leading historians, was the clearest in its implications. Specializing in the history of the Ming dynasty (1368-1644), Wu Han wrote several essays on despotic Ming emperors and the bold and outspoken officials who occasionally dared to oppose them. The earliest of these were written with Party encouragement in the late 1950s. But, in 1961, Wu Han elaborated the ideas into a full-length play, in which a courageous Ming minister speaks out on behalf of peasants victimized by local officials, and goes so far as to condemn the cruellest of the abusive elite to death. But the Emperor, hearing of the case, reverses the verdict, pardons the villain, and dismisses the brave minister from his post. It did not take a huge leap of the historical imagination to see the Emperor as Mao, the minister as Peng Dehuai, and the officials as the cadres of the Great Leap period. Wu Han's play was performed several times in Beijing and subsequently published.

Wu Han also collaborated with a group of well-known scholars and writers in Beijing to produce a series of essays: 'Notes from a Three-Family Village'. These roamed widely across Chinese history, telling of rulers who would not listen to criticism or suggestions from others, or who tried to take on too much authority. Other essays looked frankly at the reasons for man-made famines at different periods in China, examined past Chinese reformers who had bold ideas but no practical experience and contrasted a true 'kingly way' based on humanity,

Blinded by science. *The Great Leap was meant to be as much technological as agricultural. Displays, such as this exhibition of 'Industrial Progress' in 1959, were in part a response to Mao's exhortations the previous year: 'Agriculture has taken off; it's on track, but not industry as yet. Industry must be the focus. Some say "sleep on the work sites and sleep beside the machines". Next year is the year of the decisive battle.' But Mao also warned against following the teachings of Soviet leaders too closely in this area: 'Don't think the ancestors all fart fragrantly.'*
[PHOTO: BRIAN BRAKE]

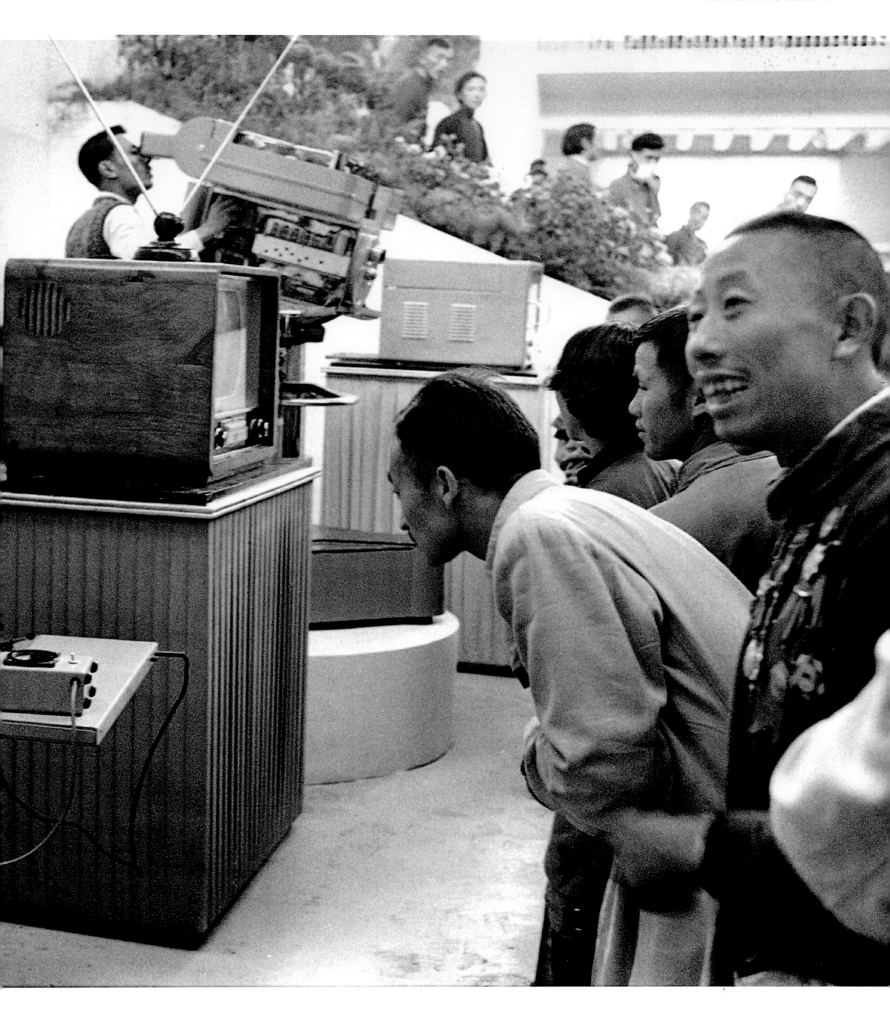

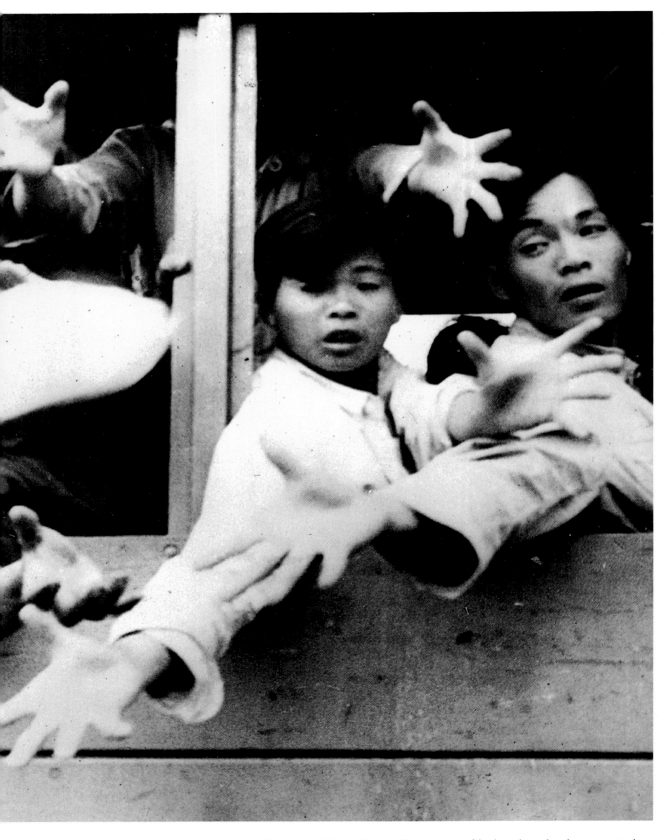

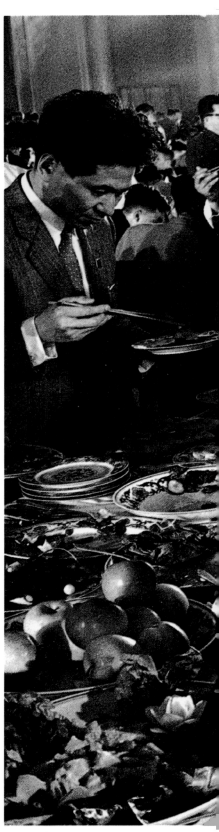

Famine and feast. *The terrible starvation that afflicted rural China between 1959 and 1962 was concealed not only from the West, but even from many of China's own people. Refugees, like those shown here begging for food after fleeing to Hong Kong in 1962, were often not believed when they told of the disasters in China. Her neighbors in North Korea, Vietnam and Cambodia were also kept in the dark, their diplomats misled by sumptuous spreads such as the one laid on for them in the Great Hall of the People on May Day 1964.* [PHOTO, RIGHT: RENE BURRI]

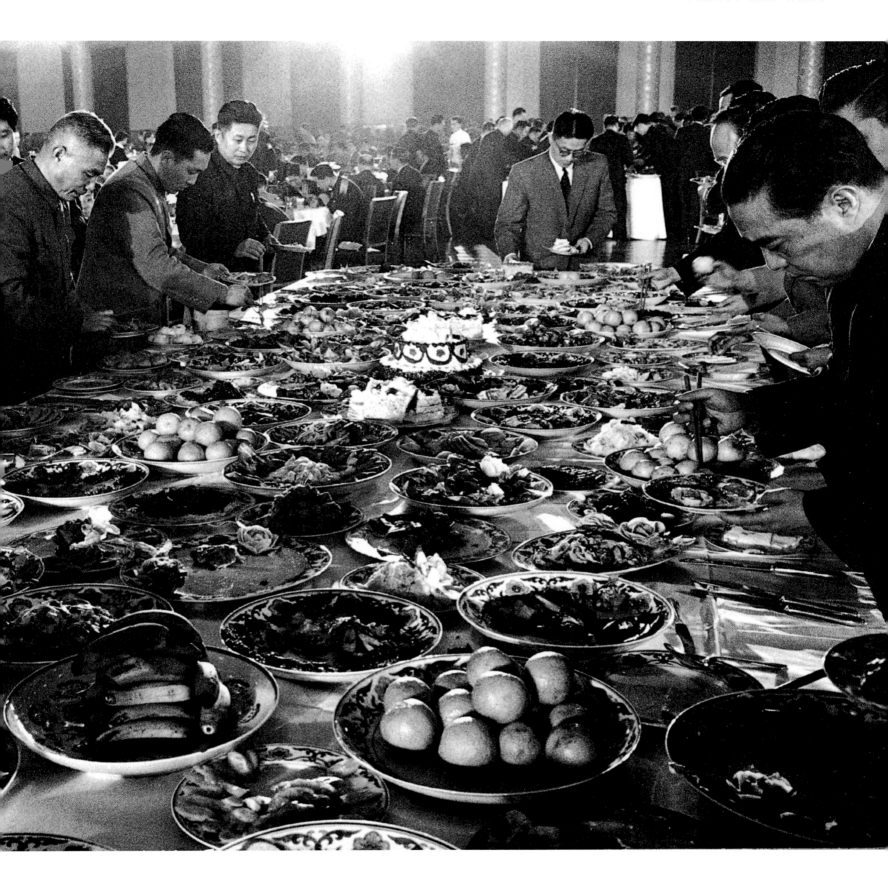

law and morality with a 'tyrant's way' that used power and violence. The essays were widely imitated.

When Mao turned against Peng Dehuai in the summer of 1959, he chose Lin Biao as Peng's replacement. Of all the senior Party figures, Lin had probably made the fewest public appearances and had kept the lowest profile; some attribute this to the fact that he was seriously ill with tuberculosis during the early 1950s. Like Peng, Lin had impeccable revolutionary military credentials. A graduate of the early Whampoa Academy, he rose rapidly through the Communist army ranks, and on the Long March he commanded an army corps. Later he became the coordinator in Manchuria of the Communists' final successful battle strategy between 1947 and 1949.

Almost immediately after being called to head the Defense Ministry in 1959, Lin Biao moved to politicize the armed forces. Claiming absolute loyalty to the principles of Mao's military and political thinking, Lin wrote in a much-publicized article that the concentration on professionalization and modern armaments, so touted by Peng, must yield to stricter ideological controls. He sent over 100,000 People's Liberation Army officers and staff to serve with the ranks at the company level or below, to sharpen their knowledge of the ordinary soldiers' lives. In 1960 Lin also sketched out his view of the correct system of values within the army, one in which men should always have priority over weapons, political work always have precedence over other military work, ideology over routine training, and the 'living thought' gained from practical experience over book learning.

By 1963, Lin Biao had supervised the compilation of a group of short revolutionary aphorisms and speeches by Mao, which he published and distributed to his troops under the title of Quotations from Chairman Mao. In his handwritten introduction to the book Lin especially emphasized those elements of Mao's thought, such as self-reliance and self-sacrifice, that were currently in disfavor among leaders in the Party such as Liu Shaoqi.

This emergent 'cult of Mao', as it was later to be termed, was given greater impetus by a mass campaign that Lin launched within the ranks of the army, to 'emulate Lei Feng'. Lei Feng's picture, along with a 'diary' that detailed his selflessness and passionate homage to Chairman Mao as supreme leader and guide, were distributed to all PLA troops. In this fabricated Party version, Lei Feng was described as having been raised by a family that had suffered repeated degradations at the hands of the Japanese, greedy landlords, and Guomindang rightists. After these enemies had driven his family members to death from poverty, disease and suicide, Lei Feng found a new family when he joined the PLA. There he learned to drive a truck, a new skill that opened up his intellectual world as he sought to understand what made the truck work, and led him to dream of a day when 'the whole vastness of China's countryside' would be 'mechanized'. Lei Feng sought only to be a 'screw in the machine' that was China. Praising the ideological initiative that Lei Feng's 'diary' represented, Mao Zedong returned the honor that Lin had given to him by gracing the title page with his own calligraphy,

Worried leaders, *caught in a rare unposed shot in January 1962, at a meeting to try and restructure the failing economy. From left to right: Zhou Enlai (premier), Chen Yun (chief economic planner), Liu Shaoqi (Mao's replacement as head of state), Mao, Deng Xiaoping (general secretary of the Party), and Peng Zhen (Beijing Party secretary). Mao's loss of teeth is apparent, caused according to his doctor by his insistence on only rinsing his mouth with green tea, as opposed to brushing. The previous year the famine had touched even these leaders; Mao's doctor noted that grain rations dropped to sixteen pounds a month, there were few vegetables, and almost no cooking oil, while hepatitis and edema had become endemic, on account of the malnutrition, even in the exclusive Zhongnanhai compound. Mao gave up eating meat, and some of his staff went to hunt wild goat in the nearby hills.*

and ordering the book to be studied in all the schools of China.

From his base in the Defense Ministry, Lin Biao moved steadily to widen his range of operations, helped by a key associate, Luo Ruiqing, a 1926 classmate of Lin Biao's at the Whampoa Academy. Luo served alongside him for many years until named Minister of Public Security, where he served until 1959, and chief of the PLA's own security. Mao then chose Luo to be vice-minister of defense under Lin in 1959, and concurrently appointed Luo as Chief-of-Staff of the PLA. In combination, therefore, Luo and Lin had a powerful military and security base from which to operate.

Mao moved from public view altogether in late 1965 and made his base in Shanghai. There his wife, Jiang Qing, who had been

developing ideas about people's art and people's revolutionary theory, had been building a potential base of operations among the Shanghai cultural bureaucracy. Though to observers Mao and his wife had not been close for several years, Mao's frustrations over his inability to get his own criticisms of the reemerging 'reactionary bourgeois ideology' published in the Party press apparently drew the two together again. Just after Mao settled in Shanghai, one of his wife's close associates published a biting attack on Wu Han's play on the Ming dynasty, pointing out that it denied the basic premise of Mao's thought. The idea of a specific corpus of 'Mao's Thought' had been developed in the Yanan period and redefined by Lin Biao. The attack went on to postulate

that the masses, not moralistic intellectuals, were the driving force of historical and social change. This criticism echoed that found in Lin Biao's military publications, and showed Mao and his followers that they had a new potential forum. Lin then gave yet more proof of his apparent political radicalism by ordering the abandonment of all insignia of rank in the PLA, returning to the simpler vision of an informal people's army that had existed in the Yanan days, but had been abandoned by Peng Dehuai. The lines were clearly being drawn for some new and complicated kind of struggle around the theme of radicalized political commitment, but exactly what form it would take, and how the issues might be presented, was still unclear.

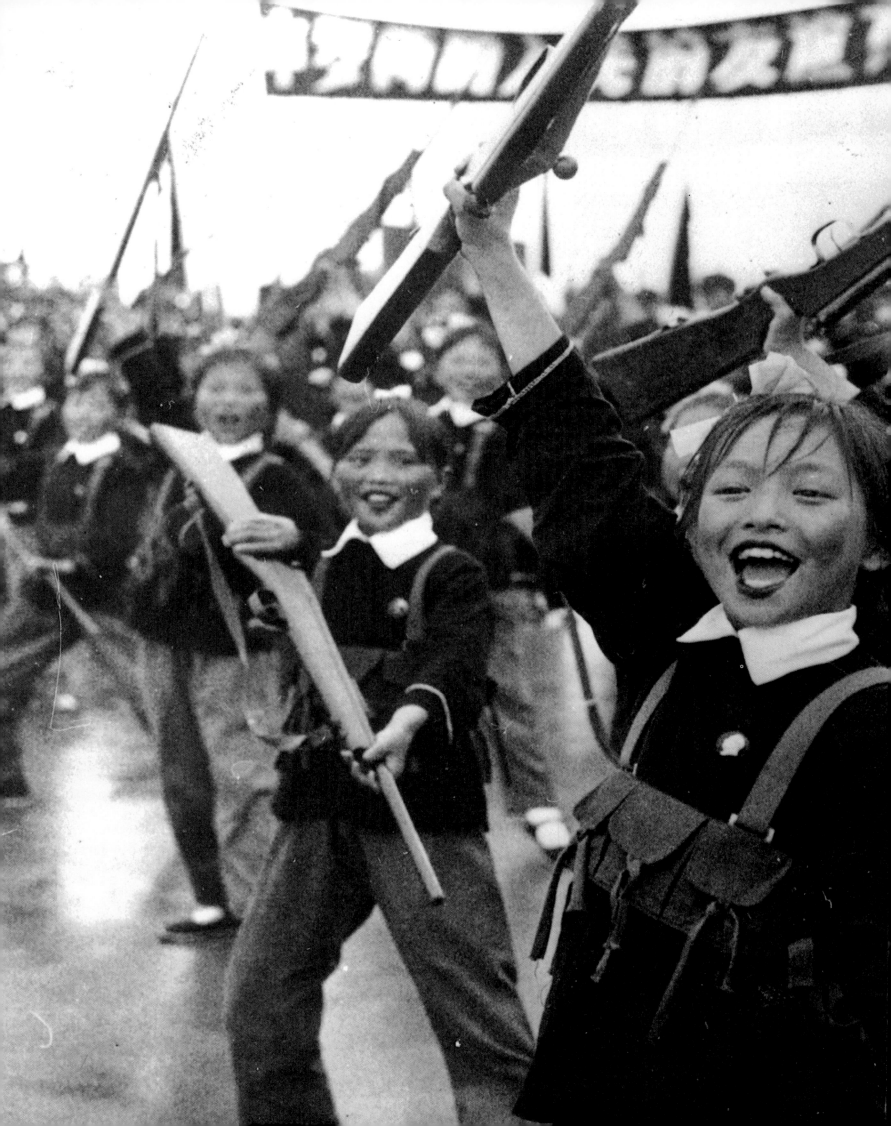

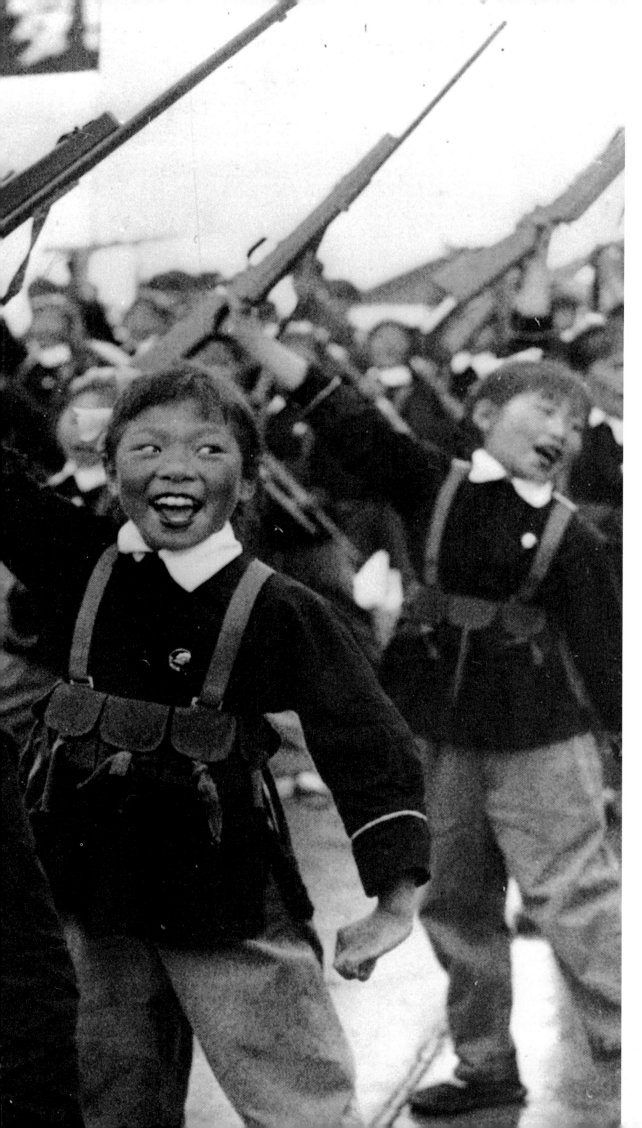

Keeping up appearances. *Despite disaster, the nation maintained a smiling face in public. Chanting schoolgirls, in a choreographed dance with wooden rifles and wearing dummy ammunition pouches, parade under a banner saluting the heroic working class of Rumania.*

CULTURAL REVOLUTION

At some time during 1964 or 1965, Mao had decided to purge the Communist bureaucracy on the grounds that it was dominated by Party leaders hostile to radical change. So the decision to attack Wu Han was a shrewd one. Not only did his writings make him vulnerable to charges of reactionary thinking and disloyalty to Mao, but his position as deputy mayor of Beijing linked him to the center of that bureaucracy. The length of time it took for the Shanghai accusations against Wu Han to be published in the national press showed how strongly senior figures in the cultural and publishing worlds sympathized with him. And when Mao ordered a committee under the mayor of Beijing, Peng Zhen, to investigate in January 1966, it issued a vague report that substantiated none of the major charges against Wu. Only Mao's repeated orders forced it at last to deepen its investigation.

It was in May and June of 1966 that the main lines of what came to be the Cultural Revolution emerged in the pronouncements of Mao and the Shanghai leaders. In calling for a full investigation of the bureaucratic and feudal tendencies still entrenched in the Party leadership and the cultural realm, they made it clear that they wanted to build up once more the country's revolutionary momentum. Though the bureaucracy was slow to respond, an alert faculty member in the Beijing University philosophy department, the only department with a Party committee controlled by scholars loyal to Jiang Qing, put up a big-character poster that accused the Party committee and the president of Beijing University of trying to suppress the students and consolidate their own leadership. The Beijing authorities ordered the poster to be torn down and a struggle session launched against the philosophy teacher. But hearing of this, Mao directed that the contents of the poster be broadcast over Radio Beijing and that it be published in the *People's Daily*. Mao commented farther that the poster 'stirred up the whole world' and showed that 'to rebel is justified', echoing some of the remarks he had made during his own revolutionary youth.

Liu Shaoqi's clumsy attempt to defuse the outcry by appointing Party work teams to investigate the situation roused more opposition from the extremists. In August 1966, groups of students formed 'Red Guard' detachments and rallied in support of Mao at certain elite high schools and colleges in Beijing. Wearing red arm bands, and a form of paramilitary uniform with caps and leather belts, the Red Guards sprung up swiftly across the country and started to launch struggle and criticism sessions against their teachers and school administrators. The attacks spread rapidly to include local Party personnel, and members of families that were known to have feudal or bourgeois backgrounds, or that had been singled out for punishment in the Anti-Rightist

Member of the Black Gang: *a young Red Guard chops off the hair of the Governor Li Fanwu in the city of Harbin in China's far north, on September 12, 1966. The placard around Li's neck identifies him as a 'member of the Black Gang', a generic term for anyone accused of trying to stand in the way of Mao's newly announced Cultural Revolution. Recruited in the name of Mao to smash all 'old and feudal elements' in their society, teenage girls often became the most strident and aggressive of the Red Guards. In* Chaos and All That, *an autobiographical memoir of the experiences of a Red Guard, Liu Sola recalled how she begged to join the Red Guards in her school at the age of eleven and was allowed to do so after she publicly cursed her own family using the vilest possible language, and helped guard an elderly ragpicker accused of being a former landlords's wife. During Liu's tour of guard duty the old woman cut her throat. Such tragedies were common in the Cultural Revolution.* [PHOTO: LI ZHENSHENG]

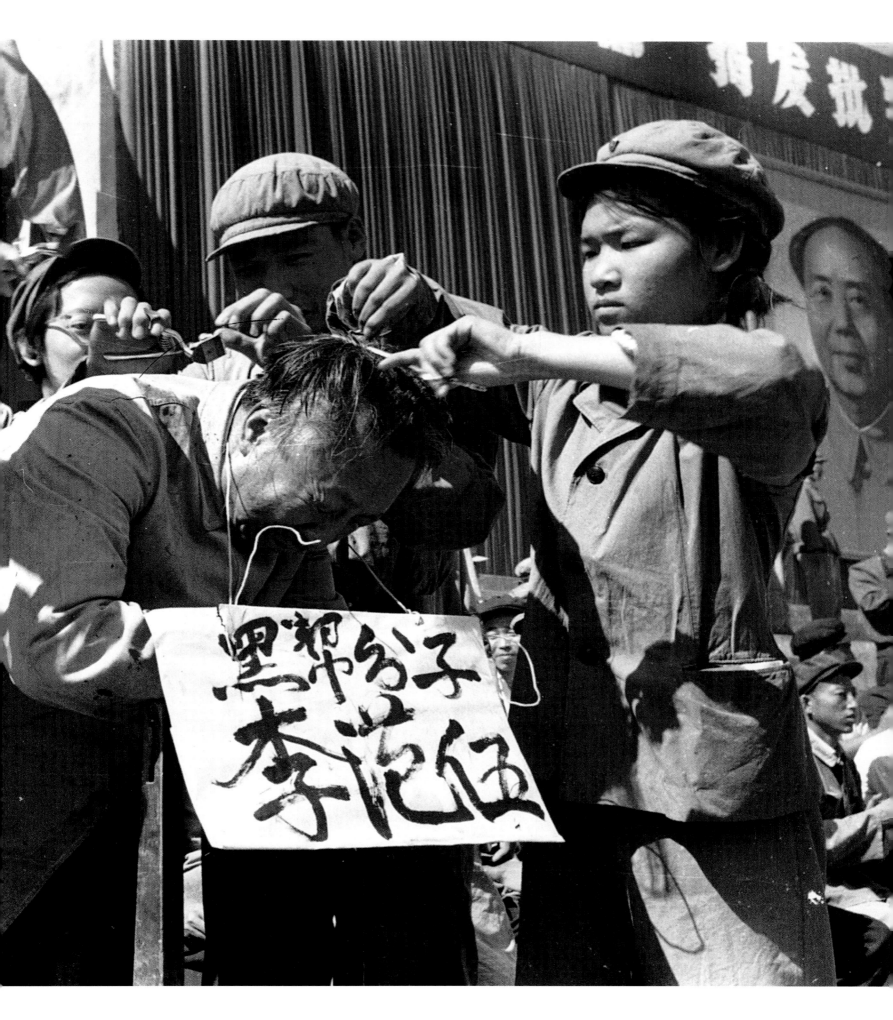

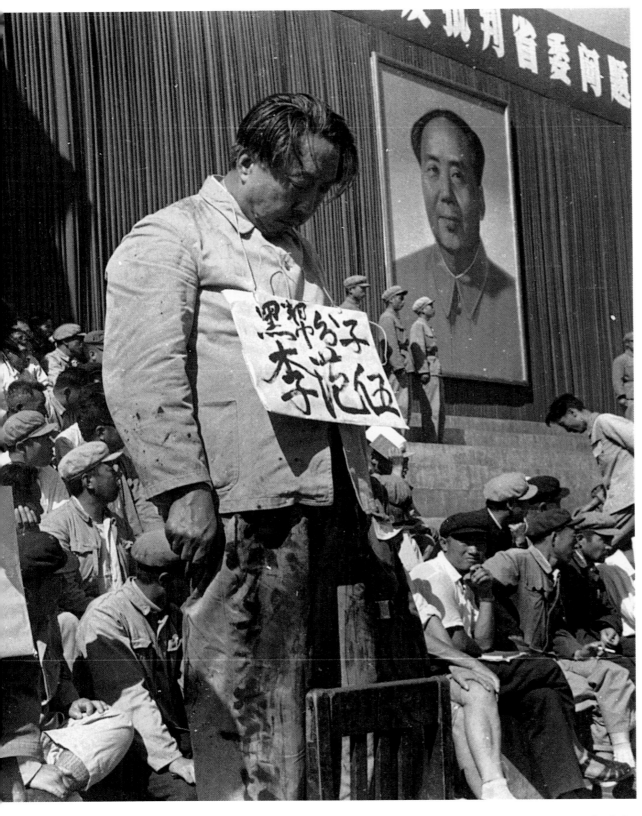

Smash and Criticize: *The scenes before and after the head shaving on the previous page. Li Fanwu, a former senior leader in the Red Army war of resistance against Japan, and longtime governor of Heilongjiang province, was summoned to attend a Red Guard meeting on charges that he had* betrayed the nation in dealings with the Soviet Union. Alerted to the forthcoming rally, the young photographer Li Zhensheng went to record the scene for the Heilongjiang Party newspaper. He was there at the moment (above left) when a Red Guard shouted that Governor Li was *not only a traitor to China, but had grown so arrogant that he dared to brush his hair like Mao. After his impromptu haircut, the humiliated governor was forced to bow to the Red Guards (above right) as his shorn hair was stuffed down his neck. The banner above Mao's photo exhorts the* Guards to 'smash and criticize' the province's government, and Li indeed lost his office and party posts. The former governor continued to protest his innocence and was subjected to a new round of humiliation and persecution in 1967. [PHOTOS: LI ZHENSHENG]

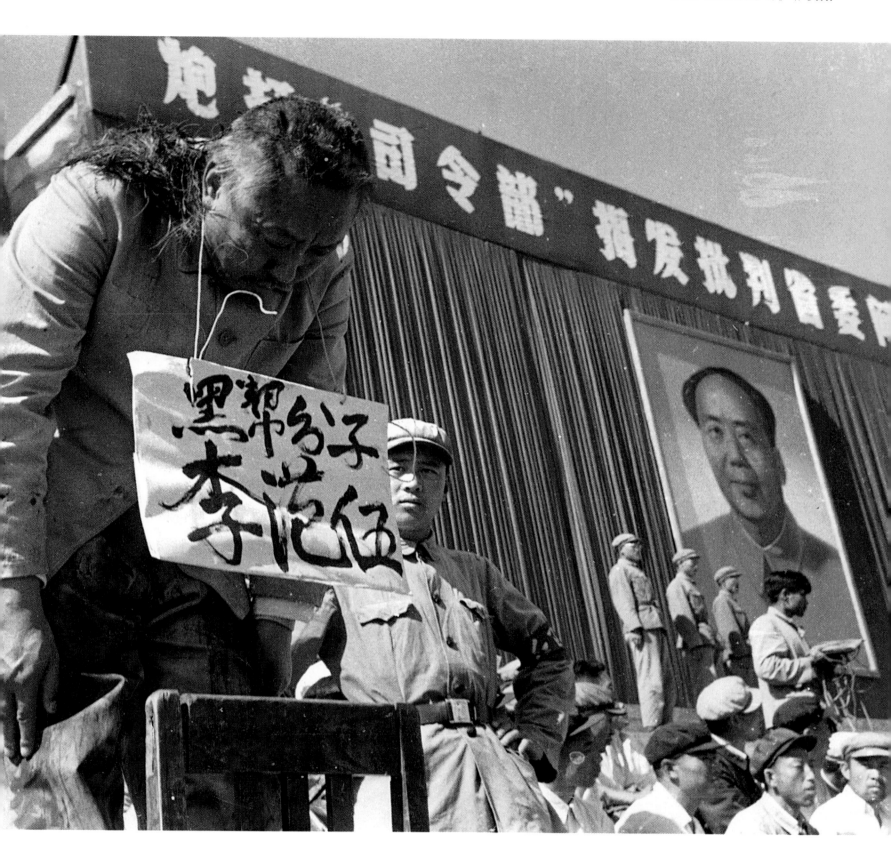

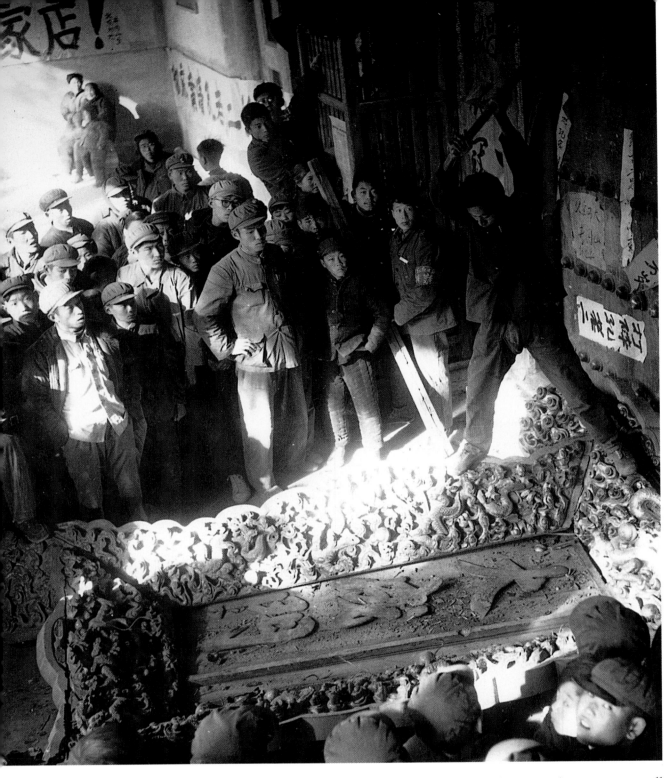

'Confucius and Co.' *The search for 'reactionaries' and elements of the 'old feudal order' ranged widely in 1966. It was only a matter of time before Red Guards targeted the shrines of the sage-philosopher Confucius, which had been maintained for over two thousand years by his family descendants in the hills of Qufu in Shandong province. A guard takes a sledge hammer to the elaborate carved marble entrance pillar to the main Confucian shrine. The banner (top left) urges people to strike against 'Confucius and Co.', a phrase first used in the May Fourth Movement in 1919. Widespread destruction of shrines and temples in China and Tibet was one of the aesthetic tragedies of the Cultural Revolution.*

True Believer. *As the Cultural Revolution deepened, Red Guards fanned out around the country, to hunt down 'reactionaries' and to share their 'revolutionary experiences'. This soldier (right) in the People's Liberation Army became famous for his revolutionary passion and vigor. Photographed on 16 April, 1968, he clasps the Little Red Book of Mao's sayings, and points proudly to the Mao buttons and badges given to him by peasant audiences around China moved by his revolutionary zeal.* [PHOTO: LI ZHENSHENG]

Campaign of 1957. That same month, Mao Zedong himself, having written his own wall poster, 'Bombard the Headquarters', and wearing a similar Red Guard arm band and a military-style outfit, stood on the reviewing stand atop the Tiananmen Gate to greet hundreds of thousands of Red Guards assembled in the Square below. By late August, as train travel was made free to Red Guards across China, their numbers had swelled to close on a million, and by the end of November 1966, Mao had in all greeted six such enormous rallies, the cheering throngs weeping with emotion as they waved their copies of the Little Red Book of Mao's sayings compiled for them by Lin Biao.

Many of the first Red Guards were the children of Communist officials and cadres, which was why they were in the elite schools and colleges in the first place, for only special connections coupled with outstanding test scores allowed entry. By proving the level of their revolutionary commitment to Chairman Mao these students hoped to guarantee their own positions within the Communist hierarchy, and to expunge any taint of improper favoritism that might have clung to them. Rapidly, however, the Red Guard groups began to fragment and then form new configurations. Those students in less prestigious schools, or young people denied advanced schooling or already graduated, whose parents perhaps had had Guomindang or foreign connections, also sought to disassociate themselves from their so-called 'bad class backgrounds' by taking radical action. They formed their own Red Guard units, with suitably revolutionary names, and began to attack schools and Party organizations. In many cases they attacked their own parents, trashing their homes, destroying

foreign books and gramophone records or Chinese works of art that had been kept there, and launching vituperative personal attacks against any family members who could be suspected of lack of revolutionary enthusiasm. Rival groups of Red Guards began to feud among themselves, to deny each other's revolutionary credentials or commitment, and finally to come to blows. Rather as peasants in the land reform movement had been drawn into complicity with the revolutionary process by being encouraged to beat up or kill their landlords and rich peasants, so the Red Guards were led to ever more violent confrontations; their helpless victims were subjected to abject humiliations, locked in tiny spaces without food, lashed repeatedly with leather belts or struck with the heavy buckles, and in some cases paralyzed or beaten to death.

One incentive for students to ransack their school or local Party offices was the chance to destroy the records of bad class attitudes. Factory workers also formed Red Guard units in their work places, to rid themselves of tyrannical managers or supervisors, to cleanse their own dossiers, and to win better work conditions, shorter hours and perhaps even better pay. But the attacks, as Mao and the Shanghai radicals had surely intended, also reached ever deeper into the Communist hierarchy, 'bombarding the headquarters'.

The director of the Party's propaganda department, Lu Dingyi, and the mayor of Peking, Peng Zhen, were accused by Lin Biao of plotting a coup against the Party. Powerful though these figures were, they paled into insignificance when compared to the two highest victims, Liu Shaoqi and Deng Xiaoping. Major criticism of the two began in October 1966, and in December 3,000 Beijing students led a rally against them. Since it was impossible to charge these two veterans with any simple crimes, they were accused of seeking to follow a 'bourgeois reactionary line' and taking 'the capitalist road'. For good measure they and their followers could also be labeled 'Soviet revisionists'. What these charges meant was that both Liu and Deng were believers in careful state planning of the economy on the Soviet model, as opposed to the kind of revolutionary voluntarism that had lain at the heart of the Great Leap or the earlier days of peasant and worker mobilization. They also believed in allowing a limited return of the small private plots that enabled peasants to grow crops or raise some chickens or other livestock, and they had encouraged such gestures after the Great Leap Famine.

Both Deng and Liu were experts at Party discipline and organization, and just as they had undoubtedly curbed the more radical assertions of Mao's visions during the Hundred Flowers Movement, and supervised the ensuing Anti-Rightist Campaign, so during the Socialist Education Campaign of 1962-64 they had deflected the Party work teams from deepening the hold of Maoist ideology. Instead, they swung the investigations against the less-educated rural cadres, who Mao believed were true revolutionaries, but whom they believed to be grossly abusing their power. For over twenty years, Deng Xiaoping had been secretary-general of the Communist Party, able to manipulate the career patterns within the bureaucracy, and promote those whose views

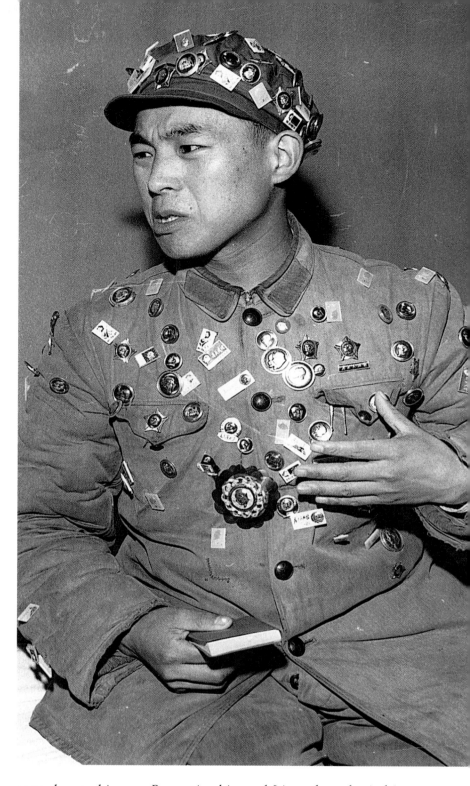

were close to his own. By ousting him and Liu – the only rival in ideological prestige to Mao himself – the Cultural Revolutionary group tried to shift the country decisively in their chosen direction.

Deng and Liu were not killed. But Liu was dragged from his home in Zhongnanhai, forced to undergo numerous struggle sessions and issue self-criticism, and was rumored to have attempted suicide. His children were arrested and mistreated, and his wife Wang Guangmei, who had been so active with him in the investigation teams of the post-Great Leap period, was also criticized and humiliated, forced to dress like a parody of a capitalist in a glamorous split-skirted qipao, with a decorative necklace around her neck. Deng Xiaoping was humiliated in public rallies by shouting crowds, attacked in insulting wall

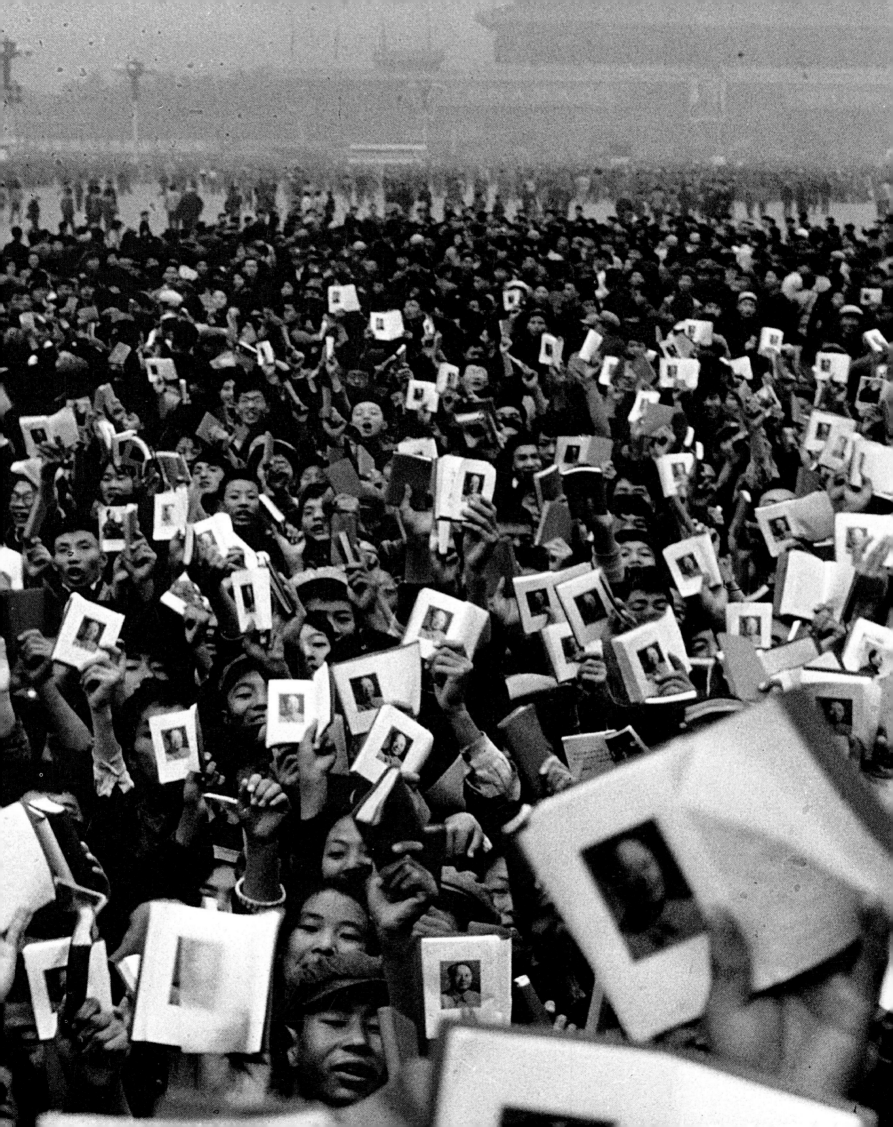

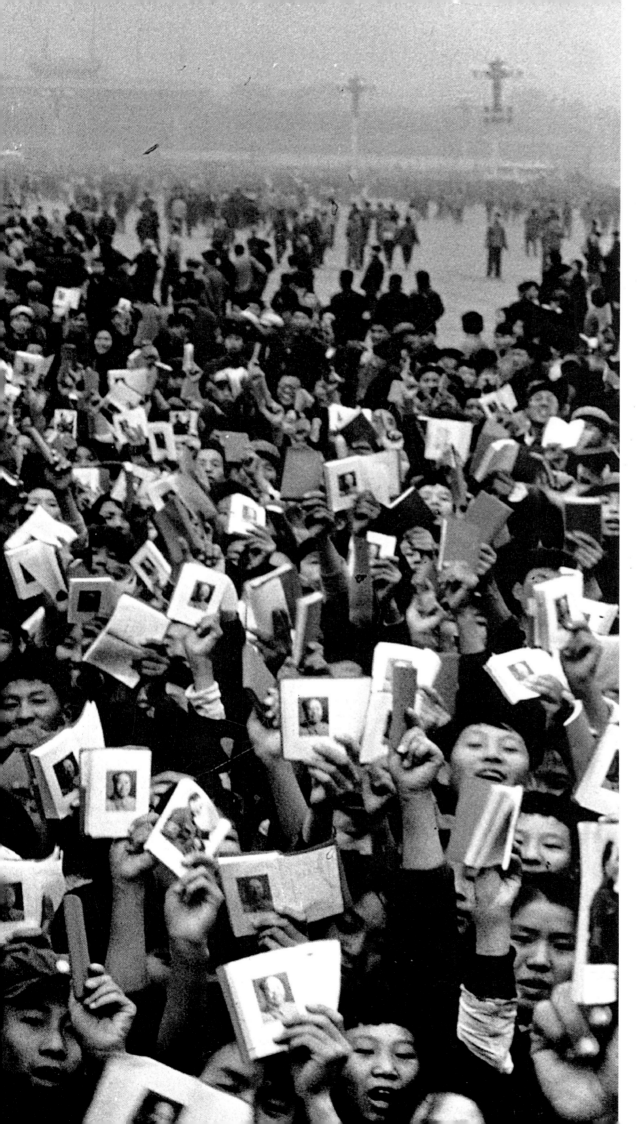

The cult of Mao. *From August 1966 well into the next year, huge Red Guard rallies were held in Beijing's Tiananmen Square, where Mao reviewed the Guards from the top of the former Forbidden City's main gate. Here, in May 1967, a group of Red Guards wave their Mao books in unison, all opened at the frontispiece picture of their leader. The former Red Guard Liu Sola wrote later that when Chairman Mao 'waved his hand at Tiananmen, a million Red Guards wept their hearts out as if by some hormonal reaction. Later on we were all conditioned to burst into tears the moment he appeared on the screen. He was divine, and the revolutionary tides of the world rose and fell at his command.'* [PHOTO: PAOLO KOCH]

Before and After. *(overleaf) Mao checks the sights of a rifle at an army shooting range in June 1964, while Liu Shaoqi (center) watches thoughtfully, and the army chief-of-staff Luo Ruiqing smiles encouragingly. Below , accused of betraying the revolution, Luo Ruiqing is jammed into a basket by Red Guards in December 1966, and carried off to a mass criticism rally. Liu Shaoqi was purged the same month.*

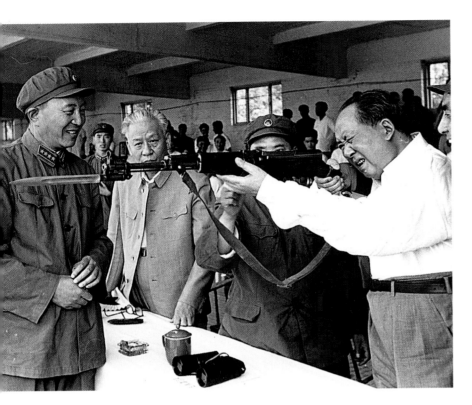

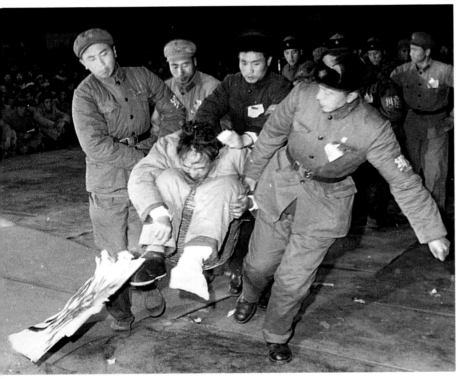

approval of the State's security apparatus and the People's Liberation Army. Since the latter were firmly under the control of Lin Biao, and he had declared himself categorically as in Mao's camp, the army could not be expected to intervene on either Liu's or Deng's behalf, even though both of them had close friends and colleagues in the army's senior ranks. Similarly, since Lin Biao had helped Mao's wife, Jiang Qing, spread her views through PLA journals and the dance and theater propaganda troupes that formed an important part of the PLA structure, it was equally unlikely that any of the senior cultural figures could hope for military protection.

The security apparatus was, however, a more shadowy force, and perhaps for this reason one of the senior Cultural Revolutionary victims was Luo Ruiqing, a close colleague of Lin Biao's for over thirty years. Thereafter, Kang Sheng, a close colleague of Jiang Qing and the Shanghai radicals, and known to have been the ruthless head of Party security during the Yanan years, assumed an ever more powerful role, so further increasing Mao's de facto power.

By the spring of 1967 China was falling into chaos. All schools and many government bureaus were closed. Railways and roads were clogged with Red Guards out sharing their 'revolutionary experiences'. Factory production was seriously interrupted, and some actions were tantamount to the strikes on which the Communist Party had tried to build its influence in the 1920s, but which it had assiduously suppressed since coming to power in 1949. In many cities rival Red Guard factions were locked in bloody combat, now often armed with rifles and even grenades and artillery that they had taken from depots or PLA units. Many Red Guards were killed in battles between rival units, and the army sometimes opened fire to protect its own installations or disperse dangerous crowds. The bureaucracy was paralyzed, and no one felt free from sudden criticism or attacks that might ruin their careers and negate a lifetime of revolutionary service. The vast throngs of Red Guards made supervision so difficult that the registration system tying peasants and workers to their communes and work units had virtually broken down, and raised the specter of serious social upheaval. Top-secret facilities, like the research establishments that were now working on China's hydrogen bomb and an intercontinental ballistic missile system, were threatened with takeover by Red Guard units that claimed their directors or scientific personnel were revisionists or rightists. Prisons and labor camps were entered by Red Guards, who forced jailers and inmates alike to manifest their Maoist revolutionary loyalties. Military units felt internally vulnerable, and in some cases were riven by factional divisions and even threatened with mutiny.

In mid-1967 a general consensus appears to have been reached by Mao, Jiang Qing and her supporters, Lin Biao, and many of the surviving senior Party figures, to restore a measure of order. The method chosen was to declare the victory of the Cultural Revolution – though the need for 'unceasing vigilance' would continue – and arrange for the formation of 'revolutionary

posters, and forced to retire from his posts. His family suffered along with him; one of his sons was pushed from a high window by Red Guards, and paralyzed for life. Liu, too powerful to release, was held in harsh prison conditions and denied medical care as his health rapidly deteriorated. He died, still incarcerated, probably in 1973. Deng Xiaoping survived his humiliation and managed to live, in retirement.

Attacks on these men, at the highest levels of the entire Communist Party, clearly could not have been carried out – even by the most zealous Red Guards – without the connivance or

committees' in towns, communes, industrial and government enterprises, and schools. The leadership of these committees would contain three components: representatives of the revolutionary masses, Party cadres of proven loyalty, and members of the PLA. Naturally the balance between these three forces would vary according to circumstances, but there would now once again be a recognized source of authority to which problems could be referred for solution. Slowly, by this means, a measure of order was restored to the central bureaucracy and to the provincial governments, though Mao and his followers did not initially abate their revolutionary rhetoric. The 'purification' of the arts in fact entered an even more rigorous phase at this time, as Jiang Qing

sought to impose on the country her own vision of what a proper 'people's art' should be by sponsoring a small number of revolutionary operas and films displaying impeccable non-feudal and non-bourgeois sentiments. Foremost among these were such heroic evocations of the guerrilla days as *Red Detachment of Women*, *The Red Lantern*, or *The White Haired Girl*, in which a future woman revolutionary has her hair turned white as a result of a landlord's cruelties. For a time in the late 1960s no other public performances were permitted to take place.

Nevertheless, the direction of the Red Guard movement slowly began to change. The Party announced that there was to be a great movement by the urban youth to go 'up to the mountains and down to the villages' so that they could share their revolutionary experiences with the peasantry and at the same time learn from them. The overarching ideological goal of this new policy was to instill some of those same visions that had been preached at the time of the Great Leap Forward: to end differences between mental and manual labor, city and countryside, and also to render men and women more equal in work and opportunities.

A Dunce's Cap. *Humiliated public figures were often made to wear dunces' caps as they were paraded through the streets in the Cultural Revolution. As the sight became commonplace, the dunces'* *caps had to be made larger to draw attention. Here a giant example is fastened to the head of the Heilongjiang Party secretary Ren Zhongyi in September 1966.* [PHOTO: LI ZHENSHENG]

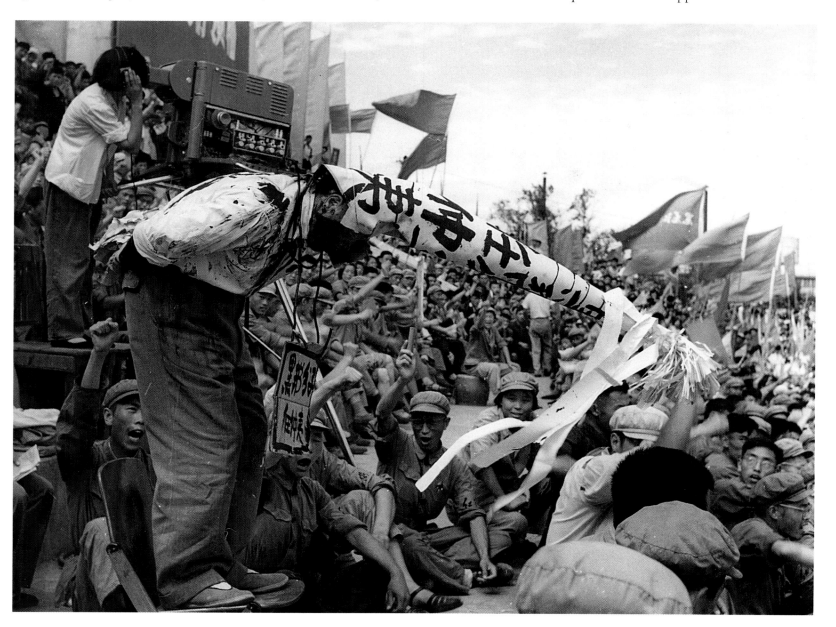

Images of Mao, *drawn, painted, woven, or sculpted, became one of the main articles of production during the Cultural Revolution. In this silk weaving factory, 80 percent of production was given over in 1967 to manufacturing his portrait printed on silk. No Chinese could risk appearing in public without a Mao badge or button, without carrying the Little Red Book of Mao's sayings, or being without large banners or pictures of Mao on the walls of their homes and offices.*

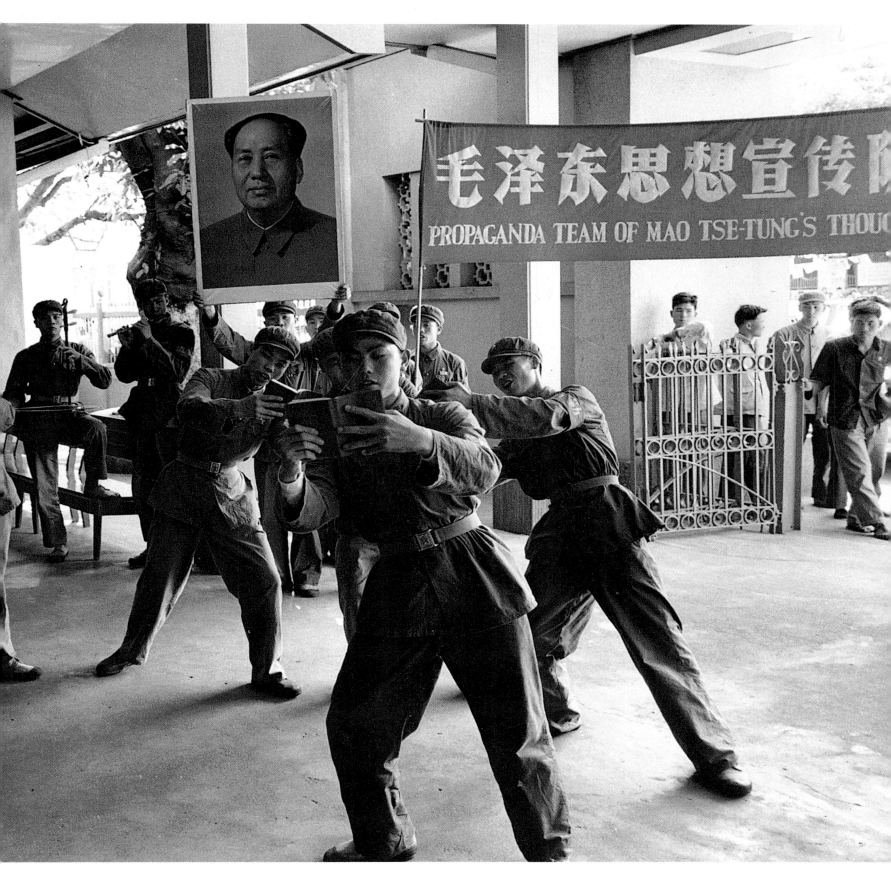

毛泽东思想宣传队
PROPAGANDA TEAM OF MAO TSE-TUNG'S THOU...

Art and Mao were inseparably intertwined in the Cultural Revolution. Mao's wife, Jiang Qing, herself a former actress, supervised the nation's culture during this period and limited the roster of acceptable dramatic works to a handful of so-called 'revolutionary operas'. These were often performed by members of the cultural troupes of the People's Liberation Army, whose commander Lin Biao was one of the most devoted public supporters of Mao and his wife. In the main railway station in Guangzhou (Canton) in 1967 an army troupe gives a balletic reading of the Little Red Book of Mao's sayings, which had been first assembled by Lin Biao three years before. Music is provided by an erhu, once called the 'Mongolian violin', and a small flute. Traditional instruments were allowed as long as they accompanied correctly expressed revolutionary sentiments.

[PHOTO: MAX SCHELER]

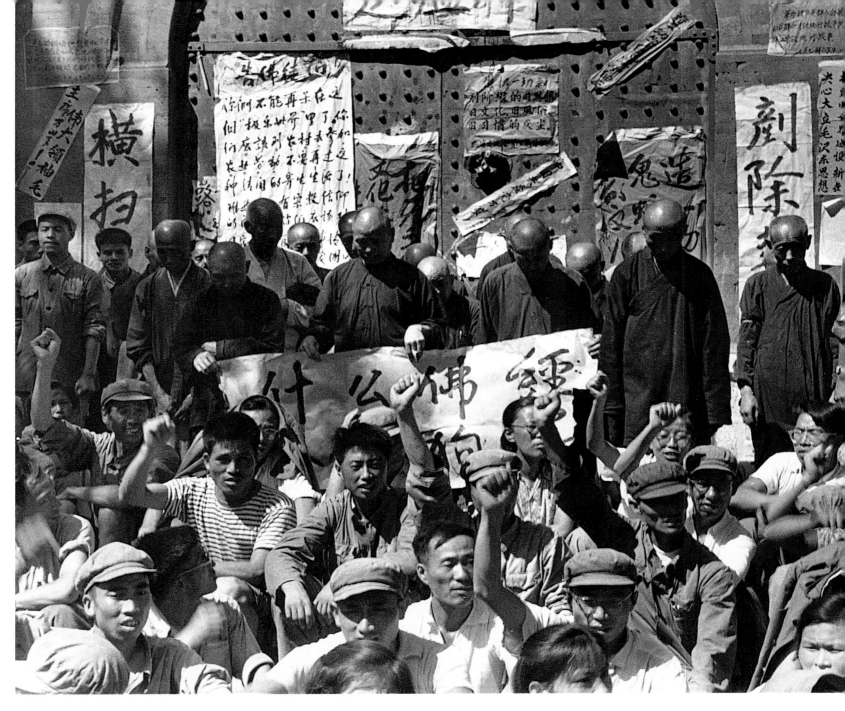

Many young Chinese in cities across China volunteered for this new call from Chairman Mao, whose image had not been clouded in their minds either by the failures of the Great Leap or by the violence and dislocations of the Cultural Revolution. Packing up their cherished possessions, saying farewell to their families, and saluted on the way to the bus or train stations by festive crowds, they embarked, some of them for the not-so-distant countryside, others for the harsh conditions of Tibet, Inner Mongolia or Qinghai.

These youths 'going down to the country' were supposed to be a new variety of Maoist elite, but, in fact, the revolutionary committees that chose them were both pragmatic and cynical; using this new opportunity as a way of purging their cities of unwanted youth, and transferring the cost of their upkeep to the countryside. Thus many of those selected were tough and restless young people, often from bad class backgrounds, had records of trouble-making, or were those for whom no jobs were available. Some had been sent away during the Anti-Rightist Campaign,

then had taken advantage of the lack of supervision in the Cultural Revolution to make their own way home, and were now being expelled once again.

The scale of the movement was vast, and between 1968 and 1972 as many as twelve million youths in all were sent from their home towns to the country. For some, the experience was deeply moving, and gave them experiences of rural poverty and hard work that they never forgot. For others, the journeys were unwanted and their reception when they at last reached their destinations was bleak. Few communes had any surplus food. Even if physically strong, the urban youth were ignorant of farm labor, and barely earned their keep even if they worked without ceasing. No time limits had been set to their rural relocation, and the realization soon set in that they might have to spend the rest of their lives in some isolated village with no electricity and no running water. The peasants were often cautious or even suspicious. There were few topics of conversation in common, and their lifestyles and expectations seemed inconceivably different. The young city men

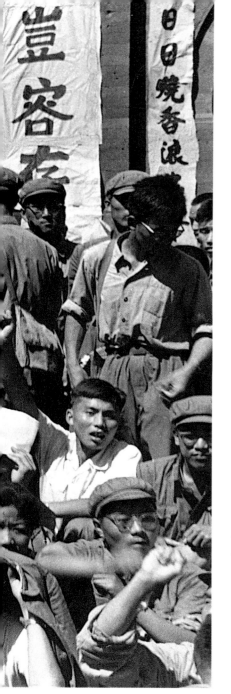

Buddhist monks *of the 'Temple of Happiness' in Harbin endure the ridicule of the masses. One poster (back left) urges the crowd to 'eradicate the ghosts and demons,' while another declaims: 'What are these Buddhist sutras? Just a collection of dog farts.' Photographer Li Zhensheng has again used his party press credentials to seize a revolutionary moment, in August, 1966.* [PHOTO: LI ZHENSHENG]

Faction-fighting. *Even as the Red Guards terrorized others, they began to fall out among themselves, with different factions claiming greater revolutionary purity than their local rivals. In January 1967, under the ever-present revolutionary slogans, the dominant Red Guard faction in Harbin forces the members of a rival Red Guard group to kneel and admit their guilt.* [PHOTO: LI ZHENSHENG]

on road building or land reclamation, tormented by their gaolers, and often driven to suicide. With no means of appeal and no means of contacting their families, their health and will power often collapsed, and, if interrogated skillfully, they often revealed details of their past lives, or those of their families that led to even harsher sentences, or else lied about their friends' alleged crimes in hopes of reducing their own sentences.

From 1970 onwards the experiences of these youths were shared by many of their seniors, as the Cultural Revolution leadership initiated a broad-ranging program to send people from cultural institutions and offices down to so-called 'cadre schools' in the countryside, where they also could experience life and labor on the land. Though not usually in the company of the local peasants, these groups of intellectuals, many of whom were elderly, were assigned to menial tasks like cleaning the open latrines in their work units. If sent to the country, because of their age and ignorance of farming techniques, they accomplished virtually nothing except deepening a sense of solidarity among themselves, and being assaulted by a Cultural Revolutionary rhetoric they despised.

The gradual reestablishing of order in China was accompanied by more jockeying for power between the surviving leaders, for by

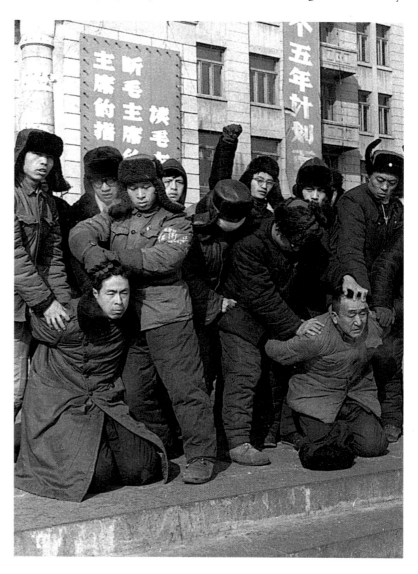

were seen as without prospects and hence as bad matches for rural girls, while city girls might seem exotic or beautiful to peasant youth and be pursued aggressively. But if they did succumb, and even get married, they faced a life of hard work and drudgery.

One solution was, either through local teaching jobs or through techniques of organization and persuasion, for the urban youth to make the villages in which they were assigned undergo the same process of class struggle that they had seen as Red Guards. In many villages, old feuds festered, and some peasant radicals felt victimized by their more successful or hard-working peers, whom they were happy to label 'feudal remnants' or 'capitalist-roaders' and to oust from their positions of leadership in the production brigades. At commune headquarters, there were often factions that ex-Red Guards could exploit, causing upheaval and violent confrontations between them in the name of revolutionary experience. If urban youth went too far they could find themselves branded as rightists and consigned without trial to one of the many labor camps, where they worked for no wages

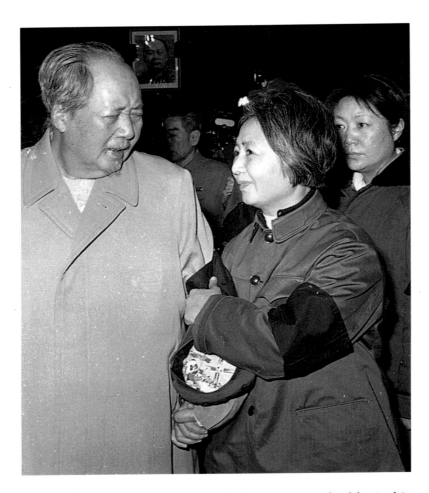

morning and evening as 'the red, red sun' in the hearts of all Chinese, and was addressed on posters and banners across the land with the term 'ten thousand times ten thousand years', used in earlier times for the emperors of China. Mao's restlessness served him now in good stead, as he traveled in his special train with his own companions, physician and bodyguards, and was enabled to get a somewhat fresher view of the course of the Cultural Revolution and the comparative loyalties of various supporters.

In early 1971 Mao apparently became aware of a plan afoot to unseat him, even to destroy his train with him aboard. In September 1971, he decided to move against Lin before Lin could strike. In a still-unexplained series of events, Lin Biao allegedly fled from north China in a jet plane, with some members of his family, and flew towards the Soviet Union. The plane crashed in Inner Mongolia, killing all aboard. This at least was the news that bewildered Communist cadres received and were instructed to pass on to the workers and peasants. For many Chinese, the official stories were so inconsistent and unbelievable that their confidence in the Party was severely shaken or destroyed altogether.

The opening up of relations with the United States that took place the following year, was almost as surprising to the Chinese people. A chauvinist aura had pervaded Cultural Revolutionary actions and rhetoric – a border war erupted with the Soviet Union in 1969, the US was presented as China's arch enemy and excoriated for its role in the Vietnam War, the British embassy was burnt down, and such foreign diplomacy as China conducted was directed to supporting the revolutionary struggles of the Third World against the 'hegemony of the super-powers'. But throughout the tumultuous years of the Cultural Revolution, China had continued to lobby for the United Nations seat still held by Taiwan and – despite the continued opposition of the US – finally succeeded in winning admission and the expulsion of Taiwan in 1971. Taking a long-range view of foreign policy, therefore, it became sensible for the Chinese to see if they could tilt the US in their direction, and further away from the Soviet Union.

To President Nixon's national security adviser, Henry Kissinger, the move also seemed opportune. Soviet intentions were unpredictable, and the rhetoric and confrontations of the Cold War continued unabated. Though the issue of Taiwan was volatile politically in the United States, because of strong lingering sympathy for Chiang Kai-shek, it was hard to fault Nixon's own record of consistent anti-Communism. So, after several months of secret negotiations between a small group of government officials in China and the United States, President Nixon's plane touched down at Beijing airport on February 21, 1972, and the same afternoon he met Mao Zedong.

The extremely cautious communiqués issued by both parties at the time promised no sweeping changes, and were especially insistent that there was only one China, thus avoiding any controversy over the independence of Taiwan. The possibilities of various kinds of foreign investment in China were raised, and cultural and scholarly exchanges brought a scattering of

1970, Mao was seventy-seven, and clearly in poor health. At his few public appearances he walked with aides or nurses at his side and his limbs trembled from the effects of his illness – his Western-trained Chinese doctor recognized it to be 'Lou Gehrig's Disease' which affected the central nervous system. Mao's wife and confidants were eager for more important positions, even though several of them had been appointed to membership of t he standing committee of the Politburo (not, however, Jiang Qing). The apparently imperturbable and diplomatically adroit Zhou Enlai, Mao's long-time second-in-command and the Premier of China since 1950, managed to survive all the Red Guards' assaults against himself and skillfully maintained his own base within the bureaucracy, but he was also frail and seemed unlikely to long outlive Mao. (Zhou, as was later discovered, was suffering the preliminary stages of the cancer that killed him in 1976.)

These political struggles and physical infirmities left Lin Biao as the most logical contender for absolute power, and throughout the period from 1967-1970 he did attempt to get himself formally confirmed as Mao's successor under the constitution, a move requiring the approval of China's pseudo-legislature, the National People's Congress, which convened in full session once every year. But Mao used his prestige to withhold this final benediction from Lin: there were rumors that even though he regularly called Lin his 'closest comrade-in-arms', he had come to distrust his ambitions. The cult of Mao had reached dizzying heights; he was constantly invoked at public ceremonies each

Westerners into the country. Many of these were skillfully misled into seeing China as an open socialist society in which citizens enjoyed full freedom and where economic deprivation had been banished, along with crime and the full panoply of personal vices. But the Cultural Revolutionary leaders showed that they intended to keep a tight grip on the nation, and in factories and communes, as in universities, foreign visitors were always received by the 'revolutionary committees' and given crash courses in the thought of Mao Zedong.

In an original twist to the idea of the mass campaign, in 1973 and 1974 Party leaders led a movement to 'criticize Lin Biao and Confucius'. Confucius had allegedly fostered a retrograde attempt to shore up the old world of aristocratic privilege in the face of the new impulses leading China towards the centralizing imperial structure of the Qin. Didactic though this approach to the past might seem, the campaign did give a rationale to people to read Confucius. In a somewhat similar development, small though the opening to the West was as yet, the mere fact that it had been

Exhausted by the chaos *that he had instigated (left), Mao was backtracking from his extreme revolutionary visions by January, 1972, when this photo was taken. He had purged the military leader Lin Biao, for years referred to as 'Mao's closest comrade-in-arms,' and had made secret arrangements for the U.S President, Richard Nixon, to visit China the following month. He clutches the hand of Zhang Qian, widow of one of his earliest revolutionary supporters Chen Yi, at Chen's funeral service. Mao has allowed his beard to grow, something he only did in periods of deep depression. By the time of Nixon's visit in late February, Mao was clean-shaven again.*

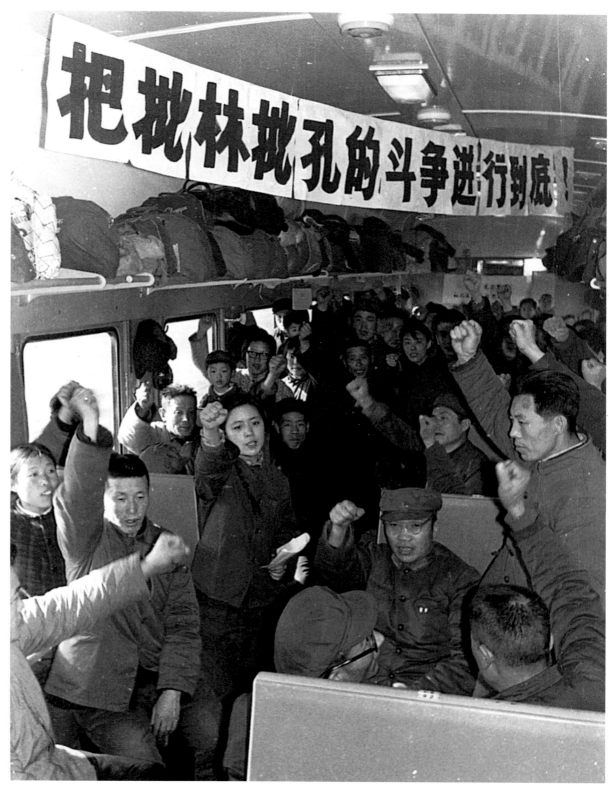

The Party Line. *Political demonstrations did not cease with the waning of the Cultural Revolution. Instead they changed focus. In this train to Beijing in 1974, the passengers assemble dutifully to shout slogans under a banner strung across the railway carriage that urges them 'to criticize Lin Biao and Confucius, and to carry on the struggle to the end'. Lin Biao had been secretly purged in 1971, but his death (allegedly in a plane accident while fleeing towards the Soviet Union) was only announced to the nation in 1972. By linking the disgraced General to Confucius, the government sought to emphasise Lin Biao's reactionary nature, and his opposition to class struggle.* [PHOTO: LI ZHENSHENG]

officially made, and by Mao Zedong himself, meant that Western books should once more be read, even if only initially to improve one's language skills. So those that had survived the bonfires of the late 1960s could be replaced on the shelves of homes and libraries. Universities and schools also began once again to receive a steady trickle of Western technical and scholarly journals.

Quietly, too, many of the important political figures who had been ousted in the earlier stages of the Cultural Revolution began to edge back to power. Deng Xiaoping's vast knowledge of the Party apparatus was once again needed if reconstruction was to begin. By late 1975, he had been reappointed to one of the vice-premierships, and had regained his Party base as general secretary. In January 1976 he gave a funeral eulogy for Premier Zhou Enlai in guarded words, praising his long-time mentor's fairness and common sense, and his sense of China's need for stability. Deng left it open whether all leaders of China could be said to have these undramatic virtues or not.

Deng's return to power was short-lived, for in April 1976 he was ousted once again, after an event unique in the history of the Party since 1949: a massive yet spontaneous demonstration in the center of Beijing. The ostensible reason for the gathering was to mourn Zhou Enlai on the day of the Qingming festival in honor of all the dead. The night before the festival citizens from all over Beijing began to gather at the Monument to the Martyrs of the Revolution, which had been erected by the Party in the center of the vastly enlarged Tiananmen Square. They brought wreaths and scrolls of poetry and flowers, and photographs of Zhou Enlai, and festooned the memorial with them. People spoke eulogies in Zhou's honor, and drew overt contrasts between Zhou's careful and pragmatic approach to politics and those of the current leadership, clearly not excepting Chairman Mao himself from their criticisms.

That night police and civic employees, summoned by the mayor, cleared the monument of the memorials and tried to forestall another demonstration. But, on April 5, huge crowds gathered once more around the monument, replaced their gifts of homage and their messages, and spoke out in even angrier terms. When riot police tried clumsily to break up the meeting the crowd grew unruly and began to fight back, and to attempt to force their way into some of the government buildings nearby. The mayor called in reinforcements and as night fell serious violence continued. The Square was cleared and many were arrested. Reports that citizens had been killed in the struggle spread swiftly through the city, though they could not be confirmed. The Politburo standing committee, hastily convened, declared the demonstration to have been a counter-revolutionary event and blamed it squarely on Deng Xiaoping, although Deng had not been there. But, in claiming that such an event had been planned, and by someone recently disgraced and removed from power as a capitalist-roader, the leadership sought to calm any suspicions that spontaneous political action, uncoordinated by the Party, was possible in China. Fearing for his life if he stayed in Beijing, Deng made his way to the south

Mao's death, *ten minutes after midnight on September 9, 1976, was announced to the nation at four o'clock that afternoon. The Party leaders decided to preserve Mao's body in the hot Beijing weather by lowering the temperature in the chamber where he was displayed, and by injecting his body with twenty-two liters of formaldehyde. The result of this treatment, according to Mao's physician in attendance, was disastrous: 'Mao's face was bloated, as round as a ball, and his neck was now the width of his head...His ears were swollen, too, sticking out from his head at right angles.' Only after several hours of intensive massage were Mao's head and neck restored more or less to their normal shape. Though many millions of Chinese may have been truly shocked and grieved, as in this scene in Shanghai, for others the response was more ambiguous. Jung Chang, whose own parents had been purged in the Cultural Revolution, wrote in her memoir* Wild Swans *that when Mao's death was announced to her at school in Sichuan that same afternoon, 'the news filled me with such euphoria that for an instant I was numb. My ingrained self-censorship immediately started working: I registered the fact that there was an orgy of weeping going on around me, and that I had to come up with some suitable performance. There seemed nowhere to hide my lack of correct emotion except the shoulder of the woman in front of me, one of the student officials, who was apparently heartbroken. I swiftly buried my head in her shoulder and heaved appropriately.'* [PHOTO: XIA YONG LEE]

of China, where he took refuge with a senior general in the Guangdong area, and from this secure base waited to see how events would go.

Given the omnipresence of the police and army in Beijing, and the lack of any experience of holding demonstrations among the people, it is not surprising that there was no immediate follow-up. But, in July, 1976, nature stirred up unrest by hitting north China, in the Shandong region around the industrial city of Tangshan, with one of the largest earthquakes in China's history. Large areas of the city and surrounding countryside were completely leveled, and buildings collapsed or were rendered uninhabitable in Tianjin, fifty miles away. Casualties were estimated at over 300,000 dead and 500,000 injured, with

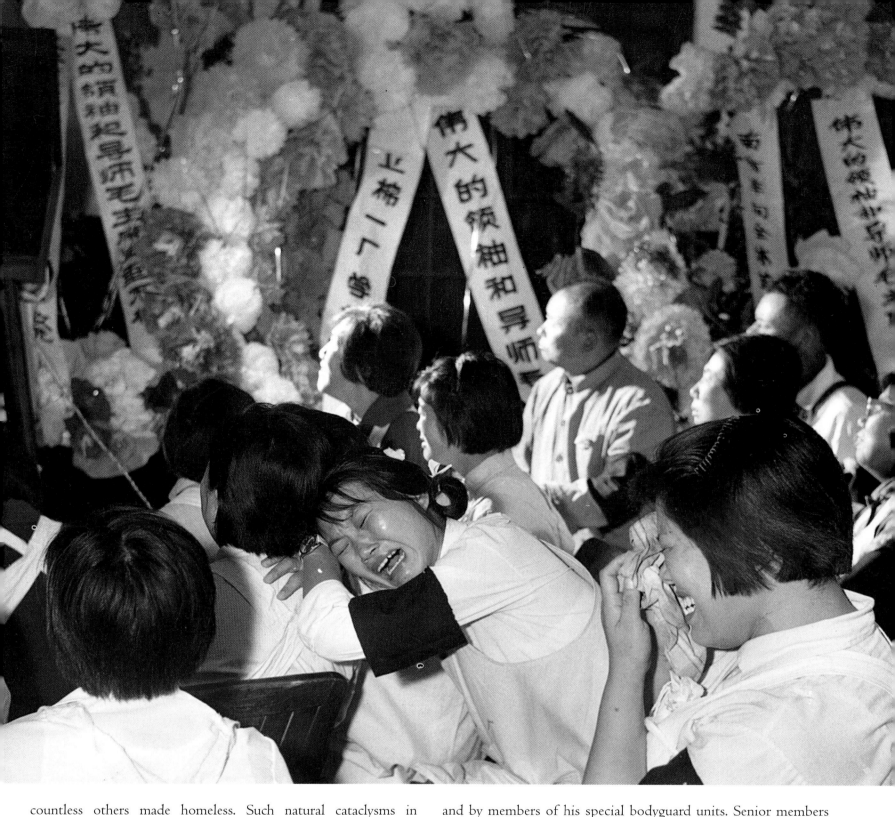

countless others made homeless. Such natural cataclysms in Chinese history were usually seen as harbingers of some dire event in the human world, and the government did everything it could to defuse such suppositions. The earthquake was handled matter-of-factly, and outsiders strictly excluded from the area. All offers of foreign assistance were declined. The aid that was sent to the area was described in proper Maoist terms, as being spontaneously from the masses, and offered in the spirit of fostering self-reliance in the face of the disaster.

Yet a portent it certainly was in the eyes of many, and in the light of history. Mao Zedong, who had suffered a series of strokes over the previous year, was comatose in bed, murmuring occasional sounds, attended by his closest female companions,

and by members of his special bodyguard units. Senior members of the Politburo stood watch as well, in rotation and in pairs, lest something unexpected happen and witnesses be needed. The senior attendant physicians were in a state of desperate anxiety, unable to see how they could keep him alive longer, and yet fearing to be blamed for his death. When death came, it was swiftly and quietly, on September 9, 1976, just after midnight. Hua Guofeng, a little-known politician from Mao's native province of Hunan, who had been assiduous in following the Maoist line, had been designated by Mao the previous month as his chosen successor, with the oracular words that 'with you in charge my heart is at ease'. Mao's death was announced that night, and the nation prepared to mourn.

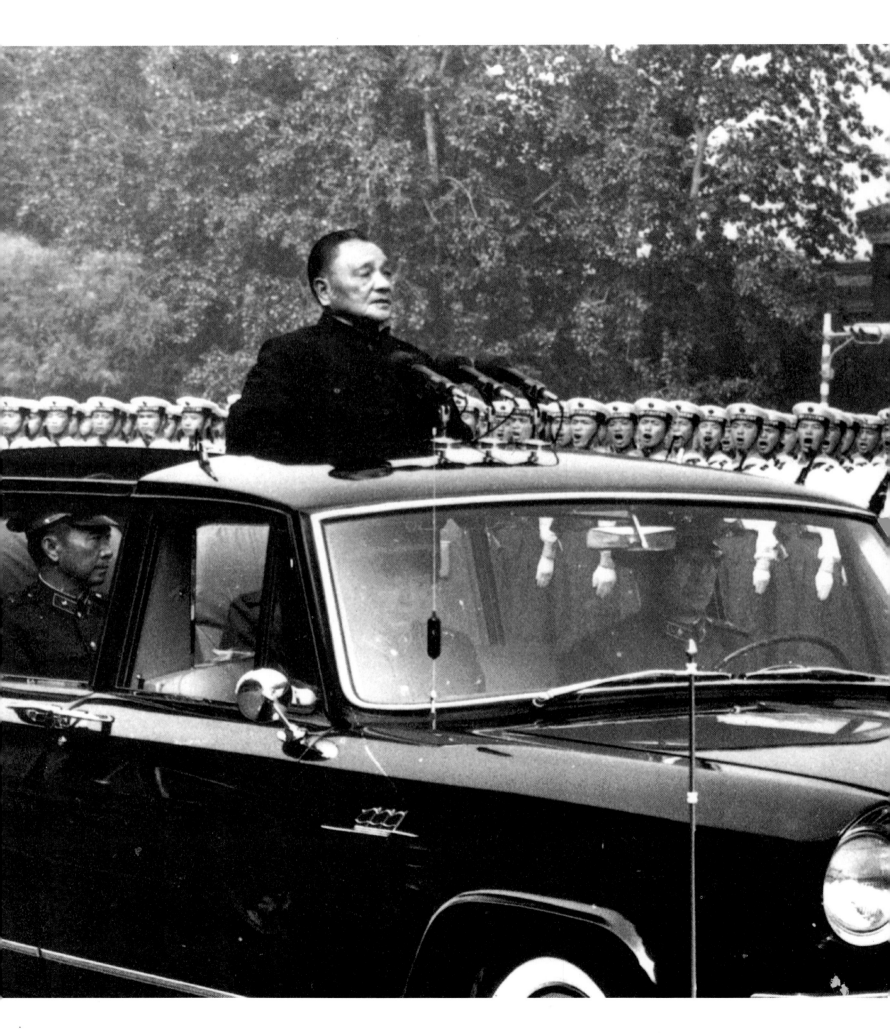

CHAPTER ELEVEN

THE POST-MAO WORLD

The Great Survivor. *Deng Xiaoping, still erect and vigorous at eighty, reviews an honor guard to celebrate the thirty-fifth anniversary of the founding of the People's Republic. His emergence as leader after the death of Mao was an astonishing tribute to his resilience. Purged from his Party positions in the Cultural Revolution of 1966, and again in the stormy political spring of 1976, Deng was able to bounce back a third time because of the strength of the support he could call on in both the People's Liberation Army and in the senior Party bureaucracy. Deng also had impeccable revolutionary credentials: born in 1904, he had joined the Communist Party as a young work-study student in France in the early 1920s. He fought through the Jiangxi Soviet and the Long March, then helped build the Communist guerrilla base in north China which was the springboard for eventual victory in 1949 in the civil war.*

THE IMMEDIATE RESPONSE TO MAO'S DEATH WAS A frantic search by his doctors for the means to preserve his remains, since the Politburo had decided that Mao should be embalmed and displayed in Tiananmen Square, as Lenin was in his tomb outside the Kremlin. The political jockeying continued unabated, and the Cultural Revolutionary groups endeavored to consolidate their hold. Hua Guofeng did not seem a person of much political substance, but he was canny enough to realize that if he was to stay in power he had to strike fast, and so he negotiated with the leaders of the Beijing armed forces, and the former head of Mao's elite bodyguard, to move against Jiang Qing and her key associates. In early October, shortly after Mao's imposing state funeral, Jiang Qing's three closest Shanghai associates were informed that there was to be an emergency Politburo meeting. The Cultural Revolutionary leaders duly appeared; as they moved to the meeting room they were arrested, and placed in confinement along with Jiang Qing herself. The initial charges were that they had constituted a small clique — 'A Gang of Four' — to illegally seize power, and that they had been responsible for untold suffering to the Chinese people. An indication of their future fate was at once apparent: though they had been prominent at Mao's funeral ceremonies, when the official photographs were released all four of them had been airbrushed out, and the spaces where they had stood were filled with neatly inserted ornamental plants and background landscape. Other associates of the Gang of Four, many of whom had held enormous power for the previous decade, were also soon arrested.

Hua Guofeng may have owed his position to his selection by Mao, but it was evident that he was a compromise candidate between conflicting forces. Mocked by his enemies for combing his hair and dressing to look like Mao, and for having no ideology except for the 'Two Whatevers' — referring to his constantly reiterated phrases that whatever Mao had said or written was right — Hua lacked his own political constituency, or a firm base in either the Party bureaucracy or the army. Within a few months, it was clear that the real beneficiary from Mao's death and the arrest of the Gang of Four was Deng Xiaoping, twice ousted from power, but still clearly indispensable. In early 1977 Deng was renamed vice-premier, and by summer of that year was once again acting as the Party general secretary.

Though he had used him for many years, Mao had always known that Deng was a pragmatist, famous for his desire to 'learn from facts' rather that merely seeking a theoretically correct answer to a given problem. Others in China were aware of Deng's sardonic phrase, with reference to the passionate searches for ideological 'correctness' that were so important to Mao, that it did not really

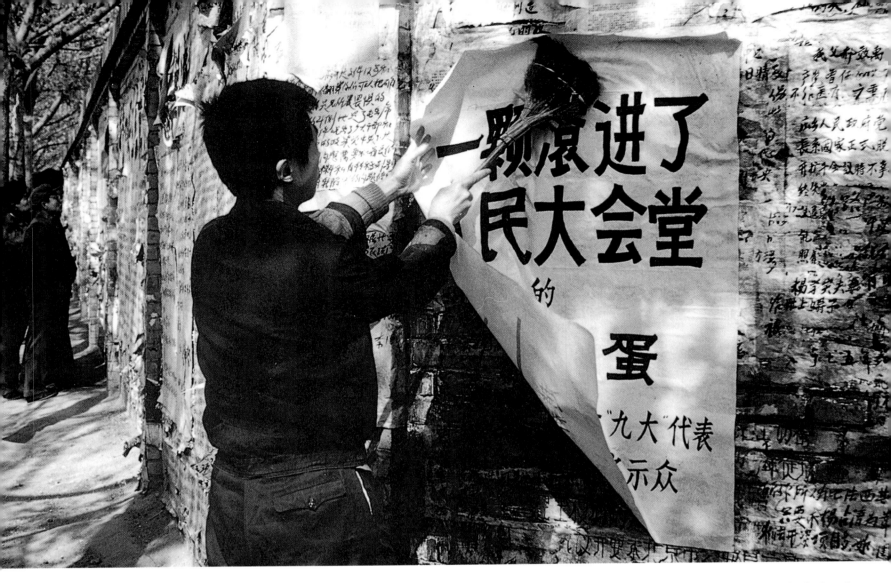

matter if a cat were white or black as long as it could catch mice. By the late 1970s Deng Xiaoping and his close associates – with Hua Guofeng in nominal charge – were moving carefully to open up the Chinese economy and to widen the opportunities for foreign contracts and investments.

Deng was especially interested in the possibilities of encouraging the reemergence of private plots and more of a free market sector in the countryside, so as to increase initiative, stimulate production, and open up new opportunities for local investment. It was just such areas that had been anathema to Mao in the period of the Great Leap, and had been branded as representing 'capitalist tendencies' during the Cultural Revolution. When Deng learned that some younger Party leaders, after being victimized during the Cultural Revolution, had now begun to implement such policies in the provinces of Guangdong and Sichuan, he gave them publicity and encouragement. The resultant increases in productivity were so high – the figures, unlike those of the Great Leap, were accurate – that Deng declared the two provinces' pattern of open development within the context of state control of the economy to be a model for the nation as a whole.

Communist Party leaders convened to discuss and consolidate these new policies in December 1978 at a full meeting for the members of the Central Committee. The concept of the need for 'Four Modernizations', if China was to move forward – in industry and trade, education, military organization, and

agriculture – had already been broached by Zhou Enlai before his death, and been repeated in broad terms by Hua Guofeng. But now careful attention was paid to what these changes would mean in practical terms, and in relation to the thought of Mao Zedong, which for so long had been the guiding ideology for the country. In a series of careful formulations, the Party leaders finally decided that 'overall' Mao's decisions had been correct 70 percent of the time. It was not precisely clear whether the remaining 30 percent of implicit criticism of Mao referred to the Great Leap Forward or to the Cultural Revolutionary period, though the latter was implied in the related conclusion that China's problems could be traced mainly to Lin Biao and to the Gang of Four.

The gathering also raised an issue that had been central in 1956, and had surfaced again in the early 1960s: namely what were the rights of Chinese artists and intellectuals, and to what extent were they allowed under the constitution to speak their minds? It seemed to reiterate the conclusions of the Hundred Flowers Movement, that open criticism and discussion should be promoted and that experimentation in the arts could also be encouraged as long as it did not undermine the Communist Party and the government, for it specified that 'people's democracy' should be carefully blended with 'centralism' and that equality of all people before the law was a right. These changes had been incorporated in the Chinese Constitution, which was revised in 1978, and the revisions ratified by the National People's Congress,

so as to defend the rights of assembly and the rights to display large-character posters. To reinforce these decisions, large numbers of cases dating back to the Anti-Rightist movement were reevaluated, and tens of thousands of intellectuals and artists were at last free to return home, in many cases after over twenty years of exile, forced labor or imprisonment.

Despite the harsh experiences of so many Chinese, they responded to the new direction in politics with excitement and energy, clearly believing that the current situation was quite different to that of 1956-1957. A host of new magazines began to appear, often handprinted or mimeographed, filled with innovative short stories and poetry, or with essays and political reflections. Some of these like *Today* and *Explorations* swiftly achieved cult status and were sold out the moment they appeared on the streets. At the same time, in Beijing, the police allowed the local citizens to post their views on a long stretch of blank wall just to the west of the Forbidden City. This area soon became a popular meeting place, jammed with writers, observers, and even the foreign journalists who were now coming to China in some numbers. By October 1978 the wall had been informally named 'Democracy Wall', in reference both to the frank political expressions in many of the posters, and to the heady days of the May Fourth Movement of 1919, when the need for 'Democracy and Science' had been the central call of the youth.

Of all the poets who wrote for *Today*, it was a writer named Bei Dao who swiftly gained the greatest popularity. Bei Dao (a pseudonym, like those used by so many of China's twentieth-century writers) was born to a prosperous professional family in 1949. So he symbolized the whole generation who had been born and grown up under the People's Republic. Like so many of his age group, he became a Red Guard in 1966 and participated in the first excited flush of the movement. But he withdrew, disillusioned by the violence, and slowly developed his own heavily metaphorical style for recording his feelings about the revolution engulfing China. In a poem that reflected his feelings after witnessing the police's violent suppression of the spring rally of 1976 in honor of Zhou Enlai, Bei Dao wrote about the power of disbelief, the need to question every so-called truth propounded by the Party; he wrote also about the paradoxes of disbelief, which can also make one disbelieve things one knows to be true. This poem became a virtual anthem to the Chinese youth in 1978. In another, longer poem, Bei Dao wrote of the fading images of revolution, still moving and potent in their way, but old fashioned now, and coated with memories and nostalgia, like icons in a little-visited museum. The hands of the proletariat might still reach out to each other around the world, but inside China a 'net' constrained people's lives.

A young electrician, also a former Red Guard from a cadre family, named Wei Jingsheng, did not trouble himself with metaphors. Wei, apparently stimulated by articles on Western politics that he read in restricted-circulation Party journals brought home by his father, made a heroic attempt to think through the implications of democratic theory for the success of Marxist-Leninist socialism. Though he professed to believe in the

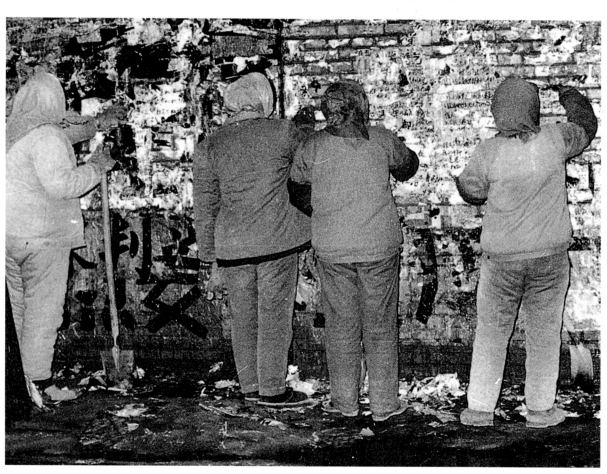

Democracy Wall *in Beijing drew its name from the frank posters and political views pasted on it in the first heady months following Deng's promise of greater openness for China during late 1978. A young Chinese adds a poster (above left) describing the autumn gathering of party bureaucrats in Beijing as 'a turtle's egg rolling into the Great Hall of the People', boldly casting slurs on the parentage of the great with a traditional metaphor for sexual mockery. When passionate calls for democracy were posted on the same wall by the former Red Guard Wei Jingsheng and others, the government reacted vigorously. On December 8, 1978, squads of workers were sent out (right) to scrape the walls clean. In early 1979 further posters were banned from the wall, and Wei was sentenced to fifteen years for his criticisms of the Party.* [PHOTO: LEFT: MARC RIBOUD]

goals of the revolution, and in the central tenets of socialism, Wei noted that ideology in China had become both stunted and dictatorial; it had lost the power to change imaginatively, and was used only to support the elite. Thus the Four Modernizations preached by Deng Xiaoping and other current leaders were not enough. There must be a 'Fifth Modernization', which Wei defined as genuine pluralism, defended by the constitution, and expressed through meaningful electoral forms. Wei circulated his ideas both in magazines like *Explorations,* which he co-edited, and through wall posters. In follow-up essays he criticized Deng Xiaoping more directly, and also wrote a piece of reportage on one of the most infamous political prisons in China, on the outskirts of Beijing, which had been carefully described to him by former inmates. A host of other young writers, in many moods and formats, developed similar ideas to Bei Dao and Wei Jingsheng, or offered their own blueprints for China's future. The echoes of what had happened in the later stage of the Hundred Flowers Movement were uncanny.

It was at this stage, in early 1979, that the demands of foreign policy and national cohesion cut across the new-found search for freedom. In January that year, Deng Xiaoping traveled to the United States, in a visit lavishly and lovingly covered by American mass media, to hold talks with President Carter, and to explore the possibilities for a host of joint-venture productions with, or purchases from, major American corporations, including Coca Cola and Boeing, and to increase the range of cultural and scholarly exchanges. Relayed back to China by television, this pursuit of foreign capitalism underlined the priorities of the Four Modernizations, and showed the Chinese a glittering range of foreign products and lifestyles.

At the same time, there was continuing Chinese anxiety over the Soviet Union's long-range goals in Southeast Asia, for the American involvement in the Vietnam War had ended in 1975, and the Soviet Union had moved into the vacuum, apparently poised to develop a major naval presence in the South China Sea harbors of Vietnam. The Vietnamese army had also overrun Cambodia, where the Khmer Rouge forces, fostered by the Chinese, gloried in their own form of a violently reinstituted Maoist rhetoric and practice. To bring the Vietnamese to heel, the Chinese Army launched what was meant to be a swift and well-coordinated raid across the Vietnamese border. The result was a botched and inconclusive campaign, which though fulsomely praised in the Chinese state-controlled press, caused heavy casualties to the Chinese armies, and led to their discomfited retreat.

When Wei Jingsheng injudiciously discussed the defeat with a foreign journalist, he was arrested for betraying national secrets. At his trial, Wei courageously restated his views on the importance of democratic values, and the need for open debate of issues in China. Unmoved, the judges condemned him to fifteen years' hard labor. Some of Wei's friends managed to smuggle tape recorders into and out of the court, and to release transcripts of the proceedings, which were swiftly recopied and widely circulated

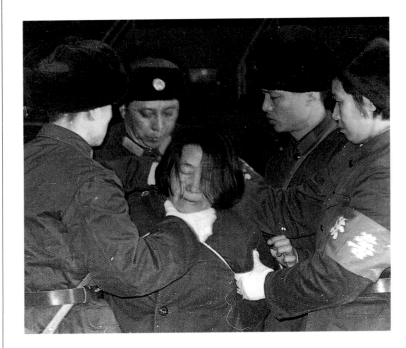

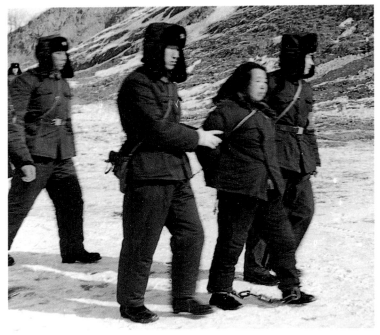

in China and overseas. Overlapping with these events, new restrictions were imposed on the expression of views at Democracy Wall, and in the spring of 1979 Chinese were banned altogether from posting their views there. Instead a supervised area in a nearby park, where writings would be subject to official scrutiny, was made available. The spate of self-expression dried up, the editors of the more vocal magazines were arrested or harried, and most of the new publications closed down. But critical reportage was allowed, especially if it was seen as offering 'constructive criticism' of areas where the government knew there were shortcomings. Thus when in mid-1979 news was circulated in the Party press that there had been a serious case of corruption in the far north, in China's Manchurian province of Heilongjiang,

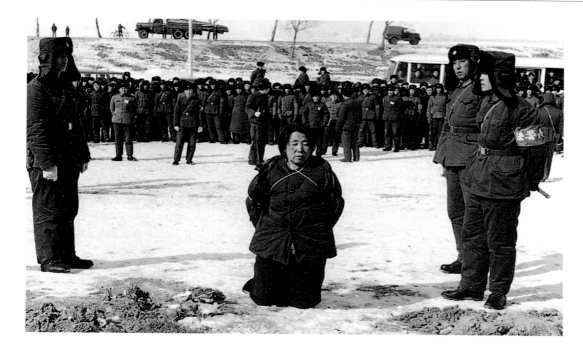

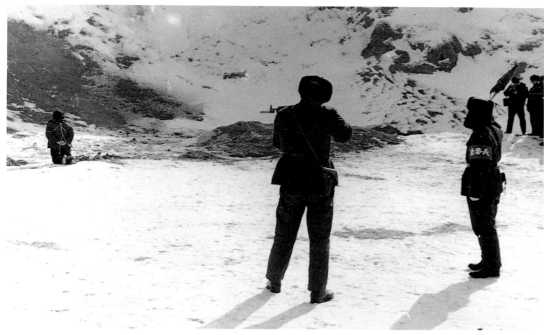

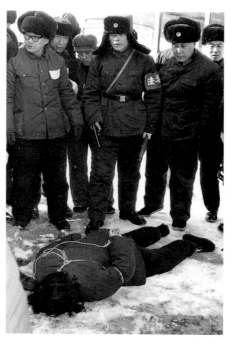

Execution of a Racketeer: *A wave of corruption cases surfaced as Deng's regime opened investigations into the country's problems. Wang Shouxin, manager of a fuel company in Heilongjiang was sentenced to death in October 1979 after a three day public trial. Her wrongdoings were famously exposed by investigative journalist Liu Binyan in* People or Monsters *who wrote that there were 'Wang Shouxins of all shapes and sizes, in all corners of the land...'* PHOTO: LI ZHENSHENG]

a Beijing journalist decided to investigate in person.

The adventurous reporter was named Liu Binyan. He had been a successful journalist in Beijing until he took Mao's challenges to speak out in the Hundred Flowers Movement literally. The result was a period of 'labor reform' from 1958 to 1961 and, following a period of partial rehabilitation, renewed punishment in May 7 cadre schools between 1969 and 1977.

The ringleader of the corruption in Heilongjiang was a woman Party member and enterprise manager named Wang Shouxin, who rose to be head of a state-run coal procurement and distribution company. During the 1970s she established a far-flung network of graft in which hundreds of thousands of dollars were stolen from the State and the local people, to feather both her own nest and

those of her accomplices. Liu was unsparing in recording these practices in his fifty-six-page report, which he entitled *People or Monsters?*, and finished in August 1979. It appeared a month later in a Beijing journal. But, as well as horrifying and entertaining his readers with accounts of Wang's greed and malfeasance, Liu also pointed out that Wang herself had been raised in a harsh environment in difficult times, and that the Communist Party — the leaders of which had gorged on meat dumplings while the people around them ate tree bark and chaff or died of hunger in the famine of 1959-62 — had made her rise all too easy and understandable. Liu also emphasized throughout his narrative that only the consistent courage of decent local people, and their ingenious use of wall posters to air their grievances, had forced the

Chiang Kai-shek In Taiwan, *with Madame Chiang (left), dominated the political and social worlds of the Guomindang party in exile. Chiang maintained that the Guomindang still represented the Chinese people as a whole, making any rapprochement with the People's Republic impossible. After his death in 1975 tentative overtures were made to ease the tension until, at last, in the early 1980s, Chinese from* *Taiwan were allowed back to the mainland for the first time in over 30 years to meet relatives. (Right) Liu Xiang, worker in a Shandong cassette factory, embraces his sister who had lived in Taiwan since 1949. Taiwanese tourists were soon coming in large numbers and were followed by direct Taiwanese investment in the Mainland or the establishment of joint business ventures.*

issue out into the open and at last compelled the state to take action.

Shortly after Liu's piece appeared, Wang Shouxin was tried, condemned to death, and shot. Her leading collaborators received long prison sentences. What was powerful about Liu's piece was its universality: everyone in China knew people like Wang Shouxin, and it made everyone think of all those who had not been brought to justice. Though Liu was criticized by some Party members — especially those in Heilongjiang, who suggested he wrote mainly for mercenary motives — he was not made the subject of a campaign like Wu Han, nor silenced like Wei Jingsheng. He remained as a living conscience of the Party in those areas that were not too tender.

In January 1979, China and the United States established full and formal diplomatic recognition, and the US severed its last formal ties with the Guomindang government in Taiwan. Supporters of Taiwan feared its loss of American support might bring serious trouble to the island but, if anything, the new policy only served to emphasize the robustness of Taiwan's economy. On the death of Chiang Kai-shek in 1975, he was succeeded peacefully by his son. Though Taiwan was a tightly controlled one-party state, in which the members of the Guomindang dominated almost all aspects of politics and public life, its economic successes had been remarkable. Chiang Kai-shek's government in the early 1950s had radically altered the agricultural system by granting land to the small farmers on highly favorable terms, and protecting them from excessive taxes so that they could improve their efficiency and productivity, both of which they did dramatically, without the catastrophic swoops and crashes, and the violence that had marked the attempts at land reform on the mainland. The growth of industry, particularly in a group of carefully selected areas in electronics and high technology, had similarly transformed the industrial base by the 1960s, changing the reputation of Taiwan from that of cheap labor supplier of cut-rate consumer goods to that of a high-tech rival to the United States and Japan. This had been achieved by government policies that focused on advanced education in the sciences and the employment of this highly educated elite at good

salaries in state-sponsored research institutes, or at specially designated plants in advanced economic productivity zones.

There could be no greater contrast to what had happened to mainland China's scientific elites. While they were subjected to grotesque humiliations, and the country forced to rely on a 'people's technology', Taiwan was able to lure many promising scientists back from highly paid jobs in the United States, and by investing massively in research-and-development, to keep at the forefront of world technologies. The result was that, by 1979, the per capita Gross National Product of Taiwan was six times that of the People's Republic. Scale of course was on Taiwan's side as far as unity and organization was concerned, for a level of advanced education and social services was possible among the 17 million Chinese there that could not be attained on the mainland, where the population was edging towards one billion, a figure finally reached, according to the census, in the year 1982.

Deng Xiaoping continued plans to expand the private sectors of the economy in the early 1980s, and to expand the role and importance of several areas designated as Special Economic Zones in southeast China, at Shenzhen outside Canton and other Guangdong cities. In these, foreign trade and investment could be at once encouraged by special tax breaks and yet isolated from the rest of the country. The Party secretary in Sichuan province between 1975 and 1977, Zhao Ziyang, had increased the amount of land peasants might farm as their own private plots to 15 percent of the land in a given commune. As Zhao's success became apparent, Deng Xiaoping transferred him to Beijing, named him to the Politburo in 1979 and to replace Hua Guofeng as premier in 1980. Figures released in 1979 showed that the hoped-for success in Sichuan was a reality. In the three years since 1976, grain production had increased 24 percent. Even more spectacular had been the increases in industrial production, after Zhao had lifted the restrictions on the role of plant managers, weaned them

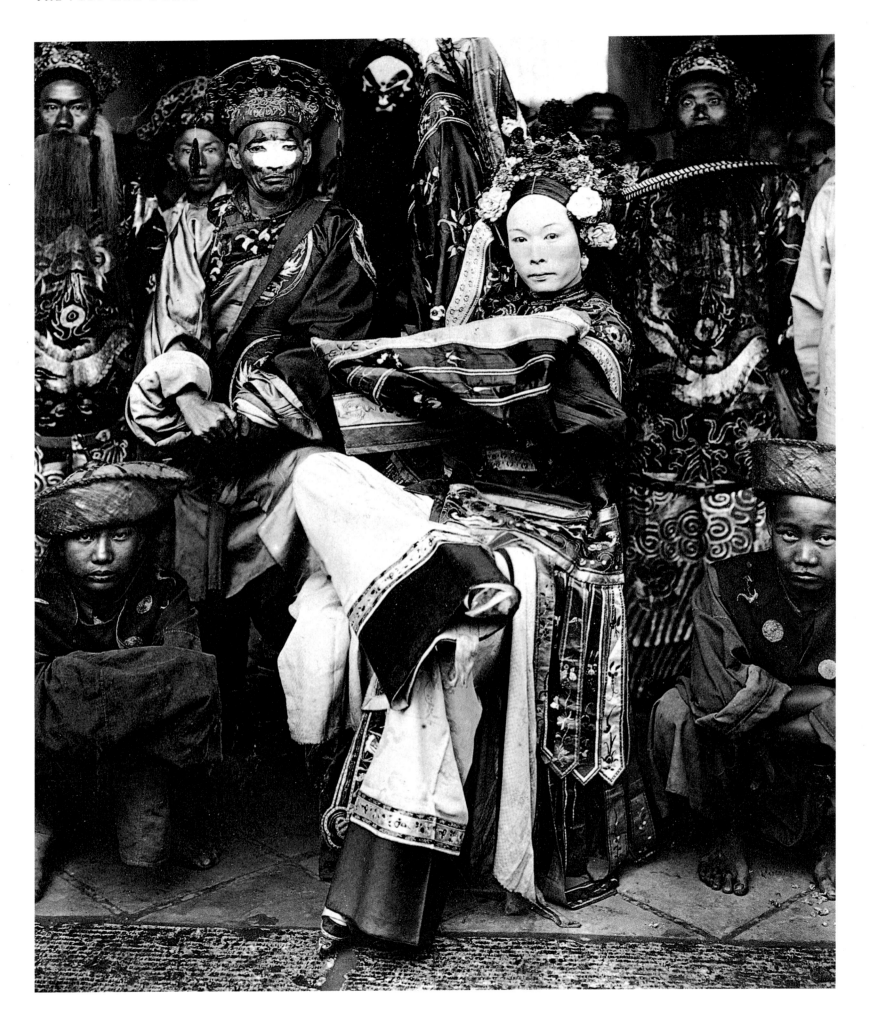

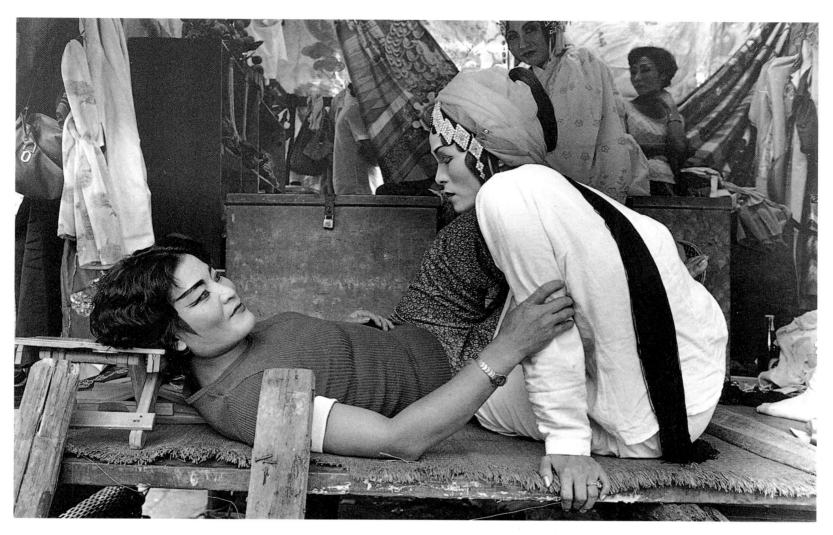

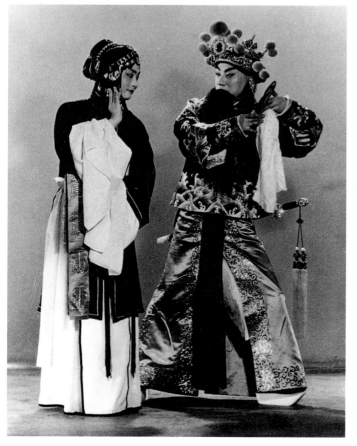

The Show goes on. *The dynasty might fall, revolution, civil war and partition might follow, but Chinese opera continued to entrance all ages in all regions. Gender role reversals had always been popular, with men playing women and vice versa. The French consul in Yunnan took a photograph in 1905 of a male rendition of a female role (far left) in the last years of the Qing. Cheng Yanqiu (left, left-hand figure) was one of the most celebrated performers of the 1920s and 1930s; though almost six feet tall, he fascinated audiences with the delicacy of his female portrayals. He was especially noted for his brilliance in depicting emotions through the movement of his flowing sleeves.*

Cheng refused to perform for the Japanese and retired to a farm, but agreed to train a new generation of actors in the People's Republic, and was named vice-president of the Chinese Dramatic Research Institute. The opera tradition was sidetracked into propaganda pieces demanded by Communist ideologues during the Great Leap and the Cultural Revolution, but it continued to grow and diversify in Taiwan. (Above) A reclining actress in Keelung, Taiwan, dressed for a male role, emulates art in a back-stage moment with her female companion in 1976.

[PHOTO, LEFT: AUGUSTE FRANCOIS]
[PHOTO, ABOVE: CHANG CHAO-T'ANG]

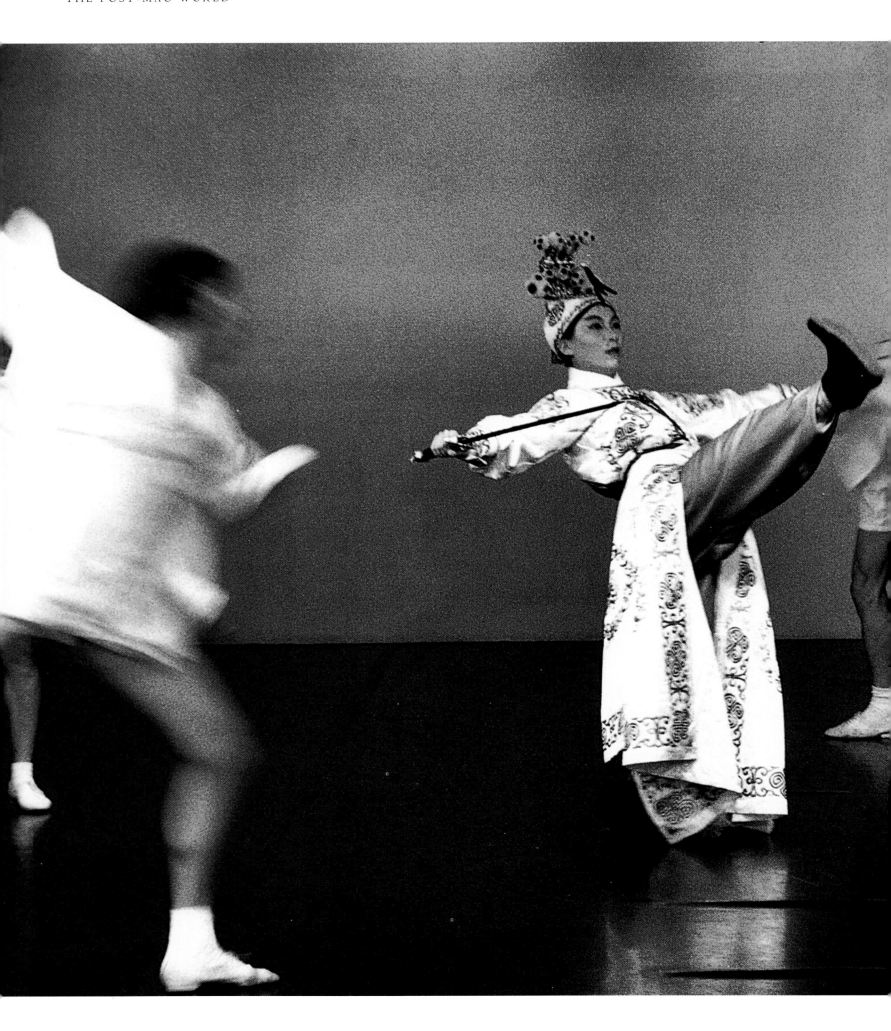

East meets West. *In Taiwan new dance forms emerged in the 1980s from the blending of traditional opera with Western influences. Here the experimental Taiwanese dance troupe Yun-men – Gate of Clouds – performs a work choreographed by Lin Huai-min, who had studied in New York with Martha Graham. On the mainland, Deng's regime, after a brief flirtation with tolerance, reasserted the claim that modern art in all its forms represented 'bourgeois liberalism', if not 'spiritual pollution'.* [PHOTO: LIU CHEN-HSIANG]

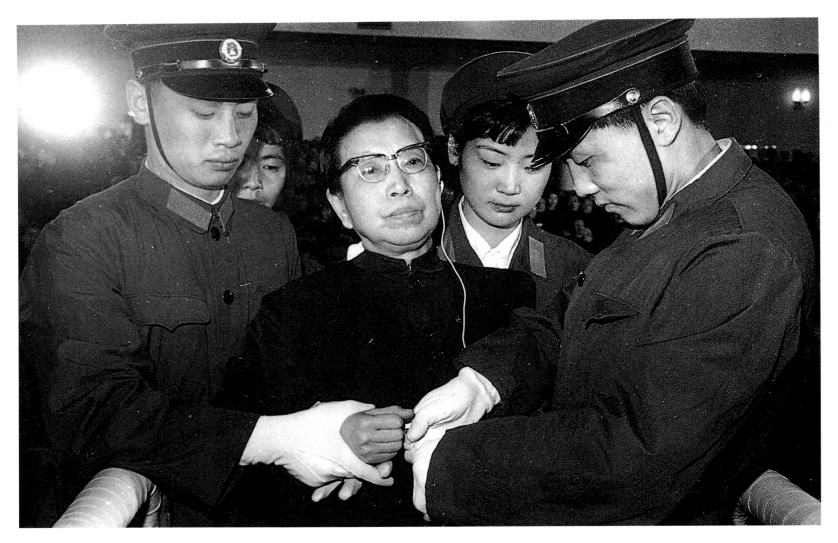

from state control, and allowed them to diversify according to their sense of market needs. During the same three-year period, Sichuan's industrial growth was 80 percent. If China was to emulate Taiwan's success, this model seemed the one to follow.

These economic successes, and the replacement of Mao's chosen successor, may have been what prompted Deng Xiaoping at last to bring the Gang of Four to trial. The long delay showed how delicate the situation was, for they could claim to have been simply following the general instructions laid down by Chairman Mao. It was also clearly absurd to blame only the Gang of Four when so many millions of people had been involved in the terror and the violence. To blur this issue somewhat, ten people were brought to trial together, in November 1980, before a panel of thirty-five judges: five of them were senior officers implicated in Lin Biao's 'plot' of 1971, one was Mao's former secretary and speech writer Chen Boda who had been a strident supporter of radical Cultural Revolution policies, and the other four were the so-called 'Gang'. With a curious precision, the main charges against the Gang were that they had 'framed and persecuted' 729,511 people while in power, and that a further 34,800 had been driven to their deaths.

Excerpts from the trial were shown on Chinese television, and emphasized the stubbornness and anger of the four chief leaders. One of them stayed silent in the face of all charges, but Mao's wife

Jiang Qing yelled in protest and insisted on her innocence, saying that Mao had supported all her actions, a claim that was hard for the prosecution to refute. With no more appearance of legality to outside observers than that shown in the case of Wei Jingsheng, Jiang Qing was sentenced to death, along with her silent colleague Zhang Chunqiao, though the sentences were to be reprieved for two years so they would have a chance to repent. The other defendants received long prison sentences. Thus, in muddle and melodrama, ended one chapter in the bizarre story of the Cultural Revolution.

If 729,511 people in China were known to have been victimized, what did that say about due process and the legal structures of the Party in general? And who could say how many millions of other sufferers were unknown and unheralded? These questions hung heavily over the trial, and remained even after all sentences had been handed down.

One man who thought tenaciously about it was the scientist Fang Lizhi. Born in 1936, Fang represented a transitional generation, not old enough to have worked in the Communist underground, like the journalist Liu Binyan, nor so young that he had never known life outside the People's Republic, like the poet Bei Dao. From a professional family, and able to continue his schooling across the great divide of 1949, Fang proved to be an outstanding scientist. Forced to undergo reform through labor

'Reversal of verdicts'. *This phrase was used in the early 1980s as Deng tried to correct some of the more glaring abuses from the Maoist period. Mao's wife, Jiang Qing, is shown (left) in January 1981 as she receives the death sentence, having been tried on charges of persecuting or killing hundreds of thousands during the Cultural Revolution. She and other members of the Gang of Four had been arrested in October 1976, a month after Mao's death. In fact, Jiang Qing was granted a two-year reprieve, and told the death sentence would be commuted to life imprisonment if she expressed repentance. Instead she declared that it would be more glorious to have her head chopped off and dared the court to 'Sentence me to death in front of one million people in Tiananmen Square'. Although she remained defiant and was held incommunicado in prison and later under house arrest, she was not subsequently executed. In 1993, it was announced that she had committed suicide. Along with other members of the Gang of Four, Yao Wen Yuan (right) was accused of plotting against Party leaders, of torturing more than thirty-four thousand people, of plotting an armed uprising and of an assassination attempt on Mao. He was sentenced to twenty years.*

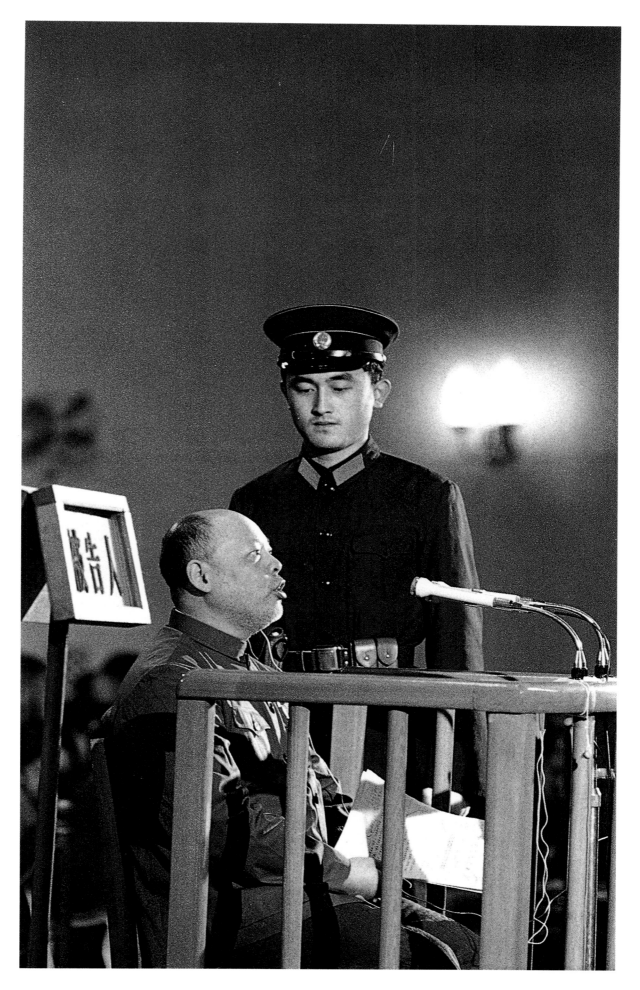

because of his criticisms of the Party in the Hundred Flowers Movement, Fang had his Party membership cancelled, though it was later restored to him after his rehabilitation. During this period of reform and labor, Fang had been able to take one book with him, a Soviet study of cosmology. Reading it again and again, he was especially drawn to the Big Bang Theory of the formation of the universe. Only later, to his cost, did he discover that the Big Bang Theory, by positing a growth of the galaxies from an initial explosion, pointed to the possibilities of an eventual return by the same route to a state of formlessness and total extinction. This contradicted the belief expressed by Engels, that the slow and steady growth of socialism would be as inevitable and powerful (and irreversible) as the processes of galactic history. Persecuted again during the Cultural Revolution for his retrograde beliefs, Fang proved irrepressible, and by the mid-1970s was once more on a successful academic trajectory that brought him to the vice-presidency of the Hefei Technical University in Anhui province, one of China's leading centers of scientific research.

Stimulated by a research visit to England in 1979, Fang began to formulate his theories of scientific knowledge. Drawing on

Ideal and reality. *Below a picture which portrays a flatteringly tall Zhou Enlai surrounded by admirers inspecting a sparkling new metro station, travellers wait for a metro train in the drab surrounds of Central Station in Beijing in 1985. It was hoped that capitalist elements introduced during Deng's crash development program would be held in check by continued insistence on the leadership role of the Party and guided by a modified form of 'Mao Zedong Thought', as symbolised by this poster.*
[PHOTO: KOEN WESSING]

them, and that the Chinese could do the same as they emerged from their long spell under Mao. What was needed in China was spontaneity, originality, creativity, and a return of the exploring instinct.

Such reflections, in private, would have had little or no impact. But delivered with great wit, rhetorical force and a biting sarcasm at the Party's expense by the vice-president of one of China's most prestigious universities, they had enormous effect; in numerous talks at other universities Fang spread his message of the need for a democratic and scientific opposition to an ossified Party. In the mid-eighties, Fang began to encourage his students to take seriously the elections that the Party allowed at the local levels of Chinese society. These had always been seen as formulaic, because of the state-selected slate of candidates, but a few communities in China had insisted on writing in their own choice of names and then voting for them, though such candidates were disallowed by the Party if they ever won. In 1986 Fang and his students at Hefei ran some of their candidates, and staged a major demonstration when the Party refused to allow a fair election. News of the demonstration spread to other cities, most importantly to Wuhan and Shanghai, the two major industrial cities that had been so important during earlier phases of the revolution.

This seemed deeply threatening to some of Beijing's leaders, and early in 1987 they took decisive action. Not content with removing Fang Lizhi from his university administrative posts, and ordering him to concentrate his energies on scientific research, the Politburo leadership decided to make a scapegoat out of Hu Yaobang, whom Deng Xiaoping had personally elevated to be the secretary-general of the Communist Party. A youthful member of the Communist Party during the Jiangxi Soviet — he had only been fourteen years old when he first became involved — Hu Yaobang had been a popular and somewhat controversial figure under Mao, known for his wit and spirit, and for special expertise in the organizing of the Chinese Communist youth corps. After a series of meetings in February, Hu Yaobang was dismissed from his post and charged with having made 'mistakes on major issues of political principles'.

Hu Yaobang's dismissal was somewhat ironic, for he had been one of the first Party leaders to label the new experimental trends in literature, the arts and the cinema in the mid-80s 'bourgeois liberalization'. But the implicit danger of these student actions appeared to the senior leaders to presage a deeper danger, one that they were later to term 'spiritual pollution'. Most of these leaders had experienced at firsthand the humiliations and horrors of the Cultural Revolution, and to them the line between exuberance and anarchy was a very fine one that China could not afford to cross again. In a gesture startling to those who believed that Lin Biao was permanently laid to rest, they resurrected the symbol of Lei Feng, the self-denying PLA truck driver who laid down his life so that the revolution could flourish. All over China, the students and their teachers were told to study Lei Feng afresh. It seemed as if China's leaders wanted once more to push China back in time to an earlier period of revolutionary zeal.

ideas that had been prevalent in the May Fourth period, Fang saw democracy and science as closely intertwined: scientific research represented a search for truth via a scrupulous respect for evidence. The scientist could not close off his enquiry simply because it seemed to be leading in a direction he did not want to follow. The great scientists of the West had seen the truth as inviolable, and had resisted the state's attempts to deflect their research. Listening to the Christmas carols in King's College Chapel in Cambridge, Fang realized that Europeans, apparently confined within the Catholic hierarchies of the Middle Ages, had been able to evade

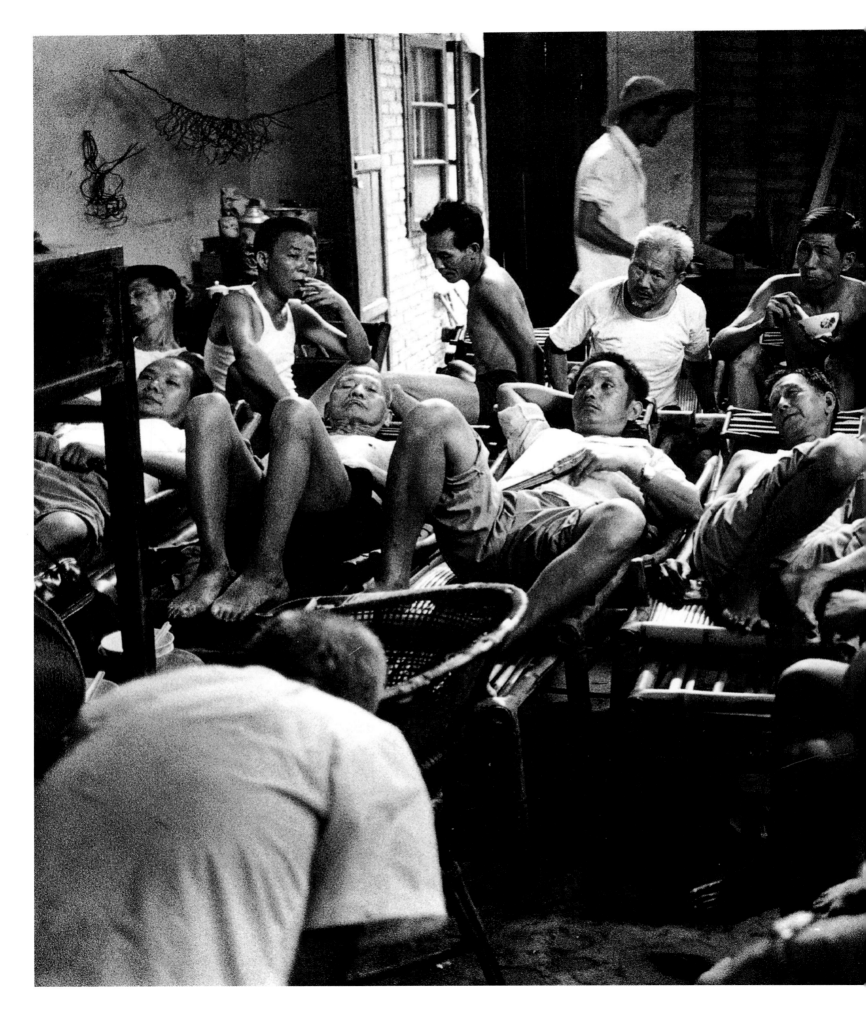

Men relax *on slatted chairs in a public bath house, snacking and smoking as they listen to a local story teller. Economic changes in China and the steady move away from collectivism in agriculture and industry brought new scope for initiative and new possibilities of prosperity to many workers, even as it brought instability and an end to a guaranteed job to millions of others. Political meetings and struggle sessions, which had taken up so much of what free time people had, were not so omnipresent now, and there was more leisure to enjoy whatever diversions were available.* [PHOTO: KOEN WESSING]

PRESSURES OF
THE NEW

To the youth who had to sit through the study and struggle sessions inflicted on them after the events in Hefei, the Party's actions seemed inappropriate, exaggerated, and tedious. To the young people of China in the late 1980s, the world was inconceivably different from what it had been twenty or even ten years before. China was now crowded with foreign visitors and tourists, thousands of Chinese went abroad to study every year, and a maze of joint ventures had brought Western businessmen not only to the booming Special Economic Zones but to cities all across China. Thousands of Western teachers were at work in high schools, colleges and universities. Both Catholic and Protestant churches began to reopen, and drew large congregations, though the Party refused to acknowledge the authority of the Vatican over Chinese Catholics. Taoist and Buddhist temples were also permitted to reopen so that earlier Chinese religious traditions could breathe again. Exchange agreements with major European and American film and television companies transformed the country's entertainment, and the foreign advertisements that came with the programs, as parts of the barter agreements, introduced more new ideas and a constantly changing sense of style. Western jazz and classical music were widely performed, and rock music was catching on among the young. Western books were pouring into China and countless new titles were translated within the country itself, with or without copyright. Tapes and video cassettes were pirated and distributed through street-stalls as well as regular retail outlets. Department stores took on new levels of glamor, making the old 'people's stores' seem ridiculously archaic, and shop staff learned to handle customers politely, rather than with the proletarian brusqueness that had been the norm before.

Perhaps more important than these direct influences from the West were the examples drawn from the overseas Chinese. For more than three decades, remittances from their relations in the USA and Europe had been a crucial source of income for many Chinese, and one of the only sources of foreign exchange for the government while it pursued a general policy of isolation. Now Hong Kong and Taiwan became of even greater significance, not least because each of these societies had been described for so long in negative terms. Tourists from Hong Kong had been flocking to China since the mid-1970s; after 1988, when Chiang Kai-shek's son died, the new president of Taiwan, Lee Teng-hui, eased almost all restrictions on travel between Taiwan and China, an offer eagerly seized by tens of thousands of families.

Reopening contacts between families separated for almost forty years had extraordinary emotional impact. At the same time, investment money from Taiwan began to flow into Hong Kong,

A young migrant laborer in simple wicker protective head-gear joins a group of hard-hat workers in the expansion of Shanghai's famous Nanjing Road shopping area in 1995. For the first three decades of the People's Republic, Shanghai's growth had been deliberately checked by the government, since it was viewed as being tainted by a triple legacy of foreign capitalist domination, organized crime, and an unruly populace. Some early Communist planners had even advocated relocating millions of residents. But with the growth of foreign investment in the 1980s, and the rapid development of enterprise zones and joint ventures, Shanghai became a center for high-speed economic growth once again. Immense demands for housing, factories, and office space, along with new roads and a subway system, brought an estimated two million migrant workers into the city by 1992. But as the city's labor force had to face inflation and the loss of their own 'iron rice bowl' jobs in sheltered state industries, they competed with the migrants in their turn.
[PHOTO: CO DE KRUIJF]

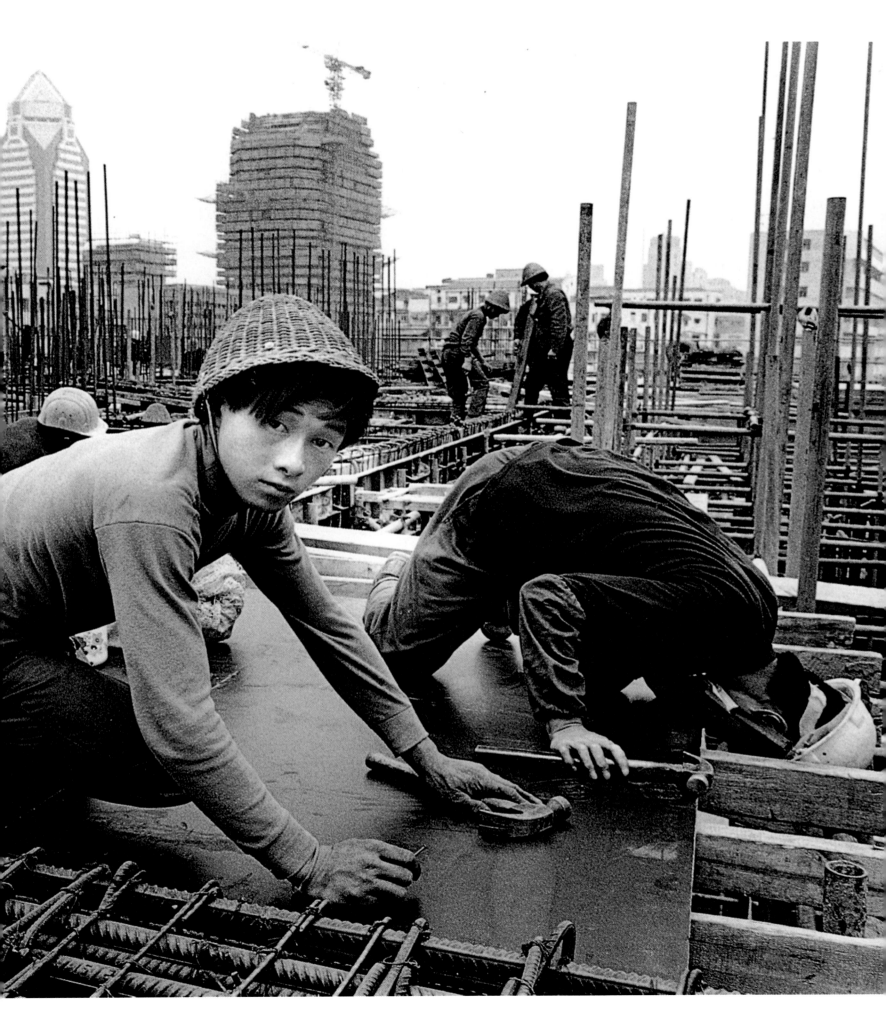

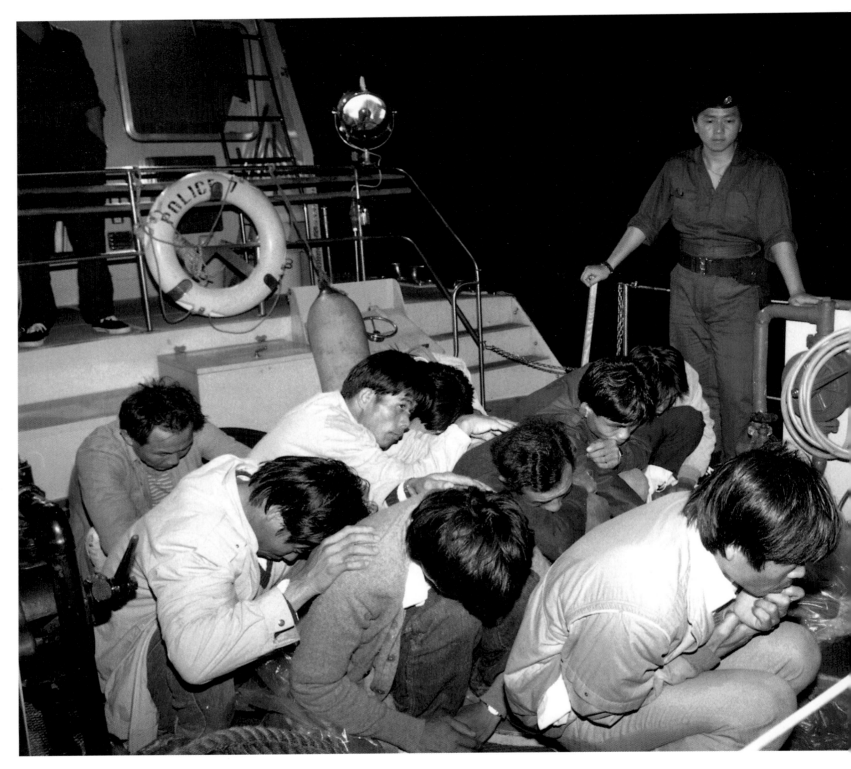

whence it filtered into China, to add to the immense amounts of Hong Kong money already invested in the special economic zones. Private philanthropy from Hong Kong and Taiwan Chinese to their birthplaces brought new schools and sports arenas to long-isolated villages, and important start-up money for new business and sideline occupations. The governmental structures of both Hong Kong and Taiwan were clearly changing. In 1984, the British government had agreed with China to return Hong Kong to Chinese sovereignty in 1997, the year that the ninety-nine-year 'leasehold' on the New Territories nominally came to an end. The British reached this decision reluctantly, but Hong Kong was not

defensible, and without the food- and water-producing New Territories there would be no way to keep Hong Kong island and Kowloon viable. (They had been acquired by the British in 1840 and 1860.) Belatedly, the British began to offer their Hong Kong Chinese subjects a measure of democratic control over their society and economy, in the hopes that by this means they could guarantee the 'one country, two systems' that the Communists had promised to honor after the 1997 transfer of power. China's hostility to these pro-democracy gestures was patent and public, and raised important questions about what the former colony's future fate would really be.

Hong Kong police *guard illegal Chinese immigrants caught on a naval patrol in 1987. Those captured were returned to the Mainland, though many subsequently made renewed attempts to find work overseas. In the late 1980s, decollectivization of labor in both towns and countryside brought new opportunities to many Chinese, but countless others lost the only support system they had ever known. Thus a growing number of Chinese workers tried to emigrate illegally in search of jobs. Despite the 1984 British agreement to return Hong Kong to Chinese control in 1997, the overcrowded crown colony continued to be a magnet for them.*
[PHOTO: PATRICK ZACHMANN]

who was from an indigenous Taiwanese-Chinese family, not a mainland-Guomindang refugee, and had been educated in Japan and the United States as well as in his homeland, all these processes accelerated. And though, like all his predecessors, he expressed himself strongly opposed to any 'Two China Policy' and to the 'Independent Taiwan' or 'Formosa Independence Movement', under his regime Taiwan was clearly moving towards becoming a prosperous and viable multi-party republic.

The collapse of the Communist Parties of Eastern Europe, for so long touted as among the People's Republic's most trusted allies, was equally astonishing, as it was followed through Western newscasts and satellite television communications in spite of the Party's efforts to suppress the information. When the same process began to happen even to the Soviet Union — which since the late 1950s had been branded by the Chinese Party as hostile to China, but had nevertheless remained a symbol of the monolithic political, economic and military power of the one-party Marxist-Leninist socialist state — the doubts were irrepressible. The attempts by Gorbachev to open up the Soviet economy mirrored on a larger scale what the Chinese Party was already doing under Deng Xiaoping and Zhao Ziyang. But Gorbachev's addition of domestic political reform, introduction of national elections, and curtailment of Soviet Party power all showed the routes which China might travel.

The changing nature of the Chinese domestic economy brought both prosperity and new tensions. Large numbers of state-run companies were either privatized altogether, or given new autonomous managerial staffs; work forces were cut back or reassigned, and dismissals for inefficiency or absenteeism grew more common. Access to export markets was permitted, and more regions were allowed to import foreign goods directly. Allocation of energy sources and key raw materials was still a State prerogative, but as the case of Wang Shouxin had shown in Heilongjiang, and as a host of even larger cases showed in the 1980s, there were myriad ways around such restrictions, through personal contacts, political influence, bribery, or the outright purloining of the necessary goods and transport facilities.

In the rural areas, the commune system was abolished altogether, and families were allowed to purchase contracts from the provincial authorities to work given areas of land in return for guarantees of a certain level of tax payment, or grain procurement. The length of such contracts steadily increased, until it reached fifteen years. This allowed the purchasers to subcontract for certain services, and even to buy the grain cheaply from other provinces in order to meet their procurement quotas, while using their own land for higher return cash crops for urban markets or for export to Hong Kong. Such practices in turn led to legal problems, in cases of death or divorce, or to tussles over the inheritance of such contracts by other family members. As economic opportunities grew, millions of families began to change their work patterns, relocating to nearby towns for instance, to work in local industry, while leasing their land, or leaving women, children and the elderly to work the land while the able-bodied

In Taiwan, too, the old days of absolute one-party rule, through the Guomindang monopoly of all important posts at the expense of the Taiwanese population, was also eroding. Chiang Kai-shek's son, Chiang Ching-kuo, had begun this process, introducing proper local and municipal elections, and beginning to convert Taiwan's pro forma 'legislature' into a body that represented the residents of Taiwan themselves. Though the idea of opposition parties running against the Guomindang was bitterly opposed until the late 1980s, and those attempting to found such parties had been harshly suppressed, that hostility too had begun to fade. With the accession to power of Lee Teng-hui,

men took jobs in factories or joined the construction crews that were at the heart of the nation's building boom. Such changes triggered waves of migrant laborers and contrasts of rural affluence and poverty that had not been seen since the Republican period. There was the victimization of women, numbers of whom were kidnapped and sent to impoverished rural areas to become, against their will, wives to local peasants. Other women, who escaped such a fate but could not make it on the land, began to turn to domestic service, and beggars once more became a common sight.

Just as the farmers now lost the subsistence level of security that they had enjoyed in the commune production brigades, and industrial workers lost their so-called 'iron rice bowls', so did the educated youth lose their guarantee of employment once they graduated. For almost forty years access to advanced education was so restricted in the People's Republic, and facilities so few, that those who emerged with their degrees and training could be sure of an assigned post, even if not exactly where or what they hoped. Education – as long as one could avoid being the victim of a mass campaign – brought prestige and a measure of social security. This assignment system came to an end in the late 1980s, the intention being to give more flexibility and opportunities to the young. In fact, the new openness brought more opportunities to those with good contacts and from prestigious Party families, but left many others directionless. In their view, the high-paying and glamorous jobs in the industrial and commercial sectors, especially those that brought access to foreign cash, contracts and perquisites, were being monopolized by gilded Party youth.

A number of prominent intellectuals, among them the scientist Fang Lizhi and the poet Bei Dao, pointed out to the government at the start of 1989 that this was a symbolic triple-anniversary year: the 200th anniversary of the outbreak of the French Revolution, the 70th anniversary of the May Fourth Movement, and the 40th anniversary of the founding of the People's Republic. It thus was an apposite time to ponder the interconnections between social progress and democracy, and to declare an amnesty for political prisoners like Wei Jingsheng, who had now served ten years of his sentence. The government either ignored these petitions, or criticized and harassed those who made them, though many students and intellectuals believed that the newly appointed secretary-general of the Party, Zhao Ziyang, was sympathetic.

The death of Hu Yaobang, the ousted Party secretary, in April, apparently from a heart attack while attending a volatile Party meeting, became the focal point for a rallying of opposition to the government, and for a host of career frustrations and anxieties, as well as giving rise to a spontaneous expression of grief for a politician many believed to have been flexible and intelligent. This movement was, in its inception, somewhat like that in memory of Zhou Enlai in the spring of 1976, as hundreds of students from Beijing-area colleges, followed by thousands of Beijing citizens, converged on Tiananmen Square with portraits of Hu Yaobang, wreaths, and messages of regret. The government forbade further demonstrations but, unlike 1976, did not enforce the order

The bright lights *of Beijing's Tiananmen Square attract a group of women students, before the great 1989 demonstrations erupted. Study space and enough light to read by were alike in short supply for China's students. Faced with the pressures of harshly competitive exams, many* *would leave their dim dormitories and libraries for well-lit public spaces, emulating those Chinese of historical and literary legend who studied by the light of glow worms, or by the cleverly reflected shimmer of neighbors' lanterns.*

[PHOTO: LIU HEUNG SH'ING]

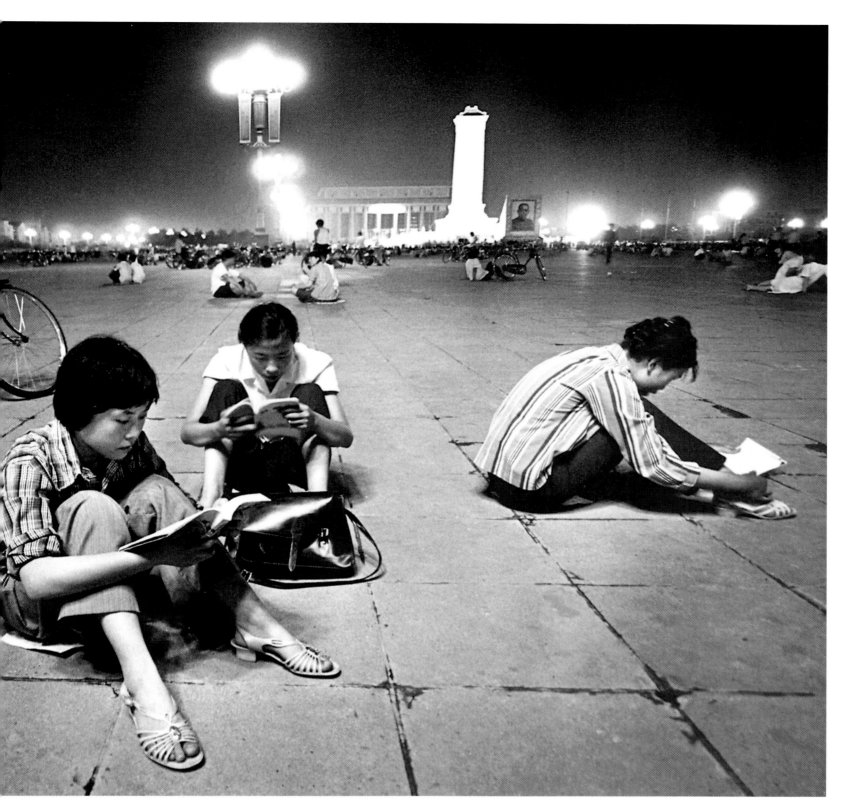

ruthlessly. So the crowds grew, the arena of debate expanded, and began to include demands for democracy along with criticisms of government corruption. Renewed government attempts to close off the Square were circumvented by determined crowds pushing through police lines, and on April 26, in an angry editorial in the Party press issued while Zhao Ziyang was out of the country on an official visit to North Korea, the demonstration was declared to be an example of 'counter-revolutionary turmoil', that was being financed and manipulated by outside agitators.

Now that they had been condemned in these uncompromising terms, many people's determination hardened. Groups of students and Beijing residents set up camp in Tiananmen Square, which swiftly took on the air of a giant carnival, with rows of tents, colorful banners flying, rock music playing and people dancing, amidst the speeches and slogans relayed by bull-horns. Though little coverage was given to these events inside China, television crews from around the world converged on the Square, partly out of interest in the demonstrations, but also because in mid-May

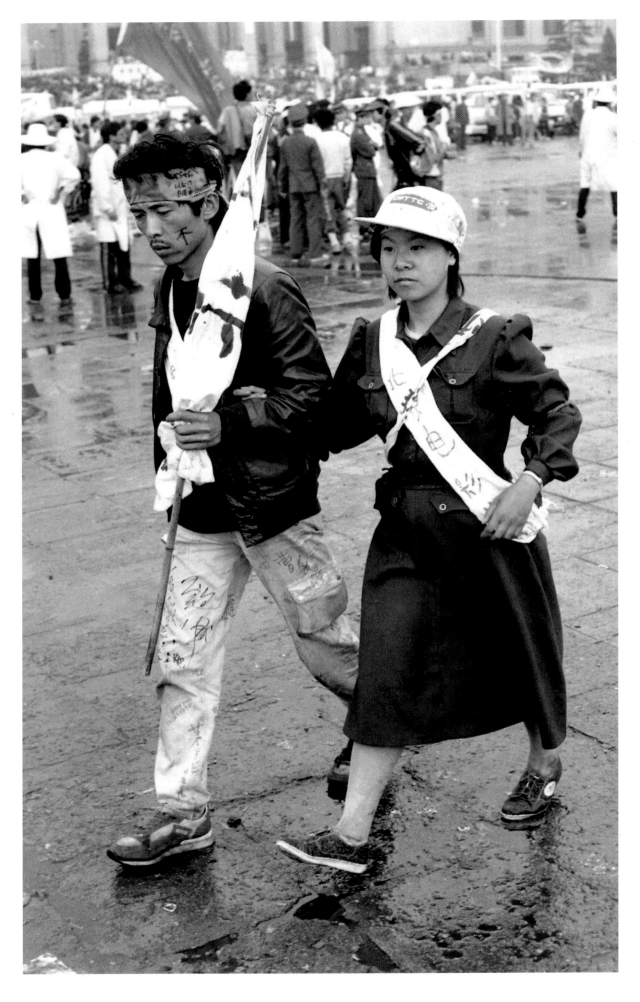

Students in the Square. *These two (left) have made the ten-mile hike from the outlying university campuses, in the rain on May 4, 1989, to join the rallies in Tiananmen Square remembering the May Fourth demonstrations of 1919 which had sought to move China onto the dual track of 'Science and Democracy'. The vast demonstrations of spring 1989 began by chance in April among students gathering to mourn the death of the recently deposed outspoken Party secretary-general Hu Yaobang. Speeches and posters soon attacked government corruption, discussed the problem of student job insecurity, and demanded a democratic forum to air grievances and plan for China's future. By mid-May thousands of demonstrators were camping out in the Square, and had begun hunger strikes in protest at the government's intransigence; the Beijing University history student Wang Dan (right) was one of those who emerged as a leader at this time. Wearing a head-band announcing he is a hunger-striker, he tries to bring some order to the demonstrations. But as the numbers swelled to over a million on some days, and the government showed its determination to use force to quell the disturbances, no individual leaders could any longer control the flow of events.*
[PHOTO, LEFT: DAVY]
[PHOTO, RIGHT: HSIEH SAN-TAI]

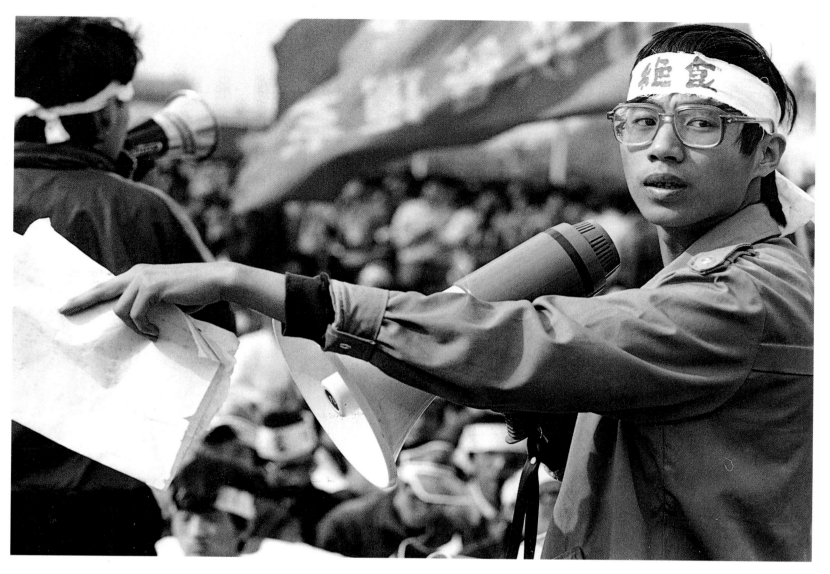

President Gorbachev was to arrive from the Soviet Union, to end the thirty-year rift with China.

By the time Gorbachev arrived, several thousands of the students had begun a hunger strike to emphasize their demands for reform, and the crowds in the Square grew to nearly a million. Gorbachev's visit was seriously disrupted, and he could not even enter the Great Hall of the People through the main entrance. The premier of China, Li Peng, who had held the office since Zhao Ziyang vacated it to take over as secretary-general of the Party, responded to students' demands for a face-to-face meeting, but he was so clearly angry, and the students so rude, that nothing was accomplished. On May 20, 1989 the Party leaders, furious, frustrated and embarrassed, declared a state of martial law in Beijing, and ordered the army to clear the Square.

Astonishingly, for almost two weeks, the troops could not – or chose not to – obey these orders. The roads to the Square were blocked by thousands of Beijing residents, with impromptu barricades or with their own bodies. They made supplies of food available to those camped in the Square, and helped keep open lines of communication between the various student groups and their own universities. Though few senior intellectuals spoke out publicly, many professionals and bureaucrats from government offices, official journals, and hospitals, showed their support by marching or appearing in the Square. The news of the huge demonstration had spread across China, bringing many curious observers or would-be participants from other provinces, along with local toughs or possible agents-provocateurs, who raised serious problems of security. Workers' groups also formed, and made their own tent base on the north side of the Square, declaring the formation of an 'autonomous workers' union'. This raised, however tentatively, the possibility of wider-scale worker involvement, even outbreaks of mass disorder and violence similar to those of the 1920s, or of the Red Guards in the 1960s.

By late May, many students along with their faculty mentors, and intellectuals who had watched the burgeoning movement with sympathy but also alarm, suggested that the students vacate the Square. They had made their point, and alerted the Chinese government and indeed the whole world to the fact that China needed radical political reform if it was to progress. But these voices of caution were overruled by the forceful arguments of other volatile student speakers, who felt that to disperse would be to abandon all their gains. Some of these students later claimed privately that they had wished for bloodshed, so the country as a whole would be shamed into change. At the end of May, students

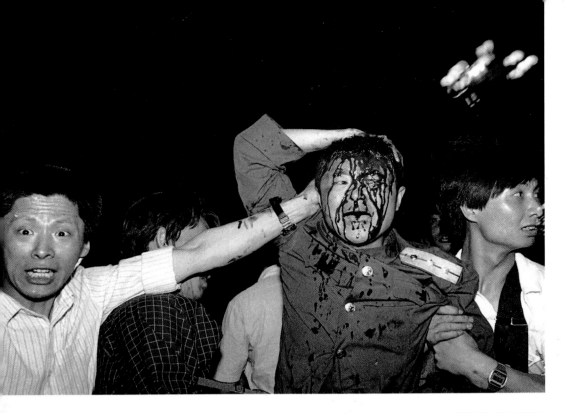

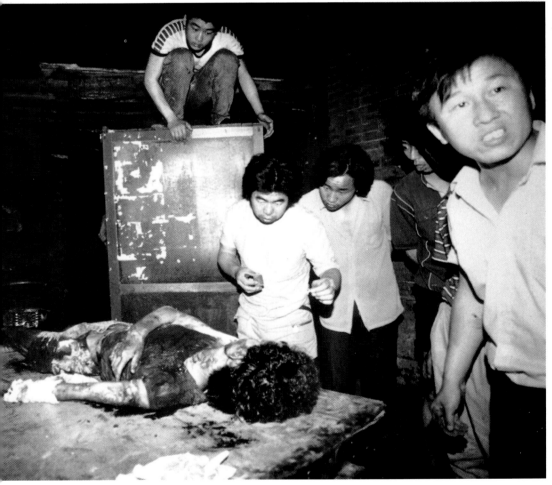

The nightmare peak of violence in Beijing came on June 4 to 5, 1989, as many hundreds, perhaps thousands, of Beijing residents were killed in the streets or in their homes by the random firing of the People's Liberation Army units sent by the Party leaders to restore order. The exact number of casualties will never be known, since a news blackout was imposed on the city, hospital records were suppressed, victims' bodies were burned or removed, and families were forbidden to mourn those members who had perished. Other demonstrations had erupted in many areas of China, but all had been forcibly suppressed by mid-June, and a country-wide hunt was ordered for all fugitives. Wang Dan (previous page) was among those arrested and imprisoned. [PHOTO, TOP LEFT: DARIO MITIDIERI] [PHOTO, BOTTOM LEFT: IMAEDA KOICHI] [PHOTO, ABOVE: ZONG HOI YI]

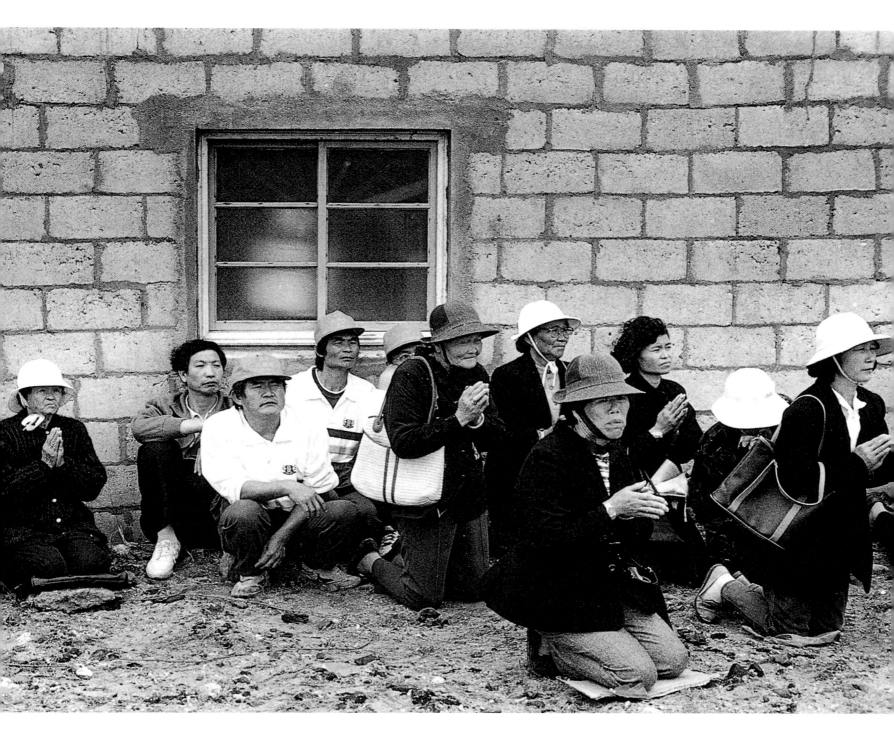

Organised religion *emerged in the mid-1980s with Party permission, because it could be a useful distraction from calls for democracy. Also, with the collapse of the Soviet Union and emergence of new Muslim-dominated central Asian republics, the Chinese government was anxious not to upset their own Western region's Muslim inhabitants (above left). Arguments with the Vatican over the appointment of bishops and the relation of Catholics to the state meant they remained divided between an accredited government-backed wing, which met in the formal church* *buildings, and those (left) who would meet unofficially for prayers and worship in the countryside. Popular cults originating in South-East China continued to thrive in Taiwan and on the surrounding islands, finding their expression through the ancient Taoist liturgies in temples and homes and even on the beach. A group of worshippers (above) on the island of Penghu pray to Mazu, the Goddess of the Sea, for her blessing and protection.*
[PHOTO, ABOVE LEFT: RHODRI JONES]
[PHOTO, ABOVE: HSIEH SAN-TAI]
[PHOTO, LEFT: YANG YANGKANG]

Monks and police. *There were renewed demonstrations against Chinese domination of Tibet in 1988, which were violently suppressed. Though many temples and monasteries had been destroyed during the Cultural Revolution, the Chinese did not forbid all Buddhist ceremonies. As shown here, in January 1995 the holy Tsong Khapa festival was held in Ganden monastery as it had been in the past, but the Chinese police presence was both watchful and highly visible.*
[PHOTO: KADIR VAN LOHUIZEN]

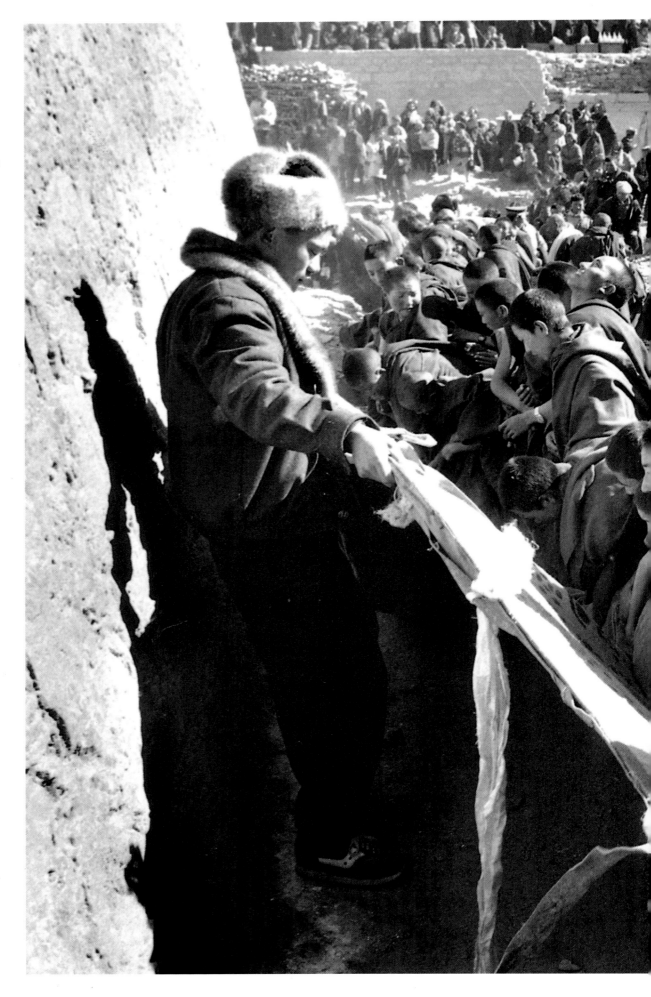

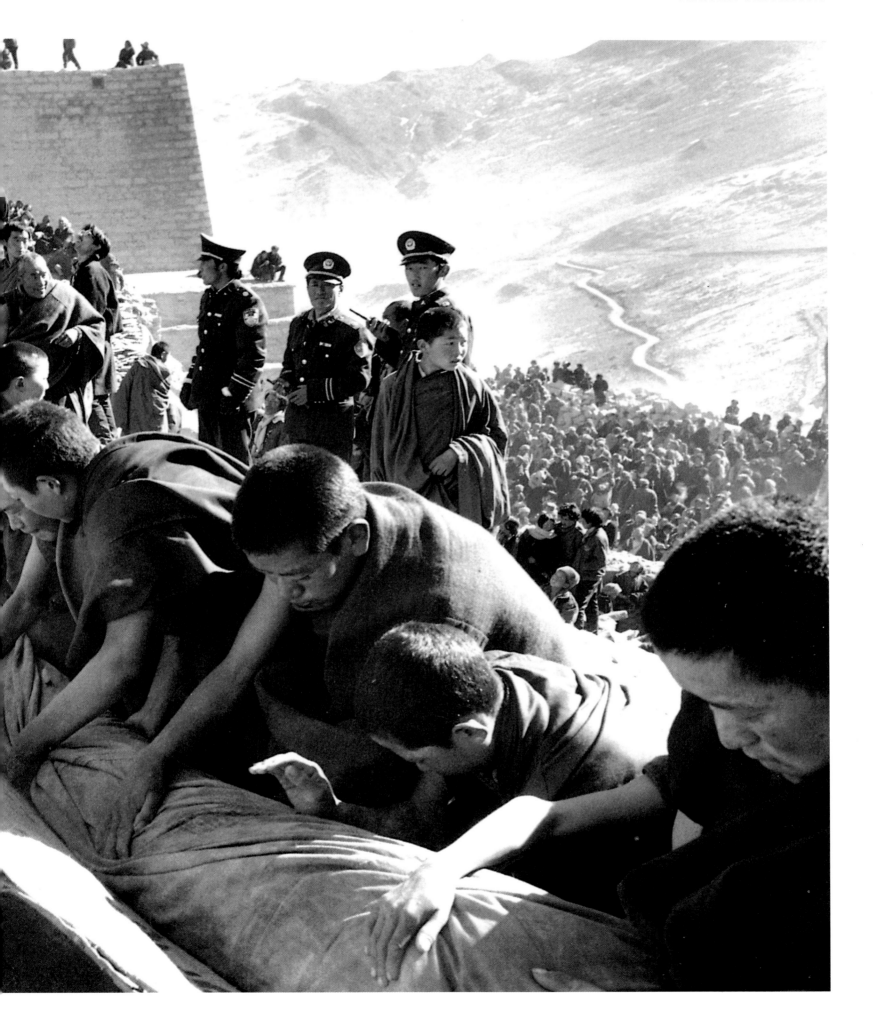

Cola and capitalism. *A Communist cadre fans herself (above) as she announces in 1993 to a Sichuan village boy standing on her right that, thanks to Coca Cola's sponsorship, he is about to be flown for a three-day all-expenses-paid holiday in Shanghai. The 1990s saw the growth of charity for the so-called 'deserving poor', which sometimes combined government initiatives through agencies like Project Hope with foreign corporate sponsorship. The boy took the trip, but it caused such*

bitterness in the village, and his family life was so disrupted, that he escaped back to Shanghai, and had to be escorted home a second time. Speculation mania (right) hit Shanghai in the early 1990s after the opening of the first Stock Exchange and introduction of lotteries. All new stock issues were snapped up, and riots broke out among those who missed out. Unscrupulous promoters were soon raising large amounts on the flimsiest of grounds.

[PHOTOS: YONG HE]

from the Beijing Academy of Fine Arts set up a large sculpture of a woman holding aloft a torch — soon dubbed the Goddess of Freedom — which stirred fresh enthusiasm. But after recurrent cycles of blistering heat and heavy rain, with sanitation problems mounting and enthusiasm faltering, it is probable that the movement would have slowly dissipated. However, the army and the Party leaders were no longer disposed to wait.

Late on the night of June 3, seasoned troops were smuggled to the edges of the Square through underground air raid shelter tunnels, and then stormed it. They were backed by other units and by tanks and armored cars that smashed their way through the outlying barriers, firing indiscriminately and crushing anyone in their path. Between dawn and noon on June 4, the Square was cleared of the last demonstrators. Many hundreds, perhaps thousands, of civilians were killed in Beijing, but a complete news blackout, the sequestering of all hospital records, the prohibition of all family mourning, the cordoning off of the Square and the burning or the removal of corpses, made it impossible to get any accurate tally. Infinitely more people had died in the civil war, during land reform, or in the Cultural Revolution, but this time the killings seemed particularly unnecessary and tragic.

Government reprisal was thorough and swift. Deng Xiaoping and other senior leaders met with the army officers and men who had ended the demonstrations, and praised them as heroes and saviors of the people. Student and worker activists, and their most prominent supporters, were hunted down and arrested. A most-wanted list of those who had escaped was circulated around the country. An unrelenting series of government pronouncements branded the demonstrators as ignorant and reckless, as betraying socialism and the state, and as being the tools of foreign manipulators. Though there had been sympathy demonstrations in many of China's other major cities, from Mukden to Shanghai, and from Wuhan to Lanzhou and Chengdu, there had been few if any foreign cameramen or observers there, and the various provincial governments were able to conceal the extent of the protests, and then to suppress them completely. The mayor of Shanghai, an engineer and career Party bureaucrat called Jiang Zemin, of little apparent distinction, did manage to control the major demonstrations that threatened to disrupt the vast city, and also defused worker agitation there by swift action. He was rewarded with promotion to the Politburo standing committee and the secretary-generalship of the Party. Outside China, the most massive sympathy protests were in Hong Kong, but they evaporated without incident. Some foreign protests were vociferous and emotional, but no governments imposed economic or diplomatic sanctions. China's leaders had won their gamble.

The Chinese government had calculated, correctly, that to most Chinese the economic gains of the previous few years were more important than the unknown and never-experienced values of democratic participation in government. In the six years after Tiananmen, as the students from China's colleges met in weekly study sessions to absorb the government's interpretations of what had occurred, and to listen to hortatory lectures on the values of

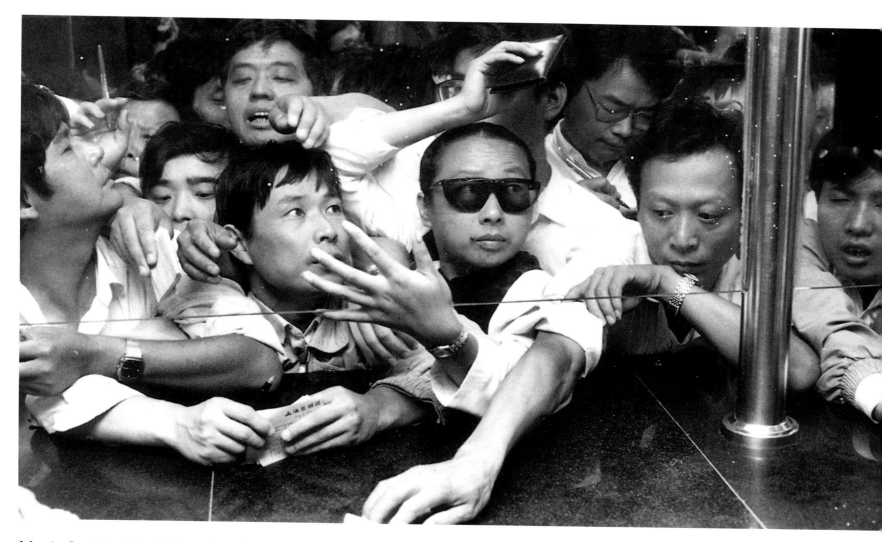

Marxist-Leninist-Mao Zedong thought, the focus of the country as a whole remained on economic growth. Recording an astonishing 13 percent growth rate in gross national product every year, and notching up a US$30 billion trade surplus with the United States, China's leaders' main problems were how to curb inflation, and how strictly to control the rate of investment and the monetary supply. There were clearly struggles within the leadership over this, and considerable caution about the wisdom of keeping growth at this level. Despite his age – he was then eighty-eight – Deng Xiaoping made a publicised tour of the new and rapidly expanding economic zones in south China in 1992, and emphasized that such change was good, and would encourage the development of a viable 'socialism with Chinese characteristics', but it was clear that he was not getting his way entirely. The collective agriculture of China was gone, but many of the huge state-controlled industrial enterprises remained, with their bloated bureaucracies, often unwanted products, and large, inefficient labor forces, since the risks of throwing so many workers on the job market were just too large to be considered.

Though the People's Liberation Army had seen both its budgets and its numbers cut in the 1980s, it had been encouraged to generate its own income by foreign arms sales, which it did with great success, including around 1 billion dollars-worth of rockets and other equipment to both Iraq and Iran. The displaced army officers were often given sinecures in the state industrial sector, and the armed forces were allowed to invest in a range of projects from hotels, resorts and nightclubs to industrial plants that brought untold revenue into their own pockets.

Such economic experimentation and success did not conceal the fact that many of China's traditional problems were still all too present. In 1991, the provincial government of Anhui blasted holes in the dikes on the Huai and Chu Rivers, flooding thousands of villages and leaving 900,000 people homeless, and a further 3 million cut off, in order to save the area's coal mines, power plants and down-river cities from being flooded and the less easily controlled urban population put at risk. The government spokesman defined this, in a metaphor drawn from Chinese chess, as 'giving up a pawn to save a chariot'. The exponential growth of cities like Shanghai, much of it locally financed or through foreign real estate companies and investors, brought different but equally intractable social problems. In 1992 the city authorities estimated that of the 100 million migrant laborers roaming China in search of work, over 2 million were concentrated in Shanghai alone – among them refugees from the previous year's Anhui floods – and the number had risen further by 1994, bringing an enormous increase in urban violence and crime, 60 percent of which was blamed on the migrant laborers. Housing and transportation became hopelessly overloaded, there was a corresponding increase

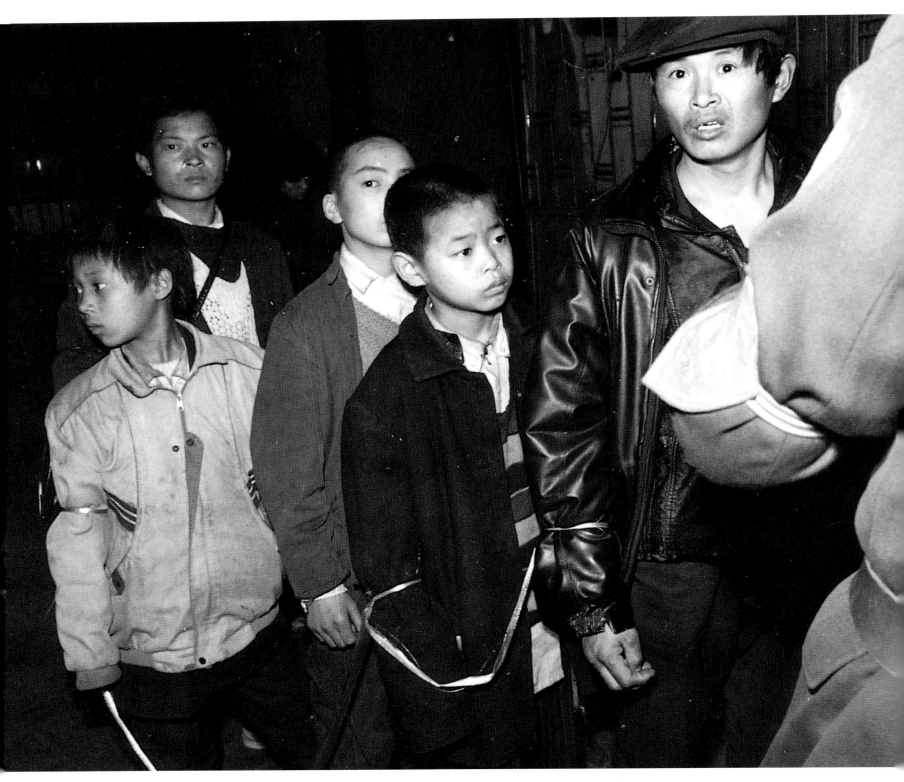

The lure of the city. *Twelve-year-old Chen Long (above, standing in dark jacket, center) awaits deportation from Shanghai fifteen hundred miles back to his home in Heilongjiang. He has managed to hitch-hike and beg his way from the north after his divorced mother remarried and abandoned him. The police regularly carried out sweeps of the new migrants to force them to return home. Chen returned empty-handed, but some (below, right) managed to cling to an armful of possessions when ordered home. Others, like the young migrant accused of stealing a bicycle (above, right), were often roughly handled by the local police and faced long prison terms if convicted. Most migrants learned*

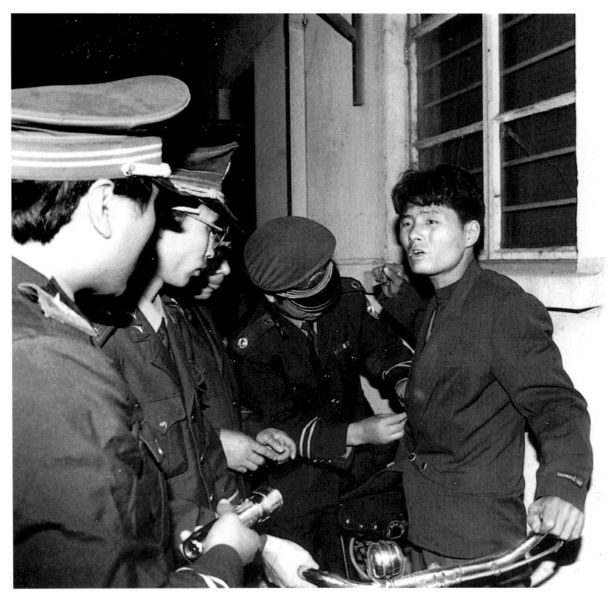

early on not to steal from locals and instead preyed on each other, increasing fear and suspicion among this enormous and dislocated floating population. By 1992 the government estimated that over one hundred million people were on the move across China in search of jobs, putting huge pressures on urban resources. [PHOTOS: YONG HE]

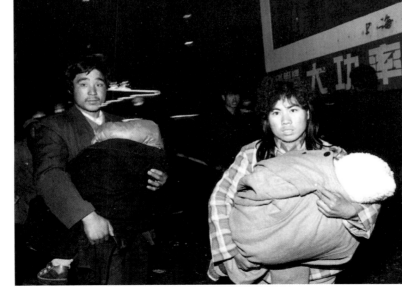

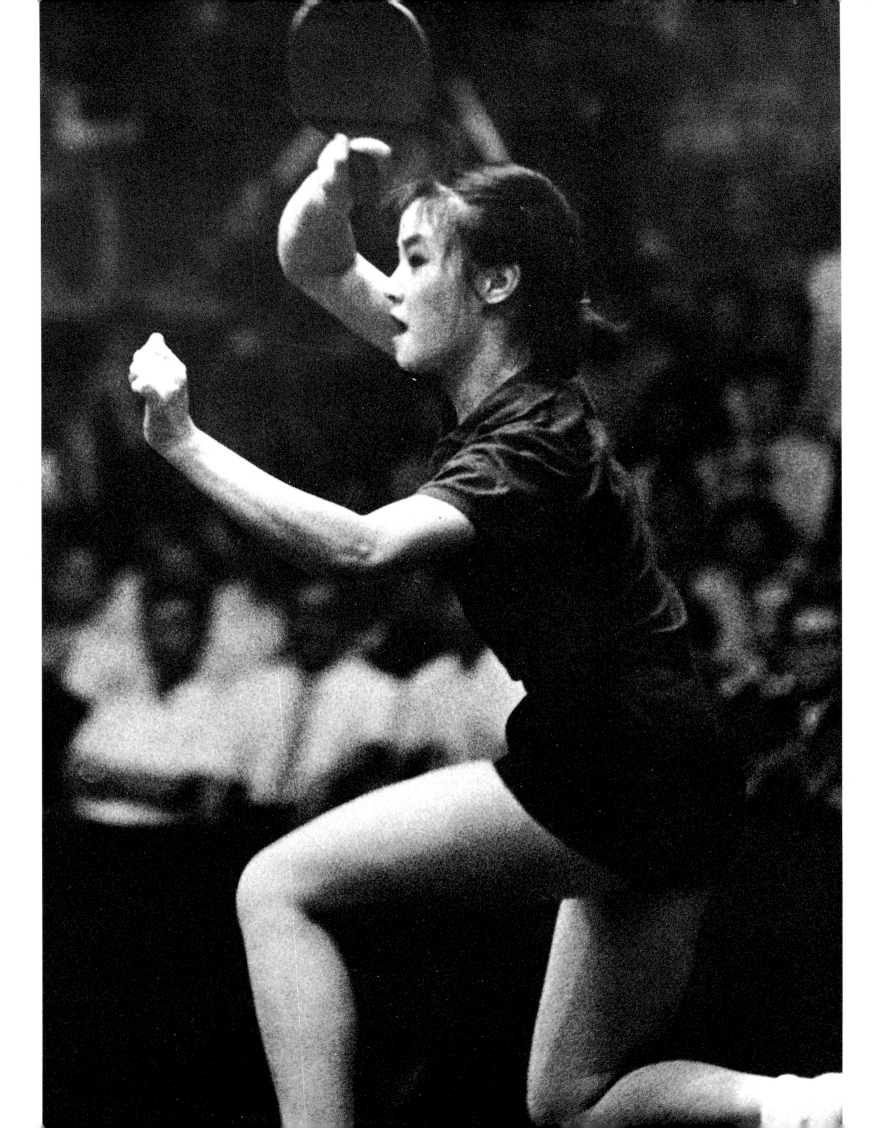

China competes. *Sports formed a rigorous but joyful release from economic and political pressures, and by the late 1980s China's athletes were becoming a formidable force on the world scene. Chinese brilliance at table tennis (far left) had in 1971 given rise to 'ping pong diplomacy' that first lifted the bamboo curtain between China and the United States. By the early 1990s selected Chinese children with the most suitable physique were being trained at ever younger ages (left) to prepare for international competition in gymnastics. In Taiwan (below), more subject to American influence, baseball became a passion in the schools, and Taiwanese boys' and girls' softball teams became regular champions on the international stage.*

[PHOTO, FAR LEFT: BRUNO BARBEY]
[PHOTO, LEFT: TOM STODDART]
[PHOTO, BELOW: RAYMOND J. YANG]

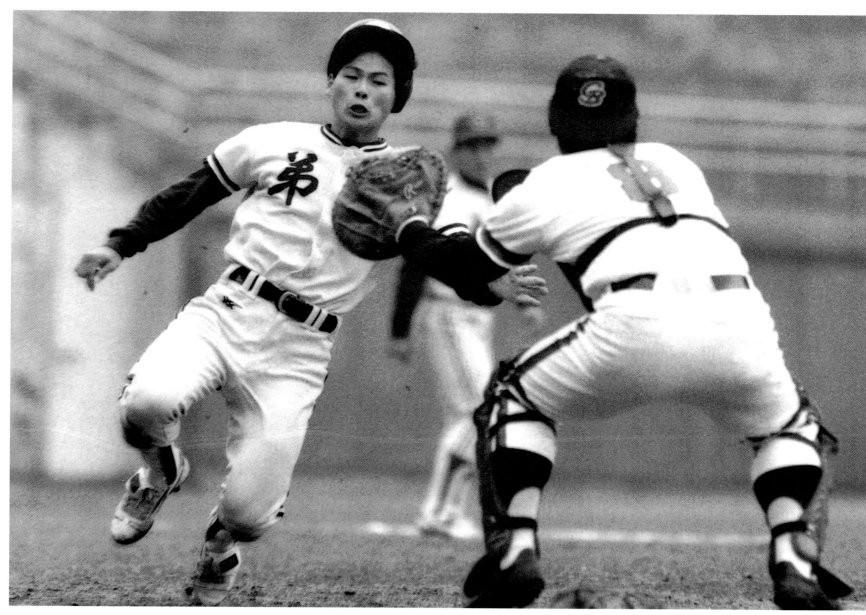

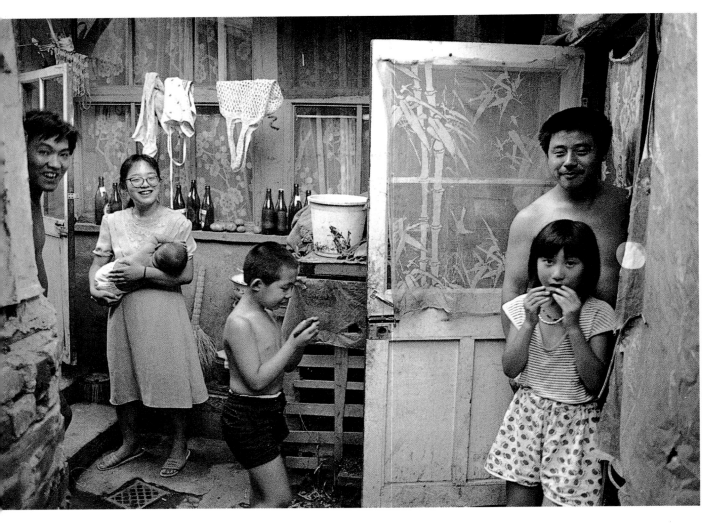

Ways of Life. *Housing remained hard to find, but countless couples made do with constricted space and shared kitchens (above), and raised their families cheerfully, as in this typical 'hutong' or alleyway dwelling in Beijing in the early Nineties. For many of the older generation (below) peace was found in the unchanged river life, in boats still built just as they had been in the Qing dynasty. There was also a new image of the untrammelled modern couple with their single child (far right), stepping out well-clothed and shod into the shiny new urban world — here it is Shanghai's luxury shopping street Huaihai lu, in 1995.*
[PHOTO, ABOVE AND RIGHT: XU YONG] [PHOTO, FAR RIGHT: CO DE KRUIJF]

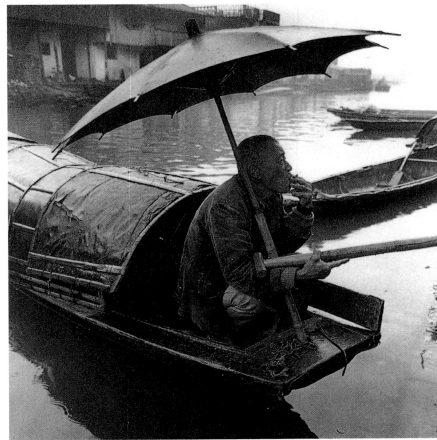

in unwanted pregnancies, and a desperately critical health situation among the migrant workers' 'tribal villages'.

The bureaucratic response to such problems was to urge ever more growth. In 1995, the municipality of Shanghai worked with German consultants and engineers and used locally raised funds to construct a subway system in the city at incredible speed, both to create more jobs and ease transportation bottlenecks. To solve flood problems, the biggest of all China's state-controlled enterprise schemes, the construction of the world's largest dam in the Three Gorges on the central stretch of the Yangzi River, was also pushed through the People's Congress by Premier Li Peng in 1994, after over forty years of debate and opposition by various planners and consultants. And only a few months after that, it was proposed to divert billions of gallons of water by aqueduct and pipe lines from the Huai River region to the water-starved north.

As the government struggled to control both the population and the economy, it was clear that the leadership was unable to maintain the same levels of supervision as in the past, but did not know how to delegate authority, or what means might be employed for social control. The rhetoric of Maoism was still widely used, and every leader from Deng Xiaoping downward emphasized that the basic political premises of their regime were unchanged. Yet by 1995, the problems affecting China were spilling over into new areas that called for imagination and forward planning on a vast scale. If not to be handled through some decentralized democratic means, they would have to be addressed by some form of central control. The membership of the Chinese Communist Party had passed the 45 million mark in the late 1980s, but in the 1990s many ambitious and educated young Chinese were making no attempt to apply for membership, so the prospects for the Party were for either a slowly aging membership or for one with a steadily shrinking educational base.

The environmental concerns that the next generation of leaders – whoever they were – would have to confront appeared truly intractable. One of these was the problem of a rapidly dropping water table all across northern China because agricultural and urban requirements had long since passed the available rainfall and the capacity to store it. The Huai River diversion scheme might partially address this, though it could not solve it, and the cost would be so immense that it was unclear how it could ever be met.

The Anhui flood *of spring 1991 triggered by immense rain storms in the Huai and Chu rivers region, was one of China's worst natural disasters in many years. As the death toll rose into the hundreds and damage to crops and property into the billions, dikes were opened to create 'flood diversion areas' and save crucial coal mines, industrial plants and urban centers downstream. In July it was announced that* *3 million were trapped by floods, 1.3 million had been evacuated and 1 million more were awaiting help. Those evacuated often had only a day's notice, and were instructed to bring nothing but their most precious possessions with them. This man was deposited by rescuers on dry higher ground during the Summer with his chosen keepsake, his coffin.* [PHOTO: YONG HE]

The shrinkage of China's arable land was rapid, as erosion and soil exhaustion combined with misuse of chemical fertilizer and the relentless sacrifice of good farmland to road building, industrial plants, and domestic housing. During the Cultural Revolution China had brought into cultivation all untilled but fertile soil — and had done colossal environmental damage by plowing up steppe grassland, stripping hillsides, and draining and cultivating lake beds and the overflow catchment areas adjacent to great rivers — one reason for the terrible Anhui floods of 1991. In the future there would have to be either massive food imports, to be paid for through increased exports of manufactured goods, or new technologies such as the hydroponic growing of crops in artificial soil substitutes, a risky and unproven area. With a population that reached 1.2 billion in 1995, China had an immense potential market for its own and foreign products, but would clearly have no

relief from pressures on the land and the food supply in the foreseeable future.

The hardships of life in the People's Republic, and the vigorous state espousal of mandatory population controls in the 1970s and 1980s, enforced by economic sanctions and sterilizations, or by compulsory abortions (often late in term) had curbed but failed to check entirely China's population growth. At the same time the policy led to agonizing social and human consequences, such as the infanticide of baby girls, the abandonment of other girl babies to orphanages in the hopes of adoption, or the use of fetal-scanning technology to determine the sex of the unborn child so that unwanted female pregnancies could be terminated. Yet, as the Party weakened, its ability to prevent such abuses and keep a brake on procreation could be expected to diminish. Water and air pollution, from fossil fuels and chemical effluents, were already so bad in the 1990s that they had led at times to open warfare between local communities and the contaminating industries of which they were reluctant neighbors. Pollution could only be expected to grow if the government implemented its plans — announced in 1995 — to build a car for every Chinese family in the coming decade. In comparison with these problems the preservation of bird and animal species threatened with extinction, so strongly urged by foreign observers, was hard to place as a top priority within China itself.

China's foreign policy was assertive after 1989. The collapse of the Soviet Union — perhaps reassuring in an odd kind of way to those in the leadership who warned of the perils of unplanned democratization without a viable economic base — presented a completely new arena for manoeuver among the newly independent republics in central Asia. China, as the new central power in that region, might gain access to water, fuel and new markets for its own far west. At the same time, the powerful Muslim forces in many of those republics raised disquieting prospects of possible unrest in Xinjiang, where the Uighur Muslims demonstrated energetically for a measure of increased religious autonomy and control in 1989. The Russians' deactivation of their main naval base at Vladivostok, when followed by the American abandonment of its own huge naval base at Subic Bay in the Philippines, made China — in the absence of a significant Japanese fighting force — the dominant naval power in the immense region extending from the South China Sea to Sakhalin. China took an aggressive stance against Taiwan, Vietnam, Malaysia, the Philippines, Brunei and Indonesia over the disputed oil and natural gas deposit in the Spratly Islands, although the area was 500 miles from China's shores. China's warships patrolled the area, and set up boundary markers in strategic locations. Its expanding nuclear submarine program, its successful launching of intercontinental ballistic missiles, its projected purchase of an aircraft carrier, and its mastery of in-flight fuelling techniques for its fighter-bombers, all highlighted the risks to the other claimants should confrontations escalate.

With the United States, major tensions continued. Despite their huge trade surplus, the Chinese were not mollified when, in

Challenges of the Nineties:
population growth and pressure for autonomy are two confronting China. Passers-by in Sichuan look uneasily (below) at an abandoned baby girl.

Demonstrators demanding independence for Taiwan in the early 1990s confront military police in Taipei (right).
[PHOTO, BELOW: CHEN RONG]
[PHOTO, RIGHT: RAYMOND J. YANG]

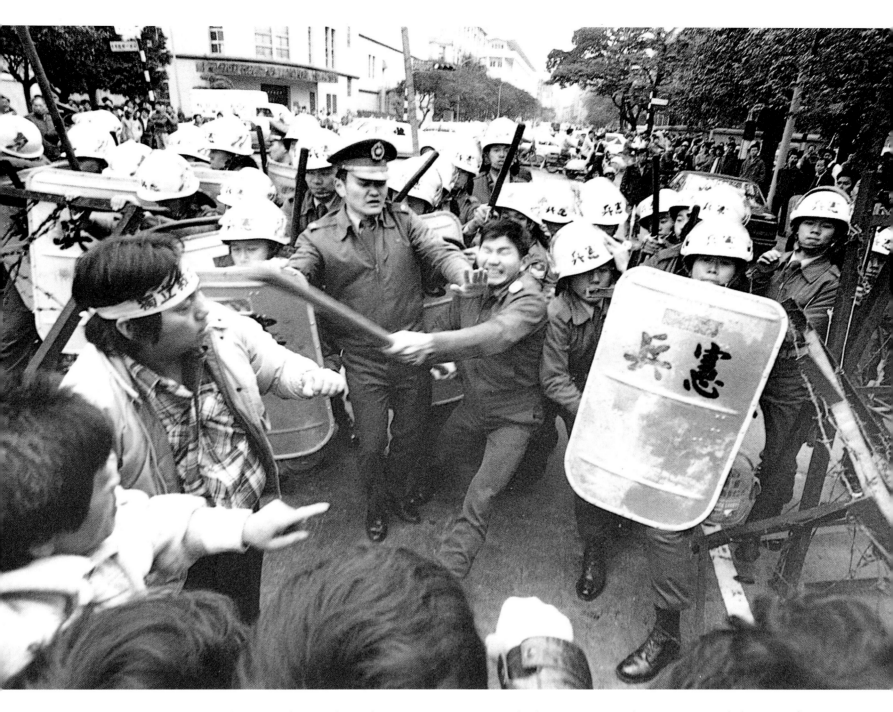

1995, the Americans ended the linkage of most-favored-nation trade status to continued 'progress' in Chinese human rights. Instead they smarted under American attempts to enforce copyright and intellectual property laws, arrested returned American citizens of Chinese ancestry if they actively pursued human rights concerns, and withdrew their ambassador to Washington when the Americans gave a visa for a short-term visit, to his old university of Cornell, to Taiwan's president Lee Teng-hui. Clearly, while the Americanization of large areas of the Chinese economy could be tolerated, the political implications that went with it were totally unacceptable. Great Britain was excoriated in 1995 for its attempts to continue working for some democratic freedoms for the Hong Kong Chinese before 1997, and for trying – through the construction of a gigantic new airfield on Lomtak Island and an enormous landfill project in

Hong Kong harbor – to strengthen Hong Kong's business future at the expense of the neighboring Chinese special economic zones in Shenzhen and Canton.

By 1996, a century had passed since the late-Qing government first tried to implement its constitutional and economic reforms, a century filled with immense hope, great experimentation, and almost unimaginable suffering. The China of the late twentieth century was undeniably stronger militarily than that of one hundred years before, foreign pressures were more muted, the economy much more diversified, and the people more unified, but the problems remained as immense as ever. A population over twice the size of that in the late Qing, and a leadership as elderly and as weakly grounded, faced as many future uncertainties and present trials as those which had confronted their long-vanished predecessors.

Into the future. *The quest for a decent material life dominates most other Chinese preoccupations in the mid-1990s. A young couple prepare for married life, assembling their wedding presents on boats in the coastal town of Xiamen, the former Western 'treaty port' of Amoy. Their possessions arranged in auspicious pairings amidst the votive candles and traditional offerings of ripening fruit, they carefully load their double mattress in anticipation of the years ahead.*
[PHOTO: XU YONG]

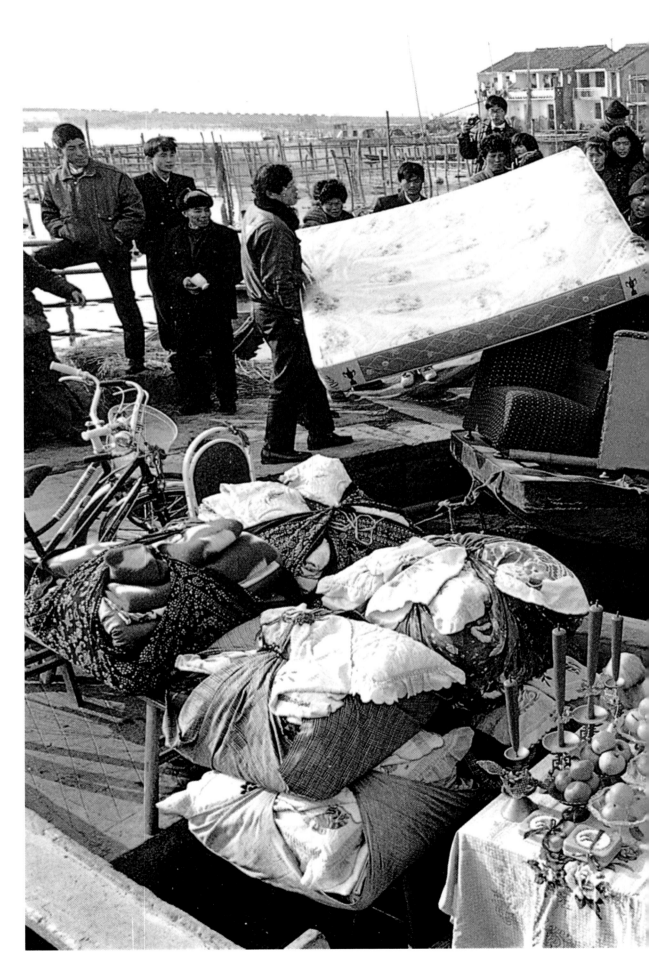

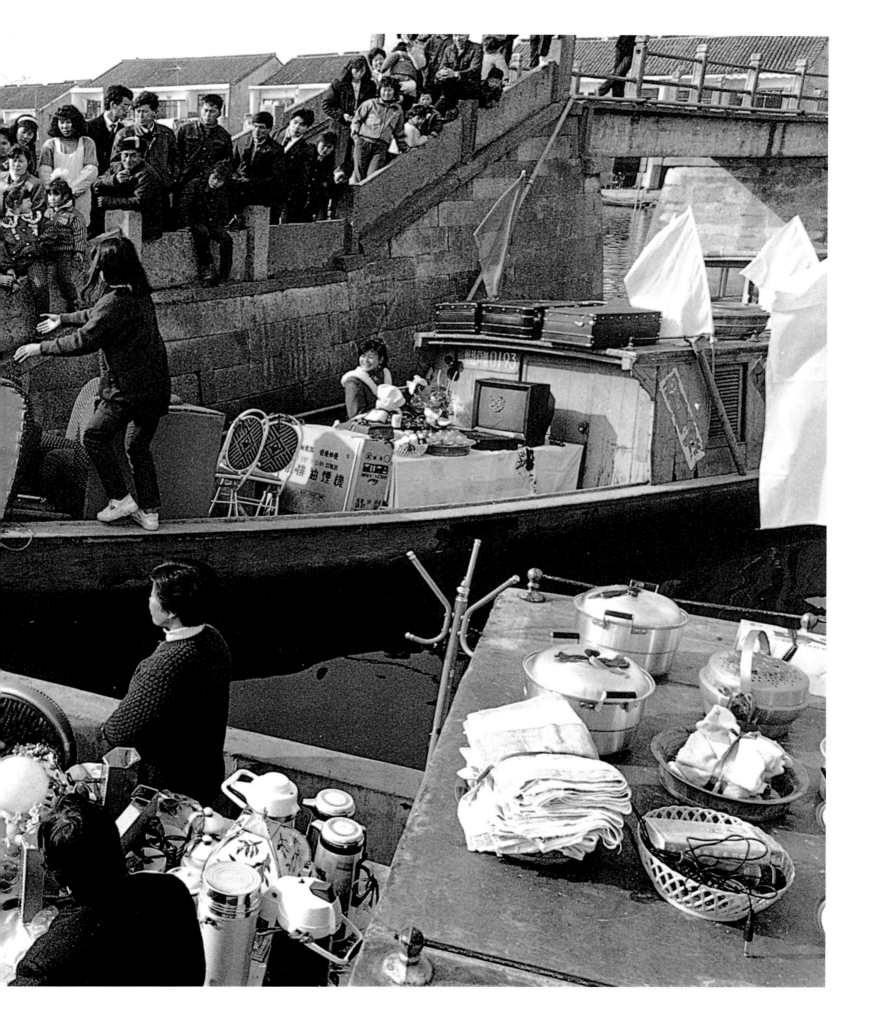

GLOSSARY & BIOGRAPHICAL NOTES

ANTI-RIGHTIST CAMPAIGN (1957) Persecution of intellectuals after Hundred Flowers Movement.

BEIJING MASSACRE (1989) On orders of CCP hardliners, hundreds of pro-democracy demonstrators were killed by PLA troops in Beijing.

BOXER UPRISING (1900) Attacks on Christians and foreigners by northern peasants originally supported by Empress Dowager Cixi, ending in unsuccessful siege of foreign legation area in Peking.

CIXI (1835-1908) 'Honorable Consort' of Emperor Xianfeng. On his death, in 1861, became Empress Dowager while her son was Emperor Tongzhi. On his death, made her nephew Emperor Guangxu in 1874. She effectively ruled China until her death.

COMINTERN International arm of Russian Communist Party, agents of which organized United Front of Guomindang and CCP.

CULTURAL REVOLUTION (1966-76) Mao encouraged 'permanent revolution' leading to countrywide chaos and attacks by young Red Guards on teachers and professionals.

DEMOCRACY WALL (1978-79) Posters advocating democracy were allowed to be put up on this wall in Beijing.

DENG XIAOPING (b1904) [Deng Shao-ping] Joined Communist Party in France in 1920. Veteran of Long March. High office in 1950s and 1960s then persecuted in Cultural Revolution. Premier 1980.

DUAN QIRUI (1865-1936) [Dwan Chee-ray] Chinese Premier after death of Yuan Shikai in 1916; made secret agreements with Japanese that sparked the May Fourth Movement.

FIRST FIVE-YEAR PLAN (1953-57) Soviet-style master plan for the economy.

FIVE-ANTI CAMPAIGN (1952) Aimed at industrialists who stayed on after 1949, it shattered individuals and families while consolidating CCP power.

FOUR MODERNIZATIONS Announced in 1978, embracing industry and trade, education, military organization and agriculture.

THE GANG OF FOUR Mao's third wife Jiang Qing and three others arrested in 1976 after death of Mao and blamed for excesses of Cultural Revolution since 1966.

GREAT LEAP FORWARD (1958-61) Utopian engineering by Mao to increase productivity through revolutionary fervor

and mass mobilization. Exaggerated reports of success hid disastrous falls in output. As least 20 million died famine-related deaths as result.

GREEN GANG Secret society which organized crime in Shanghai in 1920s and 30s. Used by Guomindang and business to suppress strikes and Communist activity.

GUANGXU (1871-1908) penultimate emperor of Qing dynasty. His Hundred Day Reforms, 1898, unsuccessful.

GUOMINDANG PARTY Nationalist Party, founded by Sun Yat-sen in 1905.

HU SHI (1891-1962) Professor at Peking University, writer. Leader of May Fourth Movement.

HU YAOBANG (1915-1989) Secretary-general of CCP. Dismissed in 1987 for supposedly supporting 1986 student demonstrations. His death a trigger for 1989 demonstrations.

HUA GUOFENG (b.1921) Premier after death of Mao. Edged out of power by Deng in 1980.

HUNDRED FLOWERS MOVEMENT (1957) Brief period when Mao asked for criticism from intellectuals.

JIANG QING (1914-1993) [Jee-ahng Ching] Mao's third wife, a former Shanghai actress. Major figure in Cultural Revolution. Arrested as part of Gang of Four, in 1976.

JIANGXI SOVIET (1928-34) Communists retreated to this mountainous area and formed new rural govt.

LEI FENG Young PLA soldier held up as a paragon of Communist virtues.

LIANG QICHAO (1873-1929) [Lee-ahng Chee-chow] Qing philosopher forced out to Japan in crackdown after Hundred Day Reforms in 1898. Later his Progressive Party an alternative to Guomindang.

LI DAZHAO (1889-1927) [Lee Dah-jou} A founder of the CCP, editor of *New Youth*. Executed by Zhang Zuolin.

LIN BIAO (1908-1971) [Lin Bee-yow] Keen supporter of Mao; compiled 'Little Red Book' of quotations from Mao. Named as Mao's successor, then killed two years later in mysterious aircrash.

LIU SHAOQI (1898-1969) [Leo-o Shaow-chee] Recognised as Mao's successor, but purged from Party in Cultural Revolution.

LONG MARCH (1934-35) 6000-mile journey by Communists from Jiangxi Soviet, fleeing Chiang's soldiers, to new base at Yanan.

MARCO POLO BRIDGE INCIDENT (1937) Japanese troops took this bridge outside Peking, beginning the Japanese invasion of China.

MAY FOURTH MOVEMENT (1919) Student demonstration in Tiananmen Square, Peking, against terms of Treaty of Versailles and deals with Japan. Also applied to subsequent intellectual ferment.

MAY THIRTIETH MARTYRS (1925) Unarmed students and workers fired on by British-led police in Shanghai.

NEW FOURTH ARMY INCIDENT (1941) Devastating attack on regrouped Communist forces by Guomindang.

NEW LIFE MOVEMENT Chiang Kai-shek's set of puritan values promoted in the 1930s to renew China's moral fibre.

NEW YOUTH Leading magazine of May Fourth period.

NORTHERN EXPEDITION (1926-28) Campaign by Guomindang - Communist forces, to reunify the country and free it from warlords.

ONE HUNDRED REGIMENTS OFFENSIVE (1940) Unsuccessful Communist attack on Japanese in N. China, countered by Japanese with great ferocity.

PUYI (1905-67) Last Emperor of China. Chief executive of Japanese regime in Manchukuo, 1932-45.

RAPE OF NANJING (1937-38) Seven-week period when Japanese plundered Chiang Kai-shek's capital city (Nanking), killing 100,000 or more.

RECTIFICATION CAMPAIGN (1942) Movement to make Mao's thinking dominant within the CCP.

RED GUARDS Students who spearheaded Mao's 1966 Cultural Revolution.

SONG JIAOREN (1882-1913) [Soong Jee-ow-ren] Prominent in Guomindang, killed on the way to take leading place in China's first parliament.

SPECIAL ECONOMIC ZONES Scheme for mostly eastern coastal cities promoted by Deng Xiaoping, allowing direct foreign investment.

SUPPRESSION OF COUNTER-REVOLUTIONARIES (1951) A campaign against Guomindang sympathizers, members of secret societies and religious sects. Thousands executed.

THREE GORGES PROJECT Dam on the Yangzi River begun in 1995.

THREE PEOPLE'S PRINCIPLES Sun's own formulation of an ideology for the Guomindang: 'nationalism, democracy, and people's livelihood'.

THREE-ANTI CAMPAIGN (1951) Attack on 'corruption, waste and obstructionist bureaucracy' in the Party, run in conjunction with the Five-Anti Campaign.

TIANANMEN INCIDENT (1976) Anti-Mao demonstration in Beijing sparked by death of Zhou Enlai. *See also* Beijing Massacre.

TWENTY-ONE DEMANDS (1915) Made by Japan and agreed to by Yuan Shikai, they increased Japanese hold on Manchuria and gave them new economic concessions in China.

UNITED FRONT Between Guomindang and CCP. The first (1923-27) was against the warlords and the second (1937-45) against the Japanese.

WANG JINGWEI (1883-1944) Leading figure within Guomindang in 1920s and 30s. In 1940 became titular head of collaborationist regime in Nanjing under Japanese.

WEI JINGSHENG Poster writer on the Democracy Wall. His calls for democracy and attacks on Party corruption got him a fifteen-year sentence. After release, renewed criticisms and gaoled again in 1995.

WHAMPOA ACADEMY Military academy near Canton. Sun Yat-sen set it up with Comintern help in 1924, and Chiang was its first commandant.

YUAN SHIKAI (1859-1916) [Yuen Shir-kye] Powerful commander of North China Army who engineered abdication of Qing Dynasty in 1912. Sun offered him presidency only to have him purge parliament and proclaim himself emperor.

ZHANG XUELIANG (b.1898) [Jahng Shweh-lee-ang] Warlord-son of Zhang Zuolin. Kidnapped Chiang in 1936 to force him to form a united front with Communists against Japanese.

ZHANG ZUOLIN (1875-1928) [Jahng Dzwo-lin] Manchurian warlord. Assassinated by Japanese in 1928.

ZHOU ENLAI (1899-1976) [Joe En-lai] Powerful and respected leader of CCP from time of the Long March.

ZHU DE (1886-1976) [Joo Deh] Chief military adviser to Jiangxi Soviet. Commander of WWII Red Army.

CHRONOLOGY

Entries in CAPITALS will be found in the Glossary opposite

1895 Sino-Japanese War and humiliating Treaty of Shimonseki.

1896 Qing attempt to kidnap Sun Yat-sen in London.

1898 Britain granted 99-year lease on New Territories next to Hong Kong. Emperor GUANGXU imprisoned by Empress Dowager CIXI, after unsuccessful Hundred Day Reforms.

1900 BOXER UPRISING. Russia builds naval base at Port Arthur and gets concessions in Manchuria.

1901 Qing army reforms begin.

1904 Russo-Japanese War, ending in 1905 with Japanese obtaining Port Arthur, and concessions in Manchuria.

1905 Anti-American boycott. End of Confucian exam system. Revolutionary Alliance (anti-Manchu) formed in Tokyo.

1908 Death of Empress Dowager Cixi and Emperor Guangxu. The Last Emperor PUYI, ascends the throne, aged 3 years.

1910 General YUAN SHIKAI removed from office by Qing regents.

1911 Republican Revolution overthrows Qing rule in central and south China. Sun Yat-sen creates provisional government in Nanjing.

1912 Elections. SONG JIAOREN organizes GUOMINDANG victory. Puyi formally abdicates. Yuan Shikai invited to become first President of the Republic. Peking is established as capital. Era of the warlords begins.

1913 Song Jiaoren assassinated.

1915 Japan's TWENTY-ONE DEMANDS accepted by Yuan Shikai, who purges parliament and declares himself Emperor.

1916 Yuan Shikai dies. He is succeeded by the corrupt DUAN QIRUI.

1917 150,000 Chinese laborers sent to work in France. Duan Qirui takes China into WWI on the side of the Allies.

1919 MAY FOURTH MOVEMENT. Demonstrations in front of the Tiananmen Gate and all over the country in protest at Versailles Treaty favouring Japan. Period of intellectual ferment. Chinese students flock to France.

1921 Chinese Communist Party (CCP) formally organized.

1922 COMINTERN agents from Soviet Russia contact Sun Yat-sen.

1923 Sun Yat-sen accepts Soviet aid and establishes military government in Canton. United Front between Guomindang and CCP.

1924 Sun Yat-sen establishes WHAMPOA MILITARY ACADEMY, with Chiang Kai-shek as its first commandant.

1925 Death of Sun Yat-sen. Chiang becomes Commander-in-Chief of Guomindang. Killing of Chinese by foreign troops in Shanghai (MAY THIRTIETH MARTYRS) and Canton, gives rise to anti-foreign feeling.

1926 Demonstrations against Japanese aggression. Chiang Kai-shek launches the NORTHERN EXPEDITION. Outbreak of civil war between Communists and Guomindang.

1927 Communists purged in Shanghai. Failure of Communist attempt to take over Canton. Mao Zedong flees to the hills. Comintern agents expelled.

1928 JIANGXI SOVIET established. Guomindang nominally rules from Canton to Mukden, with its capital at Nanjing.

1929 ZHU DE helps Mao form the Red Army. Great Famine lasting until 1931.

1931 Mukden incident, fighting between Chinese and Japanese troops. Japanese take control of all Manchuria.

1932 Japanese invade Chinese sections of Shanghai. Puyi made Chief Executive of Manchukuo by Japanese (1934, made Emperor there).

1934 THE LONG MARCH by Communist forces begins, from Jiangxi northwards. Mao Zedong takes leadership role. Japanese impose demilitarized zone in North China.

1935 New Communist base established in Yanan after Long March.

1936 After being kidnapped by ZHANG XUELIANG, Chiang forced to form a second UNITED FRONT with Communists against Japanese.

1937 MARCO POLO BRIDGE INCIDENT: start of Japanese invasion of China.

1938 RAPE OF NANJING. Chiang's capital moves to Chongqing. Mao becomes undisputed leader of the Communists.

1940 Communist ONE HUNDRED REGIMENTS OFFENSIVE defeated by Japanese. Collaborationist regimes in Peking and Nanjing.

1941 NEW FOURTH ARMY INCIDENT. 3,000 Communists killed by Nationalists. Breakdown of United Front. After Pearl Harbor in December, Nationalists become official ally of the United States.

1942 General Stilwell sent to aid Chiang by US. British lose Singapore, Malaya and Burma to Japan. RECTIFICATION CAMPAIGN within the CCP.

1944 Major Japanese offensive leads to 500,000 Guomindang losses. Chiang's reputation badly dented by evidence of corruption and repression.

1945 US drops atomic bombs in August. Japanese surrender. Russia reoccupies much of Manchuria, as agreed at Yalta, and gives arms to Communists.

1946 Renewal of civil war.

1947 US General Marshall unsuccessfully attempts to mediate when Chiang and Mao meet in Chongqing.

1948 Nationalists defeated by Communists in the north.

1949 Peking falls to Communists in January. Mao declares People's Republic of China. Peking renamed Beijing. Chiang flees to Taiwan.

1950 Outbreak of the Korean War. Tibet taken over as autonomous region. Land reform begins in Chinese countryside.

1951 SUPPRESSION OF COUNTER-REVOLUTIONARIES Campaign. THREE ANTI CAMPAIGN.

1952 CCP tightens grip on economy with FIVE ANTI CAMPAIGN.

1953 Ceasefire in Korea. FIRST FIVE-YEAR PLAN.

1955 Large peasant cooperatives formed and greater share of surpluses taken by the State.

1956 Khrushchev denounces Stalin.

1957 HUNDRED FLOWERS MOVEMENT in May. Stifled in June by ANTI-RIGHTIST CAMPAIGN.

1958 GREAT LEAP FORWARD begins. Backyard steel furnaces and People's Communes created. Violent protest against China in Tibet.

1959 Widespread food shortages.

1960 Famine, resulting from the Great Leap Forward, lasting until1962.

1963 Cult of Mao dominates Chinese society. *Quotations from Chairman Mao* published by LIN BIAO.

1965 Chairman Mao launches the CULTURAL REVOLUTION from his new base in Shanghai.

1966 RED GUARDS appear. China descends into ferment.

1967 Cultural Revolution reaches its most violent phase.

1968 Red Guards are sent to the countryside.

1969 Conflicts on the Soviet-Chinese border.

1971 The PRC gets seat at the United Nations formerly occupied by Taiwan.

1971 Death of Mao's heir-apparent Lin Biao after coup.

1971 Visit of US table-tennis team – 'Ping-pong diplomacy'.

1972 President Nixon's visit.

1973 Many officials overthrown in the Cultural Revolution return to office, including DENG XIAOPING.

1975 Death of Chiang Kai-shek in Taiwan.

1976 TIANANMEN SQUARE INCIDENT - demonstrations after death of Zhou Enlai. Deng Xiaoping dismissed again, while HUA GUOFENG rises to be premier and head of CCP. Death of Mao. GANG OF FOUR arrested.

1977 Deng Xiaoping returns to power.

1978 FOUR MODERNIZATIONS. DEMOCRACY WALL. Wei Jingsheng rises to prominence and calls for Fifth Modernization - democracy.

1979 One-child family policy begins. Four SPECIAL ECONOMIC ZONES created. Failure of Chinese Army's campaign against Vietnam.

1980 Deng becomes premier. Gang of Four tried and convicted.

1981 China opens up to foreign capital and dismantling of collective agriculture begins.

1982 Antispiritual Pollution Campaign mounted by Deng and CCP against western influence in the arts.

1984 Britain agrees to hand back Hong Kong to China in 1997.

1986 Fourteen more cities and the island of Hainan are made Special Economic Zones.

1988 Known hardliner Li Peng becomes premier of China. Violent protests against China in Tibet.

1989 BEIJING MASSACRE. Student protests crushed by Deng on June 4th in Tiananmen Square.

1990 Economic boom in Southeast accelerates.

1994 China loses bid to host Year 2,000 Olympic Games because of human rights record.

1995 China's maritime ambitions become more apparent. THREE GORGES PROJECT dam begun on Yangzi.

1996 China more bellicose towards Taiwan.

ACKNOWLEDGEMENTS

For helping us procure many precious photographs, our deep thanks go to the following individuals and institutions:

In Beijing, Wang Qingcheng and the Modern History division of the Chinese Academy of Social Sciences; Xu Peide and Zhang Fengguo at the news photo department of the Xinhua News Agency; Xia Chuntao and Zhou Yan; Su Shengwen, the Beijing Historical Museum, and the Chinese Revolutionary Museum; Tang Dajun and the Institute of Modern Chinese Literature; Cheng Shouqi at the Cheng Yanqiu family collection; the Palace Museum; Liang Congjie for the Liang and Lin family collection; the family of Fang Dazeng; Xu Yong; Li Zhensheng; Liang Xiaoyan; Gao Bo. In Jinan, Shi Panqi. In Nanjing, at the Chinese Historical Archive number two, Wang Xiaohua, Xu Shoulin, and Sun Yongxin; at Nanjing University, Shen Xiaoyun and Chen Qianping. In Shanghai, the Municipal Archives; the Historical Museum and Tang Weikang; Er Dongqian and Yong He; at Fudan University, Huang Meizhen.

In Taiwan, Su Tien-lun; Cheng P'ei-k'ai; Chin Heng-wei at *Tang-tai* monthly; Thomas Wu; at Academia Sinica, Chou Wan-yao, Wang Ai-ling, and Wu Mei-hui; Chung-yang she (Central News Agency); the Guomindang Party Archives at Yang-ming shan; the National Defense Archives (Kuo-fang Pu); Wu Chin-jung and the Wu Chin-miao collection; Chang Chao-t'ang; Hsieh San-t'ai; Raymond Yang; Liu Chen-hsiang; Lin Shou-i; the Teng Nan-kuang collection.

In the United States; Carma Hinton and Richard Gordon, Orville Schell, David Lattimore, Frederic Wakeman, Wang Chi, Ryan Dunch, Catherine Curran and the Sidney Gamble Foundation for China Studies; Raymond Lum [and the Hedda Morrison and Frank Canaday collections] at the Harvard-Yenching Library; the Peabody Museum; Harvard University; the United Methodist Archives; the Yale Manuscripts and Archives collection, the Yale-in-China Archives; the YMCA Archives; at Stanford, Sondra Bierre and the Hoover Institution Archives; in Los Angeles, at the University of Southern California, Paul Christopher and the George Krainukov collection.

In Canada, Sam Tata; in Italy, the Pontifical Institute of Foreign Missions, Milan; in France, Eric Baschet at Keystone, the Musée Guimet, Marc Riboud, Pierre Seydoux at the Association Auguste François; in Holland, Evelien Schotsman at Hollandse Hoogte; in England, the Overseas Missionary Fellowship and the Hulton Getty Collections.

PHOTO CREDITS
Agence France-Presse, Paris 190L; Agence Vu, Paris 213, 238, 241; American Museum of Natural History (Courtesy of Department of Library Services) 12-13L, 22, 31; Association Auguste Francois, Paris 222; Associated Press/Wide World Photos 98B, 152T, 157, 217; Beijing Historical Museum 55; Norman Bethune Archives/Osler Library of History of Medicine, University of Montreal 135; Black Star/Colorific 182-183, 206, 207; Central News Agency, Taiwan 115, 220; Chang Chao-T'ang, Taiwan 223T; Chen Rong 256; Chen Yanqiu Collection 223B; Chinese Academy of Social Sciences, Beijing 106, 107; Chinese Historical Archive No 2, Nanjing University 43B, 52B, 54, 56R and FR, 57, 66T and B, 68, 74, 75, 77L and R, 87R, 98T, 99, 128, 154, 155T; Paul Christopher Collection, (Contents page) 3, 116-117, 118, 120, 123, 126, 130-131, 132-133; Contact Press Images/Colorific 227, 236-237; Fang Dazeng Collection 122L; Sidney D. Gamble Foundation for China Studies, USA c1986 (Title verso page) 2, 13BR, 14T, 69, 100-101 (all photos); Guomindang Party Archives, Taiwan 30T, 33C, 50T, 56L, 71, 113, 138, 150, 155B; Harlingue-Viollet, Paris 48, 49; Harvard-Yenching Library/Frank Cannaday Collection: 14B/ Hedda Morrison Collection: 148-149 (all photos), 166B; John Hillelson Agency 45T, 189; Hsieh San-T'ai, Taiwan 239, 243; Hollandse Hoogte, Amsterdam 228-229, 230-231, 233, 253; Hoover Institution Archives, Stanford University/Milly Bennett Collection 70, 88/Alexander H.Buchman Collection 73, 93/Frank Dorn Collection 102T, 140/Jay Calvin Huston Collection 92/Joshua B.Powers Collection 24-25R, 32, 33R/Albert Wedermeyer Collection 151/Ivan D. Yeaton Collection 144; Hulton Getty Collections 51, 59, 78T, 79, 80-81, 89, 94, 102B, 103, 111, 124-125, 127, 129, 142, 143, 156B, 171, 194-195; L'Illustration/Sygma, Paris 13TR, 18T, 20T, 26, 34-35, 44-45 main photo and TL, 52-53R, 56FL, 76, 96, 97; Katz Pictures 251T; Liang Congjie 104-105 (all photos); Li Zhensheng 197, 198, 199, 201, 205, 208, 209, 211, 218-219 (all photos); Liu Chen-Hsiang 224-225; Magnum, London (Half title page) 1, (Title page) 4-5, 6-7, 168-169, 191, 214, 216, 234-235, 240B, 250; Dario Mitidieri 240T; Musée Guimet, Paris/(CR) Photos RMN 10, 15, 16; Overseas Missionary Fellowship/School of Oriental and African Studies, London 20B, 134, 166T, 167; Palace Museum, Beijing 28-29, 37, 62-63 (all photos), 110T; Panos Pictures, London 242T; Peabody Museum of Archeology and Ethnology, Harvard University/Lattimore Foundation 136-137 (all photos); Pontifical Institute of Foreign Missions, Milan/Leoni Nani Collection 17, 21, 24L, 38-39, 43T, 46TL, 46-47; Rapho, Paris 202-203; Roger Viollet, Paris 41, 90-91, 112; Shanghai Historical Museum 82 (all photos), 83, 84, 85; Shanghai Municipal Archives 86-87L; Shi Panqi 163, 176, 177; Sam Tata/Courtesy B.T. Batsford, London 158, 159; Teng Nan-Kuang Collection, Taiwan 108, 145, 146-147 (all photos); United Methodist Church Archives, Madison, New Jersey 18B, 27, 40, 42, 60, 61; Underwood & Underwood, San Francisco 110B; Wu Chin-miao Collection, Taiwan 109; Xinhua News Agency, Beijing 52TL, 114, 152B, 153, 156T, 161, 162, 164, 165, 170, 172T and B, 173, 174, 175, 178, 180-181, 184-185, 187, 193, 200, 204T and B, 210, 221, 226; Xu Yong, Beijing 252T and B, 258-259; Y.M.C.A. of America Archives, University of Minnesota 64, 65, 67; Yale University-in-China Archives, Yale Manuscripts and Archives Collection 50B; Raymond J.Yang, Taiwan 251B, 257; Yang Yankang 242B; Yong He, Shanghai 246, 247, 248-249 (all photos), 254-255.

QUOTATION SOURCES
p.58 (caption) Puyi, former Emperor, *Autobiography*; p.70 Ross Terrill, *Mao*, 1980, New York; p.70 (caption) Milly Bennett, *On Her Own*, 1993, New York; p.88 (caption) Milly Bennett, *On Her Own*; p.97 W.H. Auden & Christopher Isherwood, *Journey to a War*, 1939, London and New York; p.112 (caption) Puyi, *Autobiography*; p.119 (caption) Frank Dorn, *Sino-Japanese War, 1974*; p.121 (caption) Frank Dorn, *Sino-Japanese War*; p.122 (caption) Frank Dorn, *Sino-Japanese War*; p.127 Frank Dorn, *Sino-Japanese War*; p.128 Frank Dorn, *Sino-Japanese War*; p.135 Edgar Snow, *Red Star Over China*, 1938, New York; p.142 Joseph Stilwell, *The Stilwell Papers*, ed. Theodore White, 1948, New York; p.142 Claire Lee Chennault, *Way of a Fighter*, 1949, New York; p.142 Auden & Isherwood, *Journey to a War*; p.142 Joseph Stilwell, *The Stilwell Papers*; p.158 Derk Bodde, *Peking Diary, 1948-1949: A Year of Revolution*, 1968, Toronto; p.172 (caption) Zhisui Li, *The Private Life of Chairman Mao*, 1994, London and New York; p.176 R. MacFarquhar ed., *The Hundred Flowers*, 1960, London; p.179 (caption) Zhisui Li, *The Private Life of Chairman Mao*; p.179 (caption) R. MacFarquhar, T. Cheek, E. Wu, eds., *The Secret Speeches of Chairman Mao from the Hundred Flowers to the Great Leap Forward*, 1989, Cambridge, Mass; p. 180 (caption) Zhisui Li, *The Private Life of Chairman Mao*; p.181 Ningkun Wu Yikai, *A Single Tear*, 1993, London and New York; p.183 (caption) *The Secret Speeches of Chairman Mao*; p.188 (caption) *The Secret Speeches of Chairman Mao*; p.196 (caption) Liu Sola, *Chaos and All That*, 1994; p.203 (caption) Liu Sola, *Chaos and All That*; p.212 (caption) Zhisui Li, *The Private Life of Chairman Mao*; p.212 (caption) Jung Chang, *Wild Swans*, 1991, London and New York; p.122.

For bibliographical guidance on modern Chinese history, refer to 'Further Readings', pp. 769-788, in Jonathan D. Spence's *The Search for Modern China*, 1990

INDEX